D0835934

746.
922

673

3 MA

1 5 NO

- 7 JAN 20

1 1 APR

200

004

004

2004

R 2004 - 5 JUN 20

MAY 200

N 2004

OCT 2004

V 2004

2004

AN 2005 - 6

3 2005

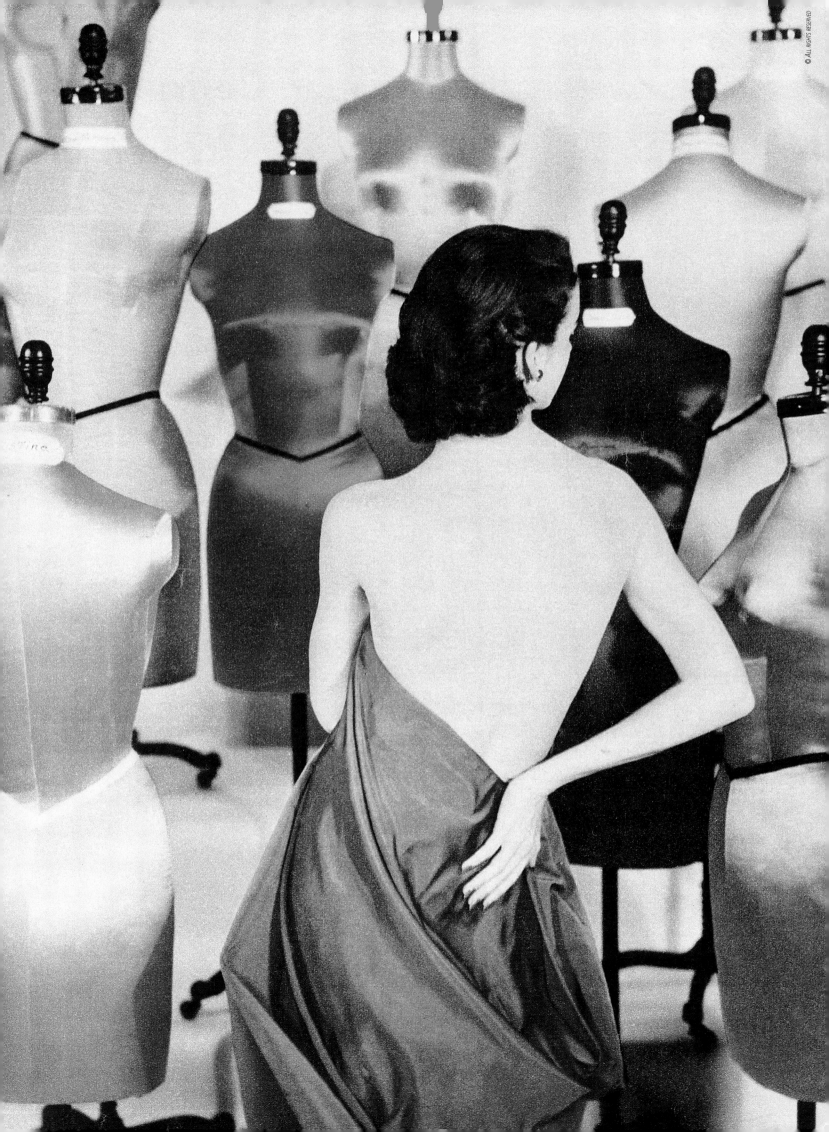

© ALL RIGHTS RESERVED

To Bernard, Ximena, Pauline, and Jean-Francis.

Original title: *Créateurs de Modes*
© 1999, Éditions du Chêne-Hachette Livre

First published in 2001 in the United States by
Watson-Guptill Publications,
A division of BPI Communications Inc.,
770 Broadway, New York, NY 10003

ISBN: 0-8320-1639-0

Library of Congress Card Number: 00-109854

All rights reserved. No part of this publication may be reproduced or used in any form
or by any means—graphic, electronic, or mechanical, including photocopying, recording, taping, or
information storage and retrieval systems—without written permission of the publisher.

Manufactured in Italy

First printing, 2001
1 2 3 4 5 6 7 8 08 07 06 05 04 03 02 01

1950
PRECEDING PAGE:
Charles James's "jennies."

FASHION
DESIGNERS

PAMELA GOLBIN

CRAVEN COLLEGE

WATSON-GUPTILL PUBLICATIONS / NEW YORK

From War Shortages to the Golden Age of French Couture (1940-1963)

"They say that the Paris air inspires designers and guides their needles."[1]

The supremacy of Parisian haute couture, which was the leading source of creativity in Western women's fashion, was seriously challenged during the Second World War. In June of 1940, the Germans made it clear that they intended to annex the entire industry and move it either to Berlin or Vienna. Lucien Lelong, president of the Chambre Syndicale de la Haute Couture, and Daniel Gorin, the secretary general, managed to obtain a waiver, thereby saving a cultural heritage of inimitable expertise and a tradition of craftsmanship.

The occupying forces initially gave thirty fashion houses (later increasing the number to fifty) authorization to present collections that had no more than seventy-five designs—in other words, one-quarter of the prewar production. Each establishment had to make do with fluctuating restrictions on raw materials. Only a highly privileged clientele—wives of Nazi dignitaries, wealthy French women, and mistresses of collaborators—had access to haute couture fashion.

Between 1940 and 1945, the traditional image of the woman at the mercy of changing fashions shifted toward that of an independent, resourceful woman for whom, despite

1. "The importance of useful things," by Claude Blanchard, *Vogue* (French edition), the Liberation issue. January 1945, page 160.

1949

1950

1951

draconian rationing measures, pragmatic, utilitarian clothes with sober, clean lines were being designed. Clothing coupons, instituted in July of 1941, ushered in four years of shortages during which any purchase of an item of clothing required a certain number of coupons. Yet by the following year, there was nothing to be found on the market, with or without coupons.

Clothes stores promoted the idea of recycling used materials and supplied designs that women could sew themselves. Women dipped into men's closets—borrowing pants and redesigning coats—in preparation for the cold winters and poorly heated apartments. Accessories were the only way to renew a wardrobe. Hats made of the most unusual materials illustrate the exuberant and whimsical sense of design of the era.

Textile rationing was set up in England in 1941. Under the auspices of the Incorporated Society of London fashion designers, known as Inc. So., English designers such as Norman Hartnell, Bianca Mosca, and Hardy Amies worked with the restrictions and shortages of raw materials, designing clothes that were both esthetic and useful. Their creations, known as Utility garments, formed the basic wardrobe of civilians through 1949, but these clothes remained in fashion for three more years.

The American fashion industry, which drew its inspiration primarily from French

haute couture, was isolated. A consequence of the war, this political situation meant that U.S. designers received unprecedented support at home. Large stores such as Lord & Taylor promoted American designs. *Vogue* devoted its annual issue, *Americana*, to local fashions. The American Fashion Critics Coty Awards were inaugurated in 1943, with the sponsorship of Eleanor Lambert, to reward the best collections of the year or to pay tribute to a career or to a new talent. Sportswear designers finally received support from their own industry, thus developing what would become the "American look." The government imposed restrictions, known as "L 85," which were embodied by the Victory Suit.

With the end of the war, the supremacy of the Parisian fashion industry was under attack. The Chambre Syndicale de la Haute Couture organized the "Théâtre de la Mode," a traveling exhibition consisting of 160 wireframe dolls (27 inches tall) designed by Éliane Bonabel. These representatives of Parisian fashion wore outfits created by forty couturiers and thirty-six milliners and were placed in miniature theater sets designed under the direction of Christian Bérard by such artists as Jean Cocteau and Jean Denis Malclès. More than 100,000 visitors came to see the tiny models when they were exhibited in March 1945 at the Musée des Arts Décoratifs in Paris. They then traveled around the world and were immensely popular wherever they were displayed.

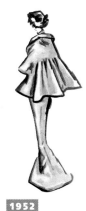

1952

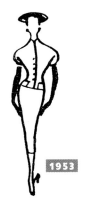

1953

1954

But it wasn't until February 12, 1947, during the presentation of Christian Dior's first collection, that Paris fashion once again conquered the international market.

Prestige Returns: Christian Dior's New Look

"The style that was universally hailed as new and original was nothing but the sincere and natural expression of a fashion I had always sought to achieve. It happened that my own inclinations coincided with the spirit of sensibility of the times." CHRISTIAN DIOR[2]

The New Look, the fashion silhouette launched in 1947, constituted a definitive break with the military styles of the preceding years. Promoting luxury, it created a fashion revolution and raised Christian Dior to the rank of fashion dictator. Based on two main themes, the first collection included two lines: "Corolle" ("Corolla" in English), distinguished by extremely full skirts, tiny waists, and tightly fitted bodices; and "8," with "clean, curving lines, open neckline, miniscule waist, and accentuated hip line." These clothes embodied the desire for a fragile, sophisticated elegance. Although rationing restrictions allowed only three yards of fabric to make a dress, *Chérie*, one of Dior's keynote

2. *in* DIOR (Christian), *Christian Dior et moi*, bibliothèque Amiot-Dumont, 1956, p. 41.

evening gowns, required five times that much material. The silhouette designed by Christian Dior revived a fashion inspired by the romantic wave of the late 1930s; its most distinctive feature was the lengthening of hemlines by some eight inches.

As the French press was on strike, the foreign press covered the event. Reactions outside France were mixed. Women in England, where rationing and shortages continued through 1949, were outraged by such a display of opulence. Industrialists in the United States were also alarmed; this new style meant a total loss of their inventories. A few American women founded a movement called The Little Below the Knee Club as a direct protest against the hemlines and full skirts. Ironically, popular opinion shifted in Christian Dior's favor in part because of articles in American fashion magazines. Both Carmel Snow, editor in chief of *Harper's Bazaar*—who coined the name New Look for Dior's style—and Bettina Ballard, her counterpart at *Vogue* (American edition), encouraged Christian Dior, promoting his look in their respective magazines. With this support, his style began to take off. In late 1947, Christian Dior received the prestigious Neiman Marcus Fashion Award, establishing the foundations for his financial and commercial success in America.

Despite some hesitation and resistance, the speed at which his designs spread confirmed the newfound influence of French fashion. Parisian haute couture had entered its

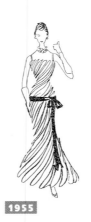

1955

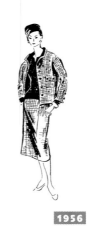

1956

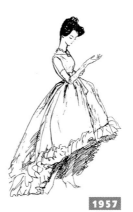

1957

Golden Age. From 1947 to 1958, the New Look became the outward expression of a new age. Each fashion designer presented his or her own interpretation of this style, which had become a kind of archetype of propriety. Largely inspired by the elegance of the Second Empire, this esthetic harked back to the codified morals and strict rules of the mid-nineteenth century, when each moment of the day required a specific and suitable outfit.

The cocktail dress was the principal innovation. The major difference between it and the evening dress was its length, with a hemline just below the knee. Bodices were corseted so that necklines could be audaciously low and asymmetrical. Evening gowns, the apotheosis of unrivaled luxury, showcased the romantic ideal of femininity prevalent in the 1950s. The structure and enormous quantities of fabric created voluminous, full clothes, yet forced women to restrict and control their movements. The physical freedom offered by the short dresses of the war years—which let women ride bicycles comfortably, among other advantages—was hampered by nipped-in waistlines and full skirts. Accessories, gloves, and hats had become essential items, conditioning women's deportment even further.

Cristobal Balenciaga and Gabrielle Chanel were exceptions. Each of these designers defined a style in which the technical fitting excluded structural artifices and eliminated superfluous ornamentation, offering more freedom of movement.

This prodigiously creative period was boosted as the sectors dependent on fashion were reconstructed. Textile manufacturers invested heavily in research and new techniques, giving fashion houses the yards of fabric they needed for their collections free of charge. In exchange, the success of a certain gown or dress guaranteed an increase in sales, as manufacturers would then order the fabric to reproduce the haute couture styles for the mass market. Concurrently, the corset industry experienced renewed vigor. All kinds of different undergarments designed to mold bodies into this new silhouette—uplift bras, girdles, waist cinchers, and petticoats—flooded the market.

"Thanks to my fashion house, we celebrate the revival of French fashion," said Christian Dior in 1956. The growing influence of fashion paralleled its globalization, a development that required the transformation of "family-run" companies into multinationals. To ensure their economic viability, fashion houses expanded their lines and manufactured brand-name accessories. An astute businessman, Christian Dior innovated once again by setting up a commercial structure that persists to this day.

Dior was one of the first fashion houses to exploit the brand-name value by granting licensing contracts. In 1948, he signed two historic contracts (in the stocking and tie sectors), which were the first among the hundreds that would follow. Elsa Schiaparelli was actually the precursor to the practice, as she had

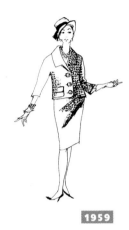

1959

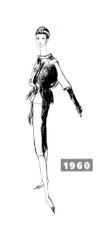

1960

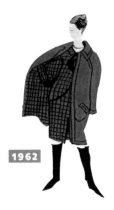

1962

already allowed her name to be used for a stocking label in New York in 1940.

French fashion supremacy had become overwhelming and other countries set out to define their own national identities. Italian fashion, for example, defied the Parisian ritual by offering an alternative to the sophisticated French styles. Giovanni Battista Giorgini, considered to be one of the founders of Italian fashion, developed the idea of bringing together all the Italian designers to present fashions that were other than mere offshoots of Paris designs. The first fashion show took place in Florence in February of 1951. Functional and elegant, Italian fashion had more in common with the American fashion tradition, offering young, practical clothes that were better suited to an active lifestyle. Immensely successful, by 1952 these fashion shows had moved to the prestigious Sala Bianca, or White Room, in the Palazzo Pitti.

The American sportswear sector began to expand after the war. Claire McCardell managed to distill French elegance and American pragmatism to create the "American Look." Her realistic, relaxed style made fashion more democratic, especially as her designs were ideal for industrial production methods.

In England, the London Model House Group (LMHG), created in 1948 to group together the major ready-to-wear companies, launched London Fashion Week in 1959; this semiannual presentatian showed English fashion.

Ready-to-Wear

"Haute couture designs are justified by at least two essential criteria. First, they are prototypes and as such are expensive. Second, they represent faultless craftsmanship... Haute couture is ahead of its time, it is completely new, and it is haute couture that makes Paris fashion the defining fashion for the rest of the world. From the couture house, it moves to the shops, then to ready-to-wear. It then invades store windows and the streets. The press, radio, film, and television all contribute to the process. In just a few months, the great migration of fashion has been achieved. Everyone, in their own way, follows fashion."[3]

Through the late 1950s, French fashion was organized into an authoritative, conservative structure based on four distinct categories. At the top of the pyramid were the couture houses, which created unique outfits, by definition inaccessible to most women. Below them were countless small dressmakers who adapted the couture designs for a bourgeois clientele. The third level consisted of paper patterns for women who cut and sewed their own clothes. And finally, there was the ready-to-wear sector, mass-producing clothes for a working-class clientele that could only dream about the fashion styles decreed by haute couture designers.

A report drawn up just after the liberation in France is edifying: 95 percent of American women wore ready-to-wear clothes, while only 25 percent of French women did. In 1943, during the German occupation, French wholesale clothing manufacturers formed an association to promote high-quality, sophisticated, and comfortable ready-to-wear fashions.

Several emissaries were sent to America to analyze the ready-to-wear industry. They reviewed production processes, distribution, and standard sizing. After his second trip, Albert Lempereur, a major figure in this budding industry, translated the American term "ready-to-wear" into "prêt-à-porter" in French. It appeared in a 1947 report on the first women's clothing industry conference. By 1951, the Weill company was using it in advertising campaigns, and by the end of the decade, it had become the accepted term.

Created in 1950, the Couturiers Associés designed and mass-produced specific outfits created by haute couture designers, who agreed to sell exclusive rights to their work against royalties. Each dress was labeled with the designer's name, followed by "Les Couturiers Associés." Before this, only the manufacturer's name appeared. The first forays into luxury ready-to-wear clothes in France thus resulted from an association between industrial production techniques and the design and prestige of haute couture.

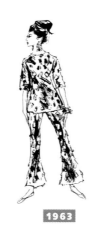

1963

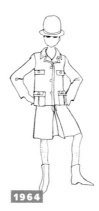

1964

1965

3. *Le Figaro littéraire*, June 8, 1957.

Baby-boomers: Youth Rules Fashion (1963-1979)

"When the decade of the 1970s began, no one could have predicted that it would be a period of total upheaval, one that was probably unprecedented in the history of fashion."[4]

The soaring birth rates after the war generated a phenomenon that transformed the formal structure of the fashion system. The number of people under the age of twenty represented approximately 10 percent of the entire population. This new clientele had energy, demands, and purchasing power, and formed a powerful social entity. With a clear idea of what it wanted, this generation imagined a radical new world, as well as a different lifestyle that would correspond to these dreams. This lifestyle then dictated its requirements to the fashion world.

Bodies were bared with increasing audacity, a trend that began in 1946 with the launching of the bikini, glorifying the image of a strong, healthy, sensual body. Provocatively narcissistic, this style was poles apart from the sophisticated, yet encased woman of the previous decade. The feminine ideal of this new generation had been redefined as a long-legged, flat-breasted, skinny adolescent sporting short hair. The English model Twiggy was the perfect incarnation of this new beauty standard that an entire generation tried to emulate.

4. Du Roselle (B.), *La Mode*, Imprimerie nationale, 1980, p. 255.

1966

1967

1968

Couture Designers

Parisian haute couture, deeply rooted in tradition, continued to clothe a cosmopolitan elite in search of prestige and luxury. Yet it was no longer the only institution defining fashion trends. As their clientele decreased, these designers adopted new strategies, while drawing from their legendary past successes. As for the new generation of designers, they sensed the change in the air and tried to expand the range of their elders to conquer an emerging market.

In 1965, André Courrèges launched a French version of the miniskirt, an event that unsettled traditionalists and threatened the institution's conservative image. He created an overall concept of the modern woman, offering his own ideals of elegance, producing custom-designed clothes, ready-to-wear outfits, and mass-produced items. Pierre Cardin, Paco Rabanne, and Emanuel Ungaro constantly sought out unusual composite materials—paralleling the work of contemporary plastic artists—to reinterpret the outdated fashion codes and rejuvenate a lackluster tradition.

Stylists

The American concept of ready-to-wear clothes had reached France with the first-generation designers, known as stylists. The spectacular

success of the first Salon du Prêt-à-Porter, held at Versailles in 1963, marked the start of a truly democratic approach to fashion. Since the 1950s, Maïmé Arnodin had been trying to promote a system that would encompass every stage of the creative process (textiles, ready-to-wear manufacturers, and distribution). She received recognition for her unstinting efforts indirectly, via the success of young designers she supported. Gérard Pipart, Emmanuelle Khahn, Michèle Rosier, and Christianne Bailly, all pioneering members in the profession, imbued the archetypal clothing designs with an authentic, but affordable "style." The clearly stated aim was to boost consumer spending. To this end, Denise Fayolle launched the slogan "beau–pas cher" (beautiful–inexpensive). In 1968, with Maïmé Arnodin, she created the consulting firm MAFIA Design, a breeding ground for new talent and a confirmation of their prophetic vision concerning mass production and consumption.

1971

1973

Boutiques

New distribution methods appeared; boutiques were outlets for new concepts, a place where people met and exchanged ideas. These shops offered a mixture of experimental expressions with a visual and audio ambience designed by and for a young generation eager for new sensations. In 1955, Mary Quant opened the Bazaar boutique in the Bohemian neighborhood of Chelsea, where she handsewed the first miniskirts.

1974

Barbara Helinki, also in London, designed and sold outfits by mail order, then opened the legendary Biba boutique in 1964. In New York, Paraphernalia, Serendipity, and Abracadabra were laboratories of creativity, flooding the market with a constant stream of ideas. In Paris, boutiques were distinguished more by the sophistication of the items on display than by a large selection, but all of them offered a global esthetic concept, crystalizing the ephemeral moment of a time marked by revolt and contradiction. Self-proclaimed designer-retailers such as Elie Jacobsen (with her boutique Dorothée bis) and Sonia Rykiel (with Laura) sold their own clothes as well as those by other designers. Yves Saint Laurent, always in the avant-garde, established a franchise structure with his Rive Gauche boutiques that integrated a system based on exclusive distribution rights between the designer and the retailer in which he controlled every detail—from the final sketch to the shape of the hanger.

Confrontation and Change

The ready-to-wear infrastructure was finally up and running, thanks to the stylists, who worked under their own names or anonymously for the major manufacturers. Consumers were able to find what they were looking for, given the nearly unlimited offer. The number of fashions and trends multiplied, and exchanges were profitable and productive to all.

Everything was allowed: miniskirts, maxiskirts, minishorts, and transparent or unisex clothes. Confusion reigned at the end of a decade marked by perpetual innovation; fashion seemed to be in a state of grace, thanks to the influence of its leading figures. It was at this point that the idea of consumerism became more confrontational and controversial.

The hippie movement, which reached Europe via the beatniks, Flower Power, and the mythical Woodstock concert, refused the so-called consumer society outright. In opposition to capitalism and the unilateral decrees handed down by the fashion industry, this younger generation advocated a return to basics, handmade clothes and crafts, and sought out distant ethnic groups, folklore, and religions. This philosophy then reappeared in colorful outfits bedecked with a medley of accessories acquired during trips to far-off countries, along with long flowing hair (obligatory for men, a manifestation that contributed to the confusion between the sexes). Topping off this instantly recognizable "costume"—which became a staple in every fashion movement—was the ubiquitous pair of jeans, the emblem of the rising new generation.

Paralleling this trend was a far-reaching change in the female wardrobe itself. Pants had finally become an acceptable item of clothing for women, even though they violated a 1909 French regulation—no longer followed, of course, but still in force—"forbidding women to wear masculine clothing, except when riding

1975

1977

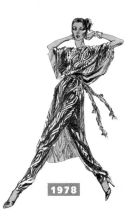

1978

a horse or a bicycle." The relationship between the sexes was in a state of flux, allowing everyone the freedom to redefine their respective roles and relationships.

"Créateurs": 1971-1979

In 1971, Didier Grumbach created the Créateurs et Industriels company (with Andrée Putman as artistic director), with a goal of bringing together talented young "créateurs" (designers) and manufacturers. This move created an entirely new breed of fashion designers. The individual styles redefined the fashion world, formulating and tangibly manifesting a personal vision that was accessible to any and all female consumers. The Frenchwoman Emmanuelle Khanh, the American Fernando Sanchez, and the English designers Ossie Clark and Jean Muir worked together to design a line of clothes targeted specifically to this clientele, rather than to a single movement or an elite. The approach of these new créateurs achieved official approbation in 1973 with the creation of a professional organization called the Fédération Française de la Couture, du Prêt-à-Porter des Couturiers et Créateurs.

This same year, the Americans—considered by the French counterparts to be manufacturers only and generally circumscribed by this role—were invited to participate in a joint fashion show at the Château de Versailles. This major breakthrough established

the Americans as serious designers. Halston, Bill Blass, Stephen Burrows, Anne Klein, and Oscar de La Renta were the five designers selected to show their clothes alongside those of five French designers: Hubert de Givenchy, Marc Bohan for Christian Dior, Pierre Cardin, Emanuel Ungaro, and Yves Saint Laurent. The major event of this gala was the enthusiastic response from the public, which rewarded the audacity, simplicity, and no-frills design of American

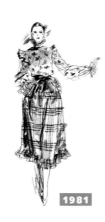

1981

sportswear with a standing ovation. This show heralded the arrival of a major-league player on the international fashion scene.

The Japanese were making a timid entrance. Kenzo and Issey Miyake showed in Paris, while Kansaï Yamamoto was working in London. These events forged a link between the East and West and introduced the Japanese into the system of Western fashion; by the following decade, they would be firmly established.

1980

Fashion Becomes Fashionable (1979- 2000)

Designers:
Identities, Labels, Images

Designers could finally rest on their well deserved laurels; the art of appearance had returned to the forefront, with its power to celebrate the individual. Despite the economic crisis and resulting recession, personal development was an idea whose time had come, especially in a society that rewarded the powerful individual. This new ethic was embodied by career women who had reached unprecedented levels of power and in the workforce and were determined to hold on to what they had rightfully earned. These resolutely modern women, who juggled their professional and family lives, sought a physical affirmation of their new sta-

1982

tus. They exercised their new power through "dress for success" fashion choices and by selecting a designer who would rise to their expectations. Since the preceding decade, the designers had dominated the fashion world by developing a signature image, recognizable by all, which distinguished their label from all others. The result was a "total look": a entirely accessorized style which, paradoxically, forced women back into a system of frenzied buying. The artistic identity of a label hence became a goal in and of itself, and it had to be constantly redesigned to maintain the interest of a demanding clientele.

New Blood

The overwhelming media coverage of these designers confirmed their reign over fashion. The globalization of fashion was a direct consequence of this process: Paris remained the hub, and any new talent seeking fame had to make an obligatory pilgrimage to the French capital.

In 1981, the fashion capital became home to Rei Kawakubo, of Comme des Garçons. The Japanese designer was suddenly in the spotlight. Fashion writers and critics attended her briskly presented show, but what stunned the public was the flagrant challenge to Western esthetics in her designs. Her work presented a disturbing asymmetry, a deconstruction of fabrics and of the way they are worn, revolutionizing the generally accepted approach toward clothing design; in other words, a glorification of the eroticized image of women. She used black, and cut holes into dresses to reveal and showcase the bloodless white skin of the models. Like a post-nuclear vision offset by a rigorous structure, Rei Kawakubo presented a conceptual approach that stood in opposition to the traditional tenets of fashion. She became the leading figure of a movement that included the new wave of Japanese creators. These designers incorporated all the components of modernism: a variety of contemporary artistic mediums; a constant reassessment of material, cut, and proportions; an approach that destabilized, disturbed, and altered the established order; and a revision of

1983

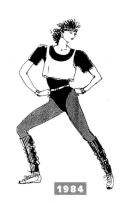

1984

1984

femininity through an asexual, scant, and pared-down body.

Meanwhile, Italian designers had also become major figures in the vast world of fashion, confirming a revival in transalpine creation. Their innate sense of showmanship and exaggeration, the flashy yet refined luxury of their flamboyant color palettes, and their mannerist brilliance, combined with a reliable manufacturing sector and unrivaled expertise in synthetic fibers and knitwear, made the Italians an essential stopover in the new schedules of ready-to-wear shows. From this point on, fashion was created and shown in Milan.

The "Best Five 1984" show, organized in Tokyo by the American publication *Women's Wear Daily* and the Japanese daily paper *Asahi Shimbun*, clearly defined the standards of elegance for five nations. Hanae Mori, participating as both hostess and designer, presented an "ultra-elegant woman," without any of the elements in the arsenal of Japanese-style exoticism. The Italian designer Gianfranco Ferré revealed his "sexy woman of action," while the English designer Vivienne Westwood, pursuing her marginal-provocative approach, presented the "naughty little girl, half-crazy, half punk." The American Calvin Klein displayed his usual no-frills outfits. French designer Claude Montana offered his vision of the "femme fatale superstar." Acclaimed by all, he was named "designer of the year."

Two-Track Fashion

The spirit of the 1980s, a decade of excess, power, speculation, and confrontation, was mirrored in fashion, which had splintered into many movements. The trend toward role reversal became even more pronounced: undergarments were worn on top, revealing a veiled desire of sexual offer. Black was the ubiquitous color, appearing in a multitude of shades; at the same time, the saturated, fluorescent, or gaudy medleys of colors became more popular.

Inaugurated on the eve of the 1987 New York stock market crash, Christian Lacroix's fashion house marked a newfound interest in haute couture. This event seemed to correspond to the unbridled energy of a decadent society in the midst of a shopping frenzy. To satisfy this frantic search for something new, buyers seized on a flashy panoply of luxury labels in order to define and confirm a social status based entirely on appearances. Couturiers and designers competed in their quest to create "total looks," in response to their clients' desire for complete designer ensembles.

A more personal mode of expression appeared alongside the decrees pronounced by the fashion professionals. This consisted of the basics, with which consumers could become stylists on their own by mixing different labels. Basics are outside the seasonal cycles of fashion, consisting of a number of simple, accessible items of clothing that form the classic

1986

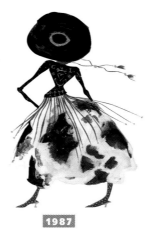

1987

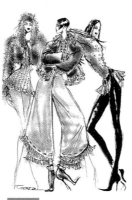

1994

components of a wardrobe. In the 1980s, the Benetton and Gap phenomena illustrated the overwhelming popularity of this type of clothing, with a selection of T-shirts, pullovers, pants, and skirts in a panoply of different colors defying any seasonal limitation. Everyone was absolutely free to mix and max items bought separately; the only restriction to the seemingly limitless possibilities was a woman's imagination.

Fin de Siècle

The megalomania and spectacular theatricality of the preceding decade evaporated quickly with the advent of the New Age spirituality that appeared in the early 1990s. This social shift culminated in the environmental movement, which called for a more natural, simple, and authentic culture. Adopting this new trend, designers expanded their range to offer environmentally friendly products to embellish the home and garden and to improve the quality of lifestyles. Styles changed constantly; one fashion overturned a previous one, then in turn fell out of fashion in short order. Grunge, "a negative image of beauty," disappeared as quickly as it had appeared, replaced by recycled items.

As this fashion whirlwind spun even faster, basics provided an anchor that was lacking in the mood of the times. They reigned in virtually every industrialized society, which

used these items to promote a global standardization.

Adopted by an increasingly diverse public, mail-order sales, another purchasing method, reached an increasingly diverse public, becoming a more profitable sector.

A great new territory opened up: the street. Young people took over the city with painted graffiti, sauntering up sidewalks in sweat pants and T-shirts, a look that became a uniform of sorts, a symbol of belonging to a tribe. This fashion, an offspring of inner cities and rap music, persists through the signals and codes of the clothes. Urban dwellers, attracted to the esthetic of sculpted, physically fit bodies, adopted the multipurpose and functional comfort of casual wear. Biking shorts and sweat suits became citywear, produced by large manufacturers such as Nike, Adidas, and Reebok. Even haute couture designers copied the informal aspect of these outfits, although they used ostentatious and luxurious materials.

The media added to the furor, by flooding the bemused public with sublime images and sumptuous bodies, creating a star system modeled after the film industry. They discovered new faces and transformed them into stars, while supermodels served as glittering messengers for the designers, who achieved the status of artistic deities.

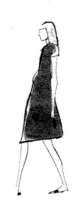

1995

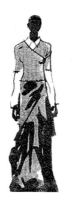

1997

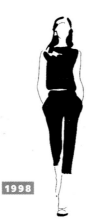

1998

5. STEELE (V.), *Women of Fashion Twentieth Century Designers*, Rizzoli, New York Pub., 1991, p. 158.

Fashion: An Eternal Quest

"Fashion design is almost like mathematics. You have a vocabulary of ideas which you have to add and subtract from each other in order to come up with an equation that's right for the times." VIVIENNE WESTWOOD[5]

In 1857, the English couture designer Charles Frederick Worth, Empress Eugénie's favorite dressmaker, revolutionized the clothing world by signing his name to his outfits. He also founded the modern industry of fashion and made Paris the heart of this system. One hundred and fifty years later, after a chaotic history, to say the least, fashion—a powerful reflection of the world around us—still appears as an essential vector in our collective memory. The development of fashion throughout the twentieth century has only deepened this historical potential and the profound impact it has in our daily lives. Fashion, as it appears today, must be considered a separate language. The thirty-five couture designers selected for this book offer proof of this unceasing work on the structure of society's codes. Through small touches or great leaps, they have skillfully and patiently fashioned this diverse language that draws from the deepest sources of creativity to reinterpret the rhythms, the beat, and the vibrations of the human body.

ALAÏA

Azzedine Alaïa

(Tunis, Tunisia, ca 1940)

"A woman is like an actress, always onstage."

AZZEDINE ALAÏA

Azzedine Alaïa has always gone his own way. He imposed his own rules in the fashion world; he introduced his ready-to-wear clothes outside the usual seasonal collections; and did not use advertising campaigns. Designed in an haute-couture spirit, his clothes embody a single-minded quest to showcase the female body.

An artist, Alaïa exalts the female form—correcting any imperfections along the way—through his skillful cutting techniques and use of avant-garde fabrics. He uses a minimum of accessories, drawing from the traditional haute couture vocabulary to make outfits that become one with the model. This fertile communion creates a second skin and allows for ease of movement. A lightly perverse sensuality runs through his tight-fitting, clinging designs, which show off the small of the back and accentuate the hips.

A student at the Tunis School of Fine Arts, Alaïa was initially interested in sculpture. He moved to Paris in 1957 and was hired by Christian Dior, although he only remained with the couturier for a few days. Next hired by Guy Laroche, he spent two seasons in the tailoring workroom. In the meantime, Alaïa was building up his own private clientele, with the help of the Marquise de Marsan. He worked for her, designing many of her clothes. Another important client was the Comtesse Nicole de Blégiers. He also met Louise de Vilmorin and

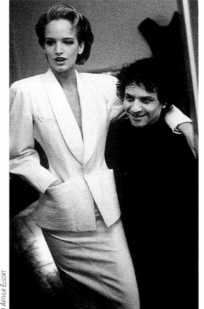

© ARTHUR ELGORT

1983

Arletty, who introduced him into Parisian society.

In 1965, with the help of Simone Zehrfuss, Alaïa set up his own shop at 60, Rue de Bellechasse in Paris. In 1979, his first designs appeared in fashion magazines, and in 1981, Alaïa finally presented his first collection. Another shop, designed by the American artist Julian Schnabel and his wife, opened in Soho, in New York, from 1988 to 1992.

Both a designer and highly skilled dressmaker, Alaïa makes elasticized, structured, and straightforward clothes that set off the curves and shape of the female form. He himself wears a Chinese suit, an impersonal uniform, which gives him complete freedom to pursue his obsession with beautifying the female body.

1990

Julian Schnabel exhibited his "Tati paintings" at the Yvon Lambert gallery. For the summer of 1991, Alaïa designed a collection inspired directly by the famous pink gingham. At the same time, he created espadrilles, tote bags, and T-shirts designed for and sold exclusively by the Tati stores.

© GILLES BENSIMON

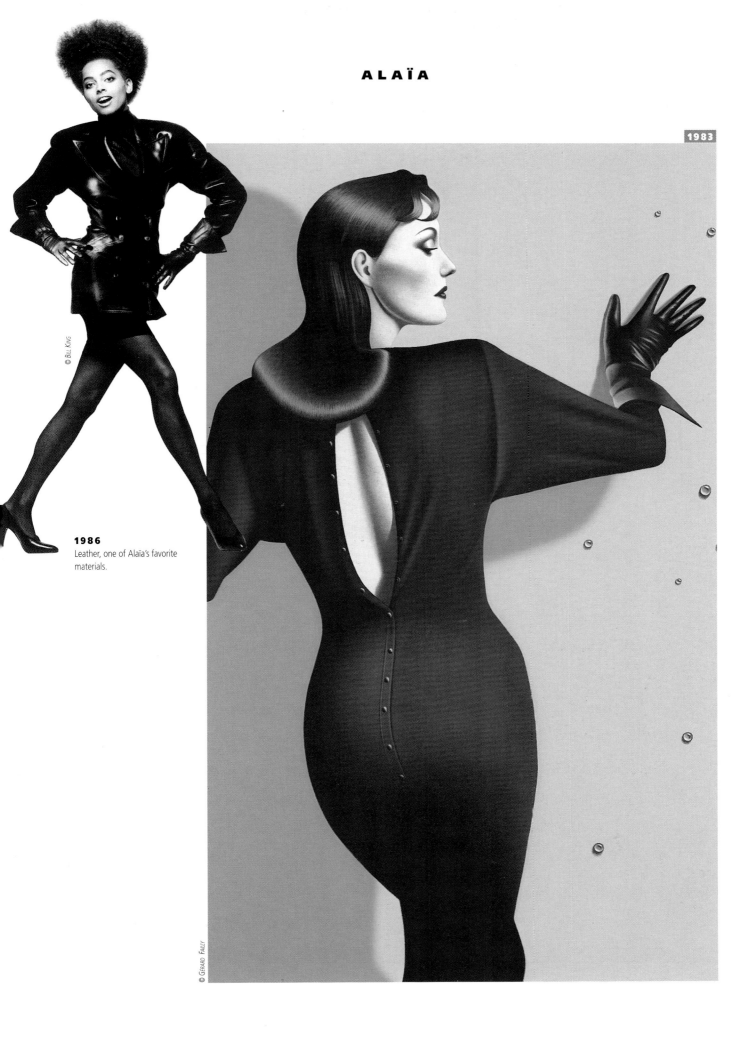

1986
Leather, one of Alaïa's favorite materials.

1983

© BILL KING

© GÉRARD FAILLY

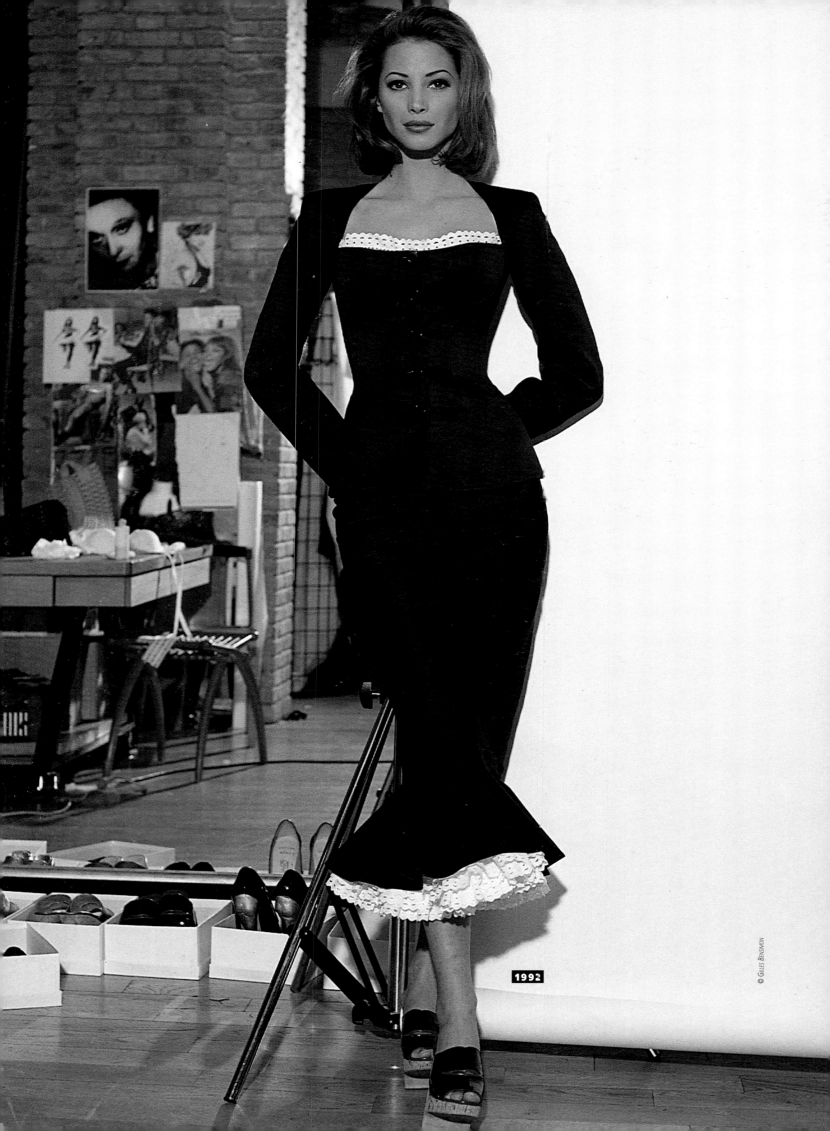

1992

© GILLES BENSIMON

© ALBERT WATSON

1985

ALAÏA

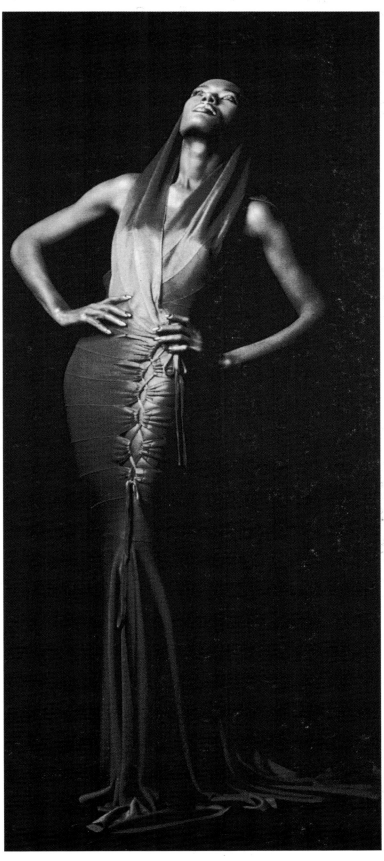

© GAMMA

1985
Singer and model Grace Jones, wearing one of Azzedine Alaïa's dresses as she presented the "Oscar" for fashion design.

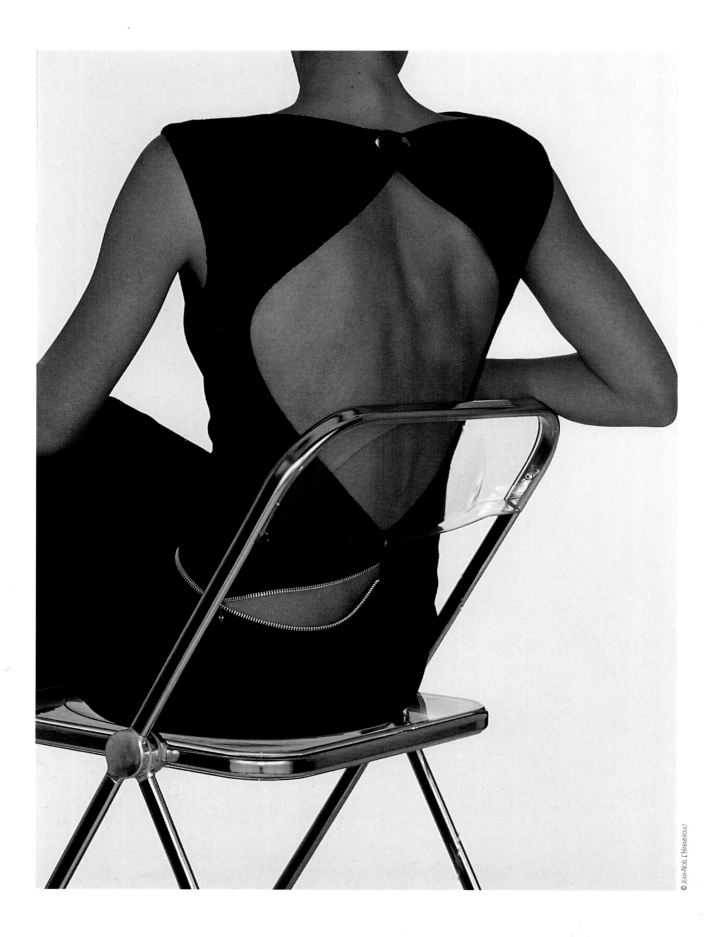

© JEAN-NOËL L'HARMEROLT

ALAÏA

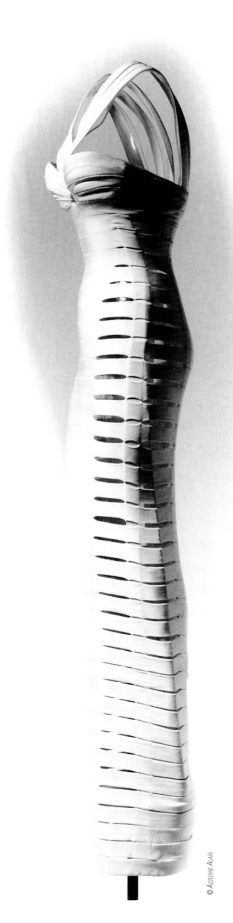

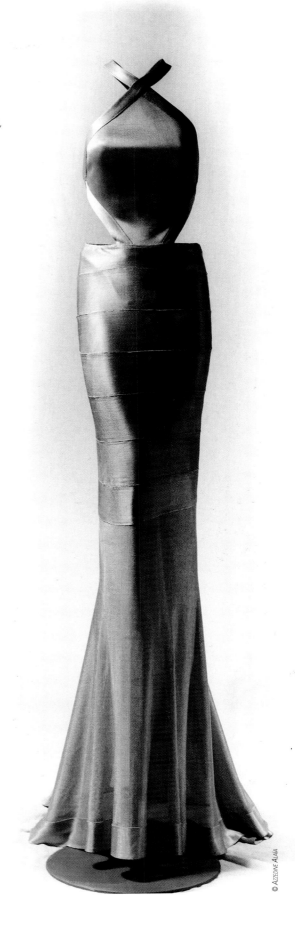

1981

OPPOSITE PAGE:
"If there is one artist who is extremely interested in the architecture of the female form and who knows how to display it, it is Azzedine Alaïa."
JEAN NOUVEL

1998

The Groningen Museum in the Netherlands devoted a major retrospective to Azzedine Alaïa.

© AZZEDINE ALAÏA

© AZZEDINE ALAÏA

BALENCIAGA

Cristobal Balenciaga

(Guetaria, Spain, 1895 - Javea, 1972)

> "A good couturier must be an architect for the drawings,
> a sculptor for the form, a painter for the color,
> a musician for the harmony, and a philosopher for the tone."

CRISTOBAL BALENCIAGA

1940

Balenciaga with a model.
"A nobility of gesture,
looking beyond appearances,
avoiding the temptations
of facility and futility."
EMANUEL UNGARO

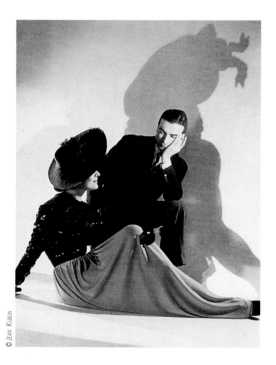

1943

Fall/Winter collection 1943-1944.
The bolero, inspired from a toreador's outfit, is drawn from the popular
imagery that was so much a part of Balenciaga's work.

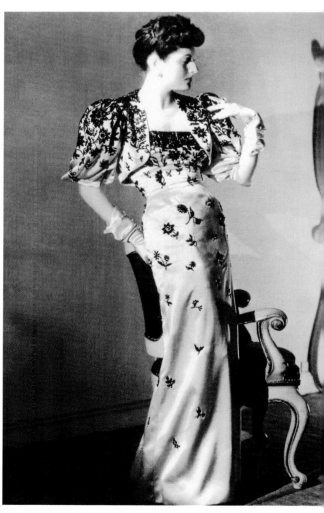

Cristobal Balenciaga devoted his entire life to the technical perfection of haute couture, which he pursued with meticulous simplification and legendary tailoring. He began his apprenticeship at the early age of thirteen, reproducing a dress for the Marquise de Casa Torres, who had hired his mother as a dressmaker. He opened his first fashion house in San Sebastian in 1915, followed by a second one in Madrid in the late 1920s. With the fall of the Spanish monarchy in 1931, both houses closed. Four years later, he reopened in Barcelona under the name Elsa, inspired by his mother's name, Eisaguirre. He traveled regularly to Paris, purchasing clothes from Chanel, Lucien Lelong, Molyneux, Paquin, Elsa Schiaparelli, and Madeleine Vionnet. On his return, he carefully dissected each outfit, trying to discover the secrets of their designs. Self-taught, he

learned as much as he could about tailoring techniques, acquiring extensive expertise in technique. He left Spain in 1937, in the middle of the Civil War, and moved to Paris, where he opened his fashion house at 10, Avenue George-V.

Clothing was his religion. A virtuoso tailor, Balenciaga was also an unbending perfectionist. His masterful designs were based on a magnificent underlying architecture. He worked in absolute silence, sewing his own muslin patterns, cutting, tailoring, and fitting the outfits himself. His audaciously sculpted dresses set new standards for elegance. The Balenciaga woman was haughty and aristocratic, characterized by an unencumbered, soft, and refined silhouette that stood apart from traditional feminine styles. Balenciaga, imbued with Spanish culture, drew his inspiration from his native country, creating toreador capes and rustic hoods. The Spanish painters Velázquez, Goya, and Zurbáran were extremely important in his work; their influence reappeared in the infanta dresses, surprising colors, black lace mantillas, and brightly colored draped fabrics.

Balenciaga developed a system that set him apart from his contemporaries, pursuing a voluptuous line and pure spirit, without ever stooping to indiscriminate flattery of the body. Diametrically opposed to Christian Dior's New Look, Balenciaga's silhouette was not based on structural artifice, but on innovative tailoring methods. Shoulders were padded and shifted the focus to the bust and the neck. Waists disappeared. With a perfect mastery of couture techniques, he worked with an infinite variety of materials, especially from the 1960s on. The basic elements of his style were irregular fabrics, such as drapes of thick, robust wools and stiff corduroys, which he selected for the way they interacted with light.

Fashion has continually sought higher levels of perfection ever since Charles Frederick Worth institutionalized haute couture in 1868. In Cristobal Balenciaga, haute couture undoubtedly achieved its most perfect form. Christian Dior described Balenciaga as: "A master for us all." He trained André Courrèges and Emanuel Ungaro, transmitting to them his high standards and expertise. In 1968, he chose to retire and close his fashion house—and with it, an entire chapter of fashion history also ended.

1947
LEFT: Balenciaga followed his own path, forming a counterpoint to Christian Dior's New Look.

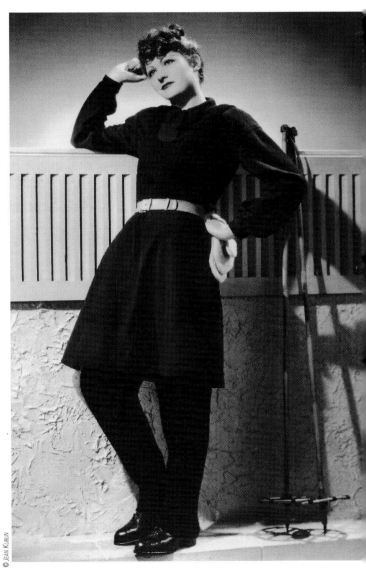

1939
ABOVE: Fall/Winter collection 1939-1940. Tapered after-ski pants.

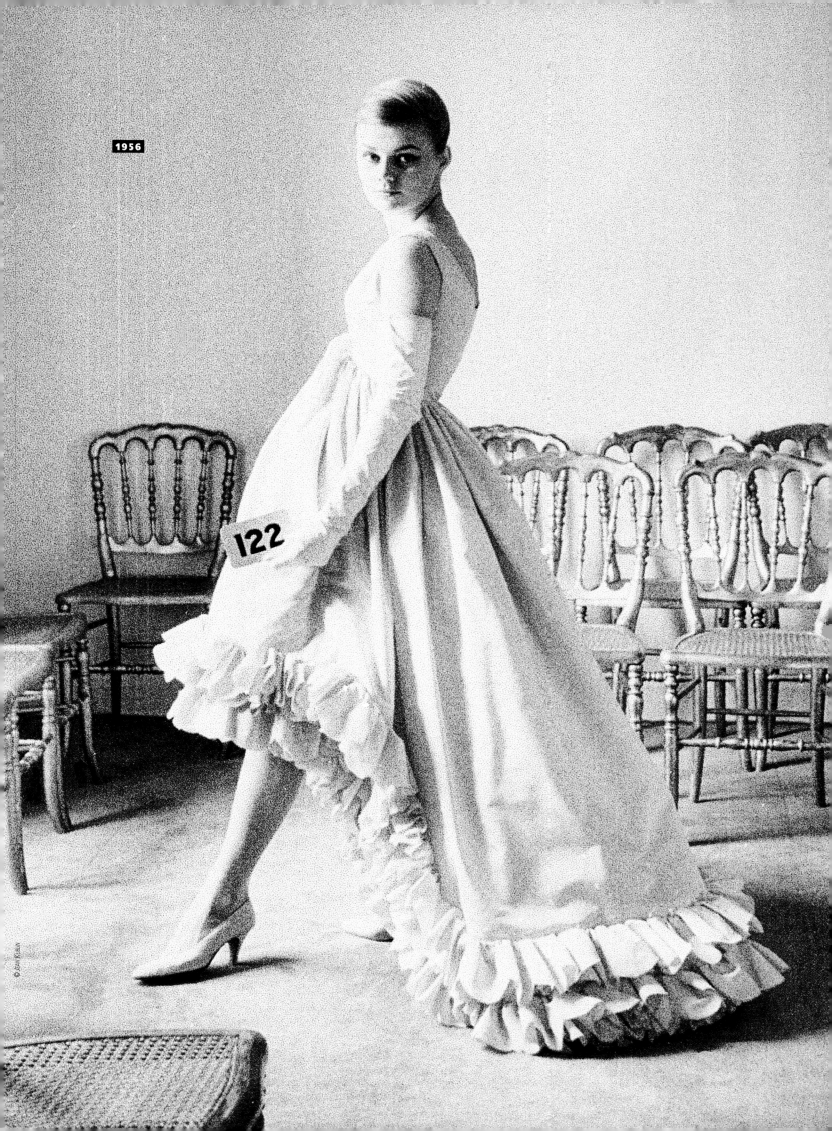

© JEAN KUBLIN

BALENCIAGA

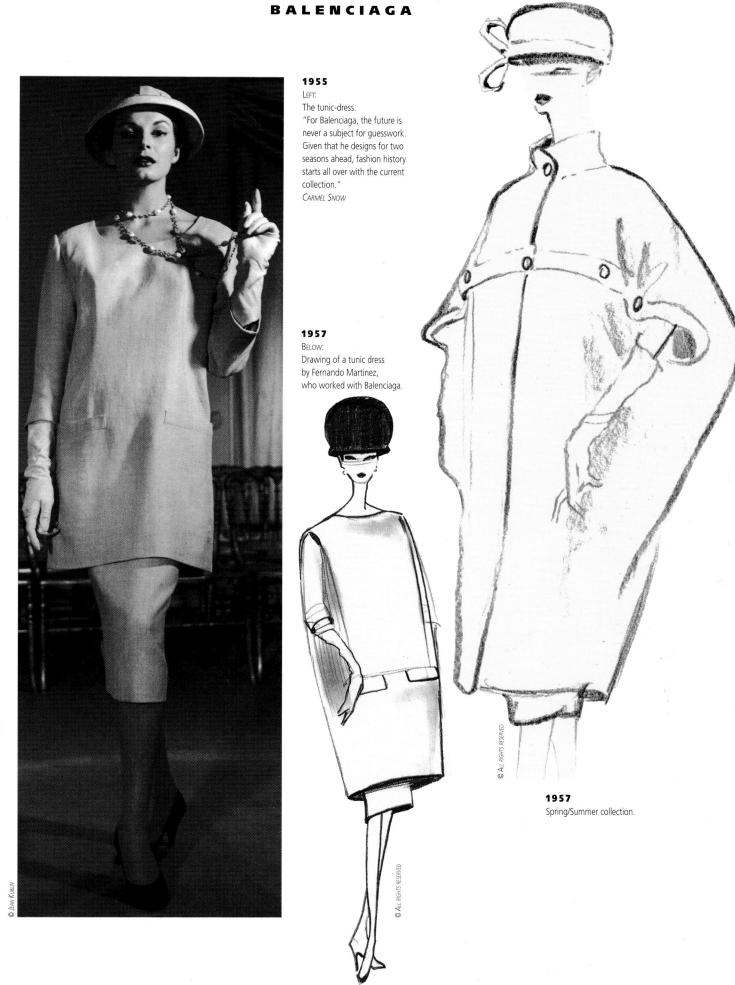

1955
LEFT:
The tunic-dress.
"For Balenciaga, the future is
never a subject for guesswork.
Given that he designs for two
seasons ahead, fashion history
starts all over with the current
collection."
CARMEL SNOW

1957
BELOW:
Drawing of a tunic dress
by Fernando Martinez,
who worked with Balenciaga.

1957
Spring/Summer collection.

© JEAN KUBLIN

© ALL RIGHTS RESERVED

© ALL RIGHTS RESERVED

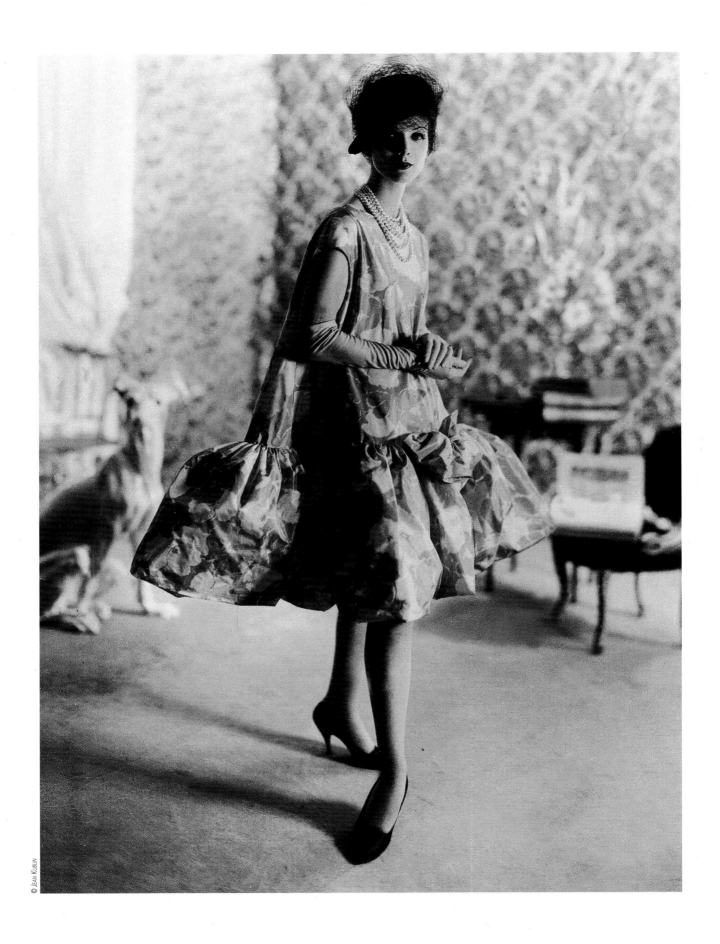

© JEAN KUBLIN

1958

OPPOSITE PAGE:
Balenciaga launches his "baby doll" dresses.

1951

BELOW:
Sleeves often illustrate Balenciaga's obsession with technique.

1961

RIGHT:
Spring/Summer collection.
"All women search for their special identity. All women have dormant qualities of luxury and mystery. Balenciaga brings the body and dress together in harmony and suddenly she finds herself in perfect rhythm with the universe." DIANA VREELAND

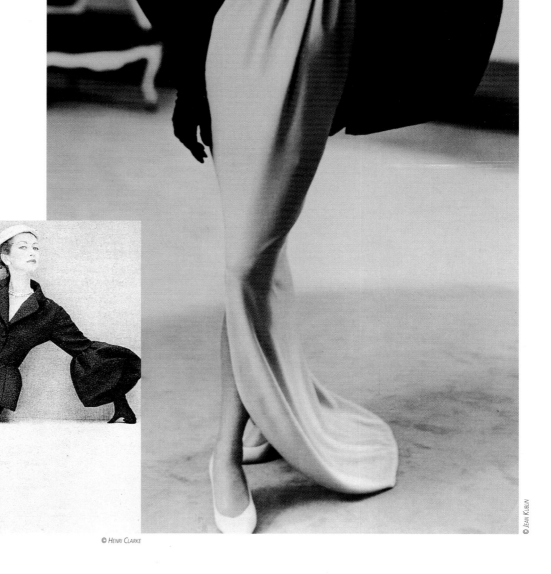

© HENRI CLARKE

© JEAN KUBLIN

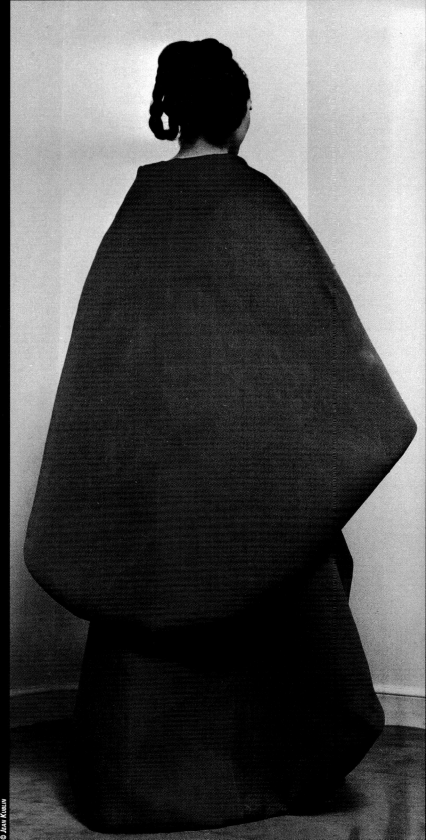
© Jean Kublin

1967

OPPOSITE PAGE:
"When the structure is solid, you can construct whatever you like."
CRISTOBAL BALENCIAGA

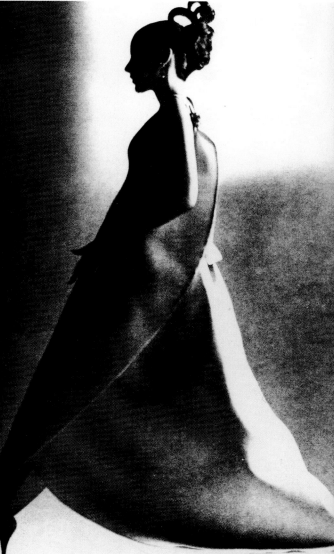

© *JEAN KUBLIN*

1965

ABOVE AND RIGHT: *Arum* dress.
"He laid the foundations and premises, once and for all,
for the modernity and contemporary design of our work."
EMANUEL UNGARO

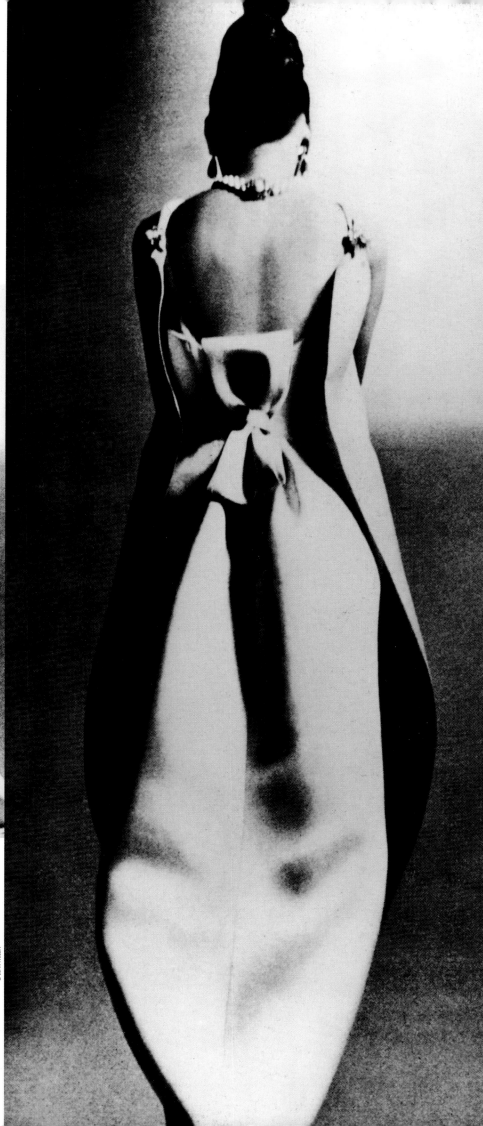

© *JEAN KUBLIN*

CALVIN KLEIN

(New York, United States, 1942)

"He is the true American puritan. Even as his style has evolved over time,
it's always about eliminating anything that is not necessary,
and always thinking about the garment as being as pure as possible."

TIME MAGAZINE

Calvin Klein has maintained the same fashion philosophy for thirty years: a decidedly muted, limited palette of colors, clean, straightforward lines, and a no-frills, minimalist, and discreet style. Based on an acute understanding of the requirements of daily life, his functional clothes are so simple that they may appear to be too reserved, yet he attracts both trendy, young clients and sophisticated executives. Consistently pursuing his same design concepts, he has been a defining force in contemporary fashion.

Klein graduated from New York's Fashion Institute of Technology in 1962, then worked for several coat makers, including Dan Millstein, who introduced him to the world of haute couture in Paris. Klein went to the fashion shows and memorized the designs noted by Millstein, later reproducing them in sketches that were perfect copies of the Paris outfits—a standard practice at the time. Despite enjoying the privilege of attending these extraordinary shows, Klein was more inspired by street fashion. He started his own business in 1968 in partnership with Barry Schwartz, a childhood friend. Convinced that the coat and suit sector could be modernized, he first specialized in this field, simplifying and redesigning shapes, using new materials. He soon added the "essentials," traditional coordinates designed with his own

© ALL RIGHTS RESERVED

1972

personal touch. Pullovers, shirtwaist dresses, and wraparound skirts were updated. He opted for the same relaxed style in his eveningwear, replacing cotton and light wool fabrics with luxurious materials.

Calvin Klein is remarkably intuitive about the fashion world. He imposed his own image, taking advantage of the sexual liberation movement that rocked American society. He took the most ubiquitous and utilitarian article of clothing in America—jeans—and transformed it into a symbol of luxury by linking a designer's name—his own—to a mass-market product. He launched a daring advertising campaign, created by Doon Arbus and Richard Avedon, featuring the model and actress Brooke Shields confiding to the camera that "nothing comes between me and my 'Calvins'." He then launched several perfumes, Obsession, Eternity, and Escape, which have been emblematic fragrances of the last two decades, followed by a line of underwear. Photographer Bruce Weber helped create and promote these provocative images that have become a Calvin Klein trademark.

Combining creativity with omnipresent and aggressive advertising images and a brilliant business sense, Klein continues to promote an authentic style that meets the demands of a contemporary active lifestyle.

CALVIN KLEIN

1980

FOLLOWING DOUBLE PAGE:
An adolescent Brooke Shields poses for
the Calvin Klein jeans advertising campaign.

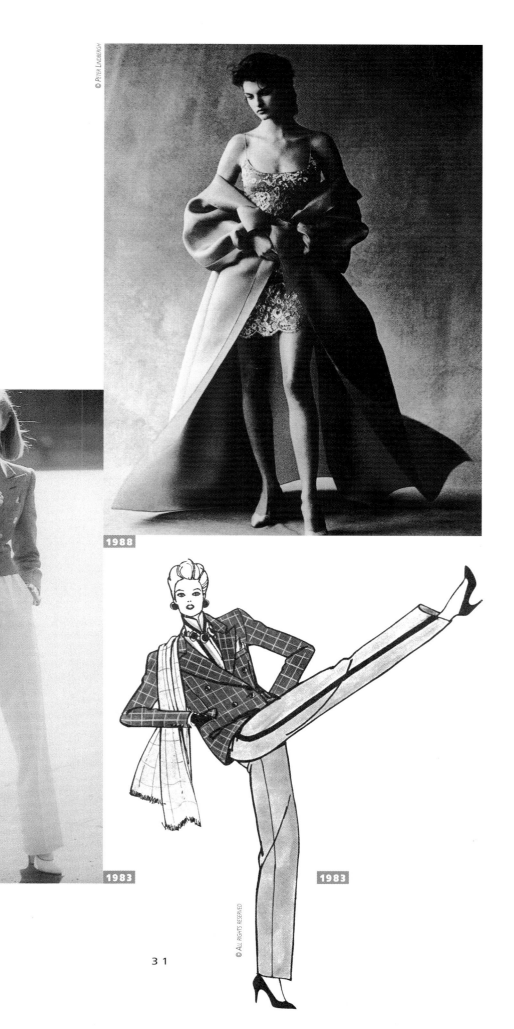

© PETER LINDBERGH

© ARTHUR ELGORT

1988

1983

1983

© ALL RIGHTS RESERVED

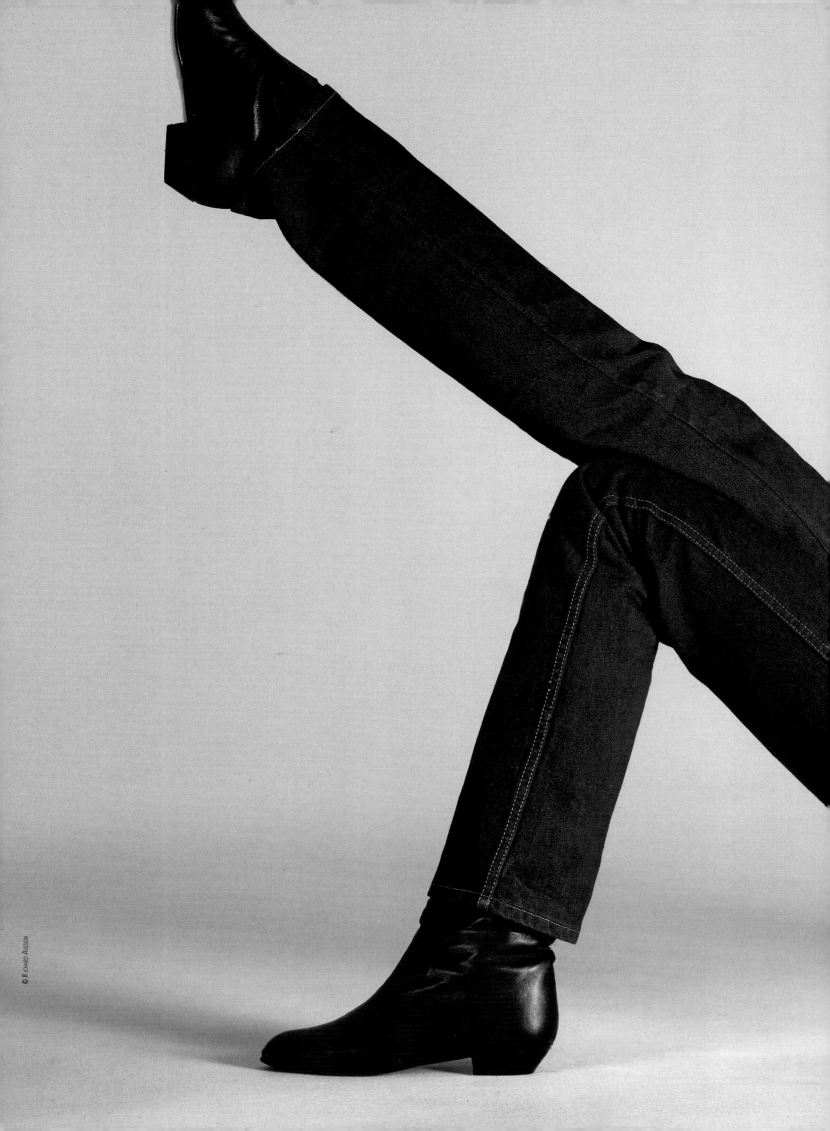

© Richard Avedon

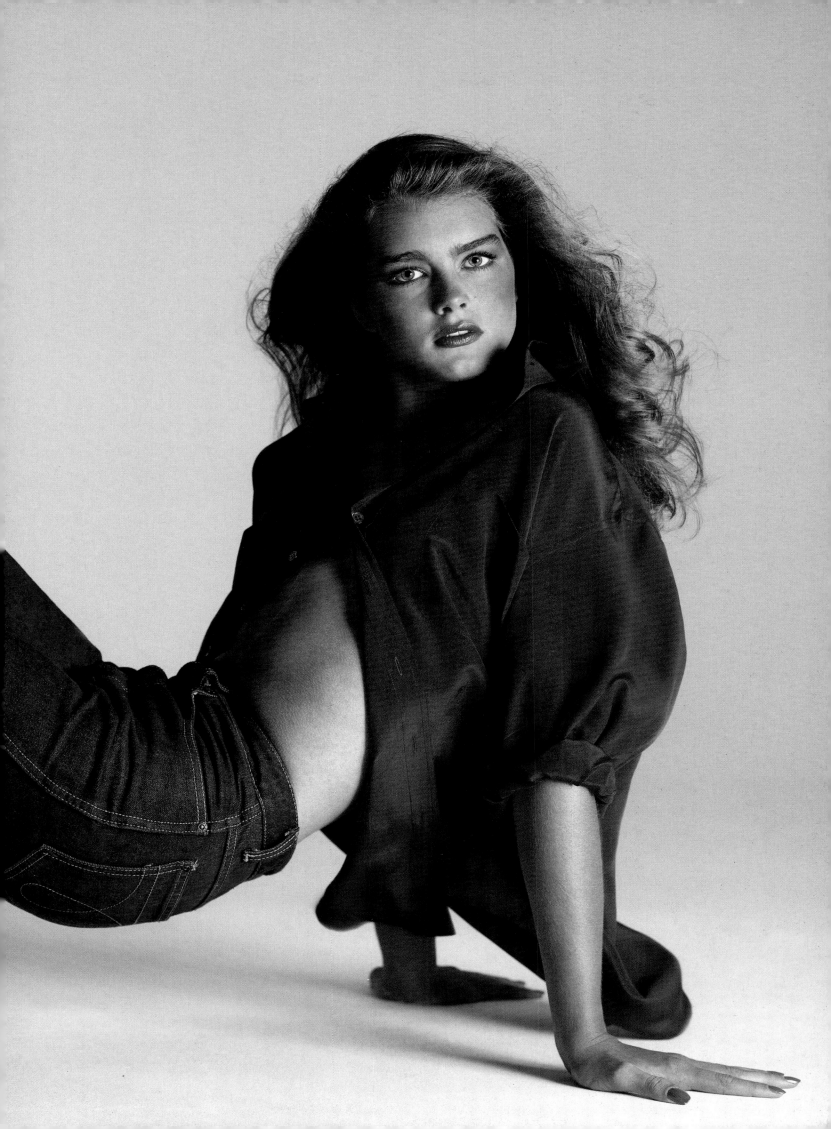

© COLLECTION GEORGES BERNSTEIN-GRUBERG

C H A N E L
Gabrielle Chanel

(Saumur, France, 1883 - Paris, 1971)

"Luxury is not the opposite of poverty;
it is the opposite of vulgarity."

GABRIELLE CHANEL

1918
LEFT:
Dressed in a man's shirt
and wide pants,
Chanel sports the first
signs of a unisex fashion.

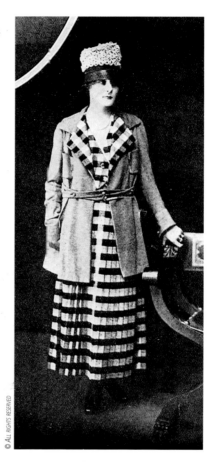

© ALL RIGHTS RESERVED

After a fifteen-year hiatus, Mademoiselle Chanel presented a new collection on February 5, 1954; it was a total break with the esthetics of the woman as object, imposed by Christian Dior's New Look. Criticized by the French press and praised by the Americans, her designs displayed an uncluttered simplicity and were ultimately recognized and copied around the world. Chanel created a lifestyle by transcending fashion trends and refusing to make any concessions to the reigning fashion of her time. She raised simplicity to a new level of elegance.

Born in the nineteenth century, Chanel left her rural home at an early age and gradually began her climb to high society, brushing shoulders with the demimonde and aristocrats. In 1909, she moved to Paris and worked as a milliner. Her hats were shockingly modern in their simplicity, as opposed to the opulent frivolities of the reigning Belle-Époque style. A sharp businesswoman, she opened her first shop in 1913 in Deauville, a fashionable beach resort. When the war broke out, hers was the only shop that remained open, and she managed to acquire a fashionable clientele. In the wake of her success, she opened a fashion house in Biarritz, another favorite resort among high-society Parisians. In 1919, Chanel moved to 31, Rue Cambon in Paris. The 1920s were a brilliantly successful period for Chanel, and she finally achieved social and professional recognition, mingling with both the haute-bourgeoisie and the artistic avant-garde. An art patron and artist herself, she designed the costumes for Jean Cocteau's adaptation of *Antigone* and his tragedy, *Orphée*. She worked on *Le Train bleu*, a work by Sergei Diaghilev, as well as for the Ballets Russes and the ballet *Apollon Musagète*, interpreted by Serge Lifar and choreographed by George Balanchine.

1917
Starting in 1913, Chanel
introduced suits made
of jersey a fabric
used for undergarments.
The problem was that
it frayed easily; Chanel
therefore simplified
her designs, removing
all trim. She eliminated
waists, shortened hemlines
to reveal the ankle, and
designed clothes free of
constricting corsets.

© COLLECTION GEORGES BERNSTEIN-GRUBERG

1922
Chanel, right, in Biarritz,
accompanied by Antoinette
Bernstein and her son Georges.

© ALL RIGHTS RESERVED

1928

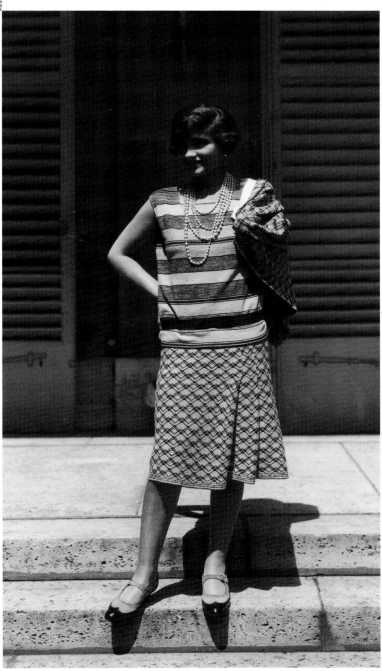

© HULTON GETTY

1929
"I always make the first
design for me."
GABRIELLE CHANEL

CHANEL

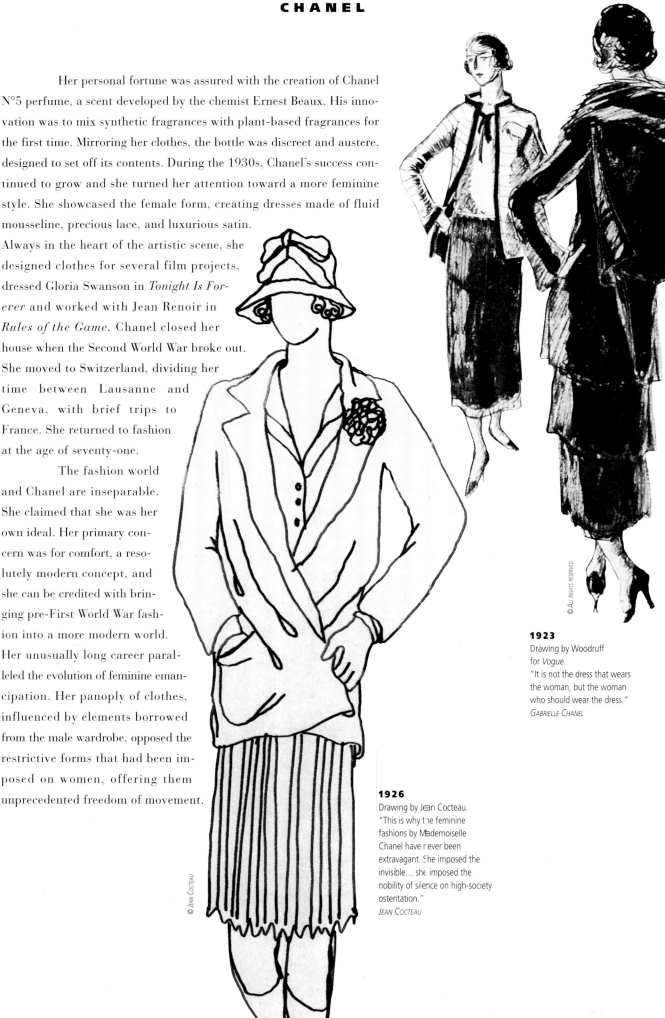

Her personal fortune was assured with the creation of Chanel N°5 perfume, a scent developed by the chemist Ernest Beaux. His innovation was to mix synthetic fragrances with plant-based fragrances for the first time. Mirroring her clothes, the bottle was discreet and austere, designed to set off its contents. During the 1930s, Chanel's success continued to grow and she turned her attention toward a more feminine style. She showcased the female form, creating dresses made of fluid mousseline, precious lace, and luxurious satin. Always in the heart of the artistic scene, she designed clothes for several film projects, dressed Gloria Swanson in *Tonight Is Forever* and worked with Jean Renoir in *Rules of the Game.* Chanel closed her house when the Second World War broke out. She moved to Switzerland, dividing her time between Lausanne and Geneva, with brief trips to France. She returned to fashion at the age of seventy-one.

The fashion world and Chanel are inseparable. She claimed that she was her own ideal. Her primary concern was for comfort, a resolutely modern concept, and she can be credited with bringing pre-First World War fashion into a more modern world. Her unusually long career paralleled the evolution of feminine emancipation. Her panoply of clothes, influenced by elements borrowed from the male wardrobe, opposed the restrictive forms that had been imposed on women, offering them unprecedented freedom of movement.

1923
Drawing by Woodruff for *Vogue.*
"It is not the dress that wears the woman, but the woman who should wear the dress."
GABRIELLE CHANEL

1926
Drawing by Jean Cocteau.
"This is why the feminine fashions by Mademoiselle Chanel have never been extravagant. She imposed the invisible... she imposed the nobility of silence on high-society ostentation."
JEAN COCTEAU

© ALL RIGHTS RESERVED

© JEAN COCTEAU

CHANEL

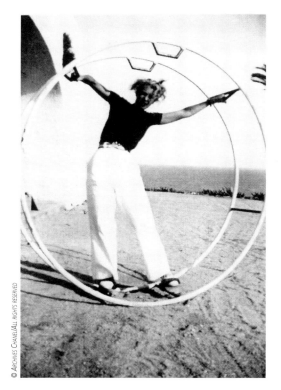

© Archives Chanel/All rights reserved

1932
Left:
Misia Sert, dressed by Chanel.

1929
Right:
"A dress is not a bandage.
It is designed to be worn.
We wear clothes with our
shoulders. A dress must be
suspended from the shoulders."
Gabrielle Chanel
In 1926, the American edition
of *Vogue* published a sketch
of a simple sheath dress.
This dress became something
of a uniform; its "impersonal
simplicity" earned it the title
of "Ford, by Chanel." One year
later, the French edition of
Vogue added: "What did Chanel
invent? A miserable luxury."

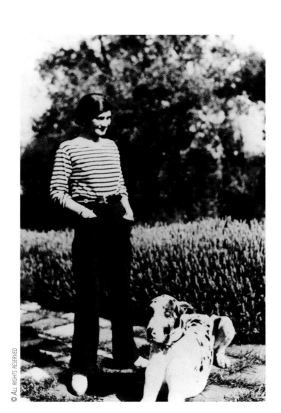

© All rights reserved

1930
Chanel with her dog Gigot
at La Pausa.
Inspired by the functional aspect
of work clothes, Chanel wears a
sailor's shirt and trousers.
An American journalist
wrote that "she managed
to get worldly women
to wear the white cuffs
and collars of chambermaids!"

© All rights reserved

37

CHANEL

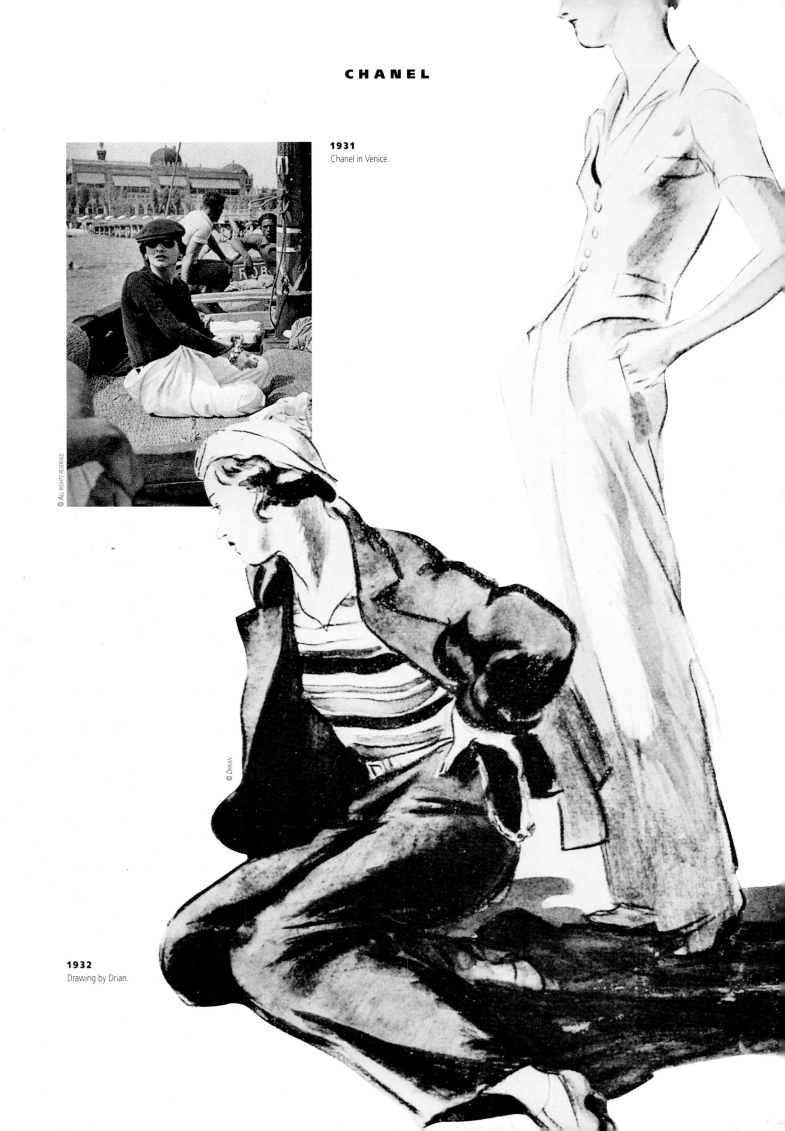

1931
Chanel in Venice.

© ALL RIGHTS RESERVED

© DRIAN

1932
Drawing by Drian.

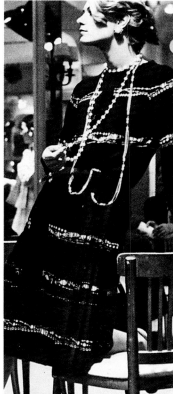

1937

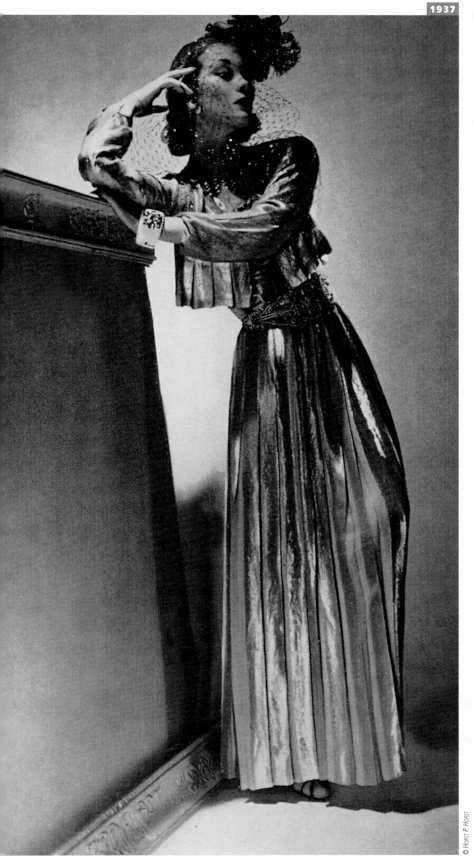

© HORST P. HORST

1971

"Clothes must have a logic."
GABRIELLE CHANEL

1938

Chanel in an evening gown in her apartment.

"Nature gives you the face you have at twenty; life gives you your face at thirty; but at fifty, you have the face you deserve."
GABRIELLE CHANEL

© HENRI CLARKE

© F. KOLLAR

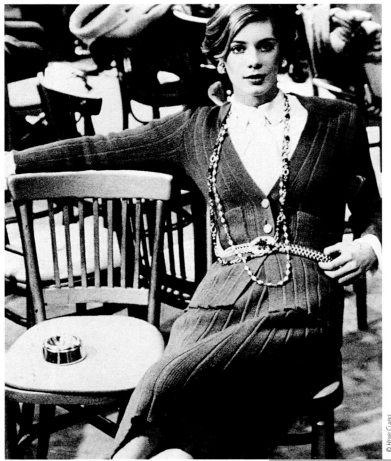

© HENRI CLARKE

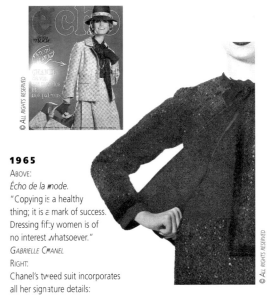

© ALL RIGHTS RESERVED

© ALL RIGHTS RESERVED

1965

ABOVE:

Écho de la mode.

"Copying is a healthy thing; it is a mark of success. Dressing fifty women is of no interest whatsoever."

GABRIELLE CHANEL

RIGHT:

Chanel's tweed suit incorporates all her signature details: overcast and topstitched seams for an even surface, a gilt chain weighting down the inside hem of the jacket, hidden zippers to slim down the waist, and a slightly tapered skirt to define a woman's legs and lengthen the bust.

1960

RIGHT:

Romy Schneider wearing a Chanel suit. Chanel dressed Romy Schneider in "Work," an episode from Luchino Visconti's film *Boccaccio 70.*

1971

ABOVE:

A dress from Gabrielle Chanel's last collection before her death.

1964

RIGHT:

Pantsuit.

Staring in 1916, Chanel offered her clientele pajama ensembles. Throughout her career, she adapted them to suit any occasion. Toward the end of her life, Chanel considered that women "almost never know how to wear pants. There are Zouave, cossack pants, short pants; it's grotesque."

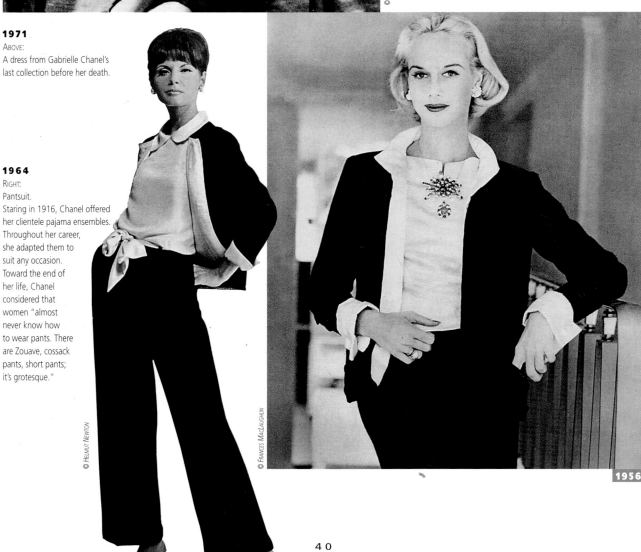

© HELMUT NEWTON

© FRANCES MACLAUGHLIN

1956

40

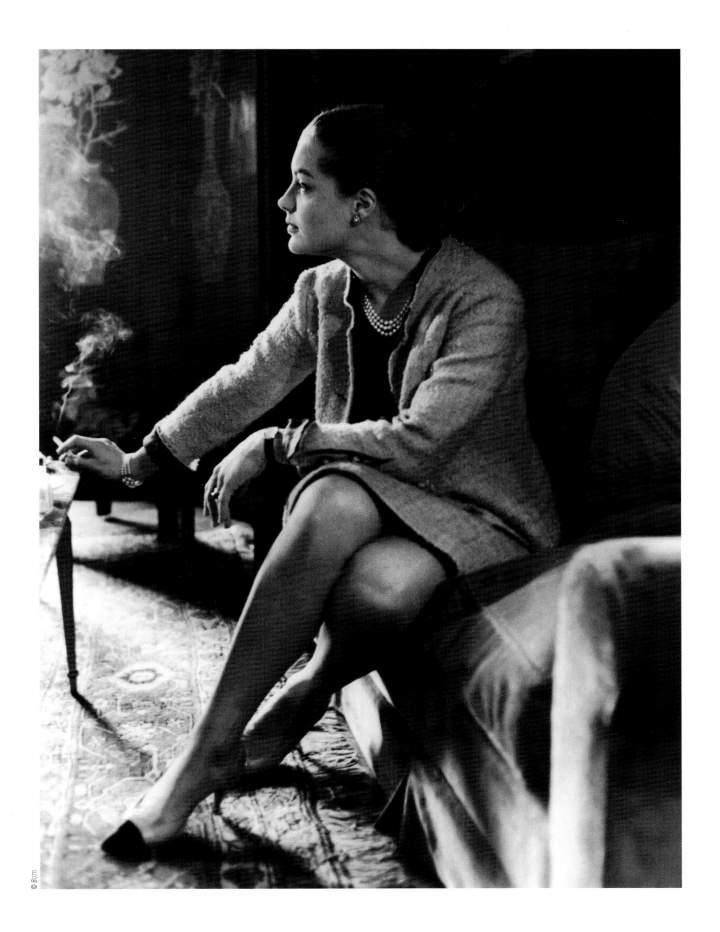

© Botti

CHARLES JAMES

(Camberley, Surrey, England, 1906 – New York, United States, 1978)

"Charles James is the greatest couturier."

CRISTOBAL BALENCIAGA

"He was the Einstein of fashion."

BILL CUNNINGHAM

1933
The *Taxi*, o *Spiral*, dress had an innovative design that integrated— and altered—a technical innovation the zipper.

© ALL RIGHTS RESERVED

The latest spiral model by **CHARLES JAMES** *fitted with* **"LIGHTNING"** *zipp fastener*

'LIGHTNING' zipp fastener

A perfectionist and a tyrant, Charles James devoted his life, his fortune, and his talent to the cut of his clothes. He did not consider himself to be a clothes designer, but more of a sculptor who manipulated, chiseled, and carved fabrics to create a living work around a body. His brilliance was based on a decidedly innovative approach to fitting and draping techniques. He corrected the proportions of couture models, whom he viewed as overly rigid, and designed smaller "jennies" (dressmaking dummies) with longer waists, which reproduced more faithfully the essential characteristics of his designs.

Strong-willed, passionate, and impetuous, Charles James calculated the shapes and structures of his work with mathematical precision. His sumptuous dresses could weigh up to twenty-two pounds, yet they always appeared to be delicate, light, and graceful, with a sense of movement created by a rigorously sophisticated construction. He was constantly aware of the thickness of air between the body and the item of clothing, because he felt that a dress had to be structured to let a slight draft of air circulate. Charles James's approach was to use fabric to sculpt this empty space, thereby establishing the

1953
BELOW: The *Abstract* or *Four-leaf Clover* design is Charles James's technical masterpiece.
This cutaway view illustrates its extremely complex structure.

Exterior cream satin outer bodice
Cotton flannel
Satin underbodice
Boning
Nylon mesh
Exterior satin
Petticoat
Nylon mesh
Fabric grain
Petticoat flare seam
Cream satin peplum
Black velvet top flounce
Under petticoat
Cream taffeta
Inverted box pleat
Nylon mesh
Boning
Non-woven fabric
Taffeta slip
Fabric grain
Petticoat flare
Faille lower flounce

© ALL RIGHTS RESERVED

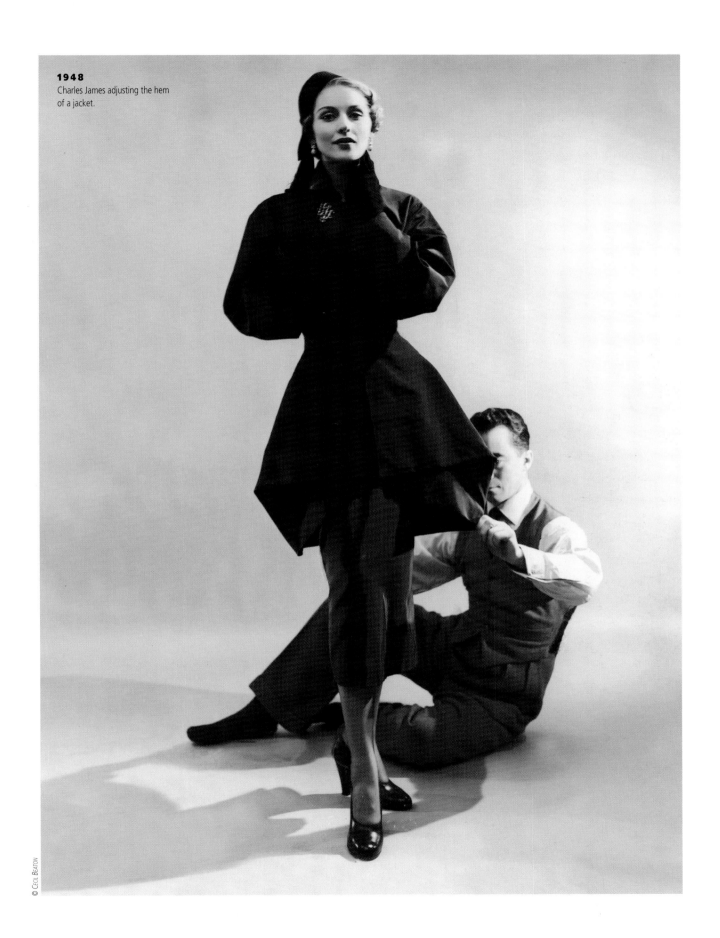

1948
Charles James adjusting the hem
of a jacket.

© CECIL BEATON

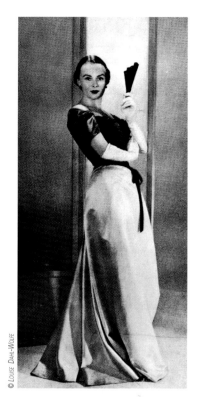

© LOUISE DAHL-WOLFE

1948
LEFT:
Mrs. William Randolph Hearst Jr., client, patron, and friend:
"His brain was an enchanted loom, weaving ideas and shifting harmonies and patterns."

1950
RIGHT:
Mrs. William S. Paley.

1978
BELOW:
Charles James had a particularly productive and decisive working relationship with fashion illustrator Antonio, who used the 1938 *Siren* dress as inspiration for his series *Metamorphosis*.

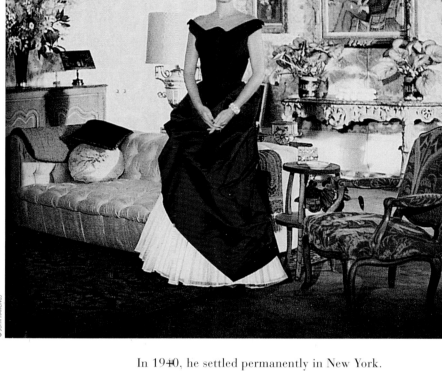

© JOHN RAWLINGS

necessary distance to create movement. He was a virtuoso in his use of materials, fashioning and refashioning colors, fibers, and textures until he considered the outfit finished.

A child of English-American parents, Charles James grew up in England. At the age of eighteen, when he refused to prepare for the entrance examination to Oxford, his parents sent him to Chicago, his mother's native city. One year later and with no previous experience, he opened a millinery shop named Boucheron. He moved to New York in 1928 and in the 1930s, opened up fashion houses in Paris and London.

1940
OPPOSITE PAGE:
One of his famous clients, Millicent Huddleston Rogers, donated her many dresses by Charles James to the Brooklyn Museum; the ensemble forms a representative overview of the designer's work.

In 1940, he settled permanently in New York. His perfectionism, combined with his notoriously demanding temperament, made it impossible for him to lower his standards to increase sales. Despite the enthusiasm and dedication of his high-society clientele and recognition from his Parisian peers, he retired in 1958, ruined by countless losses, lawsuits, and bankruptcy procedures.

Throughout his life, Charles James pursued a single-minded quest to raise fashion to a form of pure art. He believed deeply that his "works" would ultimately be judged as museum pieces. Yet his vision constantly vacillated between his belief in haute couture clothes that serve as a laboratory of ideas and his conviction that his made-to-measure techniques could be adapted to the mass market. A man outside of his own time, Charles James left a legacy that guarantees him a place in fashion history.

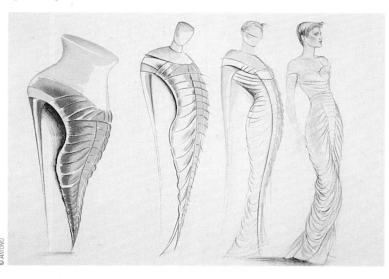

© ANTONIO

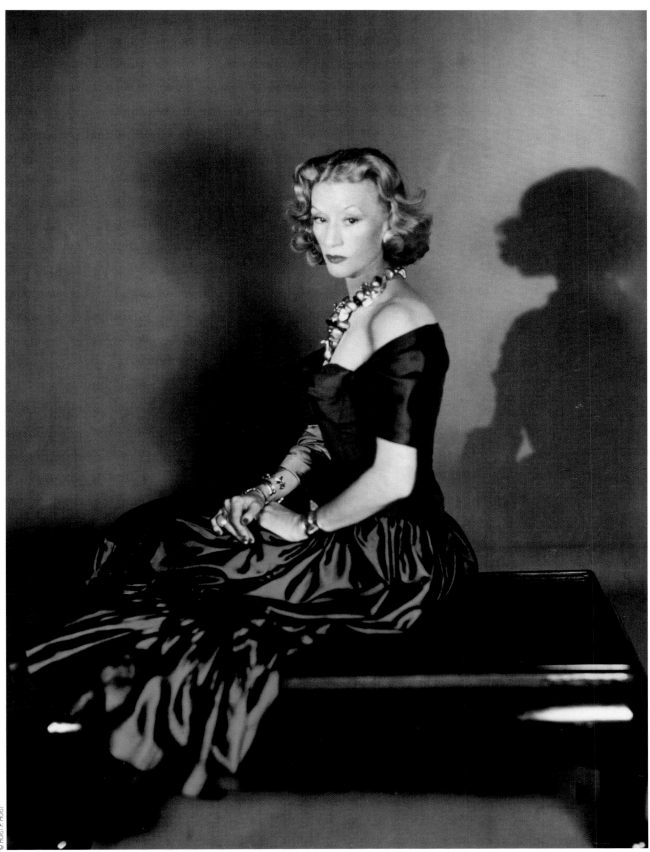

© *Horst P. Horst*

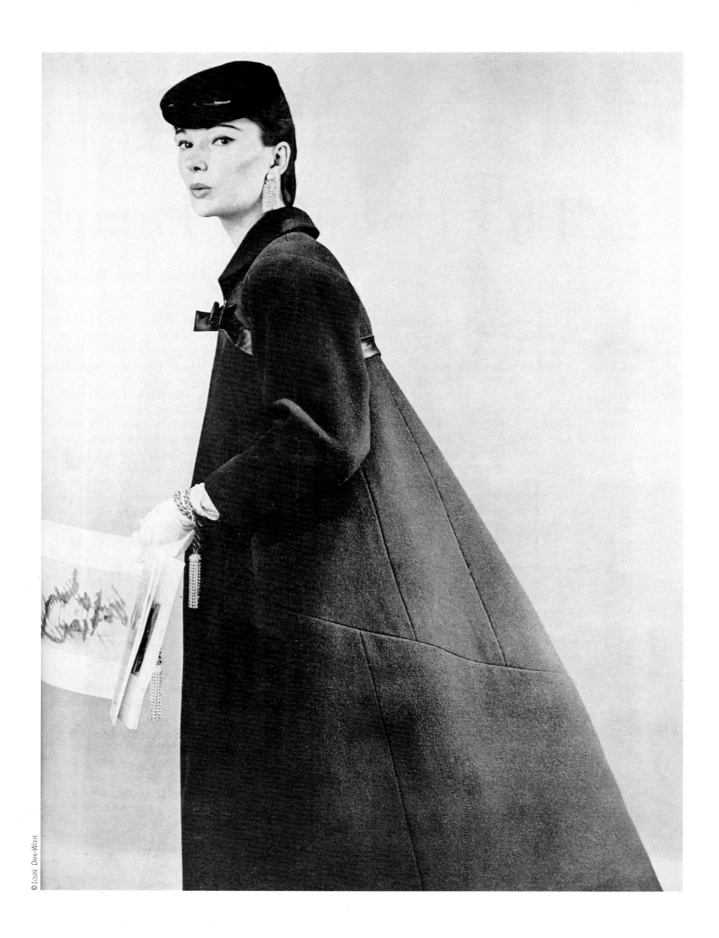

© LOUISE DAHL-WOLFE

1954
<small>OPPOSITE PAGE:</small> *Gothic coat.*

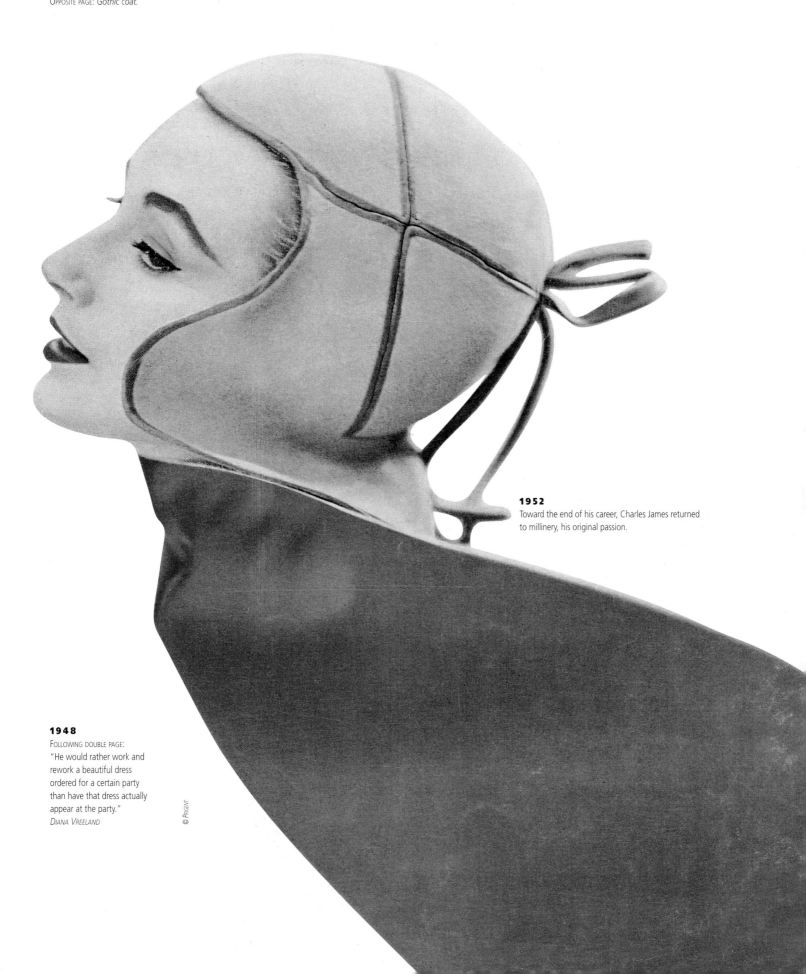

1952
Toward the end of his career, Charles James returned to millinery, his original passion.

1948
<small>FOLLOWING DOUBLE PAGE:</small>
"He would rather work and rework a beautiful dress ordered for a certain party than have that dress actually appear at the party."
<small>DIANA VREELAND</small>

<small>© PROGENT</small>

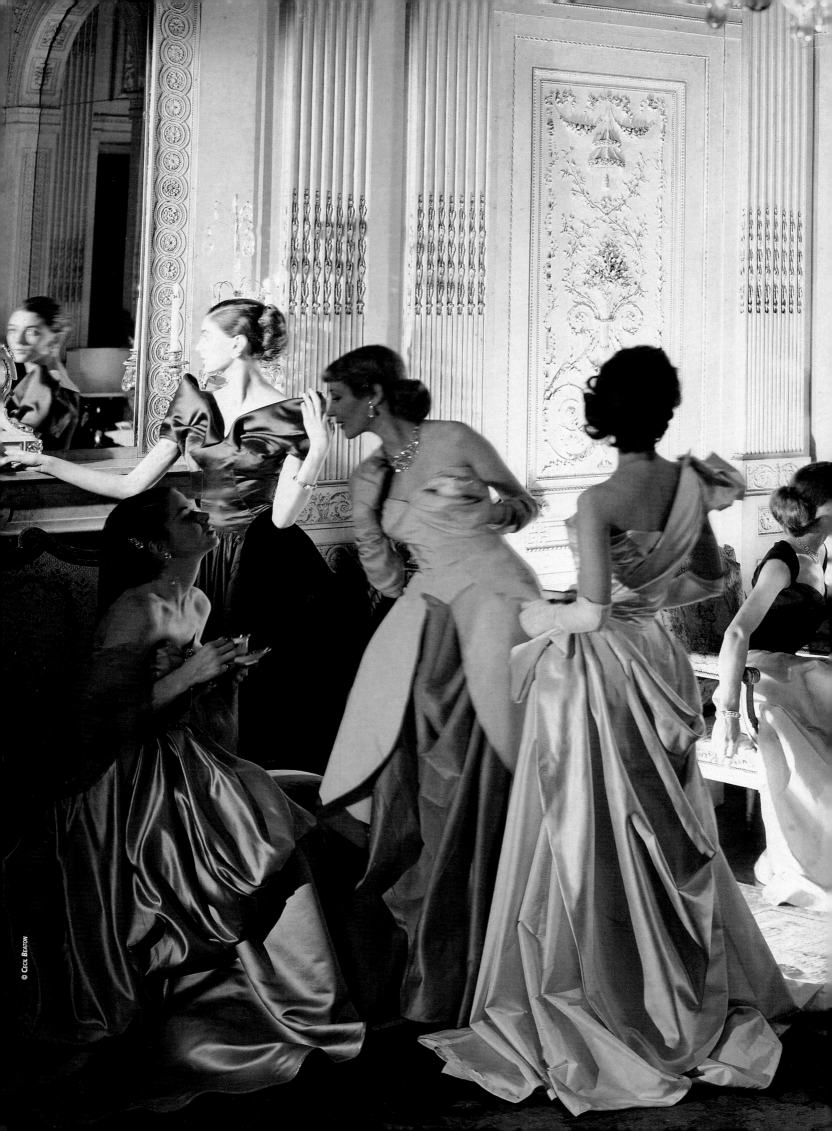

© Cecil Beaton

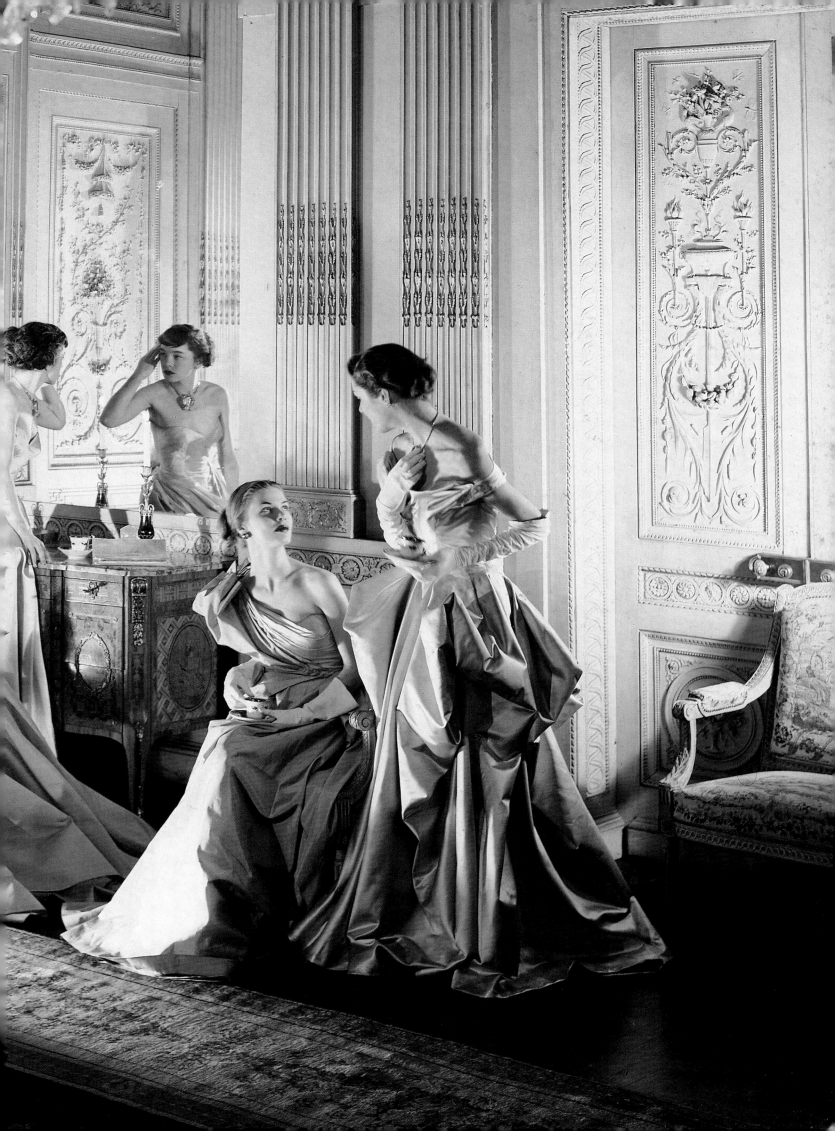

CHRISTIAN DIOR

(Granville, France, 1905 – Montecatini, Italy, 1957)

"As a result of wartime uniforms, women still looked and dressed
like Amazons. But I designed clothes for flowerlike women,
clothes with rounded shoulders, full feminine busts,
and willowy waists above enormous spreading skirts. Such a fragile air
can be achieved only by solid construction…
a technique quite different from the methods then in use."

CHRISTIAN DIOR

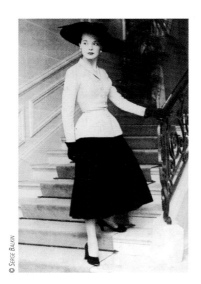

1947
The Spring/Summer collection
The "Corolle" ("Corolla)": "8"
line. "The lines of this first spring
collection are typically feminine,
designed to flatter the women
who wear them."
PRESS RELEASE, DIOR COUTURE HOUSE

RIGHT:
The famous *Bar* suit, which
symbolized the new silhouette
in fashion, in a 1947 drawing
by Christian Bérard.

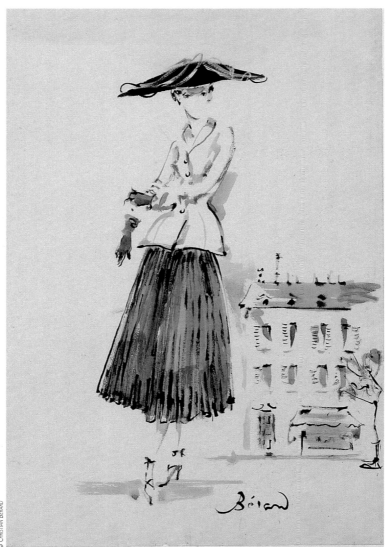

Christian Dior presented his first collection on February 12, 1947. It crystallized the esthetics of the newly rediscovered woman, offering abundance and lavish dreams of unprecedented luxury after the long and painful war years. In just ten years, from the first collection, baptized the New Look, until his death in 1957, Dior's named acquired the status of a legend. Opting for the traditional expertise and know-how of haute couture, he invented and symbolized the quintessence of femininity in the 1950s. His opulent version of a silhouette with sloping shoulders, clinched waist, and full and longer skirts reestablished Paris as the international capital of fashion. Dior, as its undisputed authority, became the most influential couturier, and was personally responsible for 50 percent of the exports of Parisian haute couture to the United States. Intuitive and gifted with a good business sense, Dior understood that his house would thrive only if his name became widely known. He developed licensing contracts, still effective today, while maintaining the prestige of his name.

Born into a well-to-do family, Christian Dior grew up in wealth and comfort. Worried about his future, Dior's parents sent him to a political-science school, despite his recognized artistic talents. After serving in the military, he opened an art gallery with Jacques Bonjean, where they exhibited works by their friends Christian Bérard, Raoul Dufy, Giorgio de Chirico, and Jean Cocteau. In 1931, his mother died of cancer, and his father, swindled out of his money, declared bankruptcy. Forced to give up his gallery, he earned a living selling fashion drawings and was then hired by Robert Piguet in 1938. Drafted into the army for one year, he lost his job, but after returning to Paris, was hired by Lucien Lelong, joining Pierre Balmain. In 1946, he met Marcel Bous-

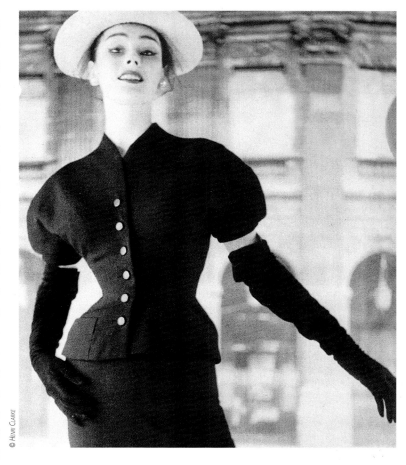

© HENRI CLARKE

1953
Spring/Summer collection. "Tulip" line. "The design that best illustrates the 1953 silhouette is a tulip in bloom. The new line completely alters proportions, with an enhanced bust and diminished hips."

1947
Spring/Summer collection. Sketch by Dior.

© ALL RIGHTS RESERVED

sac, a rich industrialist, who offered him a job as artistic director for the Philippe et Gaston couture house, founded twenty-five years earlier. Dior refused, but convinced Boussac to finance him. On December 16, 1946, at the age of forty-one, Christian Dior opened his house at 30, Avenue Montaigne.

A sociological, esthetic, and commercial phenomenon, the New Look defined its era, imposing and confirming a highly feminine silhouette. Constantly seeking a perfect harmony in his designs, Christian Dior used dualities, oscillating between structure and fluidity, luxury and discretion, and matte and shiny materials. The quest of luxury that he initiated would be perpetuated by his successors: Yves Saint Laurent (1958-1960), Marc Bohan (1960-1989), Gianfranco Ferré (1989-1996) and, finally, John Galliano.

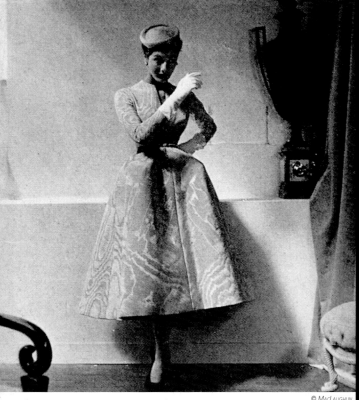

© MacLaughlin

1952
Fall/Winter collection
1952-1953. The sharply defined
lines of the *Cigale* dress.
"It is shaped with sharp,
stiffened fabrics, as this dress
is meant to be, above all,
delicate, young and precise."

1950
Right:
Illustration by Gruau
for International Textiles.

1948
Far right:
Fall/Winter collection
1948-1949.
"Ailée" ("Winged") line, *Diane*
evening dress.

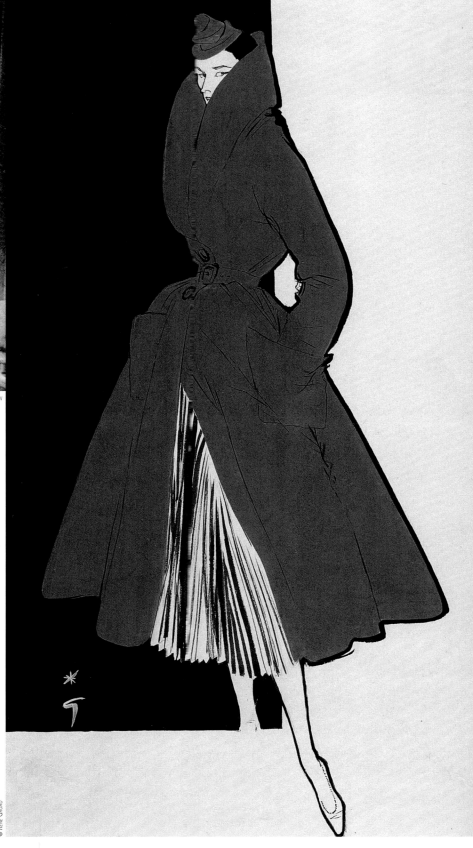

© René Gruau

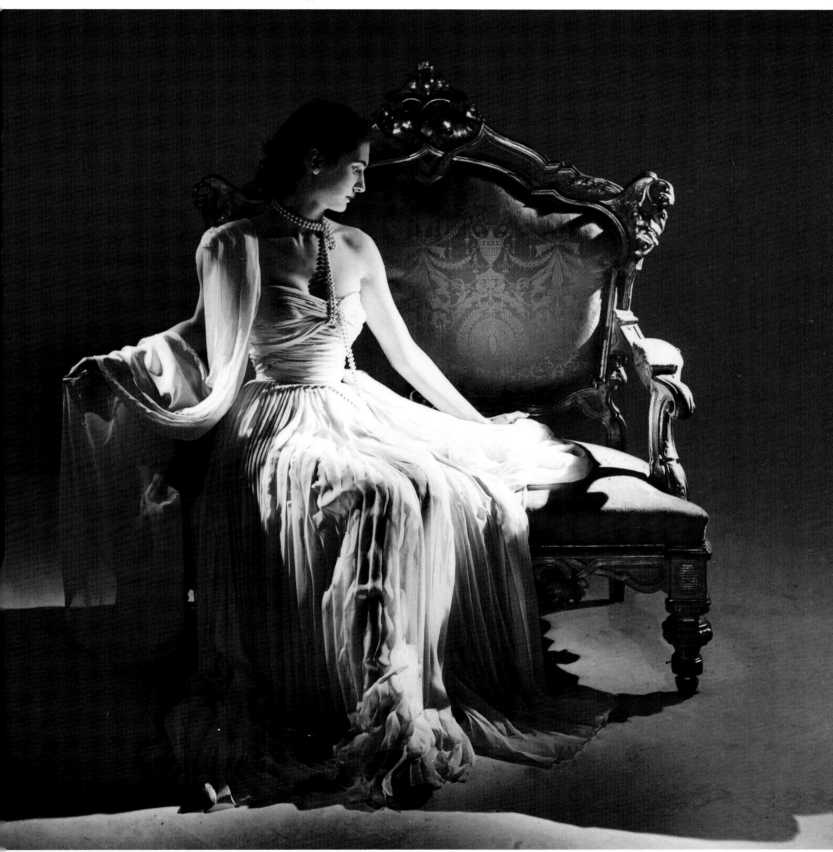

© WILLY MAYWALD

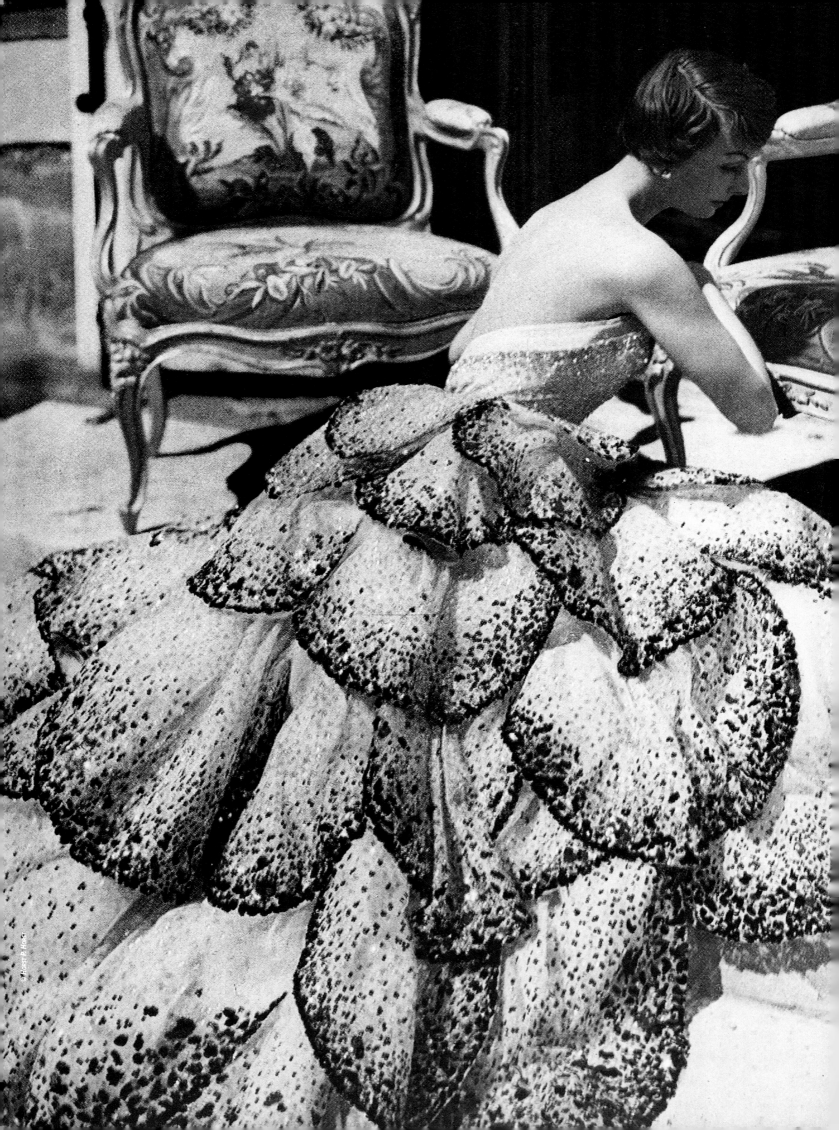
© Horst P. Horst

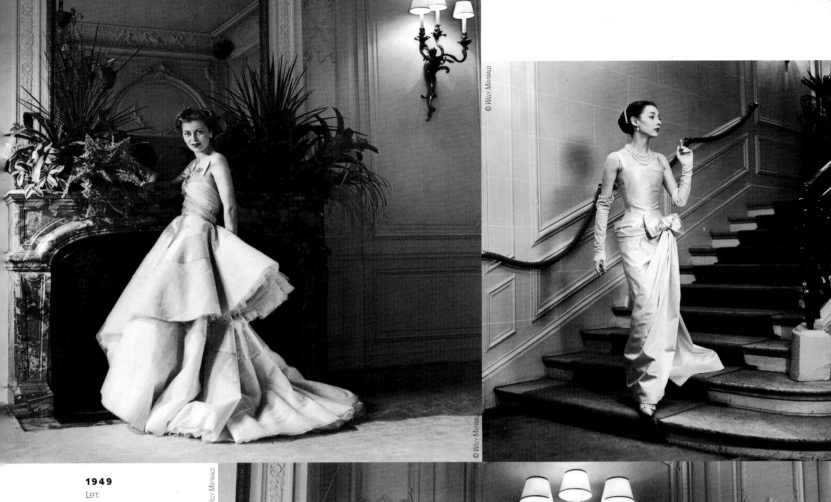

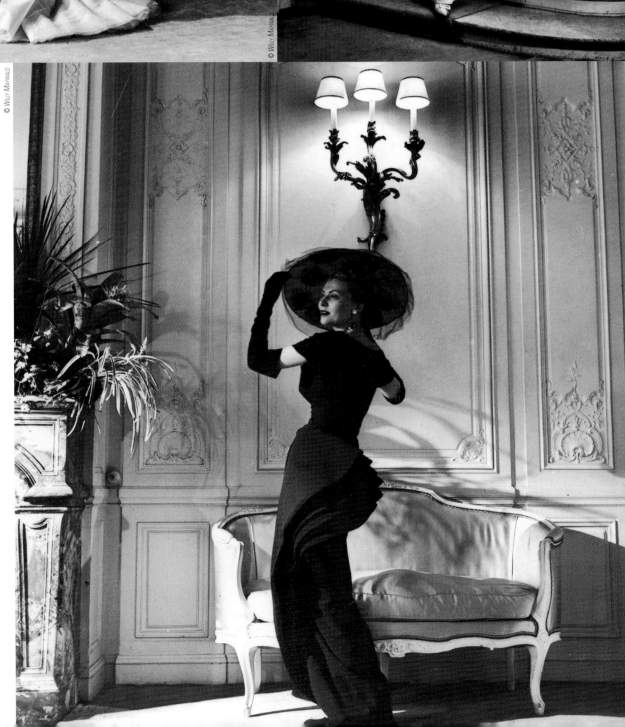

1949
LEFT:
Fall/Winter collection.
1949-1950. *Juno* evening gown.
This collection was, above all,
that of the "mid-century,"
and was meant to represent
a lifestyle and fashion.

1948
ABOVE:
Fall/Winter collection
1948-1949.
"Ailée" ("Winged") line,
Éloïse evening gown.

1954
TOP RIGHT:
Fall/Winter collection
1954-1955. "H" Line, *Angélique*
evening dress. The time had
come for an entirely new line,
based on length and pared-
down busts. These parallel lines
formed the letter "H," which
was the overall shape used in
dress, suit, and coat designs.

1948
RIGHT:
Fall/Winter collection
1948-1949. "Zigzag" line,
Fan evening dress. The new
collection was inspired by wings.
During this season, hemlines
were not the most important
element; it was the cut and
the arrangement of fabric,
which was no longer draped,
yet was designed in eye-catching
constructions.

© WILLY MAYWALD

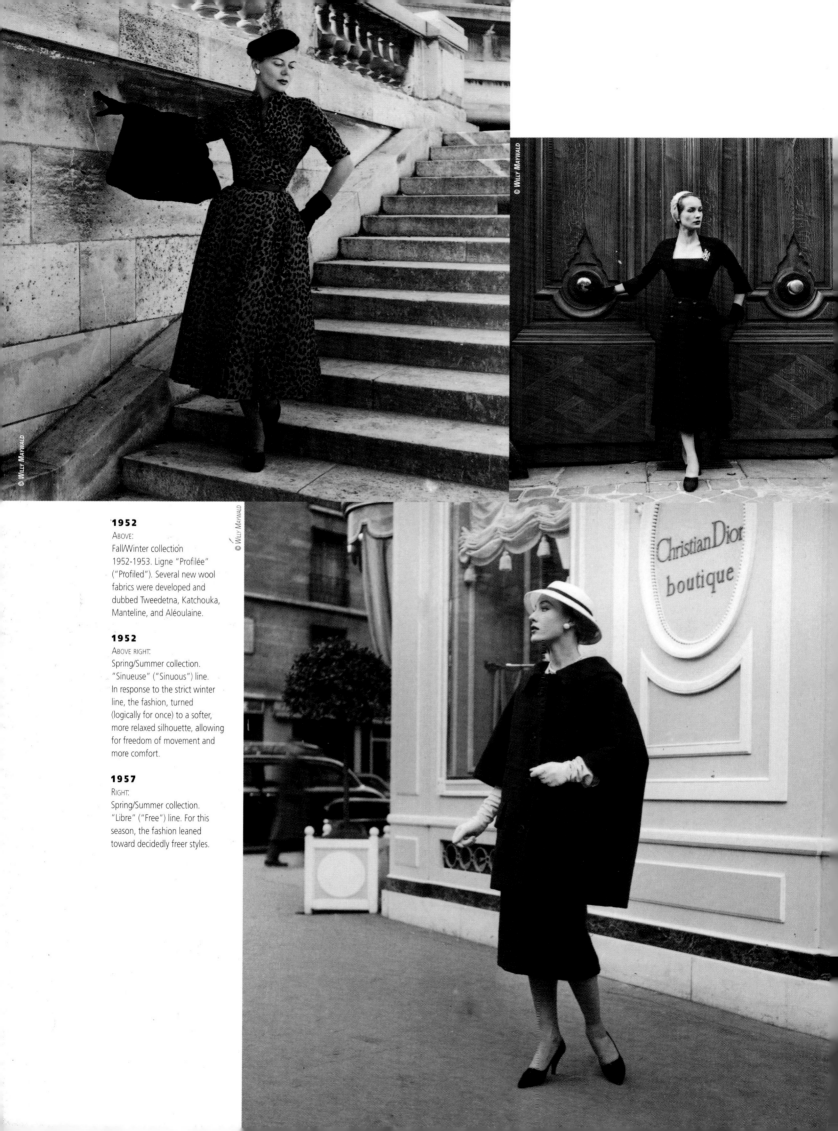

© WILLY MAYWALD

1952
ABOVE:
Fall/Winter collection
1952-1953. Ligne "Profilée"
("Profiled"). Several new wool
fabrics were developed and
dubbed Tweedetna, Katchouka,
Manteline, and Aléoulaine.

1952
ABOVE RIGHT:
Spring/Summer collection.
"Sinueuse" ("Sinuous") line.
In response to the strict winter
line, the fashion, turned
(logically for once) to a softer,
more relaxed silhouette, allowing
for freedom of movement and
more comfort.

1957
RIGHT:
Spring/Summer collection.
"Libre" ("Free") line. For this
season, the fashion leaned
toward decidedly freer styles.

ChristianDior
boutique

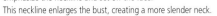

1950

BELOW: Fall/Winter collection 1950-1951. "Oblique" line. The slanted lines of the sleeves emphasize the neckline and set off the face.
This neckline enlarges the bust, creating a more slender neck.

© WILLY MAYWALD

1955

RIGHT: Fall/Winter collection 1955-1956. "Y" line, *Alibi* model. The high bust extends between the branches of the "Y," which ends at the base of the natural, slender shoulders. This line is characterized by a new sleeve design.

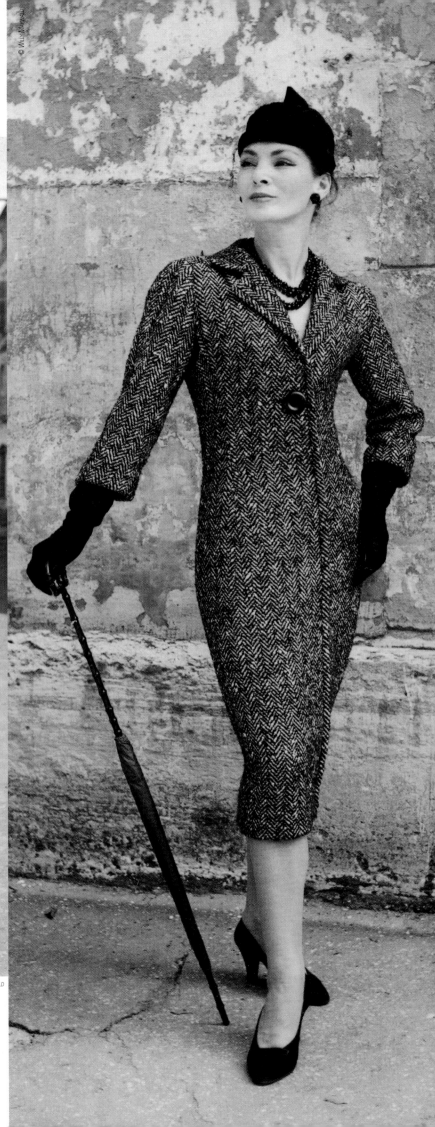
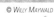

CHRISTIAN LACROIX

(Arles, France, 1951)

"My purpose is not to arbitrarily misrepresent reality,
but to capture its successful moments."

CHRISTIAN LACROIX

1988
"Luxe" collection,
Spring/Summer.

© GUY MARINEAU

Christian Lacroix's designs represent a spectacular dialogue between his Provençal roots, his obsessive taste for the vernacular, and his fascination with the history of costumes. His unusual mixes are surprising and seductive, expressing the idea of a new baroque type of sophisticated luxury. With respect, sincerity, and generosity, Christian Lacroix combines bright colors and extravagant materials with a sophisticated blend of cultures, and remote and long-forgotten traditions; these form the foundations, if not the raison d'être, of his work.

At an early age, Christian Lacroix was putting together small albums about the theater and opera, collages representing family portraits and drawings by Christian Bérard. He left his hometown of Arles to study art history in Montpellier, then moved to Paris in 1973 to attend the Sorbonne University. He was writing his master's thesis on French costumes viewed through seventeenth-century painting while attending classes at the Louvre school, with the idea of becoming a museum curator. It was during this period that he met his future wife, Françoise, and became more interested in fashion. In 1978, Lacroix was hired by Hermès, where he learned "ABCs, the technical aspects of

the trade." Two years later, he started working as Guy Paulin's assistant, before replacing Roy Gonzales as designer for Jean Patou in 1981. In 1985, he received the Dé d'Or Award for his series of dresses designed as an homage to his native Camargue region. The following year he opened his own fashion house at 73, Rue du Faubourg-Saint-Honoré with financial backing from Bernard Arnault (CEO of Louis Vuitton–Moët-Hennessy, a multinational luxury goods company). On July 26, 1987, Christian Lacroix presented his first collection. His fashions confirmed the growing trend for opulence that was sweeping through the haute couture world.

In 1988, he was awarded a second Dé d'Or by his profession.

His designs are like pieces of puzzles, bringing together a diverse group of craftsmen, including weavers, corset-makers, painters, and embroiderers. His spell-binding shows present a stylish clutter. Fantastic textures compete with embroidered materials, and fluid fabrics are blended with spangles—the perfect illustration of Christian Lacroix's flamboyant design vocabulary.

© LACROIX

1975

CHRISTIAN LACROIX

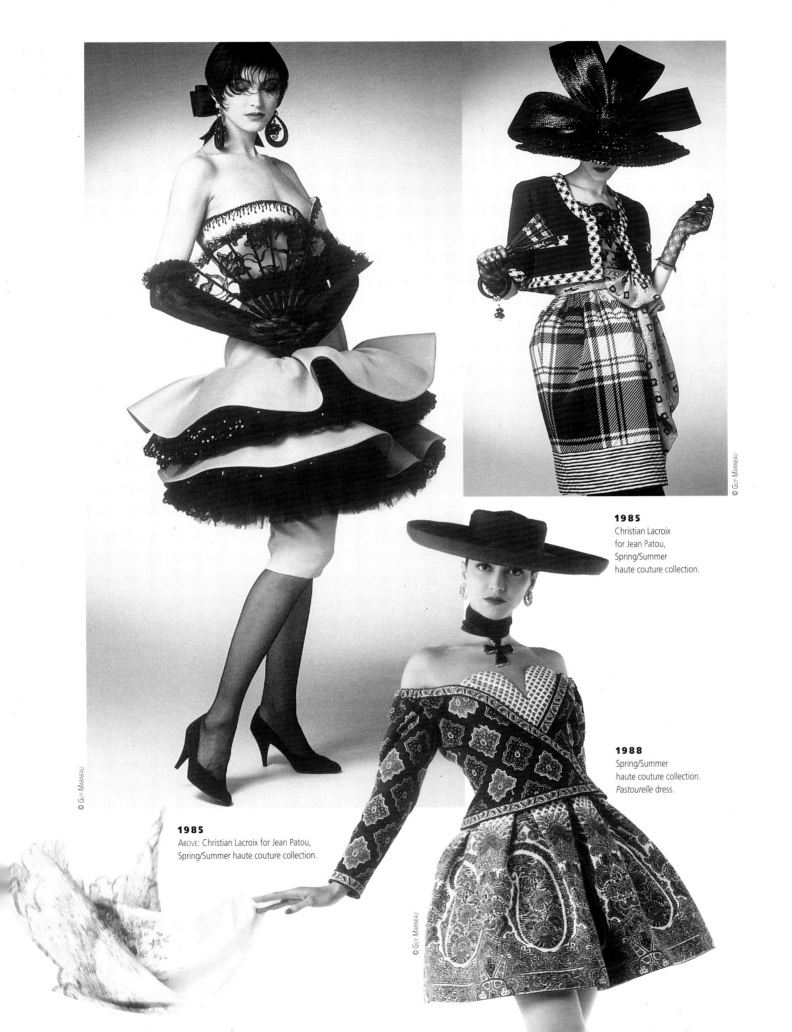

© GUY MARINEAU

1985
Christian Lacroix
for Jean Patou,
Spring/Summer
haute couture collection.

1988
Spring/Summer
haute couture collection.
Pastourelle dress.

1985
ABOVE: Christian Lacroix for Jean Patou,
Spring/Summer haute couture collection.

© GUY MARINEAU

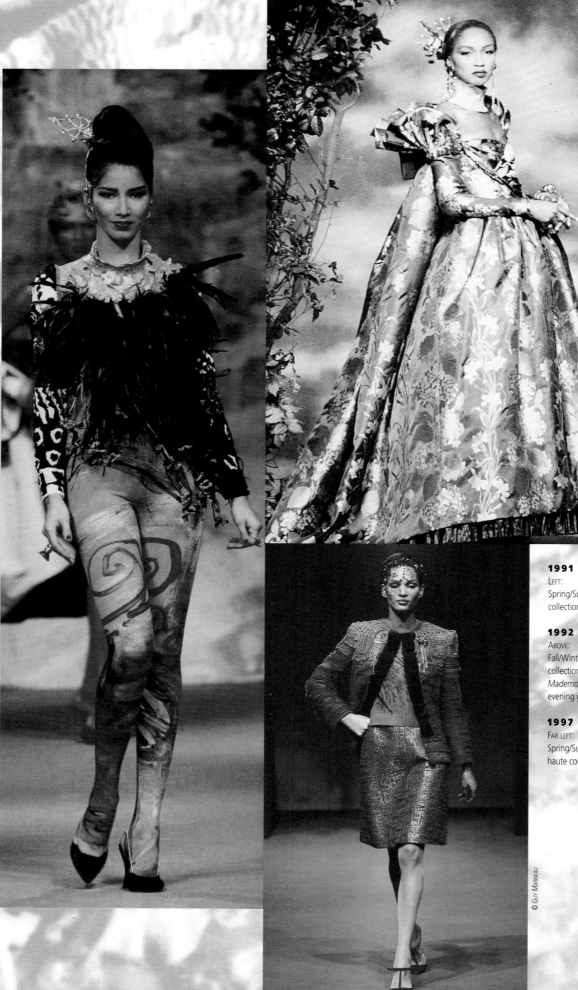

© Guy Marineau

© Guy Marineau

© Guy Marineau

1991
LEFT:
Spring/Summer haute couture
collection, *Yo-Yo*.

1992
ABOVE:
Fall/Winter haute couture
collection. 1992-1993,
Mademoiselle Hortensia
evening gown

1997
FAR LEFT:
Spring/Summer
haute couture collection.

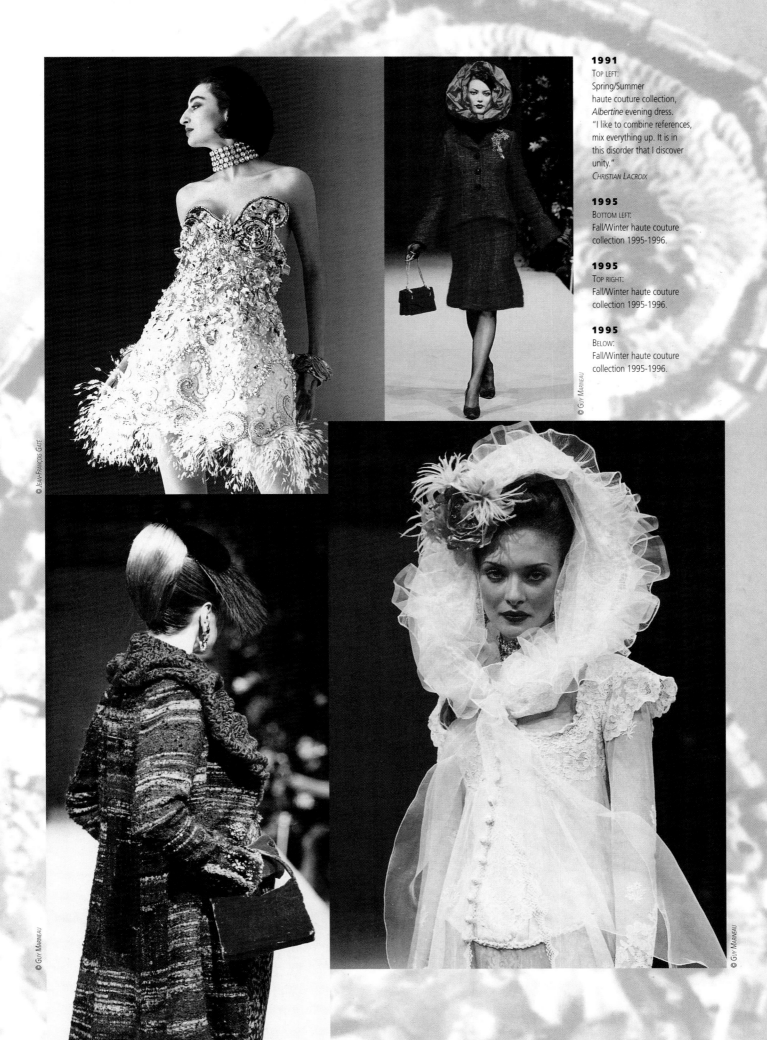

1991

TOP LEFT:
Spring/Summer
haute couture collection,
Albertine evening dress.
"I like to combine references,
mix everything up. It is in
this disorder that I discover
unity."
CHRISTIAN LACROIX

1995

BOTTOM LEFT:
Fall/Winter haute couture
collection 1995-1996.

1995

TOP RIGHT:
Fall/Winter haute couture
collection 1995-1996.

1995

BELOW:
Fall/Winter haute couture
collection 1995-1996.

© JEAN-FRANÇOIS GATÉ

© GUY MARINEAU

© GUY MARINEAU

© GUY MARINEAU

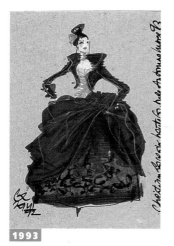

1993

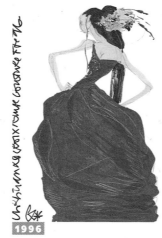

1996

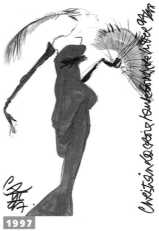

1997

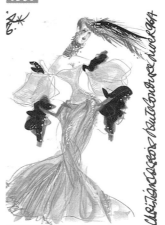

1997

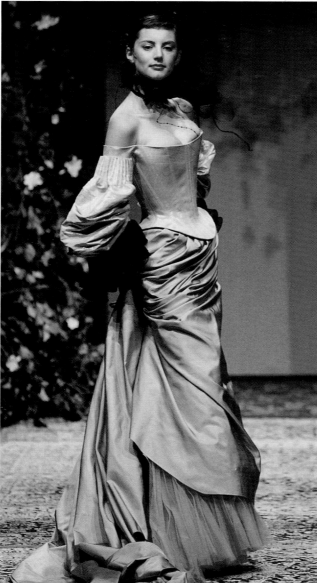

Drawings by Christian Lacroix for the haute couture collections. "Fashion is authentic, coherent, and legitimate when it is a sincere, lucid, and unadulterated reflection of the times."
CHRISTIAN LACROIX

1996

LEFT: Fall/Winter haute couture collection 1996-1997.

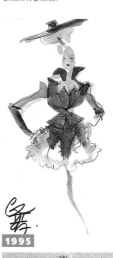

1995

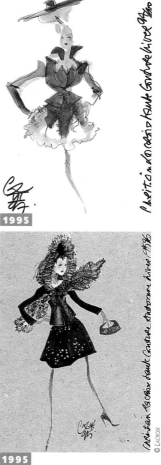

1997

Opposite Page, TOP (LEFT TO RIGHT): Fall/Winter 1997-1998. Twentieth haute couture collection. The Lacroix fashion house celebrates its tenth anniversary.

1994

OPPOSITE, BOTTOM LEFT: Spring/Summer haute couture collection.

1995

OPPOSITE, BOTTOM RIGHT: Fall/Winter haute couture collection. 1995-1996.

"I still want to believe that difference is the key to everything. At least for Christian Lacroix. Each fashion house, each designer, must create his own world. It is the ephemeral, the singular, the unique that are the strongest signs of an identity."
CHRISTIAN LACROIX

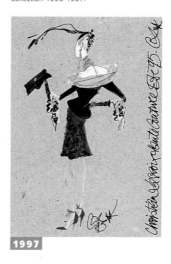

1997

1995

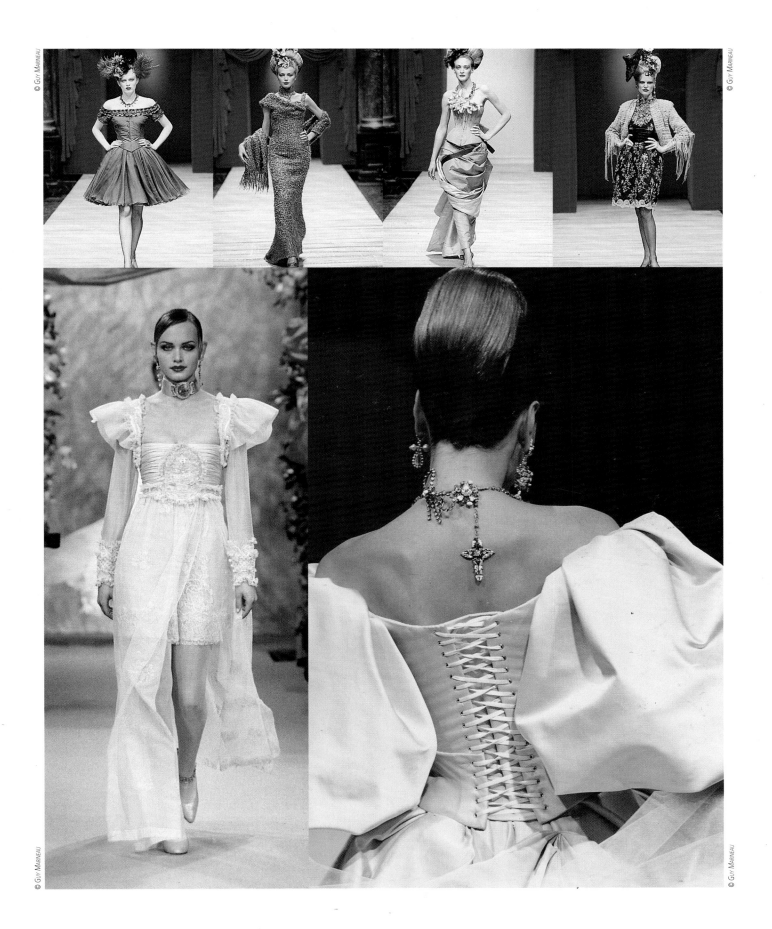

CLAIRE McCARDELL

(Frederick, Maryland, United States, 1905 – New York, 1958)

*"I've always wondered why women's clothes have to be delicate—
why they couldn't be practical and sturdy as as well as feminine?"*

CLAIRE McCARDELL

By 1940, Claire McCardell had established the "American Look." Pragmatic and unusual, her clothes always met her overriding concern for comfort. She introduced simple, flattering, easy-care and easy-to-wear clothes for every occasion. After studying at Parsons School of Design in New York, she started working as a designer for Richard Turk in 1929. She followed him when he moved to Townley Frocks, replacing him after he died. In 1938, she was hired by Hattie Carnegie. Two years later, she returned to Townley Frocks, where she created her own label.

Drawing her inspiration from the American woman, McCardell designed clothes that fostered a woman's independence and autonomy. In her quest for comfort, she transposed the functionalism of men's clothes to women's designs, with rounded shoulders for blouses, topstitching, darts, and pleated pants. She transformed hook-and-eye fasteners and zippers into trim elements, eliminated lining, and cut back on interfacing. Pockets were always easy to reach and constituted essential details in her look. She used simple materials, such as cotton and wool piqué, gingham, and even denim in an unconventional yet unpretentious way. Through her influence, ideas concerning the use of traditional fabrics for fine clothes were reassessed. Her use of colors—orange, red, and violet—was equally unusual.

1946

OPPOSITE PAGE:
Diaper bathing suit.
This cleverly designed suit is made from a single piece of fabric, knotted at the neck, wrapped between the legs and tied at the waist.

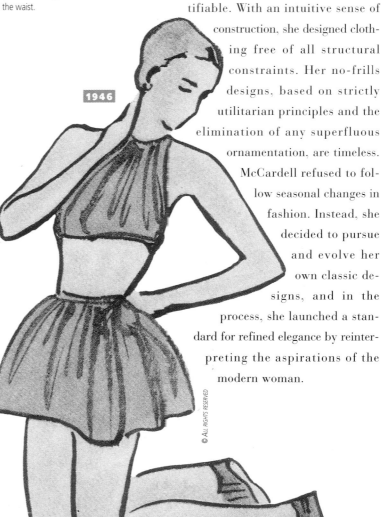

1946

© ALL RIGHTS RESERVED

Her style coincided with a new, active, independent, and more demanding type of lifestyle. During an era when American designers looked to Paris fashion for inspiration, outfits by Claire McCardell were instantly identifiable. With an intuitive sense of construction, she designed clothing free of all structural constraints. Her no-frills designs, based on strictly utilitarian principles and the elimination of any superfluous ornamentation, are timeless. McCardell refused to follow seasonal changes in fashion. Instead, she decided to pursue and evolve her own classic designs, and in the process, she launched a standard for refined elegance by reinterpreting the aspirations of the modern woman.

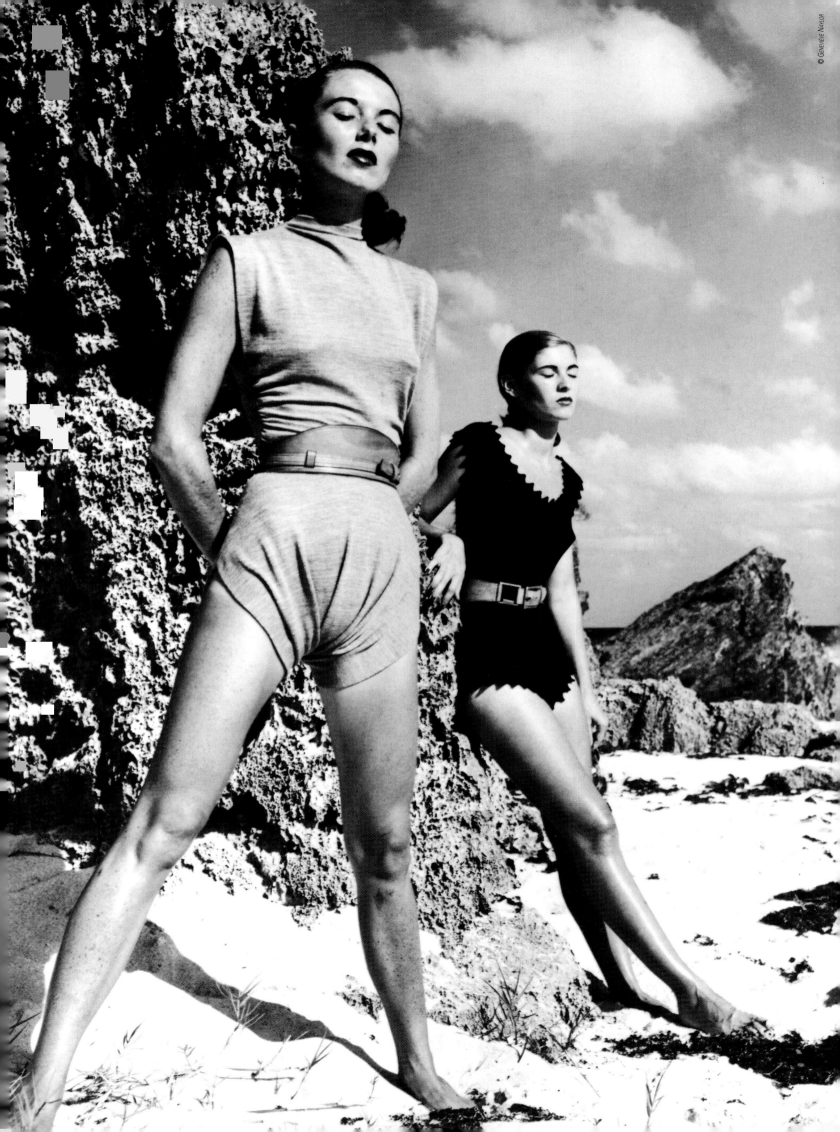

© GENEVIÈVE NAYLOR

© ALL RIGHTS RESERVED

1943
Hooks were functional and also used as ornamental details.

1950
RIGHT:
The *Monk dress* was a bias-cut piece of fabric without a front, back or waist. Extremely simple, this tent-style dress was so flexible that each woman could wear it as she chose, belting it at the waist or letting it fall free.

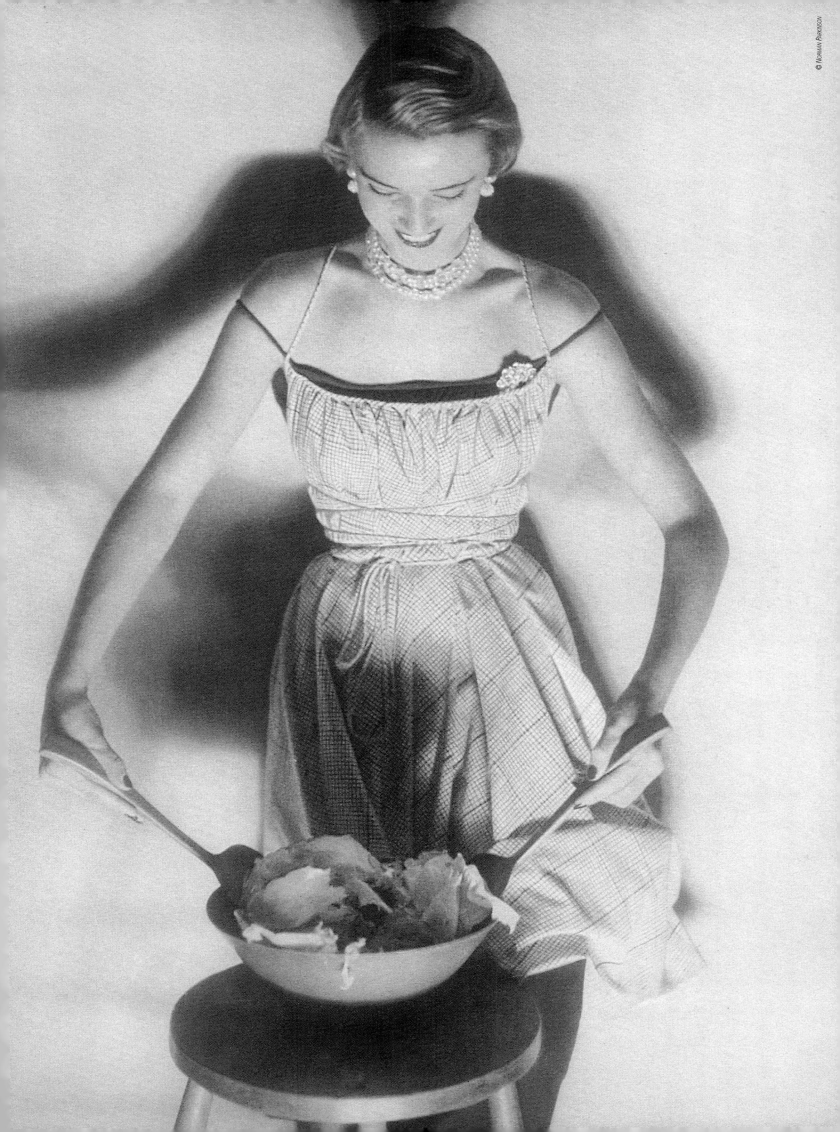

© NORMAN PARKINSON

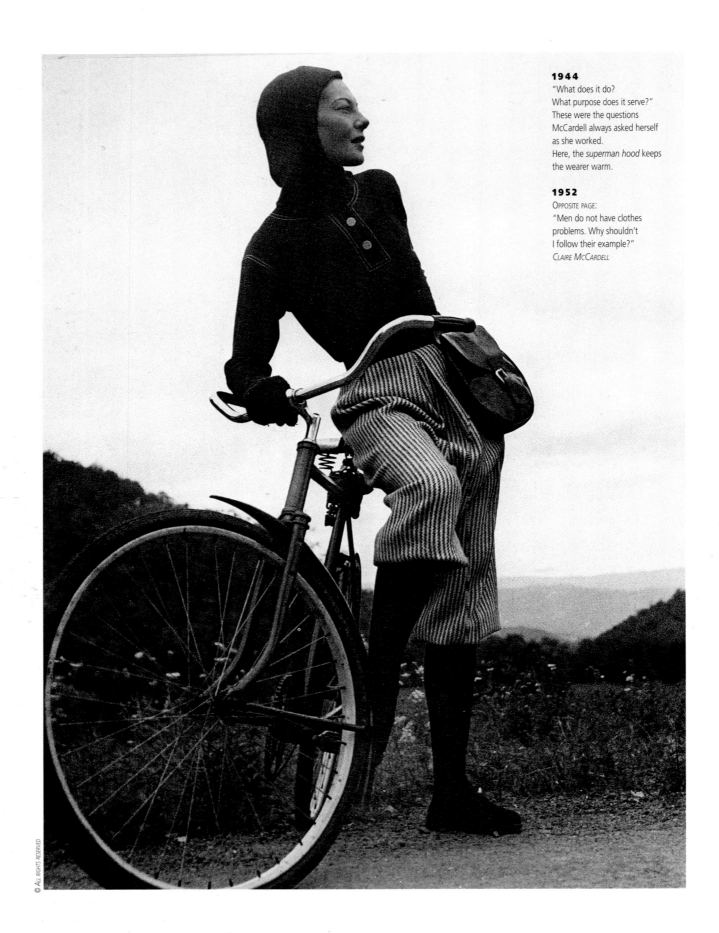

1944
"What does it do?
What purpose does it serve?"
These were the questions
McCardell always asked herself
as she worked.
Here, the *superman hood* keeps
the wearer warm.

1952
OPPOSITE PAGE:
"Men do not have clothes
problems. Why shouldn't
I follow their example?"
CLAIRE McCARDELL

© ALL RIGHTS RESERVED

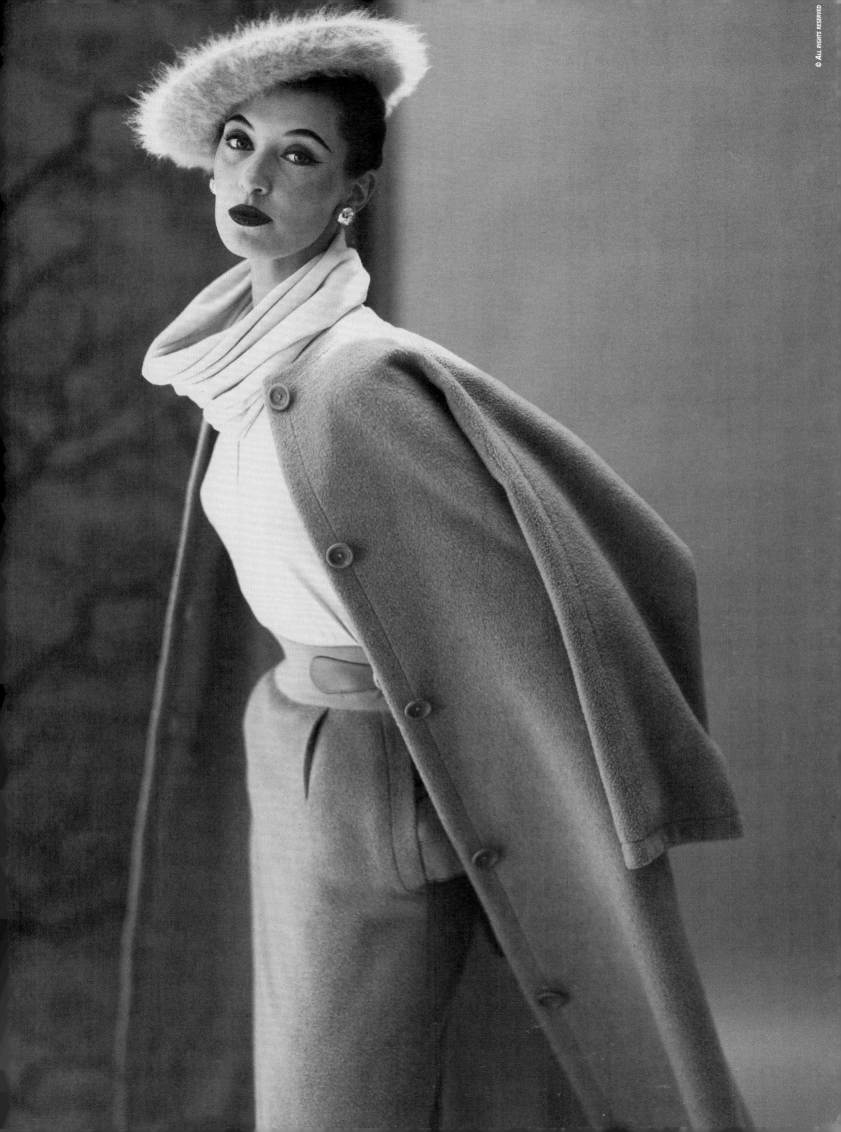

© ALL RIGHTS RESERVED

CLAIRE McCARDELL

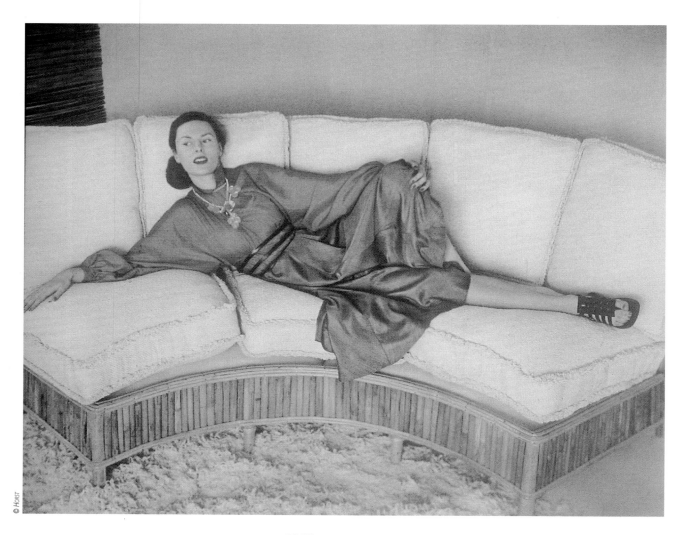

1947
"I like comfort in the sun, in the
rain, for sports, when walking
around, and to be pretty."
CLAIRE MCCARDELL

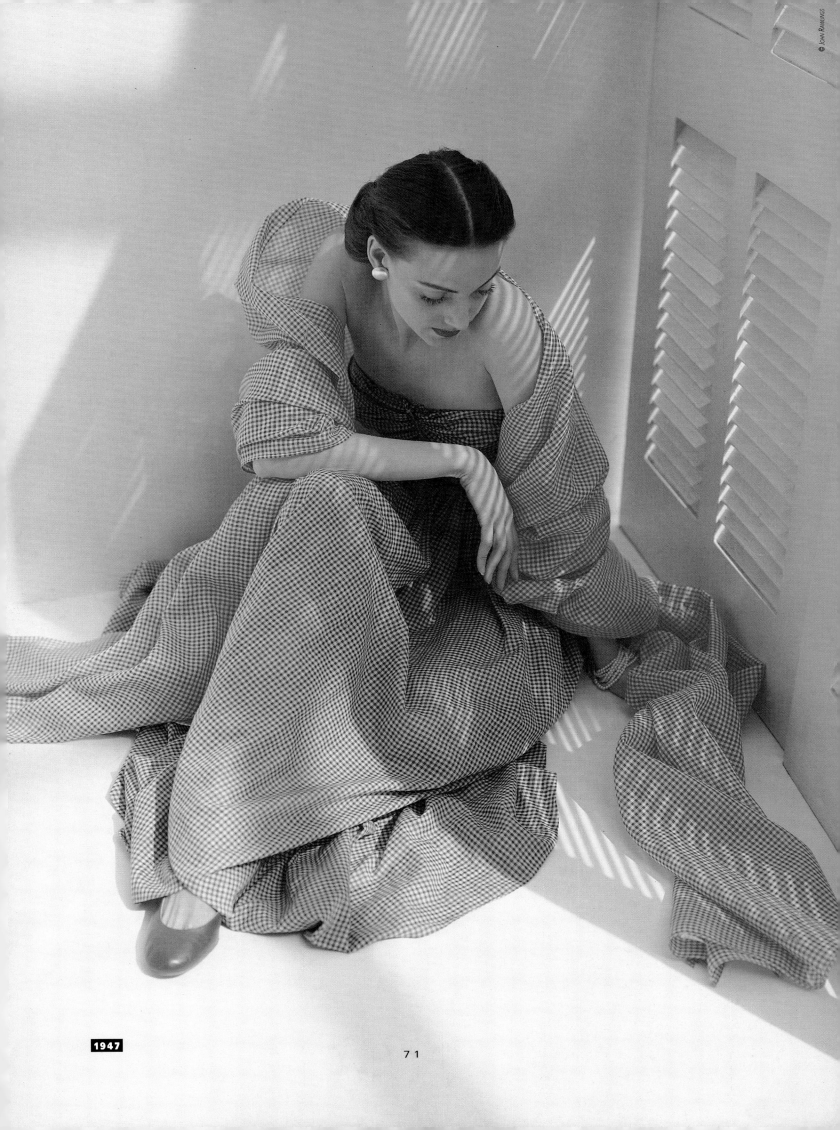

© JOHN RAWLINGS

1947

71

CLAUDE MONTANA

(Paris, France, 1949)

"I am a perfectionist. I'm always afraid that there won't be enough time and that I'll have to accept a detail that is imperfect."

CLAUDE MONTANA

Graphic, clean, and rigorous, Claude Montana's style combines spectacular structure with sumptuous technical perfection. His designs, based on exaggerated proportions, create a small-waisted, tall silhouette. Montana devotes special attention to necklines, whether scooped, cowled, or tapered, to set off the face. His accentuated forms were in total opposition to the body-hugging clothes of the 1970s, yet he was able to impose his vision, and in the process, imbued the assertive woman with a greater measure of soul. Montana used a sensuous palette of single shades, including Yves Klein blue, which remains his favorite color. Over the years, he has reduced the width of his silhouette, removing pads and paring down the oversized shoulders, replacing them with a more feminine, sensual, and mellower look, achieved through his sophisticated line and consummate cut.

Encouraged by his parents to pursue classical studies (Greek and Latin), Montana decided instead to become a walk-on actor for the opera in 1970, after earning his baccalaureate degree. He then traveled to London with a friend, where they started making papier-mâché jewelry set with colored stones. Sold at Thirty Antic Market on King's Road, their designs were widely acclaimed and promoted by the English edition of *Vogue*. Neither of them had working papers, so they were forced to return to Paris. Montana worked as a free-lance fashion illustrator for various magazines, then became an assistant to Swedish designer John Voigt at MacDouglas. This is where he discovered the techniques of leather working, a specialty of the fashion house and a material he has used consistently since then. "Leather is the first material that I touched," admits Montana, who would later become known specifically for his "leather couture."

He was also working for Rosier in Milan. In 1973, Claude Montana designed four collections for Michelle Costas, plus a small series with the label Idéal Cuir. His individual style of wide, asymmetrical proportions was taking shape. In 1976, in cooperation with a Spanish knitwear company, he

1983
"Claude Montana: the man who invented leather couture."
Le Monde.
RIGHT:
Spring/Summer collection 1987.

© Les Goldberg

© Niall McInerney

72

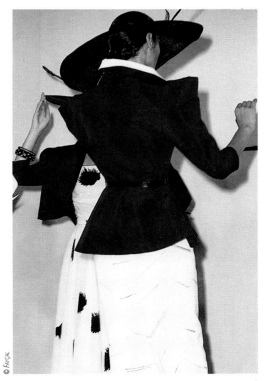

© FAYÇAL

1980
LEFT:
Spring/Summer collection.

1984
BOTTOM LEFT:
Spring/Summer collection.
"A protective covering,
a suggestive covering,
a warm covering. We wrap
the body up, the better
to display it."
CLAUDE MONTANA

created his own collection, called "Claude Montana for Ferrer y Sentis." Three years later, he opened his own fashion house and moved to a former banana-ripening depot at 131, Rue Saint-Denis in Paris. While continuing to develop his own style, Montana designed clothes for the Italian company Complice. In 1990, he took over as haute couture designer for Lanvin, where he remained for five seasons. While working for this fashion house, he was awarded two Dés d'Or, in July 1990 and January 1991.

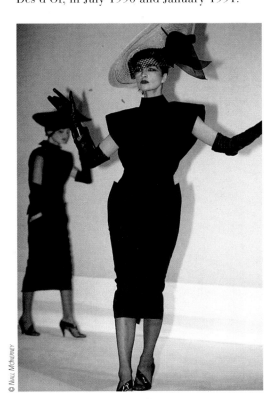

© NIALL McINERNEY

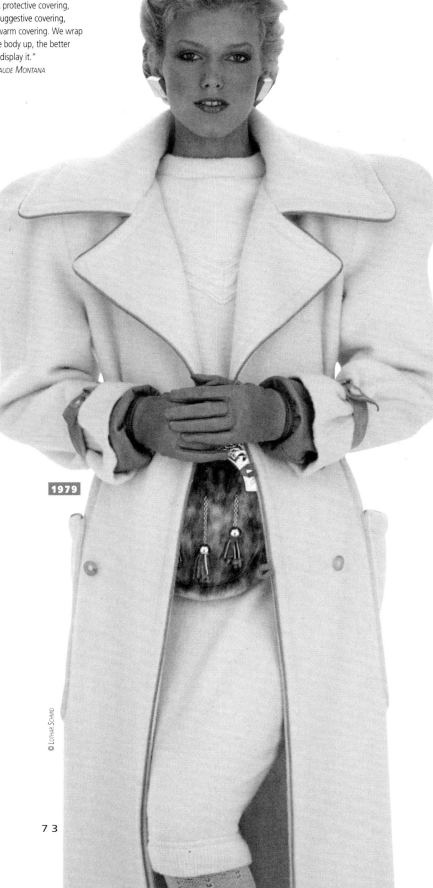

1979

© LOTHAR SCHMID

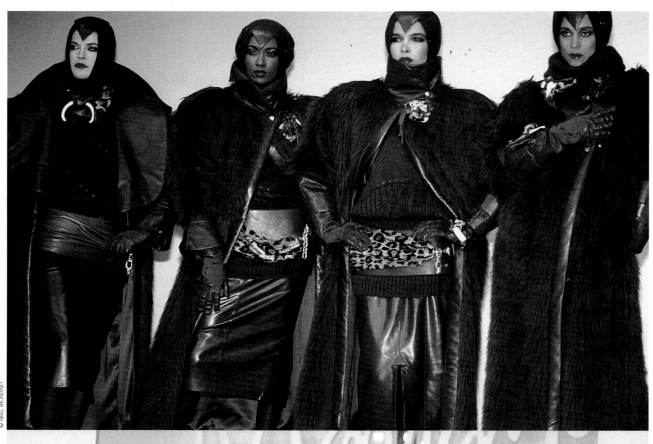

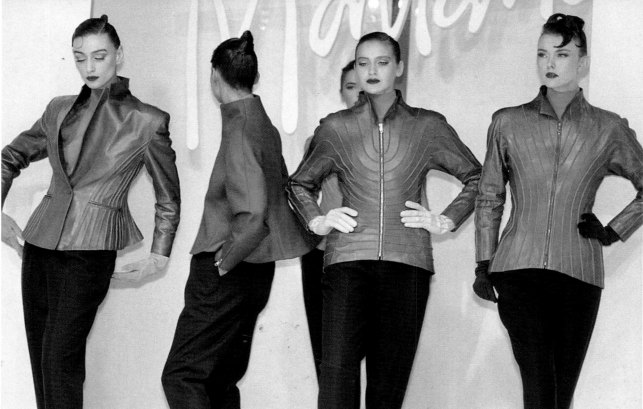

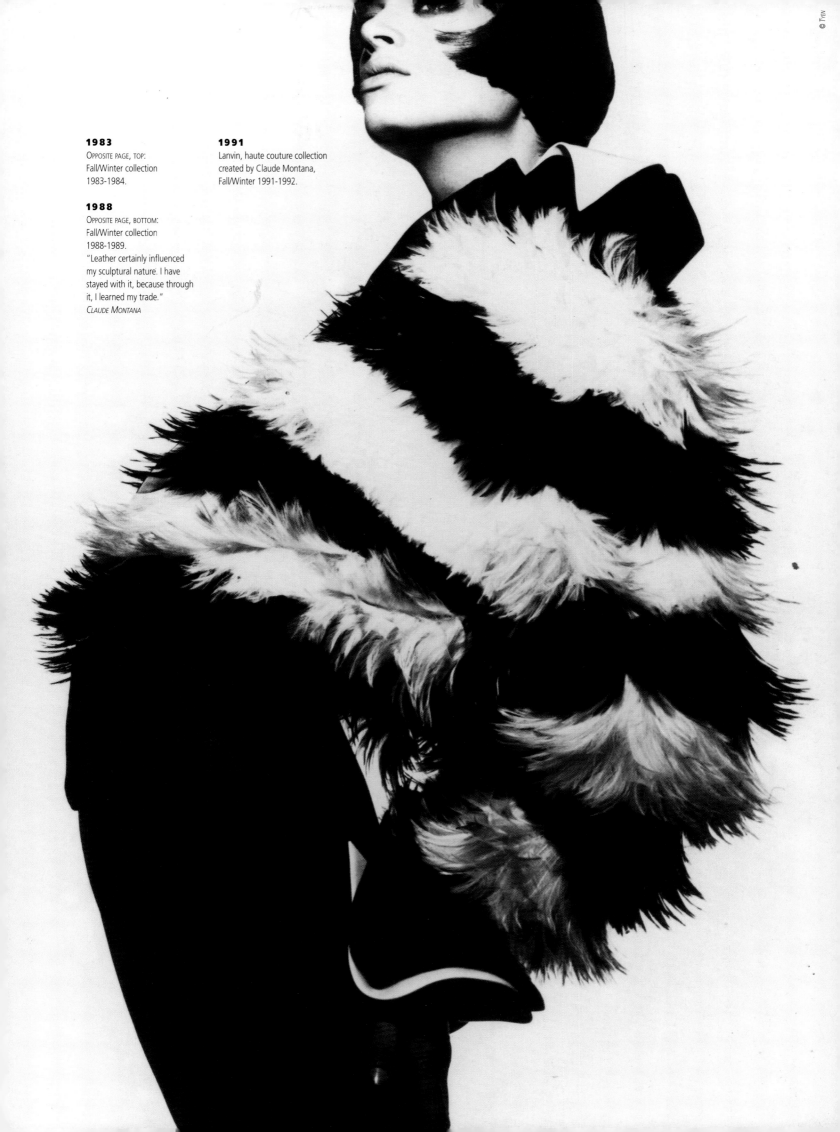

1983
OPPOSITE PAGE, TOP:
Fall/Winter collection
1983-1984.

1988
OPPOSITE PAGE, BOTTOM:
Fall/Winter collection
1988-1989.
"Leather certainly influenced
my sculptural nature. I have
stayed with it, because through
it, I learned my trade."
CLAUDE MONTANA

1991
Lanvin, haute couture collection
created by Claude Montana,
Fall/Winter 1991-1992.

© TEN

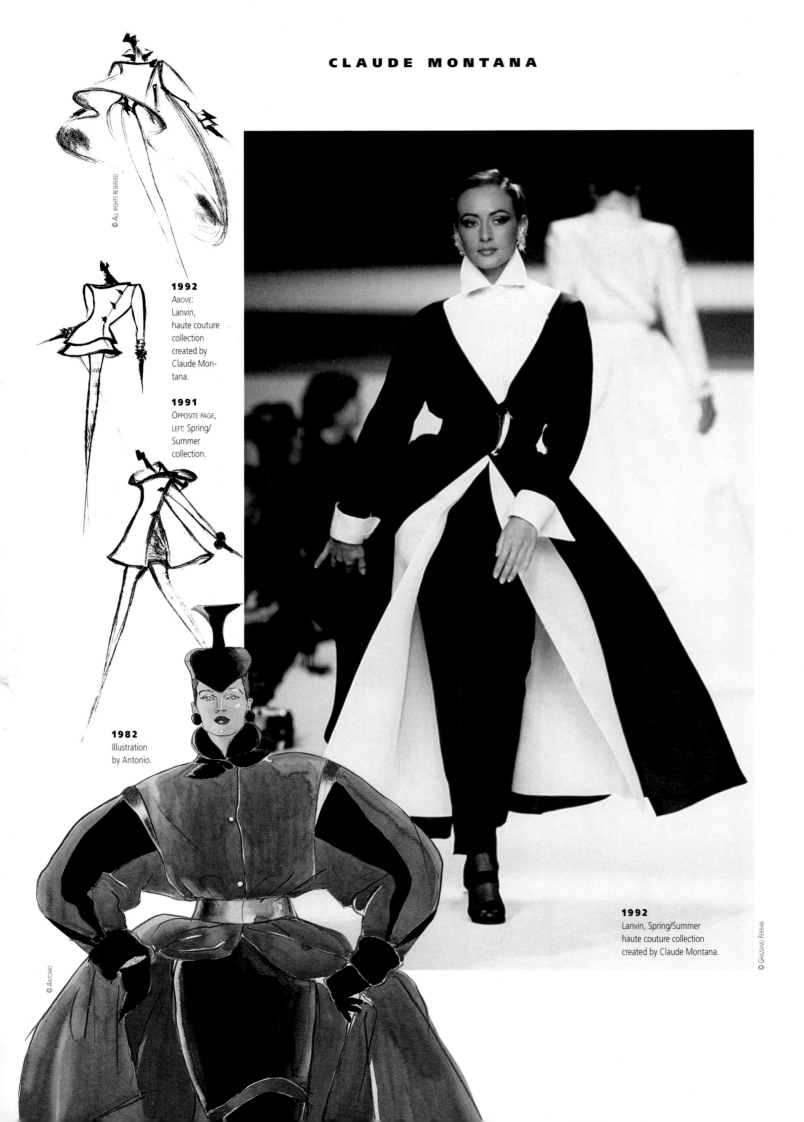

CLAUDE MONTANA

© ALL RIGHTS RESERVED

1992
ABOVE:
Lanvin,
haute couture
collection
created by
Claude Mon-
tana.

1991
OPPOSITE PAGE,
LEFT. Spring/
Summer
collection.

1982
Illustration
by Antonio.

© ANTONIO

1992
Lanvin, Spring/Summer
haute couture collection
created by Claude Montana.

© GRAZIANO FERRARI

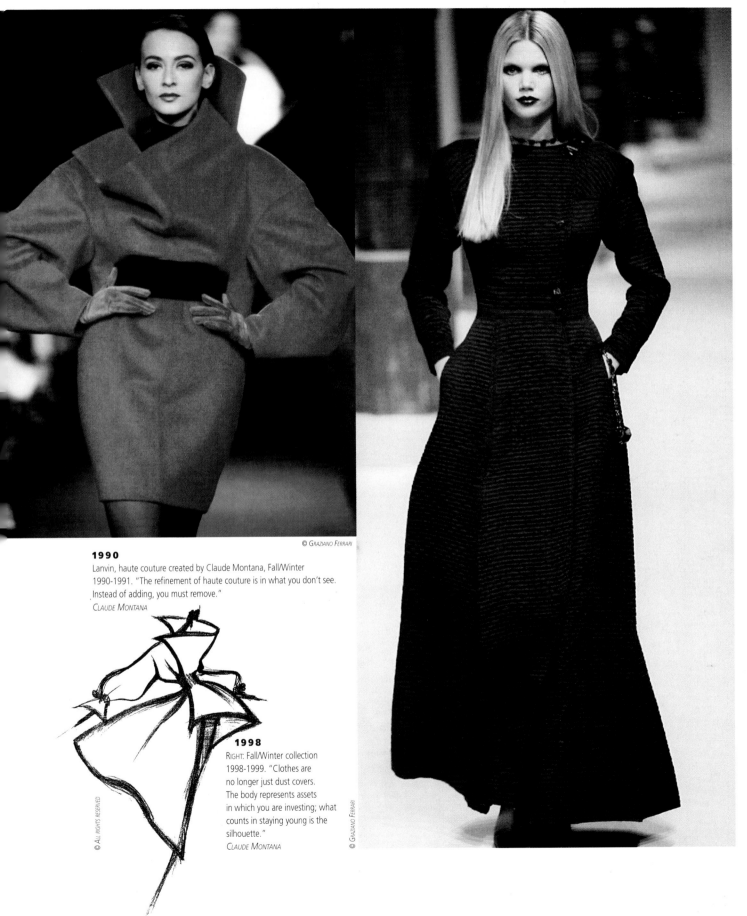

© GRAZIANO FERRARI

1990
Lanvin, haute couture created by Claude Montana, Fall/Winter
1990-1991. "The refinement of haute couture is in what you don't see.
Instead of adding, you must remove."
CLAUDE MONTANA

1998
RIGHT: Fall/Winter collection
1998-1999. "Clothes are
no longer just dust covers.
The body represents assets
in which you are investing; what
counts in staying young is the
silhouette."
CLAUDE MONTANA

© ALL RIGHTS RESERVED

© GRAZIANO FERRARI

COMME DES GARÇONS

Rei Kawakubo

(Tokyo, Japan, 1942)

"You can never shock for the sake of shocking."

REI KAWAKUBO

Rei Kawakubo founded Comme des Garçons in 1973, creating a bomb with her unclassifiable designs that shocked the fashion world. When she presented her first collection in Paris in 1981, she unveiled an entirely new approach to clothing, based on a timeless creation free of any historical reference. She sought a radical transformation of the accepted esthetic. The result was an independence and freedom that overturned social codes by eliminating every mark of social status and masking identifying information about sex or age.

The clothes, conceived as works of conceptual art, define the space and environment in which they are situated. Her masterful technique contributes to the well-balanced proportions and volumes. The silhouette is deconstructed; in other words, dissected into separate components, then reconstructed. She aims for the incomplete and the unfinished, leaving history to reassess her work, while alluding to empty spaces and shadows. Her impeccable cut is not the ultimate aim of her research; it is merely the best way to reach her goal. Rei Kawakubo took the classics and subjected them to the vicissitudes of time; her power to manipulate time has become a luxury.

The stylistic developments are based on an unusual use of asymmetrical, irregular lengths of fabric pieces, which are draped, knotted, torn or cut up, and then restructured. The image of an outfit in which the body moves freely and comfortably is created by the carefully worked fabric. The texture defines the form, the proportions, and the harmony of the silhouette. Black, Kawakubo's favorite color, is not only a color; it also defines an ambience, a metaphor, and a philosophy. Black has become the uniform of everyday life. Beyond the clothing designs themselves, Rei Kawakubo's approach incorporates the principles of art and of identity.

1997

LEFT:
Fall/Winter collection 1997-1998.
"I would rather that people watch and see something powerfully beautiful; it's not important that they understand. Superficial beauty is not enough."
REI KAWAKUBO

OPPOSITE PAGE:
Spring/Summer collection.
"My perception of beauty is not the same as everyone else's. Bumps were beautiful for me, but others laughed. I am working on new forms of beauty, even if they are not always understood."
REI KAWAKUBO

© COMME DES GARÇONS/ALL RIGHTS RESERVED

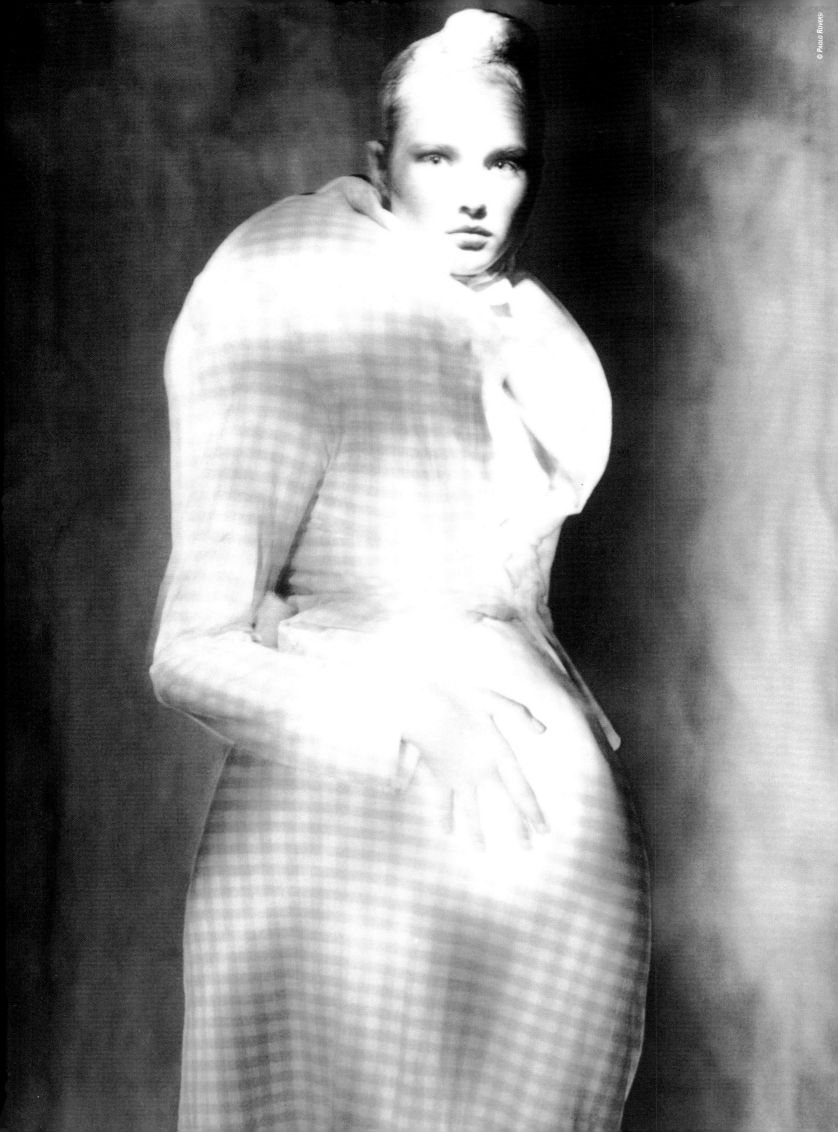
© PAOLO ROVERSI

1998

BELOW:
Fall/Winter collection
1998-1999.
"No, there is never a message
in the clothes; you don't need to
try to understand."
REI KAWAKUBO

1999

RIGHT:
Spring/Summer collection.
"I don't want to talk too much.
My clothes speak for themselves.
It is an old Japanese mentality;
it's what you do that matters."
REI KAWAKUBO

1997

OPPOSITE PAGE:
"I interpret the world, and this
vision is what I try to re-create
through my work."
REI KAWAKUBO

© CRAIG MCDEAN

© THOMAS SCHENK

© ANNIE LEIBOVITZ

COURRÈGES

André Courrèges

(Pau, France, 1923)

"Courrèges: It's totally new."

VOGUE, 1965

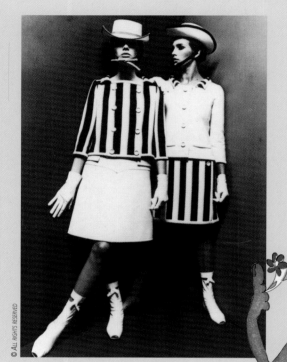

© ALL RIGHTS RESERVED

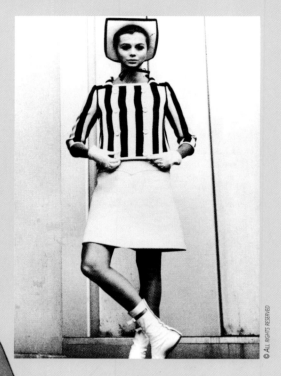

© ALL RIGHTS RESERVED
© ALL RIGHTS RESERVED

The "Courrèges bomb" exploded in the spring of 1965, marking a defining moment in the history of fashion. André Courrèges had redesigned the feminine silhouette, drawing his inspiration from the "modern woman" and her active life. Her demands for mobility, comfort, sexual equality and a more clear appraisal of her newfound body nourished his designs, which offered a resolutely contemporary look at clothing.

Courrèges imposed short hemlines (revealing knees for the first time) and trapeze-shaped skirts, along with pantsuits designed for all occasions. This itself was an innovation; pants had, up to then, been worn only as sportswear. He accessorized the silhouette with square hats lined with blue piping; short, bright white gloves; and square-toed, flat-soled boots with cutouts. Each

1965
The Courrèges bomb, Spring/Summer collection. "I didn't aim to antagonize people; the shapes that I create are already in my mind. I always try to remain true to that. And what they called a 'revolution' was just everyone else accepting it."

1969
Sketch by André Courrèges.

1969
OPPOSITE PAGE:
Two black models (an unusual and daring choice for the era) sport the audacious one-piece body stocking, designed in white knit fabric for winter wear.

detail was carefully planned to achieve a perfectly proportioned piece. His masterful cutting guarantees a perfect fit, without darts. Heavy, double-sided wools structured the line, which was accentuated by topstitching. The easy-care fabrics came in a color palette ranging from pastels to white. White, one of the most difficult colors to produce in fabrics, was omnipresent; in response, textile manufacturers pursued innovative techniques.

Courrèges's look, created as an entire concept, required strict production controls. He launched three lines with three different prices ranges: Prototype, his haute couture collection; Couture future, a ready-to-wear line; and Hyperbole, a mass-market label. Inspired by the Bauhaus theory of movement, according to which,

© ALL RIGHTS RESERVED

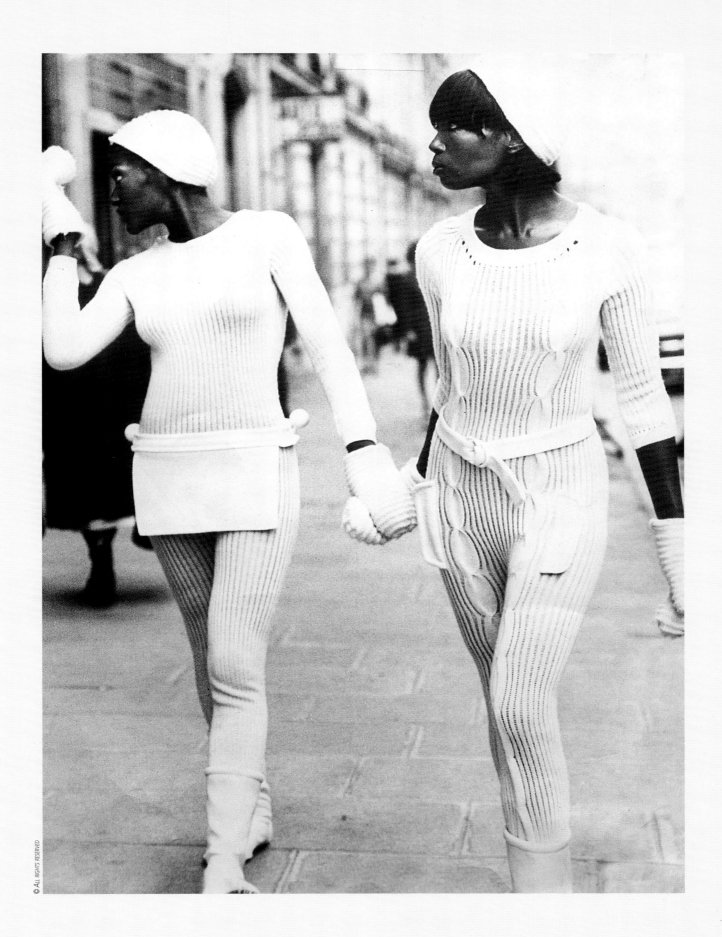

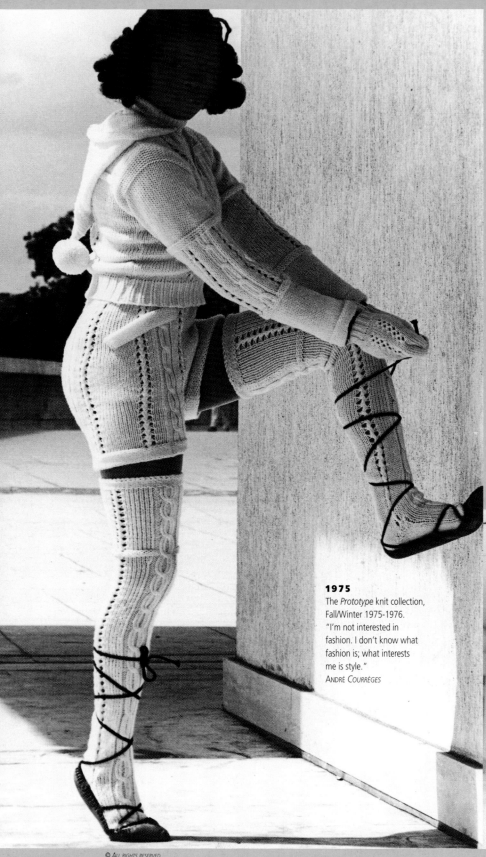

© ALL RIGHTS RESERVED

function defines form, Courrèges combined the manufacturing sector and haute couture. In 1968, he set up a pilot plant in Pau to guarantee the quality of his mass-produced clothes.

A graduate of the École des Ponts et Chaussées (a French engineering school), Courrèges became interested in fashion illustration and moved to Paris in 1945. In 1950, after spending some time with Jeanne Lafaurie, he joined Balenciaga as a cutter; this was where he acquired a solid mastery of couture techniques. In 1961, he opened his own fashion house, a "temple to light," with a simple, unadorned decor. Courrèges provided women with the clothing vocabulary they demanded for personal expression. His amazons, dressed in white and designed to live in a futuristic city, broke free from all academic traditions and laid the foundations for radical new developments in fashion.

1967
Sketch by the designer, Spring/Summer.

© ALL RIGHTS RESERVED

1975
The *Prototype* knit collection, Fall/Winter 1975-1976. "I'm not interested in fashion. I don't know what fashion is; what interests me is style."
ANDRÉ COURRÈGES

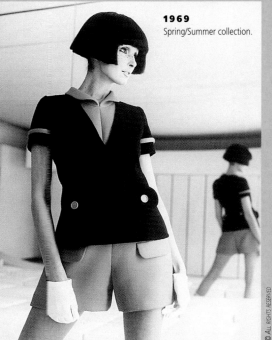

1969
Spring/Summer collection.

© ALL RIGHTS RESERVED

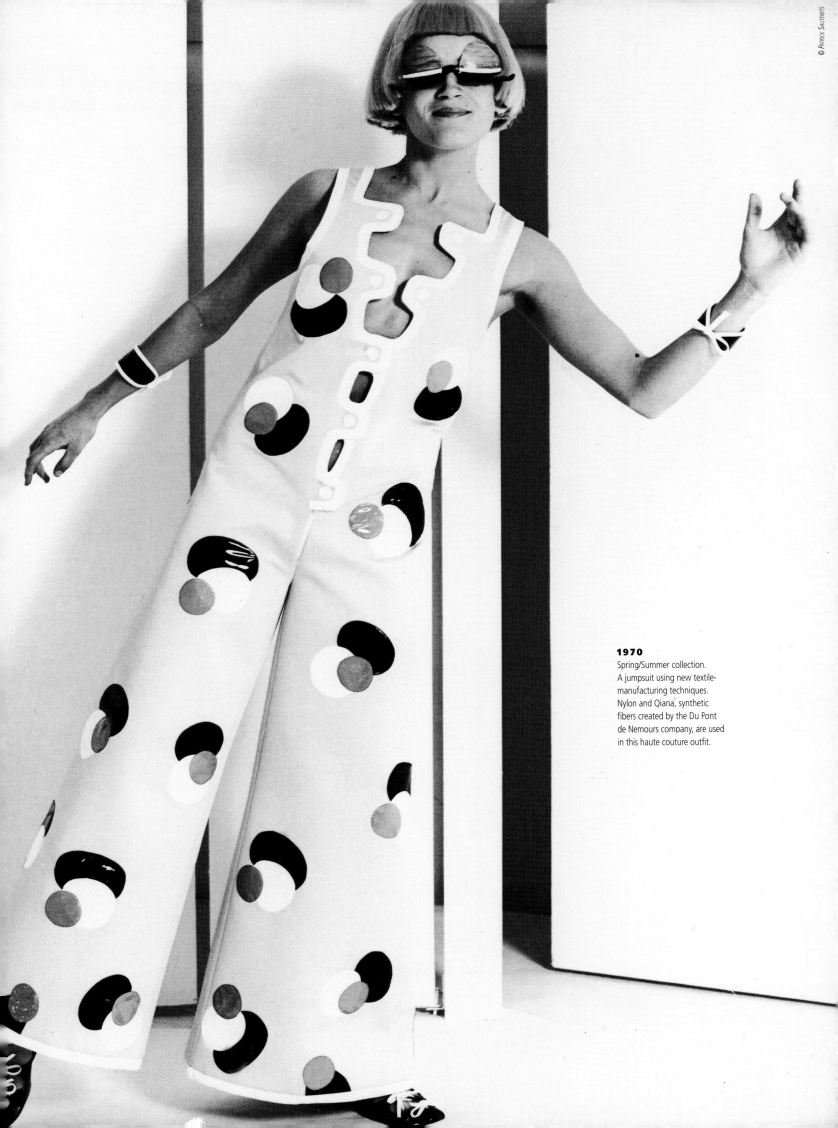

© PATRICK SAUTERETS

1970
Spring/Summer collection.
A jumpsuit using new textile-manufacturing techniques.
Nylon and Qiana, synthetic fibers created by the Du Pont de Nemours company, are used in this haute couture outfit.

D O N N A K A R A N

(Forest Hills, New York, United States,1948)

"I never think Donna Karan is about fashion. It's about women."

DONNA KARAN

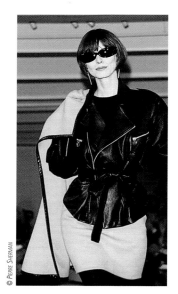

© PIERRE SHERMAN

Starting in 1985, Donna Karan offered professional women a wardrobe that could be adapted to form a "personal uniform." She did not simply design clothes; she responded to a lifestyle by proposing timelessly sophisticated yet simple outfits. Active women could be well-dressed for work without neglecting their femininity.

Donna Karan's approach to clothes is based on two principles: flexibility and practicality. Inspired by the mix-and-match elements in a man's wardrobe, Karan's designs—most of which are in neutral colors—aim to dress a woman using "basics" made from luxurious materials. Her line initially consisted of seven items—bodysuit, skirt, jacket, pants, blouse, sweater, and coat—made from fabrics suitable for both winter and summer wear. Karan's trademark color is black, which she uses as a background color, thereby giving women the greatest possible freedom to select accessories. The cut of her clothes is essential, as the clothes hug the body in a comfortable, flattering way.

The bodysuit, the basis of her collection in the 1980s, was the starting point, over which full skirts and fitted jackets were worn. In the 1990s, Karan reinterpreted luxury by creating a strict silhouette and

1991
LEFT:
Fall/Winter collection 1991-1992.

1985
BELOW:
Jewelry designed by Robert Lee Morris for the Fall/Winter collection 1985-1986. His work with Donna Karan provided the perfect counterpoint and touch of austerity.
RIGHT:
Fall/Winter 1985-1986
The trademark outfit of Karan's first collections.

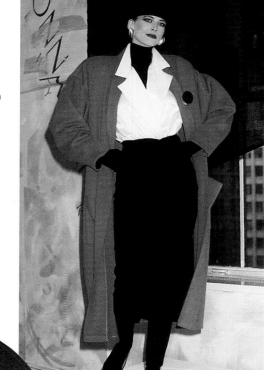

© PIERRE SHERMAN

© PIERRE SHERMAN

DONNA KARAN

1994
Fall/Winter collection 1994-1995.

1994
Spring/Summer collection.

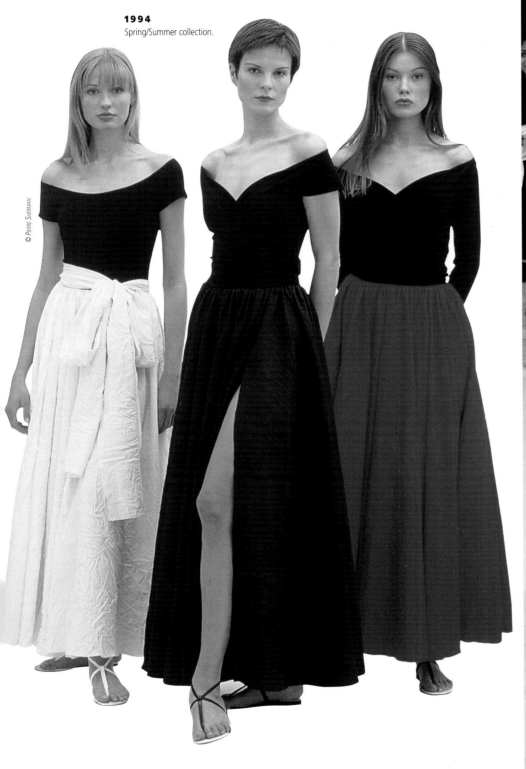

1995
Spring/Summer collection.

1987
Below:
Iman models for the Fall/Winter collection 1987-1988.

1995
Right:
Fall/Winter collection 1995-1996.

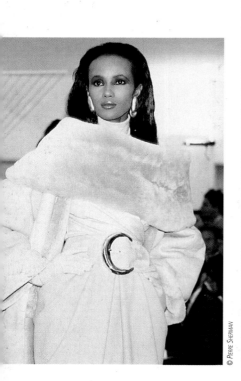

© PIERRE SHERMAN

© HERB RITTS

using modern fibers. The dress became more important than the bodysuit.

Fabric, the catalyst for the entire collection, is draped over a model with wide shoulders and rounded hips. As a woman designer, Donna Karan is better suited to anticipate her clients' expectations and desires. She uses her own body and measurements to develop new designs. After thirty

1986
Opposite right:
Illustration of the modern, active woman, a true representative of Donna Karan's concept.

years of experience, Donna Karan, who began her career with Anne Klein in 1968, still pursues the same goal: to use the imperfections of the female body to best advantage.

Her designs follow the tradition of American sportswear, in that the clothes facilitate everyday life without sacrificing an informal elegance.

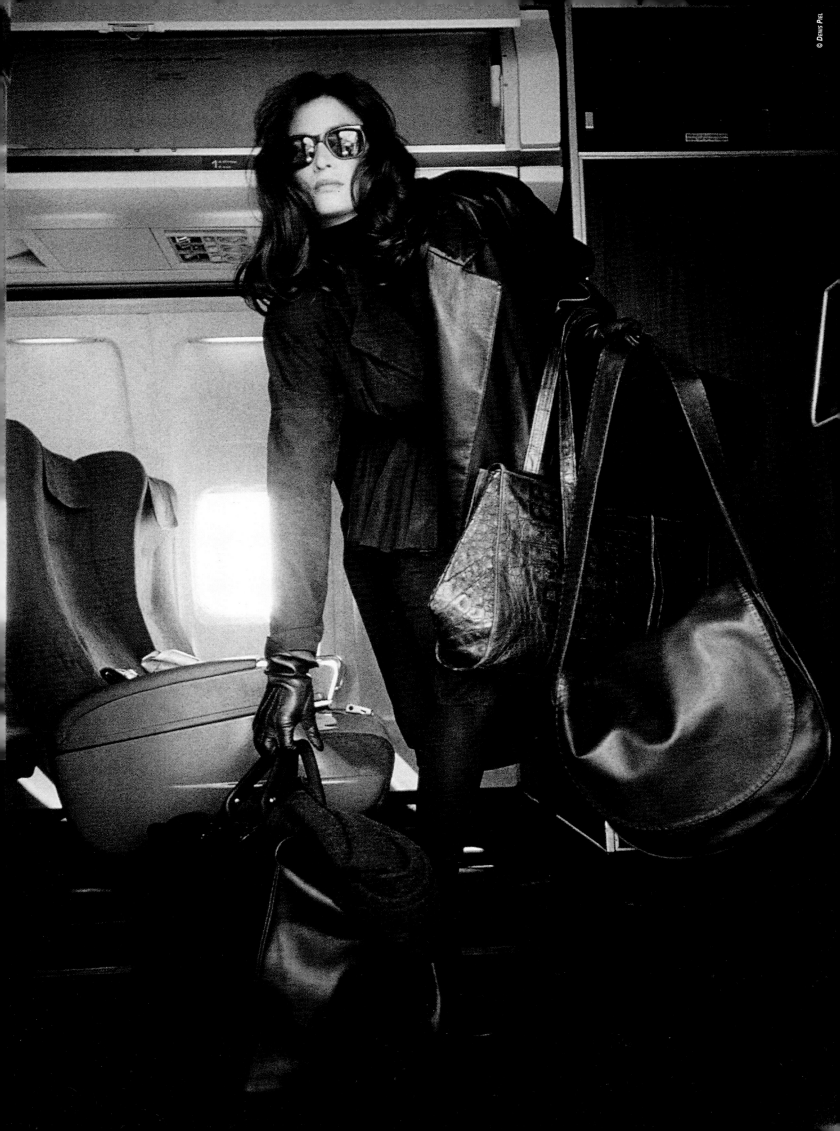

© DENIS PIEL

EMANUEL UNGARO

(Aix-en-Provence, France, 1933)

"Work is a daily discipline."

EMANUEL UNGARO

Trained in his father's tailoring business in Aix-en-Provence, Emanuel Ungaro moved to Paris in 1955, where he was hired by Christiani, a well-known men's tailor. Three years later, he started working for Balenciaga as an assistant designer, gradually working his way up in the company. Several years later, he was named head of design for the Spanish branch of this illustrious fashion house. After integrating a strict sense of discipline and acquiring an unassailable technique, he decided to leave his master. He first went to work for his former colleague André Courrèges, then established his own firm.

With the opening of his fashion house in 1965, Ungaro applied his technical expertise to the design of strict, geometric forms, highly fashionable at the time. He innovated by introducing unexpected and spectacular colors and patterns. He worked with Sonia Knapp, a textile designer and longtime associate, to expand the possibilities of this color palette.

During the 1970s, he developed a softer, more voluptuous line, replacing his initial rigidity with an increasingly fluid look. By the early 1980s, Ungaro had achieved an unquestionable sophistication that paid tribute to female sensuality. His draping hugged the body, illustrating his constant quest to create seductive clothing. The layering and mixtures of textures and colors had reached new heights; he overlapped pillow lace and needlepoint with silk brocade, and boldly combined clashing striped or spotted fabrics.

© DROITS RÉSERVÉS

1968
Sketch for the Spring/Summer collection.

LEFT:
Balenciaga and Ungaro during fitting sessions in the 1960s.
"I was inspired by the radiating magic of this man's presence as he worked so intensely; every movement was scrutinized and retained, as if he were royalty."
EMANUEL UNGARO

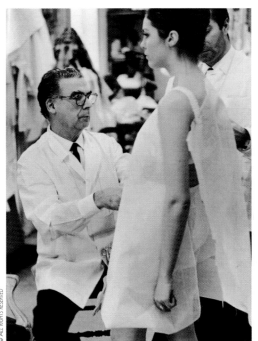

© ALL RIGHTS RESERVED

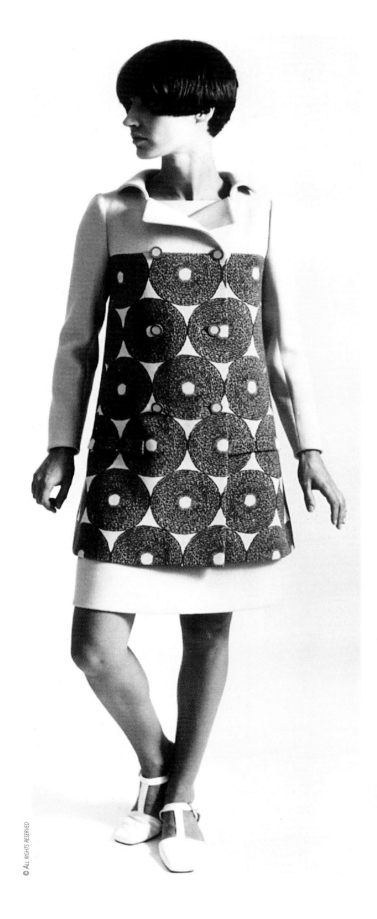

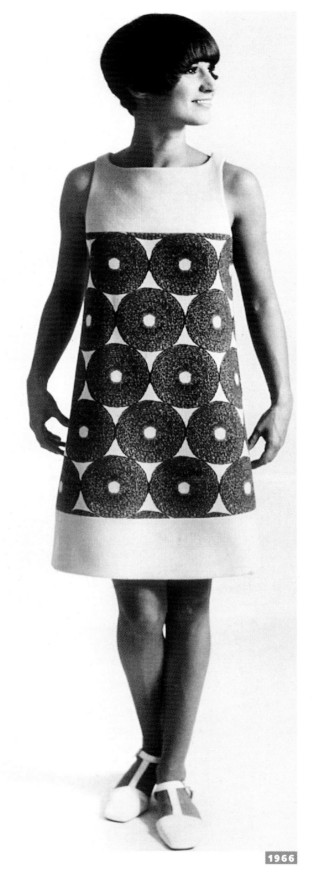

© ALL RIGHTS RESERVED

1966

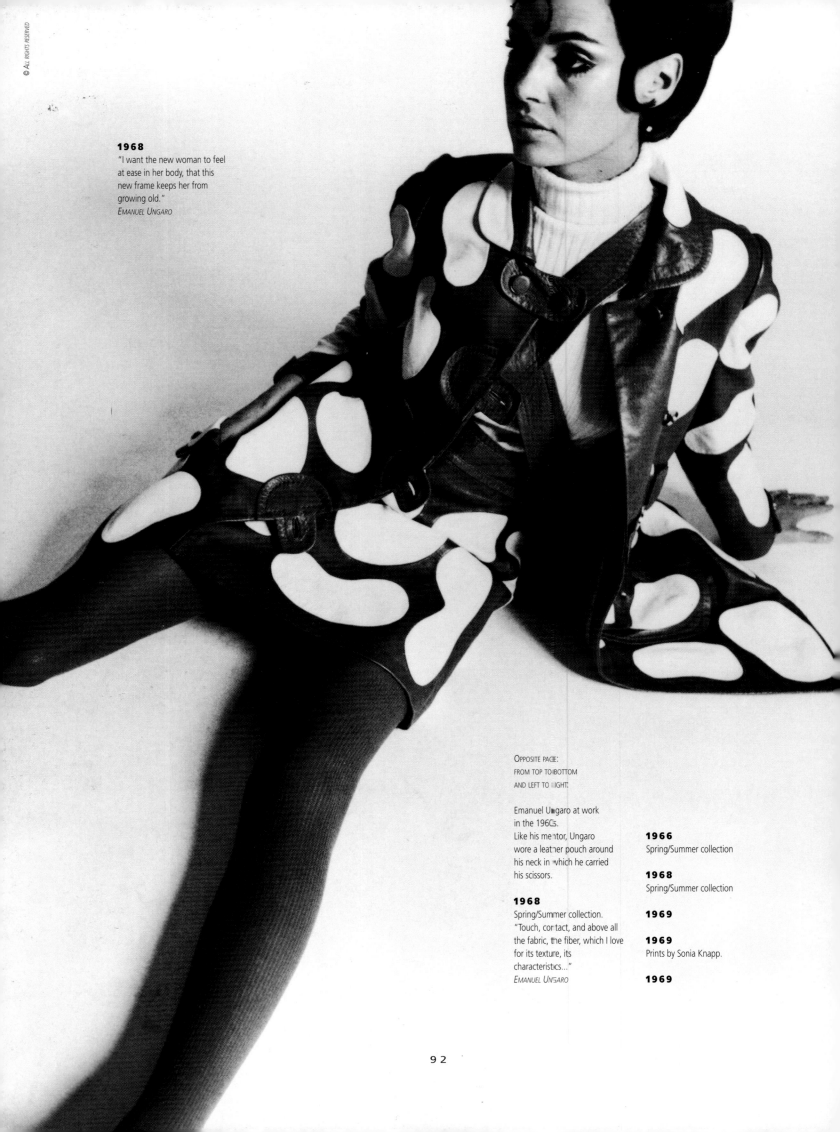

© ALL RIGHTS RESERVED

1968

"I want the new woman to feel at ease in her body, that this new frame keeps her from growing old."
EMANUEL UNGARO

OPPOSITE PAGE:
FROM TOP TO BOTTOM
AND LEFT TO RIGHT.

Emanuel Ungaro at work in the 1960s.
Like his mentor, Ungaro wore a leather pouch around his neck in which he carried his scissors.

1968
Spring/Summer collection.
"Touch, contact, and above all the fabric, the fiber, which I love for its texture, its characteristics..."
EMANUEL UNGARO

1966
Spring/Summer collection

1968
Spring/Summer collection

1969

1969
Prints by Sonia Knapp.

1969

© ALL RIGHTS RESERVED

His personal style is reflected in his ongoing research into the cut of the fabric, aimed at creating a skillfully constructed piece of clothing. The details, which combine colors, fabrics, and layering—without ever erring on the side of excess—set off his harmonious proportions.

Emanuel Ungaro is a born technician. To create his own muslin patterns, he drapes fabrics directly on a live model, remaining in close touch with the female figure.

The cut is an extremely important aspect of his work, serving to reveal the refined and luxuriously simple motif.

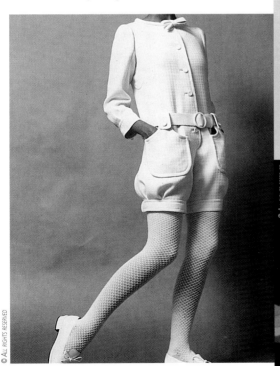

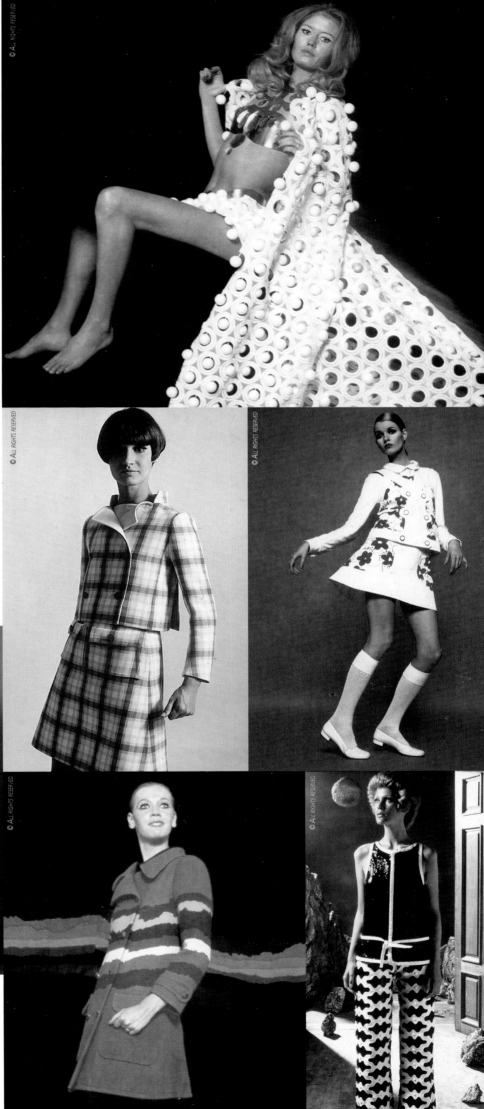

© ALL RIGHTS RESERVED
© ALL RIGHTS RESERVED
© ALL RIGHTS RESERVED
© ALL RIGHTS RESERVED
© ALL RIGHTS RESERVED

© DROITS RÉSERVÉS

1972
Sketch for the Spring/Summer collection.

© ALL RIGHTS RESERVED

1979

© ALL RIGHTS RESERVED

1977

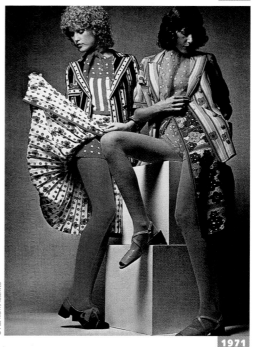

© ALL RIGHTS RESERVED

1971

EMANUEL UNGARO

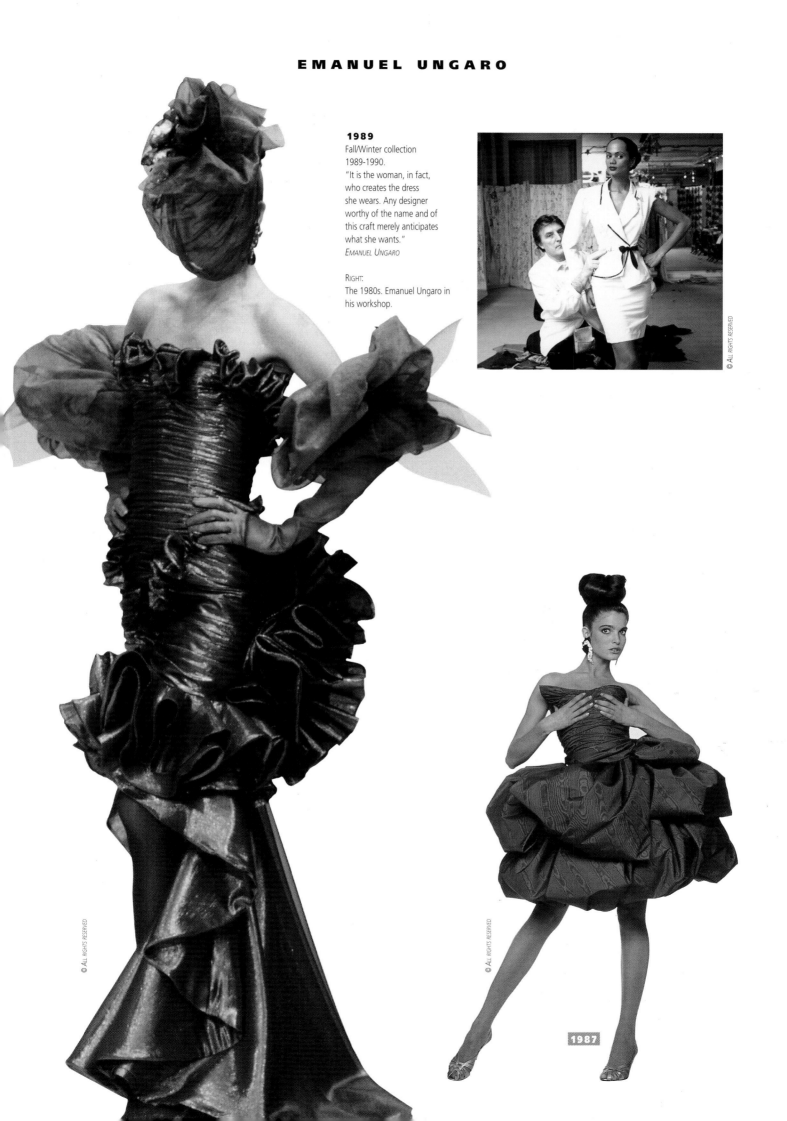

1989
Fall/Winter collection
1989-1990.
"It is the woman, in fact,
who creates the dress
she wears. Any designer
worthy of the name and of
this craft merely anticipates
what she wants."
EMANUEL UNGARO

RIGHT:
The 1980s. Emanuel Ungaro in
his workshop.

1987

© ALL RIGHTS RESERVED

GEOFFREY BEENE

(Haynesville, Louisiana, United States, 1927)

"If clothes are not wearable, they should have another name."

GEOFFREY BEENE

© NIALL McINERNEY

1990
Spring/Summer collection.
"Curved" stitching technique.

© JOE EULA

1968
Advertising campaign
by Joe Eula.

With a thorough command of anatomy and meticulous grasp of his craft, Geoffrey Beene has forged a style that transcends fashion cycles. He initially intended to become a doctor, but left medical school in 1947 to attend classes at the Traphagen School of Fashion in New York. One year later, he entered the school of the Chambre Syndicale de la Haute Couture in Paris. While in France he worked as an apprentice with Molyneux. When he returned to New York in 1951, Beene produced designs that were clearly influenced by his Parisian experience: a harmonious silhouette, elimination of superfluous details, and discreet elegance. He did, however, adapt to American demands for comfort and pragmatism. After working for two ready-to-wear companies—Harmay in 1952 and Teal Traina from 1958 to 1963—Geoffrey Beene established his own fashion house.

A formalist, he seeks perfection in textures, cut, and piecing. Over the years, he developed four distinct techniques for shaping fabric to the female body. He structures his clothes using pleating and quilting methods, thereby eliminating the need for darts, padding, or lining. He accentuates the silhouette by adding transparent or triangular panels, which reveal the neck, thighs, or back. He eliminates flat seams along the sides and armholes in his way of draping, extending the fabric on the back of the outfit to the front. Finally, he uses "curved" seams that hug the body, imbuing his dresses with a strong element of sensuality.

For more than three decades, Geoffrey Beene has presented designs that have been perfectly in tune with their times. From the younger generation of the 1960s to the independent woman of the 1990s, he has constantly innovated, while maintaining his strict standards and authenticity.

1990
OPPOSITE PAGE, TOP RIGHT.
Fall/Winter collection
1990-1991.
"The body has to move within the fabric. My clothes are about freedom in a way; they're never confining. I think modernity involves movement."
GEOFFREY BEENE

GEOFFREY BEENE

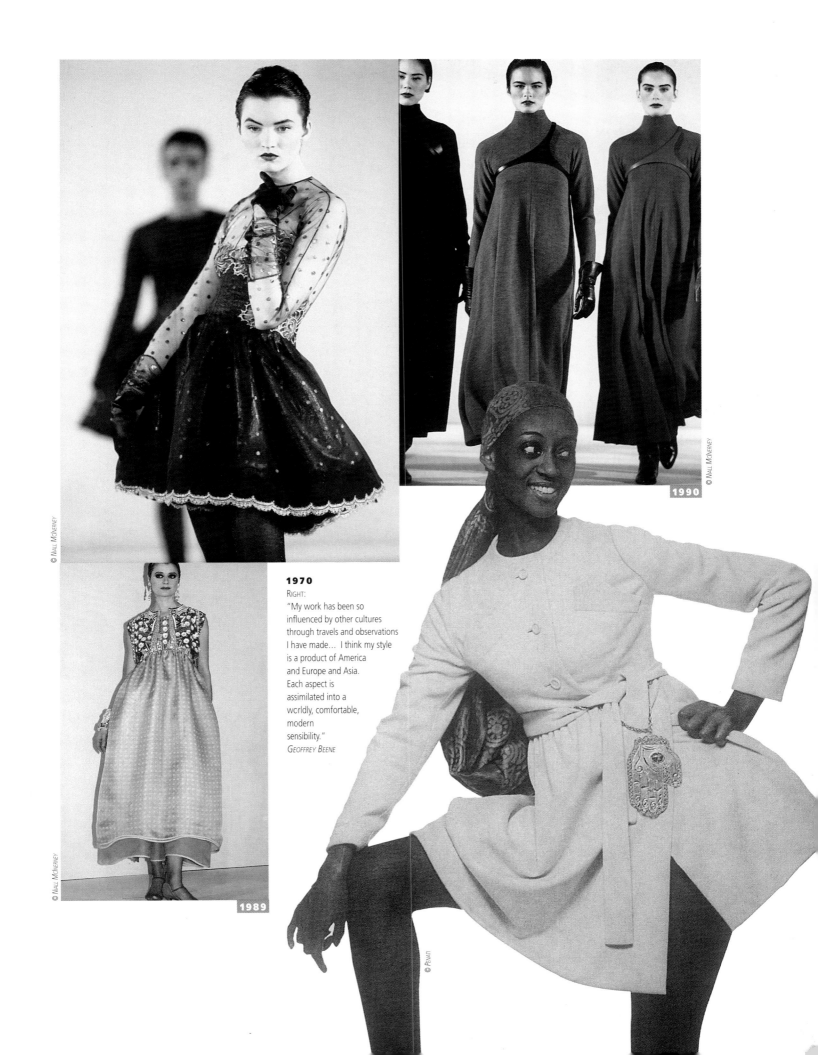

1990

1989

1970

RIGHT:

"My work has been so
influenced by other cultures
through travels and observations
I have made… I think my style
is a product of America
and Europe and Asia.
Each aspect is
assimilated into a
worldly, comfortable,
modern
sensibility."

GEOFFREY BEENE

© NIALL MCINERNEY
© NIALL MCINERNEY
© NIALL MCINERNEY
© PENATI

© ANDREW ECCLES

1991
OPPOSITE PAGE: The transparent panel accentuates and reveals the shape of the body.

1975
The pleats in the fabric eliminate the need for darts, while hugging the curves of the body.

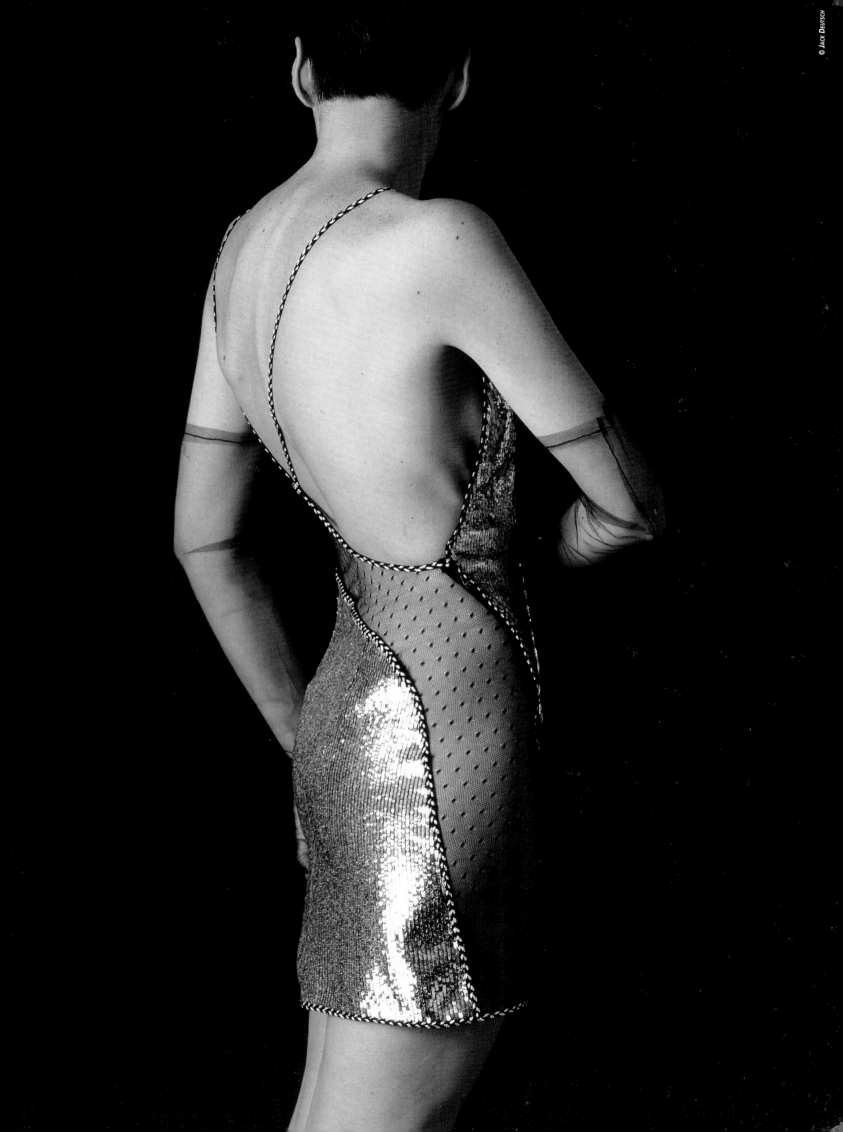

© JACK DEUTSCH

GIORGIO ARMANI

(Piacenza, Italy, 1934)

"I want to demonstrate that you can stay contemporary without putting on a show, without being dramatic."

GIORGIO ARMANI

The simple men's jacket, which combines a sense of physical power and elegance to create a discreet and sophisticated sensuality, is the centerpiece of Giorgio Armani's style. Pared-down, lengthened, and loosely fitted, his jacket underwent a process of restructuring that produced a softer tailored look. He eliminated iron-on interfacing, and replaced the synthetic rigid cloth in fashion during the 1970s with soft, luxurious fabrics.

A quest for comfort is a mainstay of Armani's approach; this has produced an austere style that can be worn by all ages. Over the years, he has altered the cut of his collections in tiny increments, always working toward his goal of achieving technical perfection.

After serving in the Italian army, he entered medical school, which he left in 1953. He was then hired by La Rinascente, a chain of department stores in Milan. During this period, he later said, he acquired invaluable experience in mass distribution and began to develop his pragmatic approach to fashion. Several years later he was hired as a designer by Hitman, an Italian men's jacket manufacturer owned by Nino Cerruti. Fully immersed in the fashion business, Giorgio Armani learned technique, silhouette, and composition, furthering his knowledge about the structure of clothes and tailoring techniques.

In the early 1970s, Giorgio Armani left Cerruti and set up a freelance design company with Sergio

1980
Sketch, Fall/Winter collection 1980-1981.

© DROITS RÉSERVÉS

1976
Sketch, Fall/Winter collection 1976-1977.

© DROITS RÉSERVÉS

1989
Spring/Summer collection.

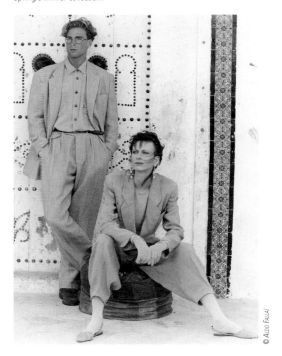

© ALDO FALLAI

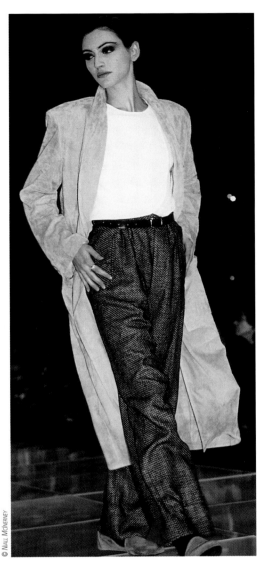

© Niall McInerney

1984
LEFT:
Spring/Summer collection.

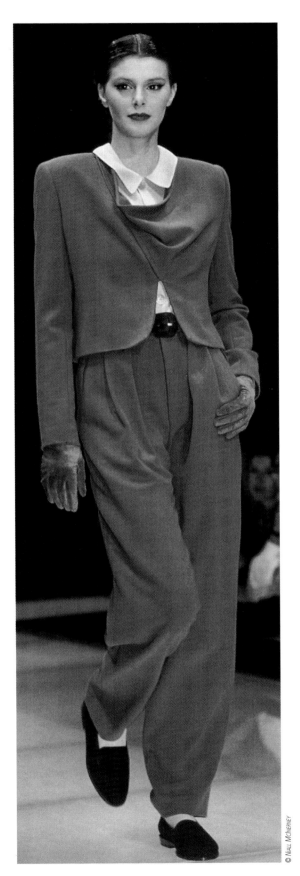

Galeotti. In 1974, he introduced his own collection of menswear. The following year, he created the Giorgio Armani company and launched his first collection of womenswear. His designs for women are reinterpretations of his menswear line; he adapts the same forms and a palette of neutral, interchangeable colors to the female body.

During the 1980s, Giorgio Armani introduced the power suit, confirming a new cultural identity for the high-level working woman. This uniform, which conveyed an image of authority and respect, became a trademark outfit for an entire generation.

1988
RIGHT:
Fall/Winter collection
1988-1989.
"Man does not need to distort forms, but rather alter them."
GIORGIO ARMANI

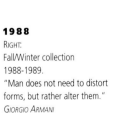

© Niall McInerney

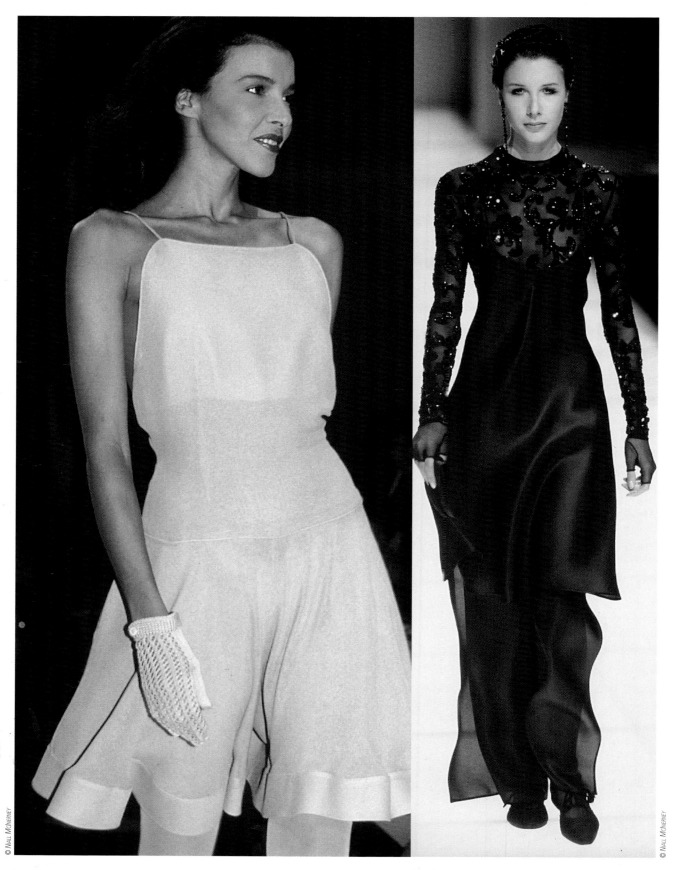

© NIALL MCINERNEY

1988
Spring/Summer collection.

1984
Spring/Summer collection. "For me, it is essential to eliminate all superfluous elements. Everything must serve a purpose and be in harmony with the rest." GIORGIO ARMANI

© NIALL MCINERNEY

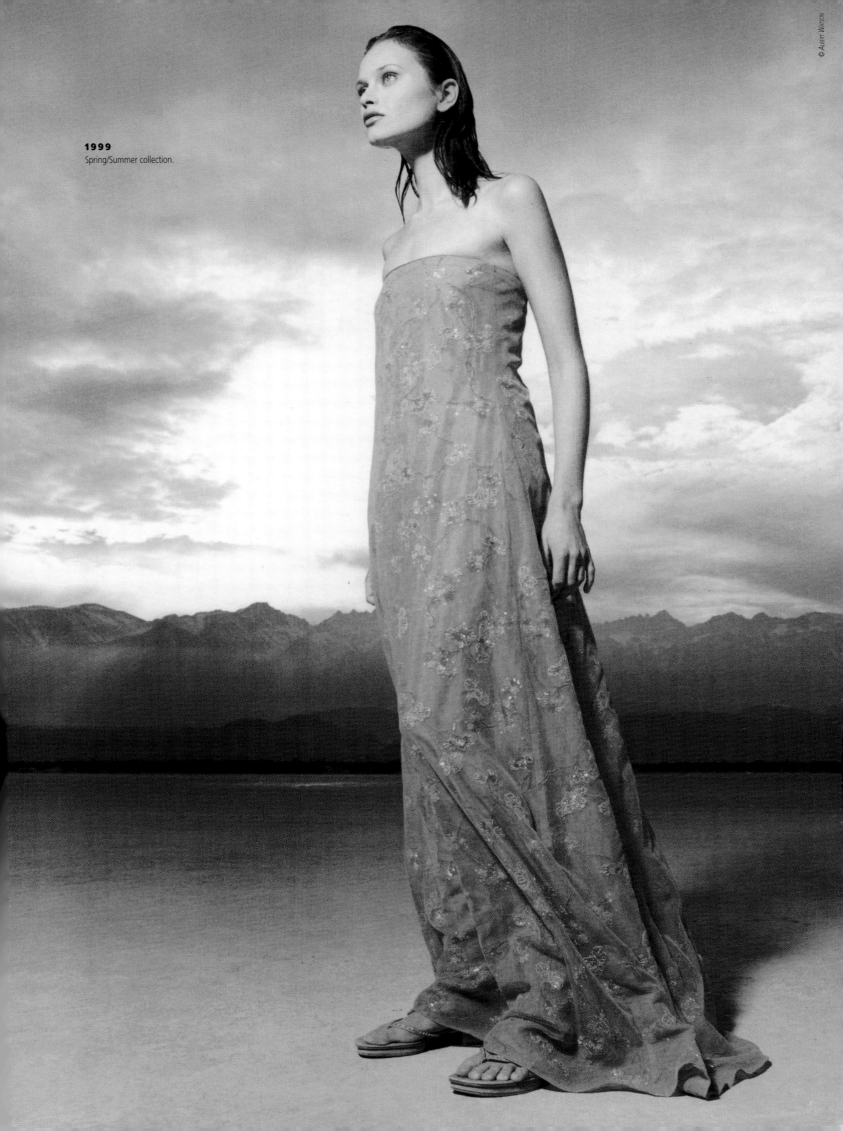

1999
Spring/Summer collection.

© Albert Watson

GIVENCHY

Hubert de Givenchy

(Beauvais, France, 1927)

"The art of our trade, like that of a painter, is to create the impression that
the work simply appeared fully developed.
The only way to do this is to totally master technique."

HUBERT DE GIVENCHY

The elegant, restrained style created by Hubert de Givenchy is based on simplified forms and clean, precise lines. Following in the great haute couture tradition, he adapts cutting techniques and fabrics to satisfy the needs and requirements of his clientele.

At the age of eighteen, Hubert de Givenchy left his hometown of Beauvais and moved to Paris. In 1945, he started working with Jacques Fath, where he quickly received recognition for his designs. The following year he was hired by the Swiss designer Robert Piguet, who ran his company with a sense of order, organization, and severe classicism. In 1947, he joined Lucien Lelong, where he met Pierre Balmain and Christian Dior. Six months later, the Italian designer Elsa Schiaparelli made him head of her boutique on Place Vendôme in Paris, where he remained for four years.

After acquiring a broad range of experience, he presented his first collection, which he based on luxuriously comfortable designs, on February 2, 1952. Pragmatic and inexpensive, the prototypes in the fashion show were made of percale: Hubert de Givenchy then let his clients select the fabrics they wanted. His separates, designed as interchangeable items of clothing, received instant acclaim for their simplicity. Bettina Braziani, a model he met during his stint at Jacques Fath, took over public relations for his company. One year after opening his fashion house, Givenchy met two people who would have a decisive impact on his career: Audrey Hepburn, the embodiment of his feminine ideal, and Balenciaga, with whom he developed a lifelong friendship.

The Givenchy line integrated these multiple influences, developing a timeless, audacious look and a clear identity based on a skillful blend of pure lines, opulent luxury, geometric designs, and decorative elements. When Hubert de Givenchy retired in 1995 at the age of sixty-eight, the British designer John Galliano took over. Since 1996, another Englishman, Alexander McQueen, has been the company's artistic director.

OPPOSITE PAGE,
CLOCKWISE FROM
TOP LEFT:

1956
With Givenchy, fitting
for a dress designed for
Audrey Hepburn.

1954
Bettina in an outfit designed
by Givenchy.

1961
Sketches from the fashion house.

1957
Evening dress from the collection.

1961
RIGHT:
Audrey Hepburn, dressed in
Givenchy for the film
Breakfast at Tiffany's.

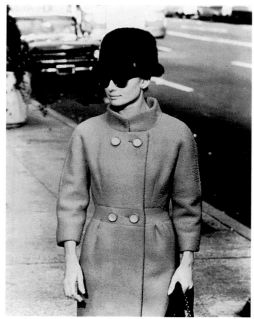

© ALL RIGHTS RESERVED

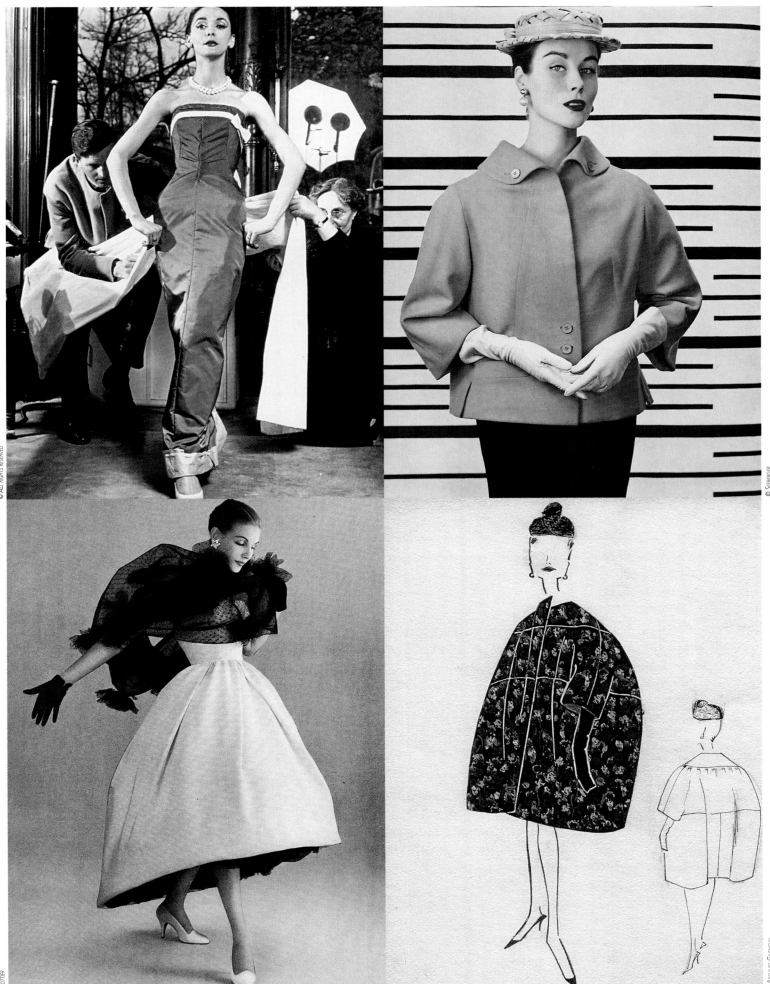

© POTTER

© ALL RIGHTS RESERVED

© SEEBERGER

© ARCHIVES GIVENCHY

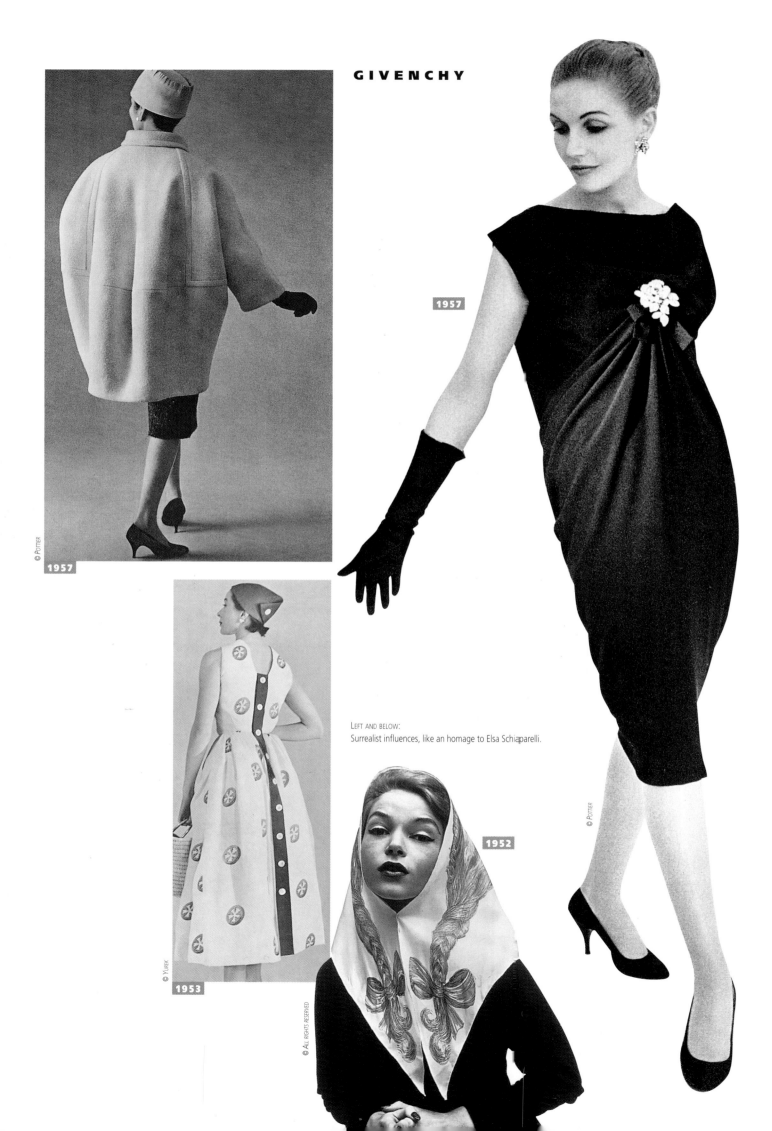

GIVENCHY

1957

1957

LEFT AND BELOW:
Surrealist influences, like an homage to Elsa Schiaparelli.

1953

1952

© POTTER

© YUREK

© ALL RIGHTS RESERVED

© POTTER

1989
Spring/Summer collection.
"A dress must look like it has just been placed on the body."
HUBERT DE GIVENCHY

1968
Spring/Summer collection.

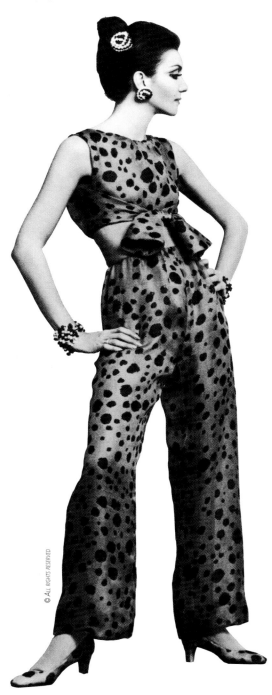

© ALL RIGHTS RESERVED

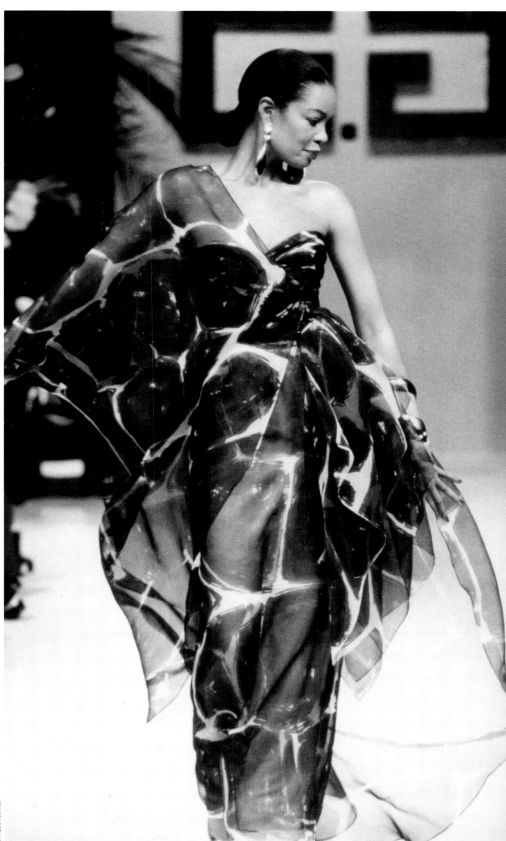

© JEAN-LUC FOURNIER

107

GIVENCHY

© All Rights Reserved

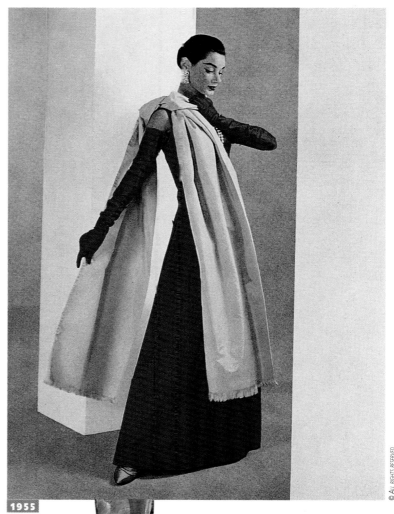

© All Rights Reserved

1955

1992

FAR RIGHT:
Fall/Winter collection
1992-1993.
"I dreamed of a freer woman,
no longer corseted and
encased in stiff lining. All my
styles reflect movement taken
straight from life. My dresses are
ultralight, without corseting,
without padding; they graze the
liberated body like a breath..."
HUBERT DE GIVENCHY

© Archives Givenchy

1966

Sketch, Spring/Summer collection. "As always, my fabrics determined the
shapes of the dresses, which are as simple as possible."
HUBERT DE GIVENCHY

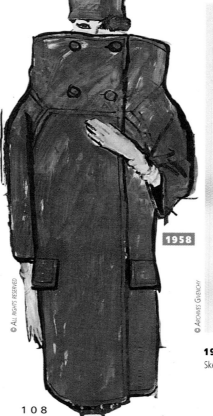

© All Rights Reserved

1958

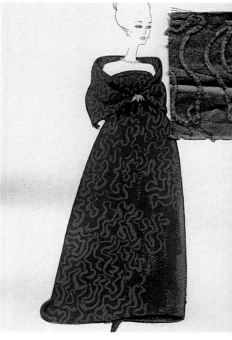

© Archives Givenchy

1966

Sketch, Fall/Winter collection 1966-1967.

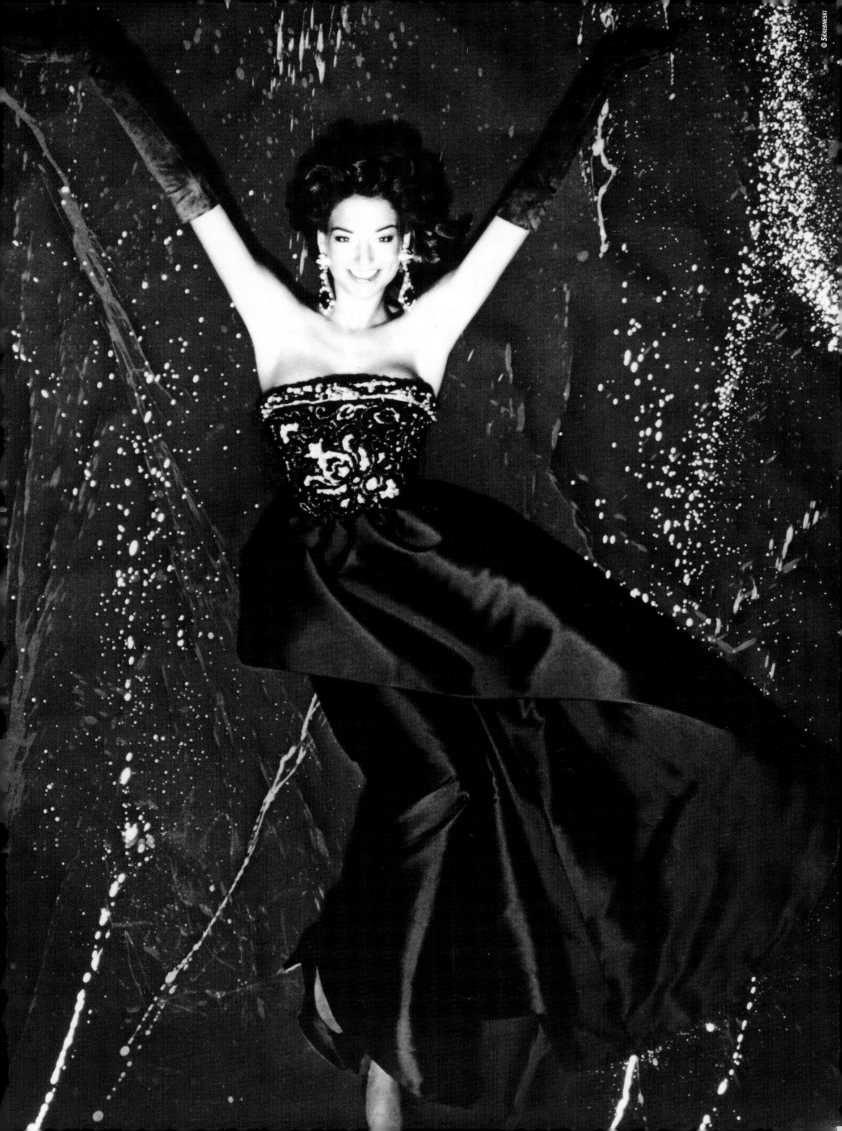

© SKREBNESKI

GRÈS

(Paris, France, 1903 – 1993)

"What is elegance?
A woman of taste, a discreet woman who dresses simply."

MADAME GRÈS

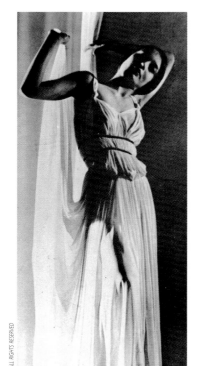

© ALL RIGHTS RESERVED

Madame Grès, an uncompromising perfectionist, cultivated an air of voluptuous austerity and a fluidity in her search for a sensual, pure silhouette. She had always wanted to be a sculptor, but abandoned her plans when her bourgeois family objected. She then pursued her personal vision of beauty by turning her talents to fashion and its traditions. With inventiveness and ingenuity, Grès draped, pinned, and attached fabrics, forcing them to obey and undergo the metamorphosis she desired. Her draped dresses—a signature style—were unique living sculptures, developed directly on the model's body. Clearly inspired from Hellenistic clothing, her designs were not, however, overly exotic or mere historical reproductions; she assimilated various inspirations to then forge her own style. The monochromatic dresses revealed and disclosed the body, creating an aura of seduction and desire. Variations on the ancient peplum were another aspect of her work. Added to this was Grès' extensive experience in cutting and tailoring, put to use in her designs for suits, coats, and capes. She also drew ideas from the unstructured styling of such traditional garments as the jellaba, burnoose, and kimono.

Madame Grès, born Germaine Krebs, made and sold muslin patterns for the Grands Magasins in the early 1930s, then became partners with Julie Barton in 1933, designing clothes under the name Alix Barton; the following year the name was shortened to Alix. Germaine Krebs designed highly successful bathing costumes for the Alix label, but it was her draped dresses made of silk jersey, specially woven to a double width, that

1937
LEFT:
"When I drape a piece of silk over a model, it moves between my hands, and I try to understand and assess its reactions. The dress I create follows the lines and form that the fabric itself would naturally have."
MADAME GRÈS

1948
BELOW:
Fashion show at Grès, Rue de la Paix.

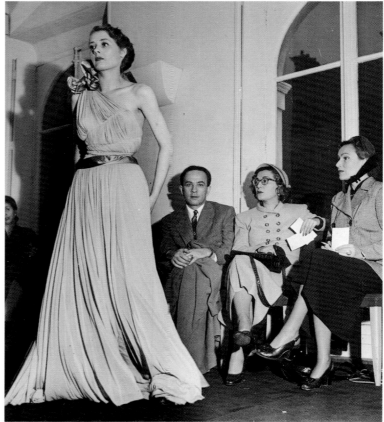

© EUGENE RUBIN

1939
A wedding dress designed under
the Alix label.

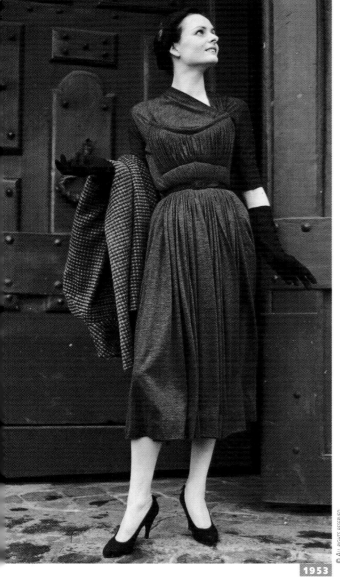

1953

© ALL RIGHTS RESERVED

© ALL RIGHTS RESERVED

© ALL RIGHTS RESERVED

Madame Grès is one of the rare designers who created two different labels, both extremely successful. She died at the age of ninety, although her daughter Anne, Madame Grès' only child, publicly announced the news one full year after her mother's death.

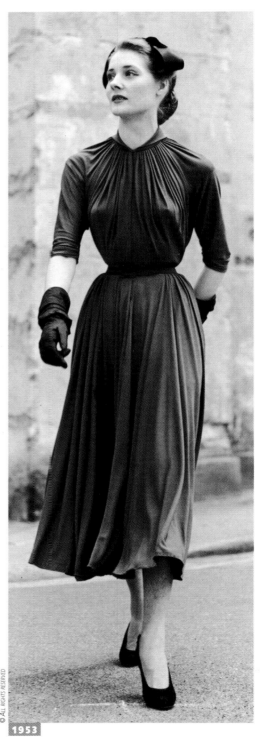

© ALL RIGHTS RESERVED

1953

established the reputation of the fashion house. She broke with her financial backers in 1941 and then moved to 1, Rue de la Paix in Paris. Just after showing her first collection, the Grès fashion house (an anagram of her husband Serge's name) was closed down by the Germans, who were offended by the patriotic aspect of her blue, white, and red clothes. She reopened the following year. In 1958, the International Institute of Education sent Madame Grès to India on a mission to reorganize textile production. In 1972, Grès became president of the Chambre Syndicale de la Couture Parisienne and was appointed honorary president in 1991.

1948
ABOVE:
"To create a dress, you first need inspiration, then fabric."
MADAME GRÈS

1949
OPPOSITE PAGE:
"Perfection is something I constantly aim for. If a dress is to survive from one period to the next, it must be extremely pure. This is the great secret to the survival of a design."
MADAME GRÈS

© ALL RIGHTS RESERVED

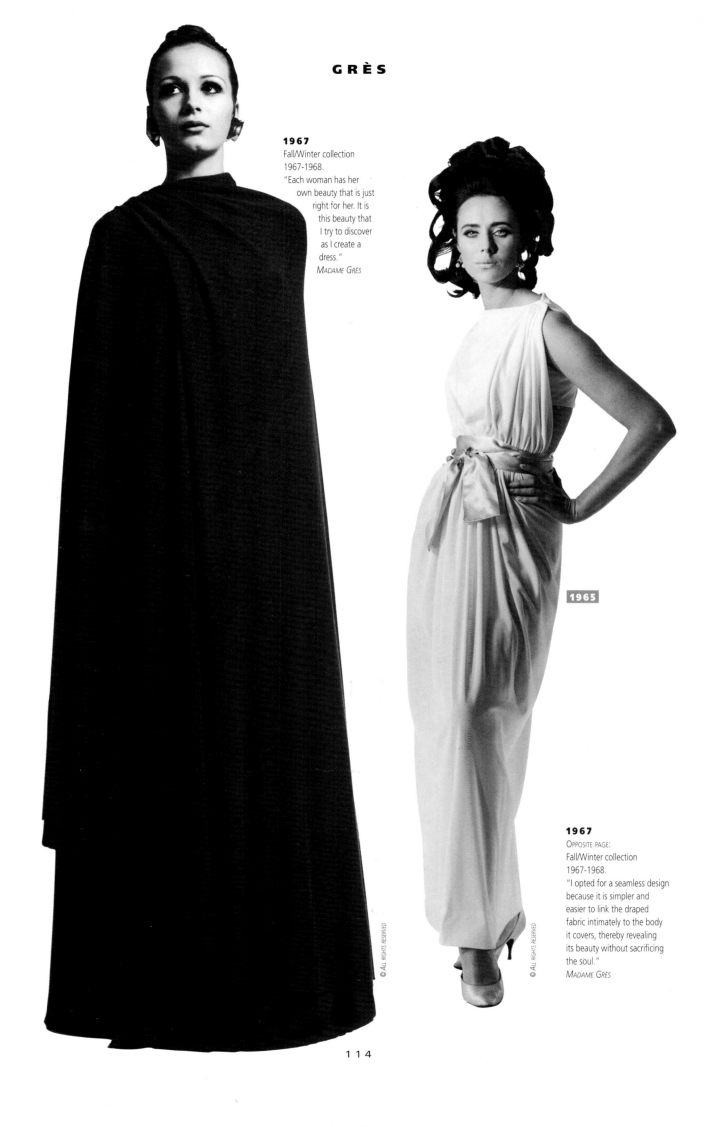

GRÈS

1967

Fall/Winter collection
1967-1968.
"Each woman has her
own beauty that is just
right for her. It is
this beauty that
I try to discover
as I create a
dress."
Madame Grès

1965

1967

OPPOSITE PAGE:
Fall/Winter collection
1967-1968.
"I opted for a seamless design
because it is simpler and
easier to link the draped
fabric intimately to the body
it covers, thereby revealing
its beauty without sacrificing
the soul."
Madame Grès

© ALL RIGHTS RESERVED

© ALL RIGHTS RESERVED

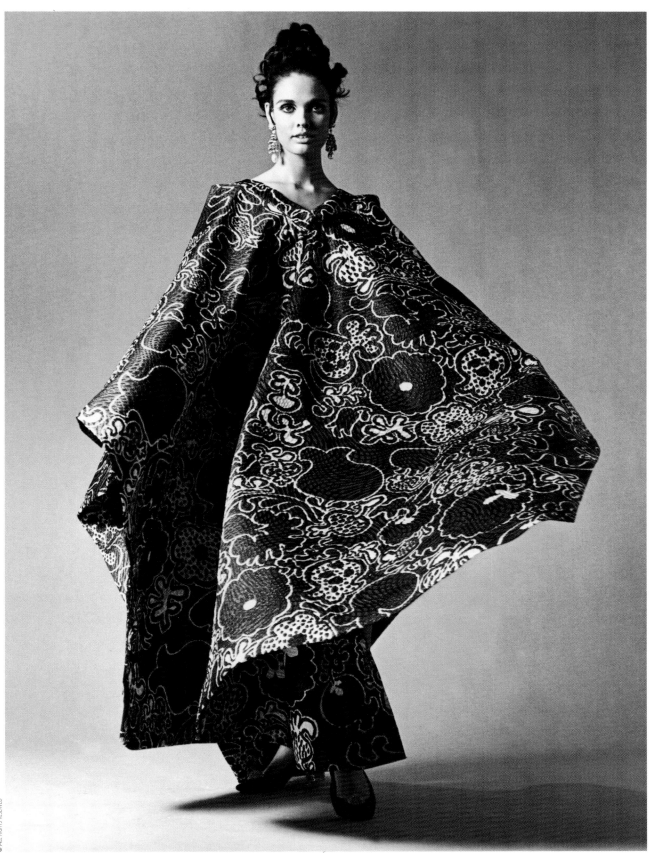

HALSTON
Roy Halston Frowick

(Des Moines, Iowa, United States, 1932 - San Francisco, California, 1990)

"Fashion starts with fashionable people. The fact that they are wearing it makes it fashion. A designer is only as good as the people he dresses."

HALSTON

Roy Halston Frowick's clothes were comfortably elegant; his was a refined style in which discretion and sobriety were combined to embellish and flatter the silhouette. His early years as a milliner taught him how to transpose three-dimensional volumes and to master proportions and the fall of draped fabrics, down to the smallest details. Named "the greatest fashion designer in the United States" by *Newsweek* magazine in 1972, Halston offered a functional and contemporary fashion, which, in its undeniable simplicity, reigned supreme.

After studying for a short time at Indiana University and the Art Institute of Chicago, Halston opened a small millinery shop in 1953 in the famous Ambassador Hotel, a mainstay in Chicago's social life. In 1957, hired by the renowned milliner Lily Daché, he moved to New York. He left one year later to join the staff of the prestigious luxury store Bergdorf Goodman. Responsible for a workroom employing more than 120 people, he requested that his name appear on the label. The company agreed, and Halston became the first milliner to sign his own designs at Bergdorf Goodman.

He had already achieved unprecedented recognition from high-society Ameri-

1975
Jewelry designed by Elsa Peretti.

can women when his Pillbox hat, created for Jacqueline Kennedy, propelled him to even greater heights in the international couture world. Bergdorf Goodman launched Halston's first ready-to-wear collection in 1966. This line consisted of eighteen interchangeable separates. Two years later, he set out on his own, establishing his own company. During the 1970s, Halston became the symbol of social success. His style was based on basics, twin-sets and pants, off-the-shoulder evening dresses, and low-cut asymmetrical caftans, all made of opulent, regal, and luxurious fabrics. Ultrasuede, made in Japan, became Halston's signature fabric. This synthetic suede could be tossed in a washing machine. His no-frill outfits were accessorized by silver jewelry created by Elsa Peretti, his friend and associate. His deep affection for Martha Graham inspired his designs for her company's ballet costumes. In 1982, Halston created mass-market collections for JCPenney, with more than 1,700 sales outlets. This move was poorly received by the industry, however, which disapproved of lowering the standards of luxury clothes to make them available to everyone. Yet this decision gave Halston the opportunity to dress every American woman.

HALSTON

© ALL RIGHTS RESERVED

1975
LEFT: An outfit worn by the model Lauren Hutton.

1972
In 1972, *Newsweek* names Halston
"the premier Fashion designer in America."

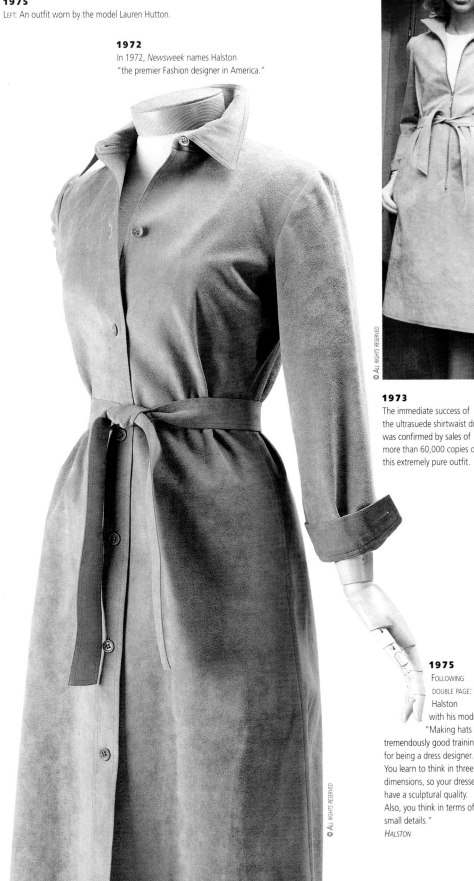

1973
The immediate success of
the ultrasuede shirtwaist dress
was confirmed by sales of
more than 60,000 copies of
this extremely pure outfit.

© ALL RIGHTS RESERVED

1975
FOLLOWING
DOUBLE PAGE:
Halston
with his models.
 "Making hats is
tremendously good training
for being a dress designer.
You learn to think in three
dimensions, so your dresses
have a sculptural quality.
Also, you think in terms of
small details."
HALSTON

© ALL RIGHTS RESERVED

1974

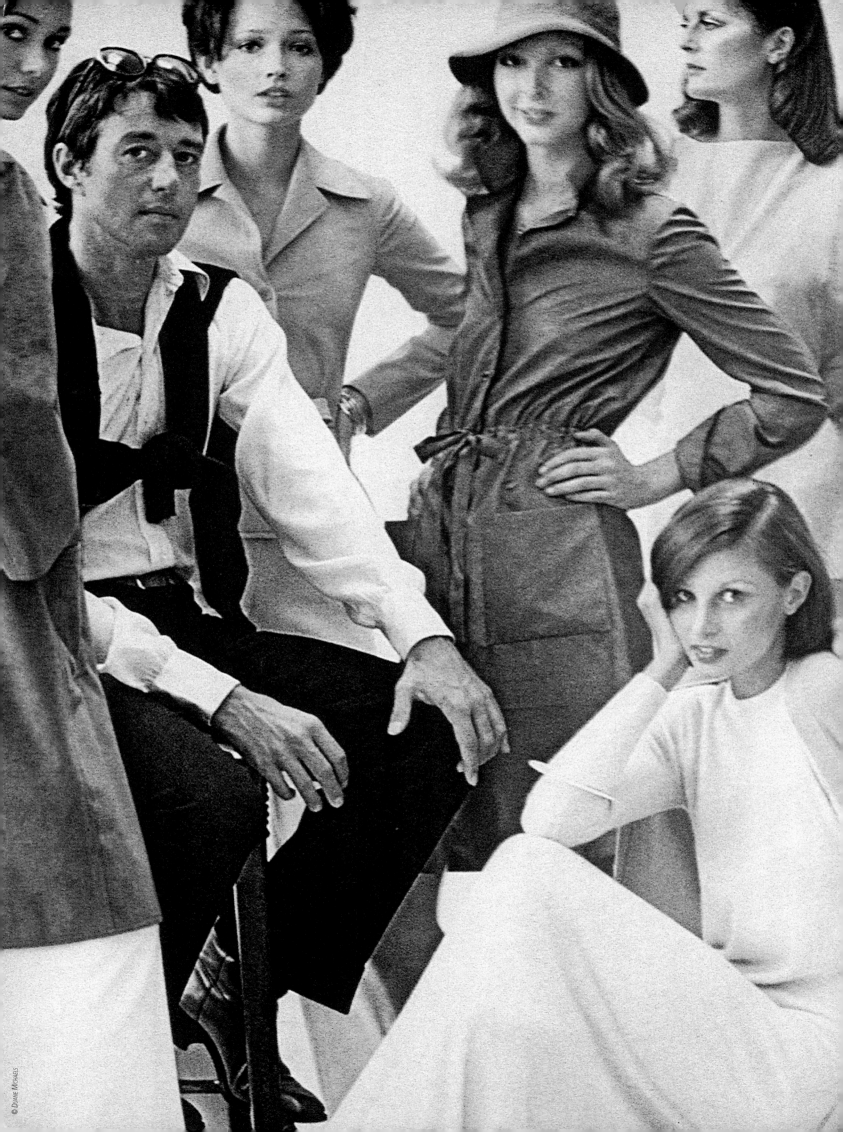

© Duane Michals

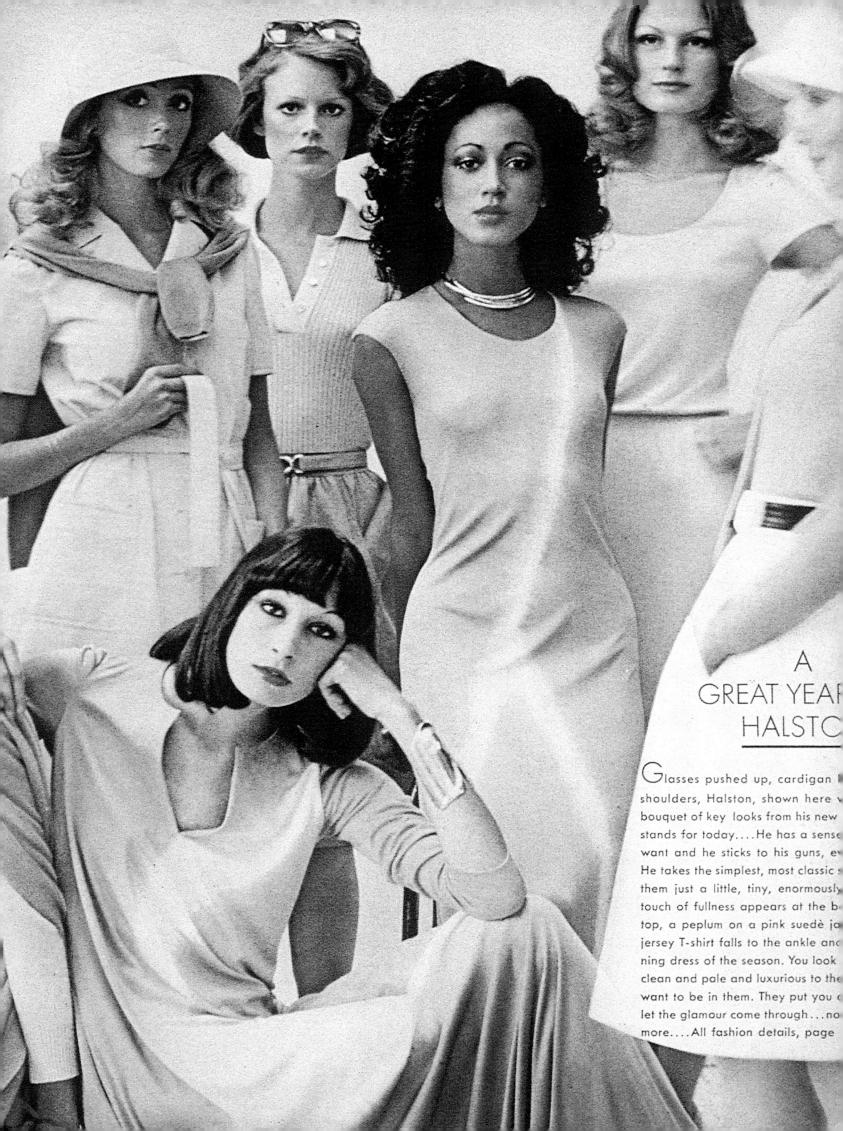

A
GREAT YEAR
HALSTO

Glasses pushed up, cardigan
shoulders, Halston, shown here
bouquet of key looks from his new
stands for today....He has a sense
want and he sticks to his guns, e
He takes the simplest, most classic
them just a little, tiny, enormously
touch of fullness appears at the b
top, a peplum on a pink suede ja
jersey T-shirt falls to the ankle and
ning dress of the season. You look
clean and pale and luxurious to the
want to be in them. They put you
let the glamour come through...no
more....All fashion details, page

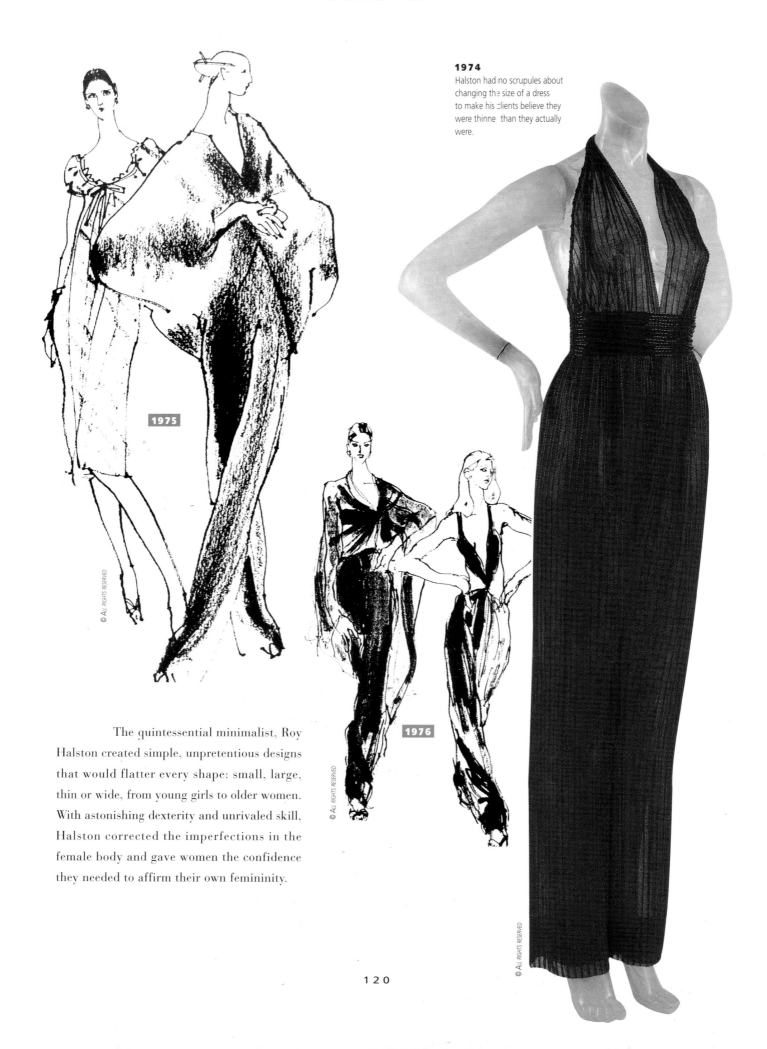

HALSTON

© ALL RIGHTS RESERVED

1975

© ALL RIGHTS RESERVED

1974

Halston had no scruples about changing the size of a dress to make his clients believe they were thinner than they actually were.

1976

The quintessential minimalist, Roy Halston created simple, unpretentious designs that would flatter every shape: small, large, thin or wide, from young girls to older women. With astonishing dexterity and unrivaled skill, Halston corrected the imperfections in the female body and gave women the confidence they needed to affirm their own femininity.

© ALL RIGHTS RESERVED

120

© ALL RIGHTS RESERVED

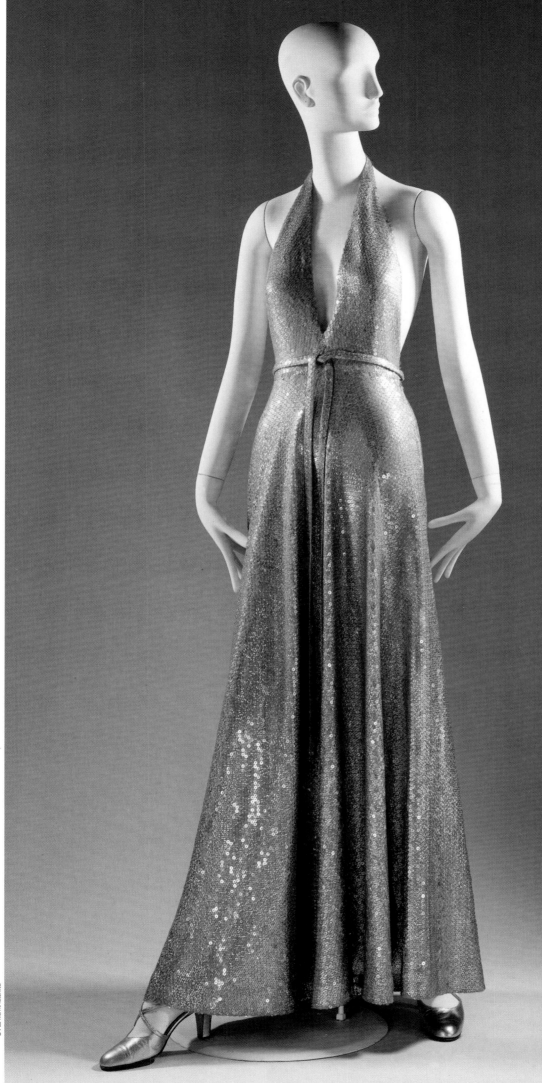

© ALL RIGHTS RESERVED

1974

ISSEY MIYAKE

(Hiroshima, Japan, 1938)

"A creator, me? Never! This is a word that applies only to God."

ISSEY MIYAKE

Issey Miyake respects the integrity of the body; his work is based on a quest for proportion, produced by creativity and craftsmanship. Designed to set off the personality of the person wearing the clothes rather than to be a reflection of the social role imposed by the outfit, his designs offer complete freedom of physical movement. A synthesis of tradition and technology, his innovative and authentic pieces explore the outer limits of form and comfort. His clothes embody—both externally and internally; in other words, for the wearer—an uncompromising research into the relationship between the body and movement. Fabric is the primordial element in this creative process, the guiding principle that binds beauty and function. Miyake transforms and sculpts cloth into corrugated, swirling, quilted, lacquered, curled, or bleached shapes. He bases this work on the two-dimensional technique used to cut kimonos, in which geometric panels are fitted without regard for the curves of the silhouette. The body then creates volume.

A graduate of the Tama Art University, Miyake went to Paris in 1965. He worked for Guy Laroche, then for Hubert de Givenchy.

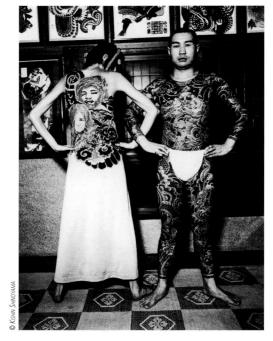

1970
This outfit from the Spring/Summer collection called *Tatoo*, based on traditional Japanese tattoos, is an homage to Janis Joplin and Jimi Hendrix..

1980
Plastic body, Fall/Winter collection 1980-1981. This collection represents the ultimate expression of Issey Miyake's research into the plasticity of the body and clothing, and the space that exists between them.

Four years later, he traveled to New York to collaborate on one of Geoffrey Beene's collections. In 1970, he returned to Japan and established the Miyake Design Studio, an experimental platform integrating art, fashion, and design. Like the Bauhaus movement, it was part of a design trend that aimed to create beautiful objects for everyday life. In 1971, he presented his first collection in New York. The following year, he was invited by the Paris-based Créateurs et Industriels organization, which was bringing together designers and manufacturers to promote the new generation of designers. His fashion show was held in Bourse de Commerce in 1973. In 1977, he started organizing exhibitions of his work: "Issey Miyake in the

122

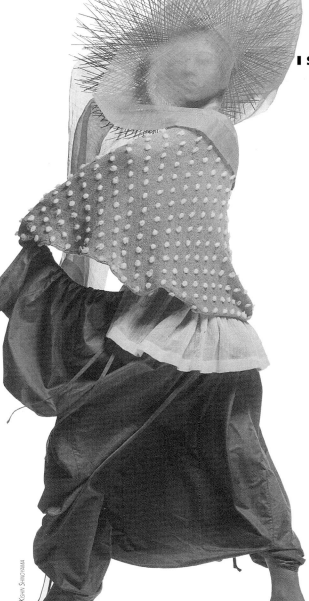

© KISHIN SHINOYAMA

ISSEY MIYAKE

1982

"The issue is not whether these clothes are worn or not. What counts is communication. Without a dialogue, without an exchange, no creation is possible."

ISSEY MIYAKE

resistant, washable, designed without darts or zippers—began as a line of fourteen pieces (tunic, vest, dress, pants) that can be layered, forming the essential components of a contemporary wardrobe: a twenty-first-century uniform on the brink of dethroning bluejeans.

Always working to reconcile form and function, Miyake forces people to look at clothing in a new way by exploring his own ambivalence through the body and space, the static and dynamic, the material and the ephemeral. In his own words: "My clothes can become physically fused with someone. Perhaps I create tools. People buy the clothes that become tools of creativity for those who wear them." He retired in 2000, naming Naoki Takizawa as his successor.

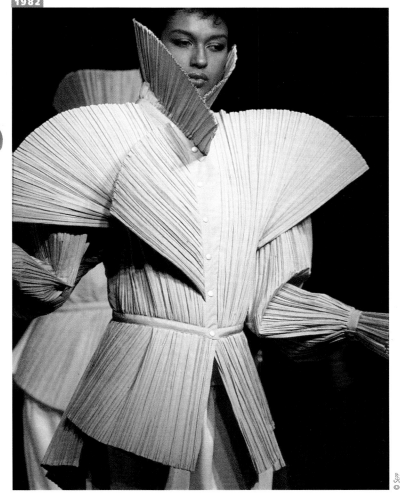

1982

© SEPP

Museum," (1977); "Issey Miyake Spectacle/ Bodyworks" (1983); "Issey Miyake A-Un (1988); "Issey Miyake and Iga Noguchi Arizona (1997); and "Issey Miyake Making Things" (1998-99).

Miyake's world is represented in four different lines: "Issey Miyake," a limited edition of designs, considered to be his research laboratory; "Plantation," created in 1981, which are simplified, less expensive versions of the concepts developed in the first line; "Permanent," which Miyake uses to demonstrate the ephemeral aspect of fashion by reviving older designs; and finally, "Pleats Please," initially established in 1993 for the William Forsythe company, demonstrating body dynamics directly inspired from dance. The "pleats"—wrinkle-

1970

Below and right:

Constructible clothes.
As part of the fashion show for
The Toray Knit Exhibition
in Tokyo, Miyake elaborated on
his philosophy of design:
"I try to create clothes that are
entirely devoted to the
movement of the body.
As opposed to a fashion that
you wear, I want to create a
fashion that you take off,
because this is the true beauty in
mankind's primal energy."

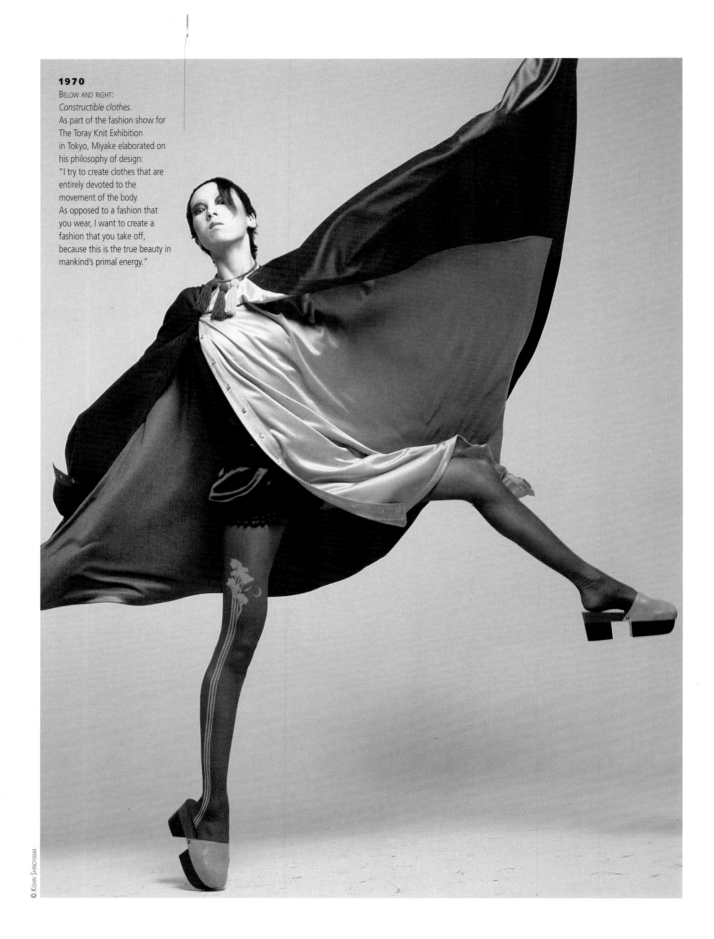

© KISHIN SHINOYAMA

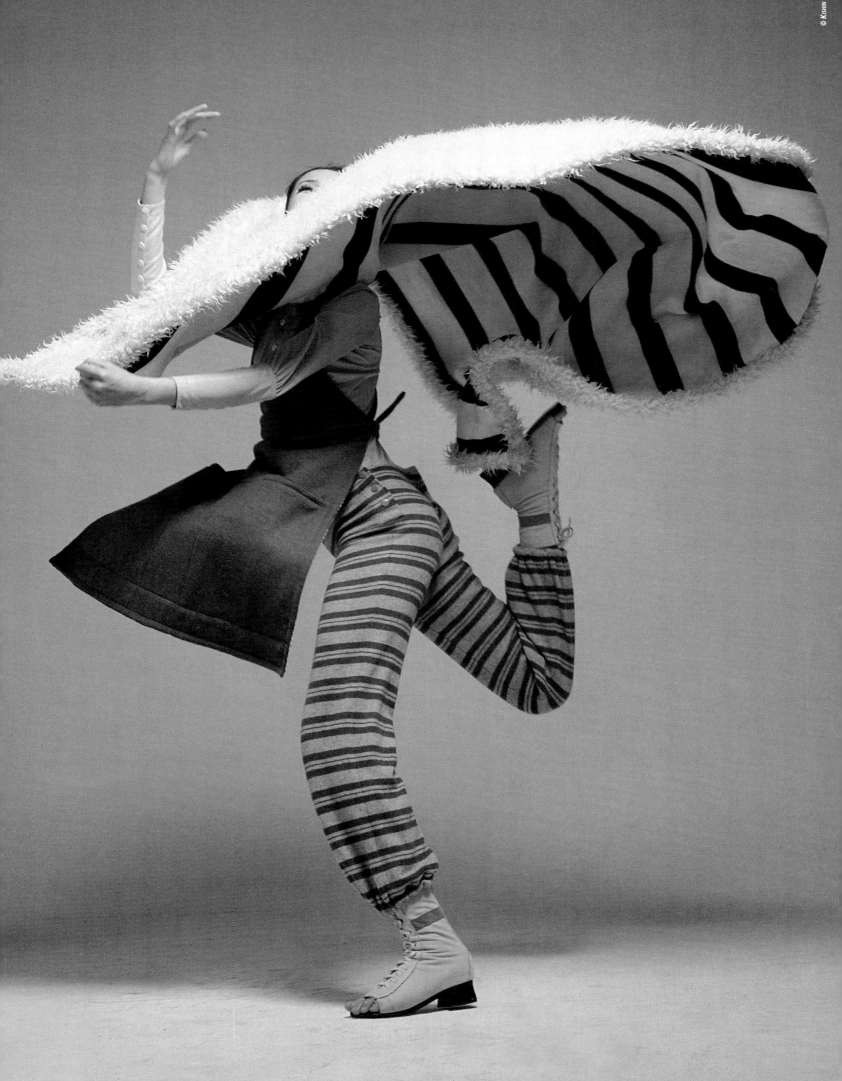

© KISHIN SHINOYAMA

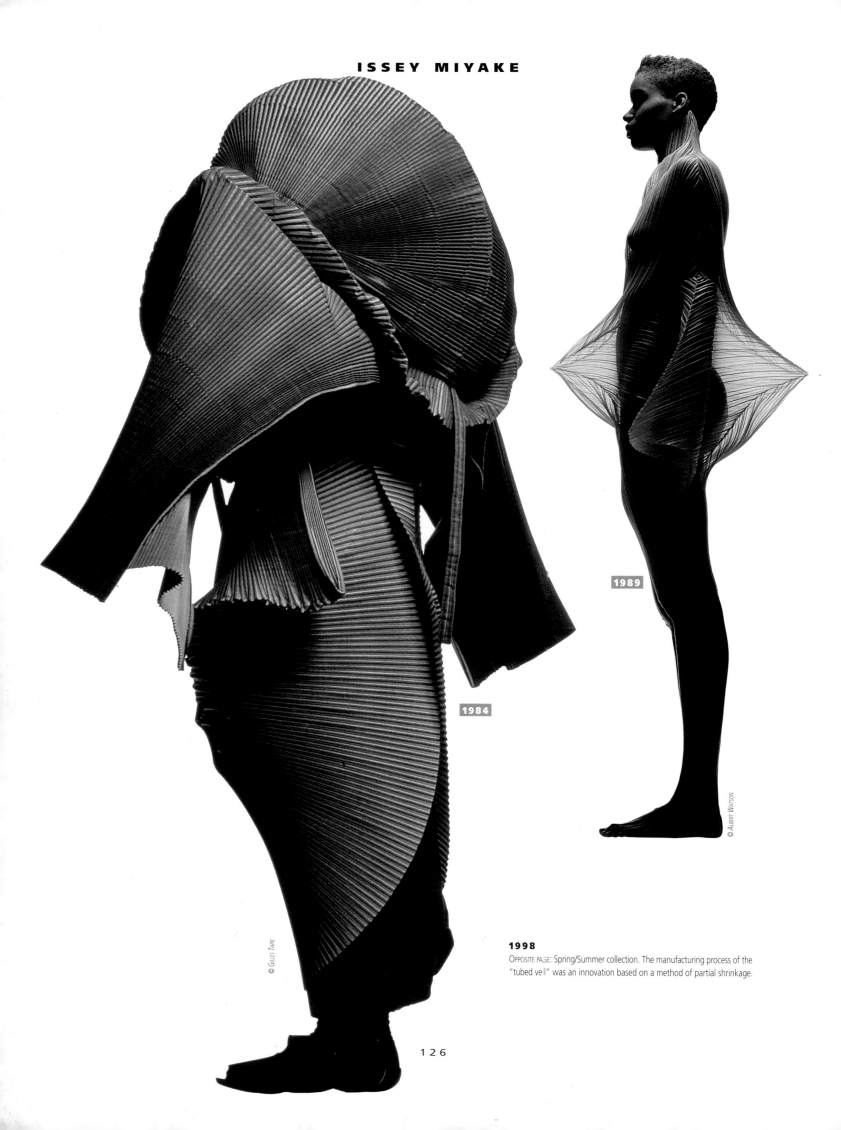

ISSEY MIYAKE

1984

1989

© GILLES TAPIE

© ALBERT WATSON

1998

OPPOSITE PAGE: Spring/Summer collection. The manufacturing process of the "tubed veil" was an innovation based on a method of partial shrinkage.

126

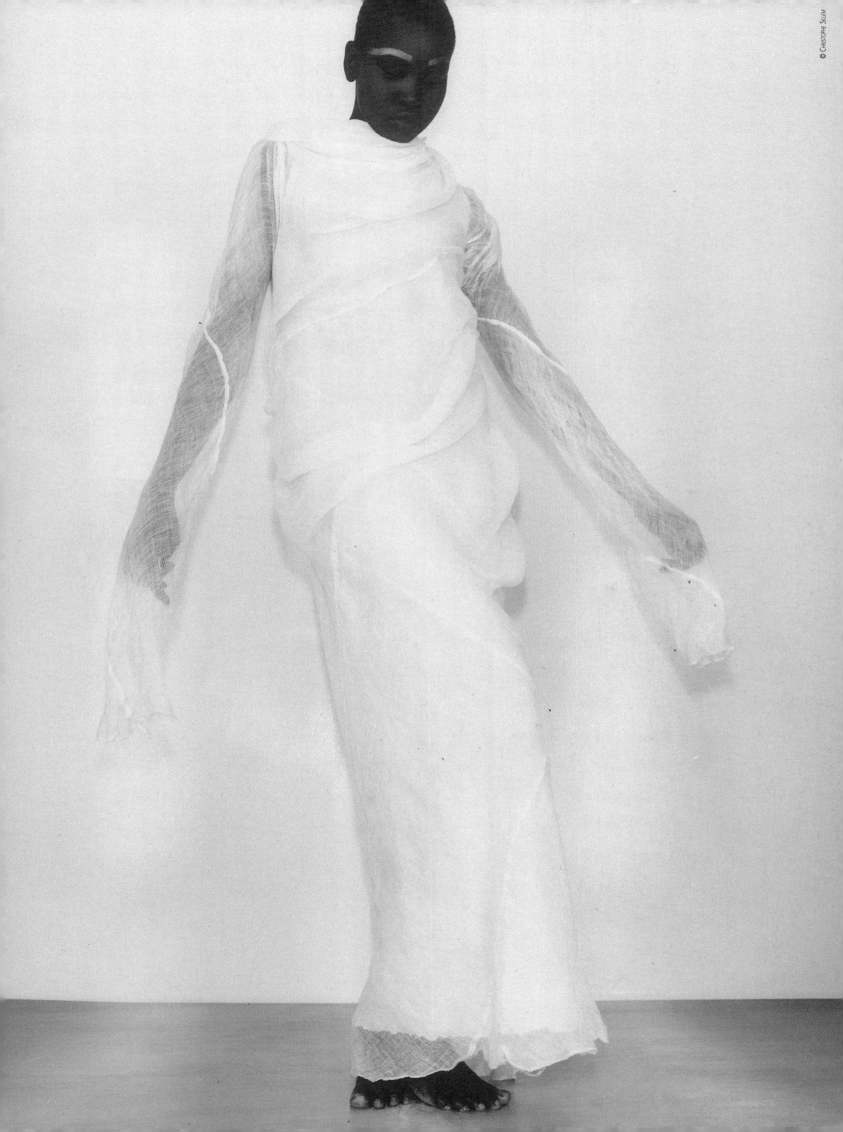

© CHRISTOPHE SILEM

JACQUES FATH

(Maisons-Laffitte, France, 1912 – Paris, 1954)

> "He had the showy elegance of a character from
> a Cocteau play… and the charm of an *enfant terrible*."
>
> CÉLIA BERTIN

1947
Jacques Fath, photographed
for the magazine *Silhouette*.

1949
BELOW:
Simone Bodin, nicknamed Bettina by Fath, was the muse
of the fashion house.
She is shown here during
a fitting session with the
designer.

© ANDRÉ OSTER

Jacques Fath designed his own unique version of the New Look, creating a woman dressed in an overtly feminine style, blending striking sophistication with a gloriously young look. His designs, which he constructed by draping fabric directly on his models, reflected his personal fashion vocabulary: asymmetrical lines, artificial restructuring, longer forms adorned with gathers, straps, bows, piping and flares, along with daring combinations of colors, all contributing to a surprising, glamorous silhouette. The distinctive feature of the vivacious line was the closely fitted and uplifted bodice. Waists were tightly cinched; the overall effect was to emphasize the swelling of the hips and bust, creating well-balanced proportions.

Regarded by his contemporaries as "whimsical," "mischievous," or even "eccentric," Jacques Fath was as famous for his society personage as for his designs. He played the part of a dress designer in Roger Blanc's detective film *Scandale aux Champs-Élysées*, and carried on a glittering social life, organizing lavish parties at his Corbeville home.

Initially destined for a career in finance, Jacques Fath gave this up when he started working for the publisher Henri Lavauzelle. At the same time, he attended night classes in drawing and cutting. Three years later, with the help of his tailor's sister, Jacques Fath opened his own business in a two-room shop on Rue La Boétie and showed his first collection of some twenty dresses. In 1939, he married a famous model, Geneviève Boucher, who would become an ambassador for the Fath style. One year after he was discharged from the Army, he moved to 41, Rue François-Ier, then in 1944 to a lavish private mansion on Avenue Pierre-Ier-de-Serbie, where he hosted a wealthy international clientele that included Rita Hayworth—who ordered her entire trousseau for her marriage to Prince Ali Khan.

1950
RIGHT:
Bettina, wearing the *Red Shoes*
evening dress in the Fall
collection.

Sketch, 1946.

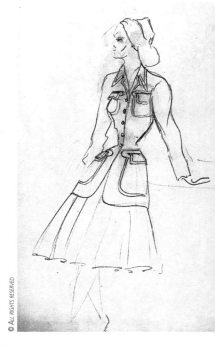

© ALL RIGHTS RESERVED

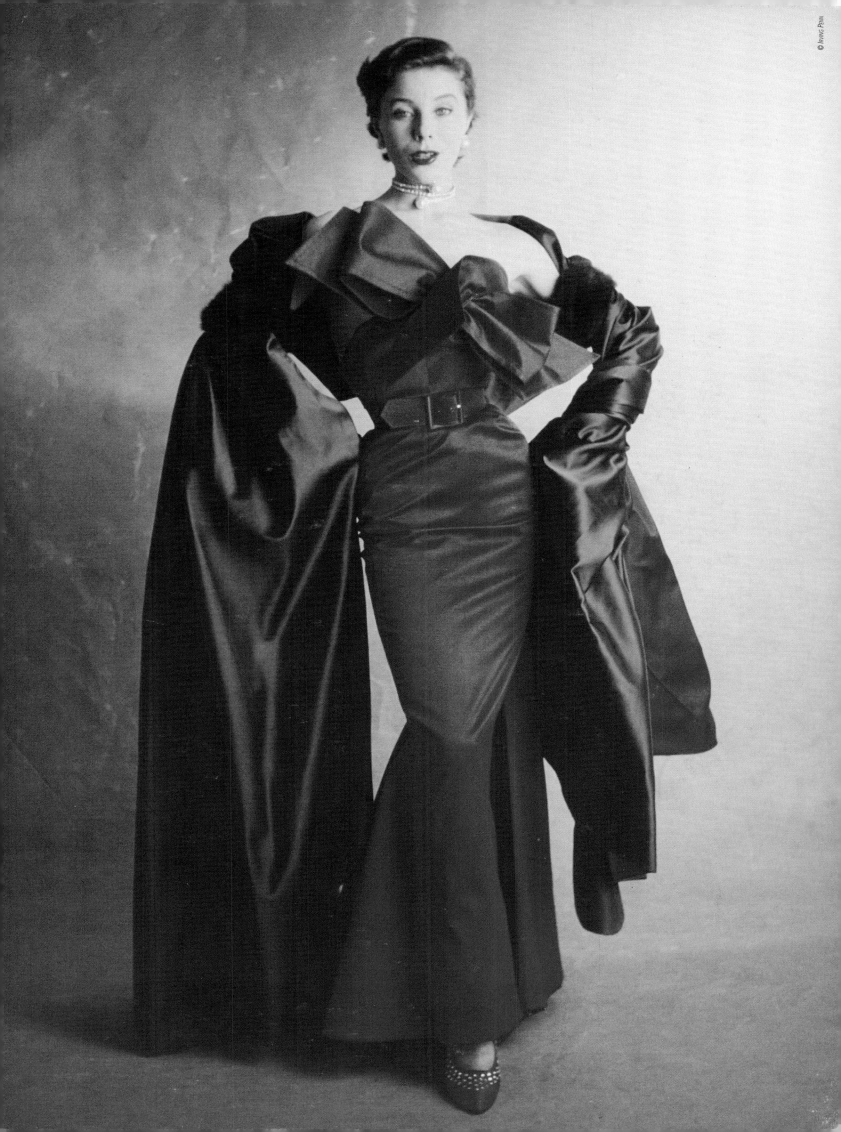

© IRVING PENN

A good businessman, Fath diversified in 1948 by signing a contract with Joseph Halpert, an American ready-to-wear manufacturer. Fath traveled to New York twice a year, creating forty designs, which Halpert manufactured. Sold by Lord & Taylor, each dress was labeled, "Designed in America by Jacques Fath for Joseph Halpert." He made several other agreements. In 1949, Les Patrons de Vogue published patterns by Fath, then he joined the Couturiers Associés, which promoted exclusive outfits intended for the emerging French ready-to-wear sector. In 1953, Fath became partners with the industrialist Jean Provost to produce a line of skirts under the Jacques Fath-Université label. One year later, he died of leukemia. His wife, Geneviève Fath, took over as artistic director and continued the label until 1957, the year of Fath's final haute couture collection.

1947
RIGHT: Geneviève Boucher, a model who became Mrs. Jacques Fath, wearing an outfit from 1947.

1949
BELOW: Bettina.

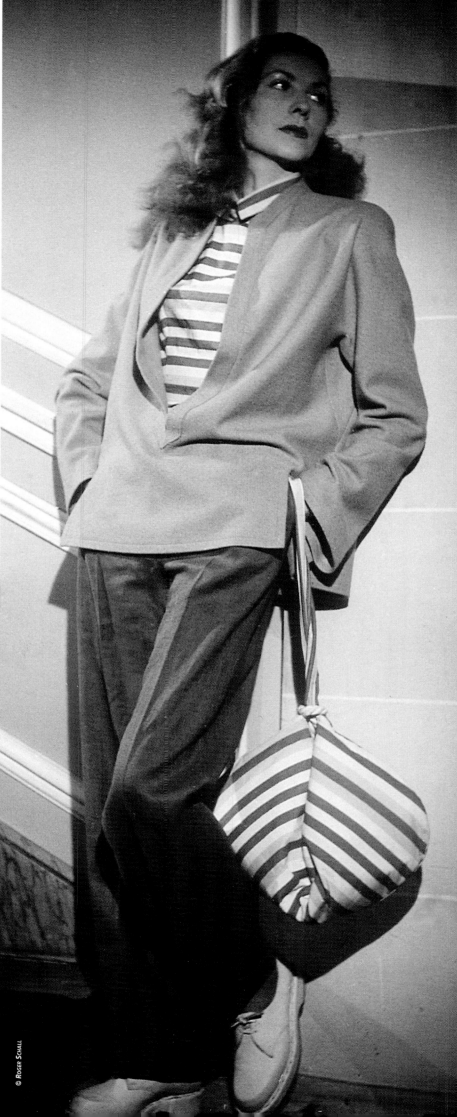

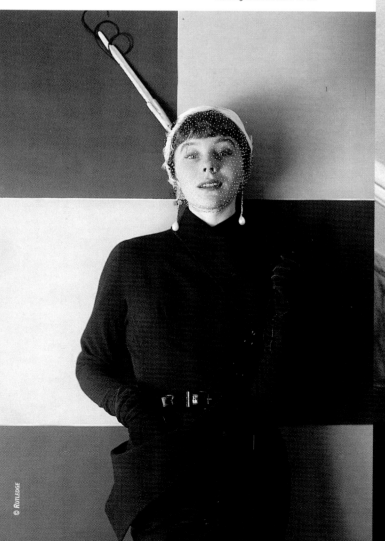

© RUTLEDGE

© ROGER SCHALL

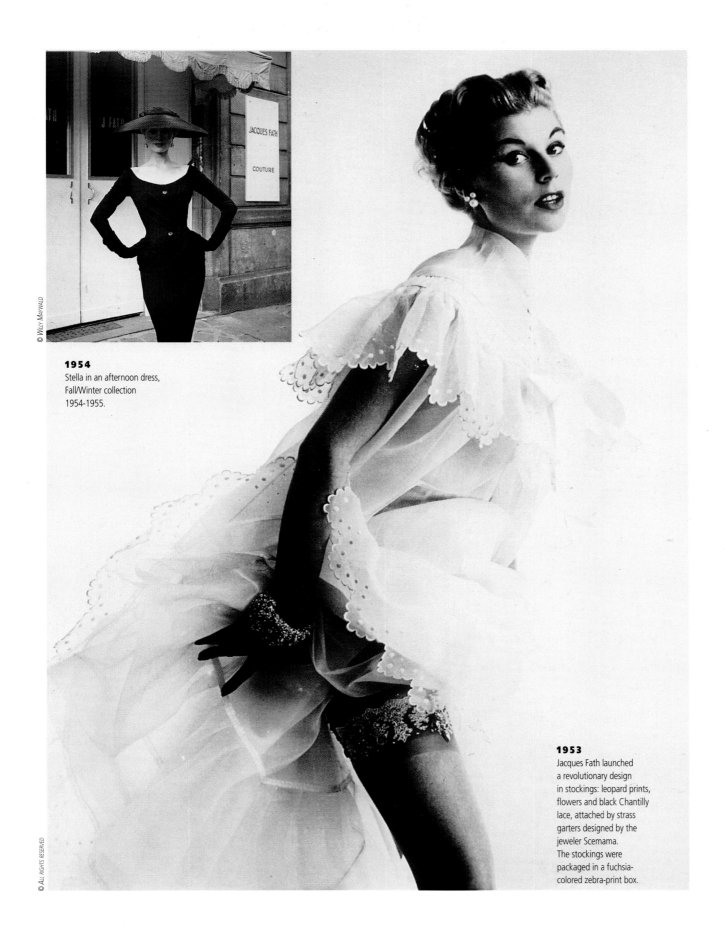

© WILLY MAYWALD

1954
Stella in an afternoon dress,
Fall/Winter collection
1954-1955.

© ALL RIGHTS RESERVED

1953
Jacques Fath launched
a revolutionary design
in stockings: leopard prints,
flowers and black Chantilly
lace, attached by strass
garters designed by the
jeweler Scemama.
The stockings were
packaged in a fuchsia-
colored zebra-print box.

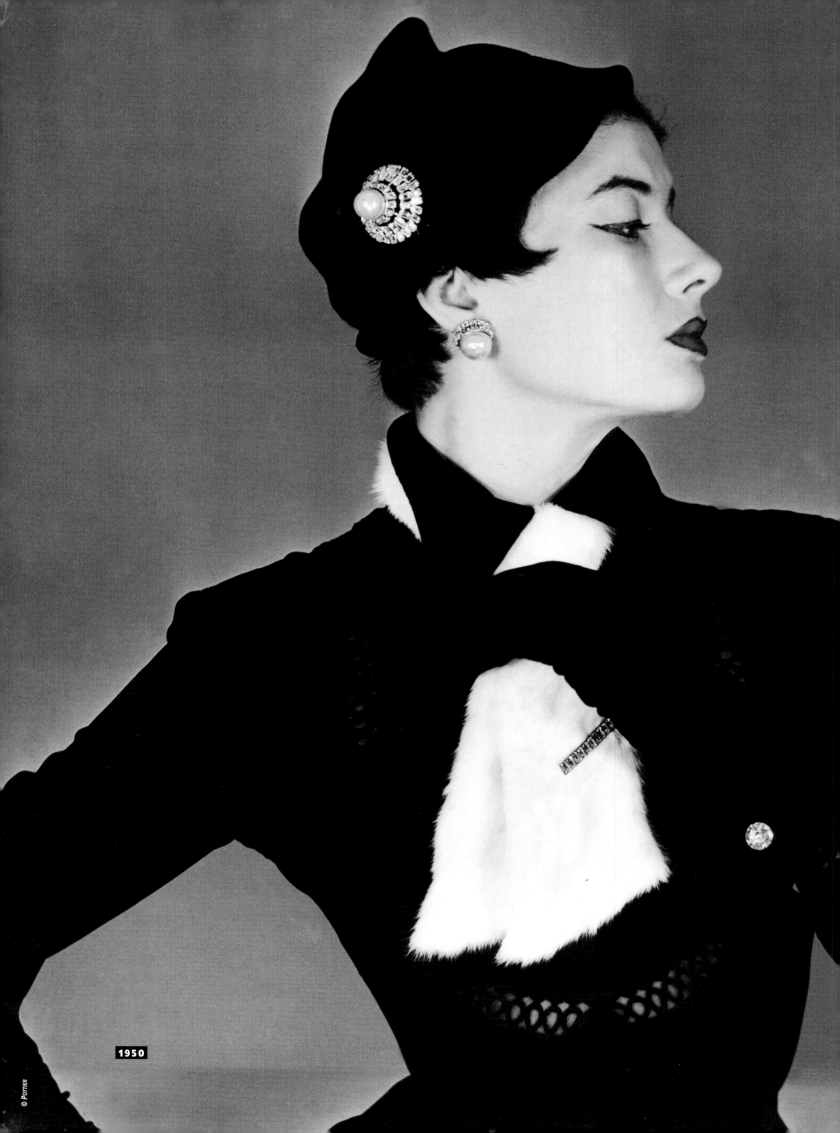

1950

© POTTIER

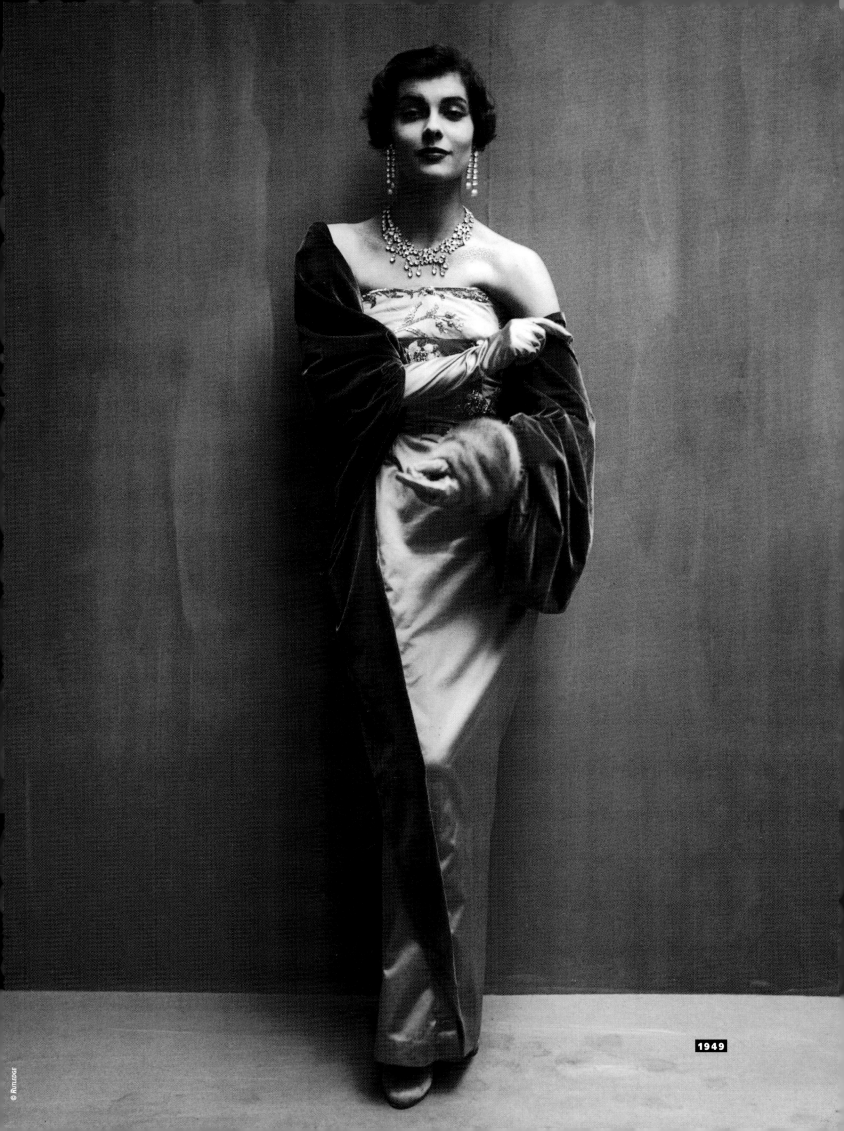

© RUTLEDGE

1949

JEAN-PAUL GAULTIER

(Arcueil, France, 1952)

"I would rather reconstruct than construct.
Everyone is beautiful, if you look at them individually.
There is no noble material."

JEAN-PAUL GAULTIER

1968
Spring/Summer collection
First drawings. "The little details
that make the outfit: a briefcase
holder, the necklace attached to
the pocket."
JEAN-PAUL GAULTIER

© ALL RIGHTS RESERVED

Ever since 1967, when he first started to draw fashion illustrations, Jean-Paul Gaultier has tried to reconcile the heritage of classical couture design—which he devoured in newspaper reports—and the tradition of the famous "Parisian chic" that he saw around him. His purpose, he explains, is to change the way we perceive each other. He combines diametrically opposed materials in a single outfit as if they were words from different languages brought together as one.

Self-taught, he learned the meticulous techniques of couture design while working for Pierre Cardin in 1970, then with Jacques Esterel (who promoted the unisex style), and finally, in 1970, working alongside Michel Goma for Jean Patou. In 1974, he returned to Pierre Cardin, who sent him to the Philippines to oversee a licensing line for the American market.

He presented his first ready-to-wear collection in October 1976. A joker with an ironic bent, Jean-Paul Gaultier challenges the reigning criteria for good and bad taste. He recycles and alters conventional ideas. He shocks, disturbs, provokes, and has good fun while scrambling the differences between menswear and womenswear, with a skirt for him and a men's suit for her—presenting an interchangeable, ambivalent wardrobe.

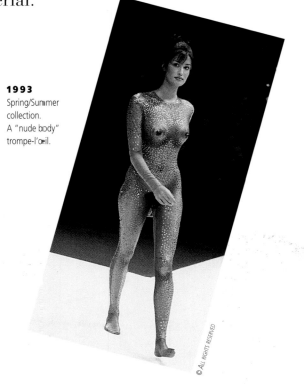

1993
Spring/Summer
collection.
A "nude body"
trompe-l'œil.

© ALL RIGHTS RESERVED

Gifted with a prodigious imagination, Gaultier styles each of his collections around a specific theme. Presenting wearable and impeccably crafted clothes, his shows tell a spectacular story. His selection of atypical models, from a pregnant woman to a seventy-year-old, redefines the canons of conventional beauty.

Fascinated by the media, Jean-Paul Gaultier pillages, juggles, and appropriates its splintered references, transcribing them into his own clothing vocabulary. His creations are like explosive collages or globalized video clips—a mixture of influences and cultures that he warps lightheartedly into fin-de-siècle classics.

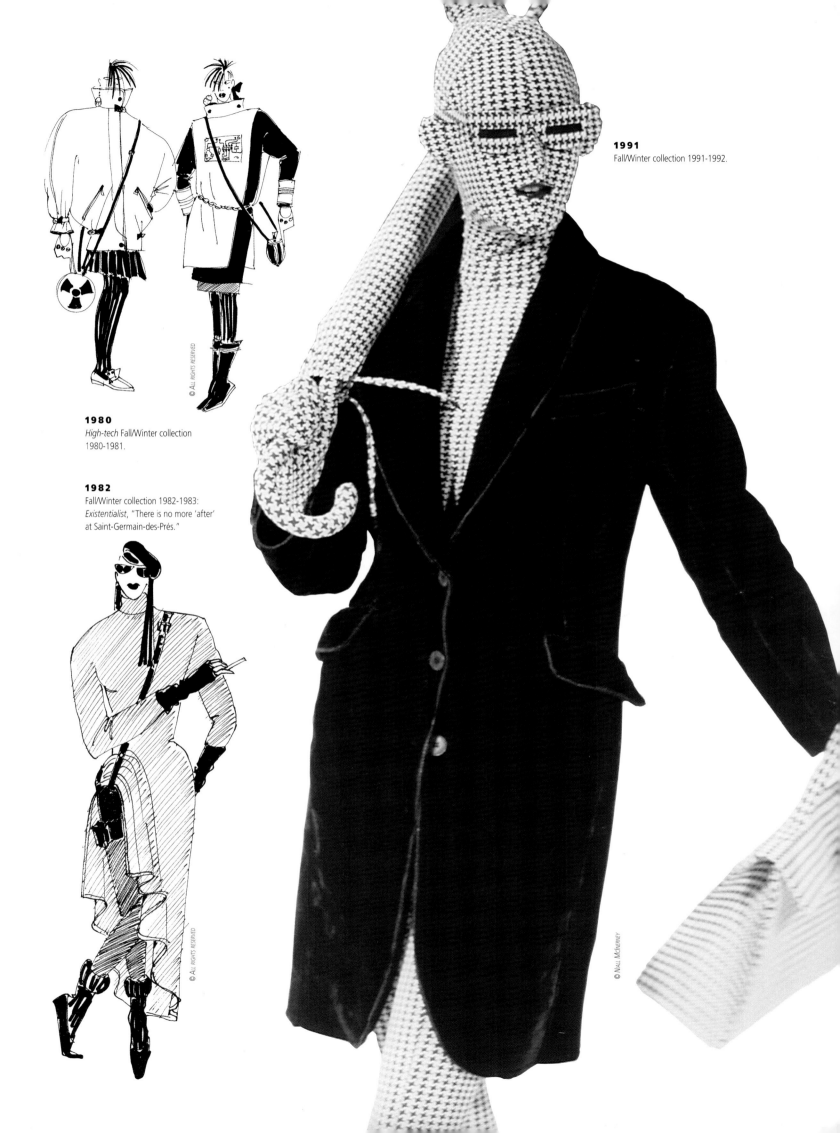

1991
Fall/Winter collection 1991-1992.

1980
High-tech Fall/Winter collection
1980-1981.

1982
Fall/Winter collection 1982-1983:
Existentialist, "There is no more 'after'
at Saint-Germain-des-Prés."

© ALL RIGHTS RESERVED

© ALL RIGHTS RESERVED

© NIALL MCINERNEY

JEAN-PAUL GAULTIER

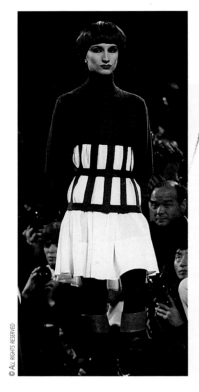

© ALL RIGHTS RESERVED

1989
Fall/Winter collection
1989-1990:
With *Femmes entre elles*
(Women Among Themselves),
Gaultier scrambles signs and
meanings.

1985
Fall/Winter collection
1985-1986:
*The uptight charm of
the bourgeoisie,*
caricatures of the classics.

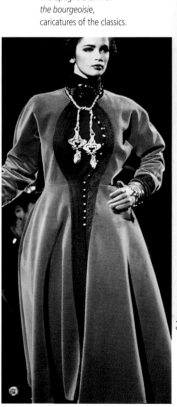
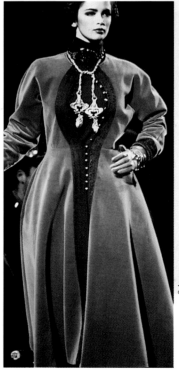

© ALL RIGHTS RESERVED

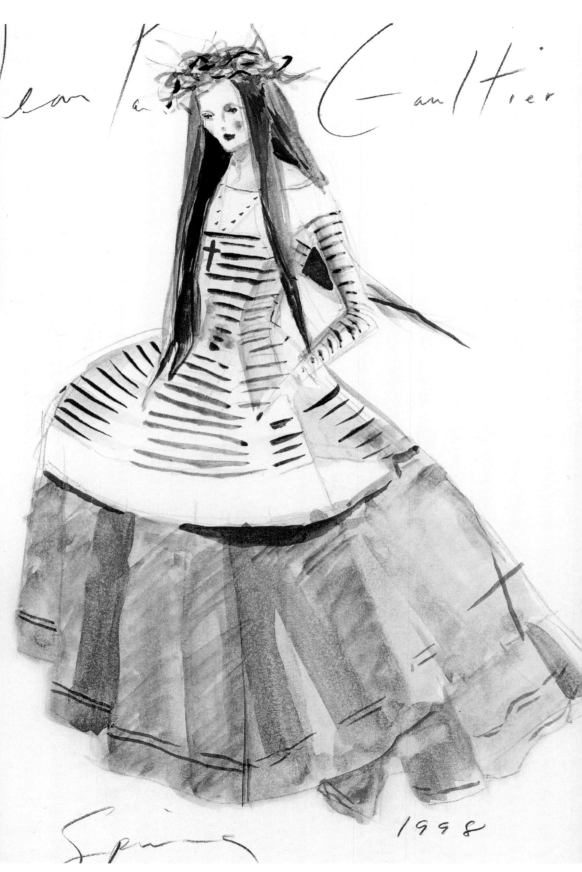

1998
Spring/Summer haute couture collection.
In 1997, Jean-Paul Gaultier launched an haute couture line. His signature fisherman's sweater reappeared in the luxury world of haute couture.

JEAN-PAUL GAULTIER

© ALL RIGHTS RESERVED

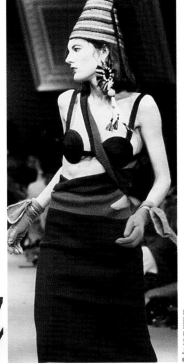

1982

Spring/Summer collection.
The bracelet made from an
empty can of food is a reference
to his 1980 *High-tech* collection.
He returned to the idea for the
packaging of his perfume,
launched in 1993.

1992

LEFT, MIDDLE:
Spring/Summer collection:
Casanova at the gym.

© ALL RIGHTS RESERVED

1984

Spring/Summer collection

1987

Spring/Summer collection:
Trois fois rien pour un bon à rien.

© ALL RIGHTS RESERVED

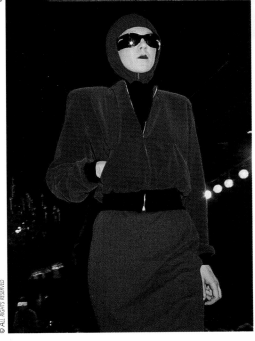

1990

Costumes by Gaultier for Madonna's Blond Ambition World Tour.

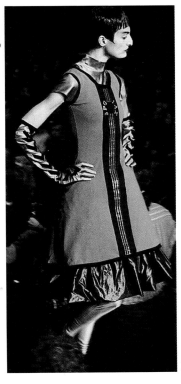

1979

Fall/Winter collection 1979-1980: *James Bond.*

© ALL RIGHTS RESERVED

© ALL RIGHTS RESERVED

JEAN-PAUL GAULTIER

1994
Fall/Winter collection 1994-1995: *Mongol*. Mixed races, androgynous figures, and ethnicity.

© JEAN-MARIE PÉRIER

JIL SANDER

(Wesselburen, Germany, 1943)

"I believe that fashion should convey a kind of confidence,
strength, and pleasure that reflects both
the feminine and masculine elements of a woman."

JIL SANDER

For thirty years, Jil Sander has been creating clothes for active, independent women in which form and content are combined to create a sophisticated style. Her pure, sober style evolves via subtle, nearly imperceptible changes. Her guiding principles, however, never vary: highly refined details, perfectly cut jackets and suit pants—one of her favorite designs.

Her standards for textiles are extremely high, and she innovates by experimenting in her own textile plant, creating unusual blends of natural synthetic cloth. Jewels and accessories are banned from her clothes, leaving a no-frills understated silhouette in which the luxury fabrics and perfect cut contribute to her pared-down, minimalist vision.

Heidemarie Jiline Sander was born north of Hamburg in a small village, where her mother sought refuge from the Allied bombings during the Second World War. In 1961, she lived near Düsseldorf, where she spent two years studying textiles at the Krefeld School of Textiles. She left Germany in 1963, traveling to Los Angeles, where she attended classes at UCLA. Two years later, she was in New York, working as a fashion journalist for *McCall's*.

1978
Inès de La Fressange models for Jil Sander in Paris in the late 1970s. Opposed to the "femme fatale" fashion, Sander created a pared-down, decidedly masculine style.

She returned to Hamburg when her stepfather died and was hired as an editor for *Constanze et Petre*. At the age of twenty-eight, she opened her own boutique, called Jil Sander. She showed her first collection in Paris in a suite at the Plaza Athénée, then held another fashion show at the Intercontinental Hotel in 1978. Her discreet minimalism, which was in total opposition to the extravagant proportions and opulent fabrics then in fashion, received a chilly reception. She decided to return to Germany and showed her collections in Hamburg from 1980 to 1987. Her first official fashion show was held in Milan in 1987. When she decided to come back to Paris in 1993, she opened a boutique at 50, Avenue Montagne, the former address of Madeleine Vionnet's fashion house.

With no secondary line and no licensing contracts, Jil Sander remains focused on her single womenswear line. "It costs more to buy good clothes. I don't think people need to buy so many clothes. What's important is the quality, and if you can combine that with something that fits your style, you should stay with it." The apparent simplicity of her designs conceals a balanced opposition between a rigid structure and fluid curves, as if to give a woman the complete freedom to express her innermost personality.

JIL SANDER

© ALFREDO ALBERTONE

1992
Spring/Summer collection.
"Pure design can be elegant
to the point of opulence,
but it requires an enormous
attention to detail and an
unbelievable level of energy."
JIL SANDER

1993
Fall/Winter collection 1993-1994.

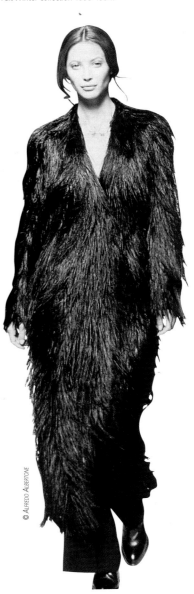

© ALFREDO ALBERTONE

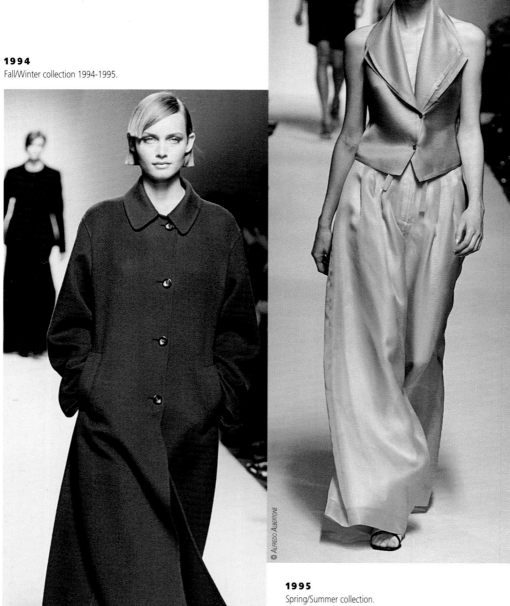

1994
Fall/Winter collection 1994-1995.

1996
Spring/Summer collection.
"I'm interested in what is just barely perceptible."
JIL SANDER

1995
Spring/Summer collection.
"I started very early to believe in an inside-out concept—that if you look as good as you can, you will feel better."
JIL SANDER

© *ALFREDO ALBERTONE*

1998

Spring/Summer collection.
"I don't want my clothes to
change for the sake of it.
I want them to develop, to be
better every time, and then
to change when it's necessary."
JIL SANDER

1997

Fall/Winter collection 1997-1998.

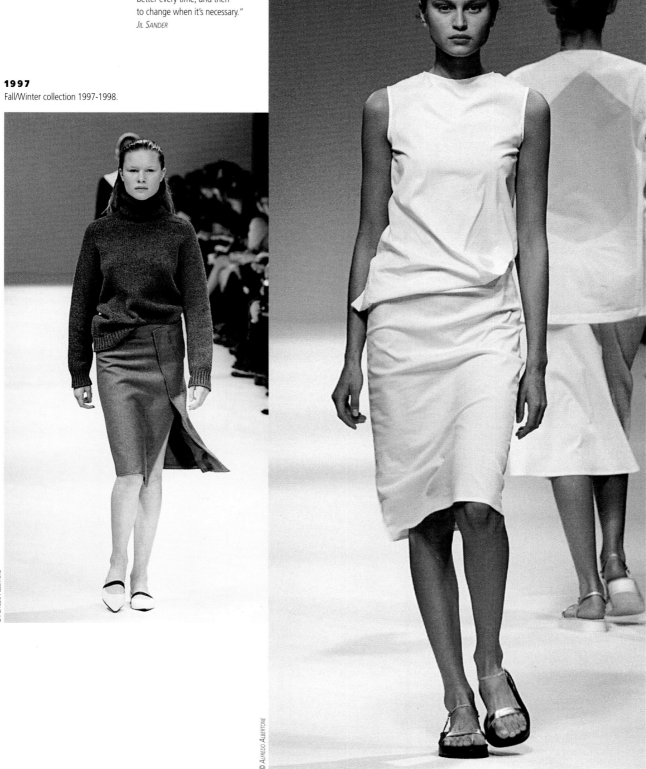

© *ALFREDO ALBERTONE*

KARL LAGERFELD

(Hamburg, Germany, 1938)

"To me, a woman is a fascinating and potentially beautiful creature.
I have always wanted the clothes I design to be a natural extension
of her body—to flow out of her skin—to be not only a reflection
of the way she looks, but of the way she lives."

KARL LAGERFELD

Karl Lagerfeld's energy, wit, and lucidity, combined with a prodigious creative spirit, makes him an extravagant chameleon of fashion. With an implacable sense of humor and irony, he is able to use his versatile talents to create an individual style for each of the many labels for which he works. Armed with an astonishing historical culture, he draws from the past to reinterpret a contemporary and modern style.

The son of a wealthy family of industrialists, Karl Lagerfeld moved to Paris at the age of fourteen to attend secondary school. In 1954, he entered the International Wool Secretariat design contest and won first prize in the "coat" category: this design was then made by the Balmain fashion house—where he was soon hired as an assistant. Rigor, discipline, and humility were the guiding principles of his apprenticeship as a couturier. At the age of twenty, he was hired as artistic director for the House of Jean Patou. In 1963, Karl Lagerfeld launched a prolific career as a free-lance designer for a number of French and foreign ready-to-wear labels, including Timwear, Krizia, Mario Valentino, and Ballantyne.

From 1964 to 1984 (and again from 1992 to 1997), he designed for the luxury label Chloé, where he developed a style of classical elegance, combining the sophistication of haute couture with mass-production techniques. Starting in 1965, he also began a fruitful collaboration with the Fendi sisters in Rome. Together, they redefined the furrier's design concepts by treating the pelts as if they were fabrics. In 1983, he was named artistic director for Chanel.

1986
Karl Lagerfeld published *Journal de mode*, in which he showcased his friend and muse, the fashion editor Anna Piaggi

© ALL RIGHTS RESERVED

© ALL RIGHTS RESERVED

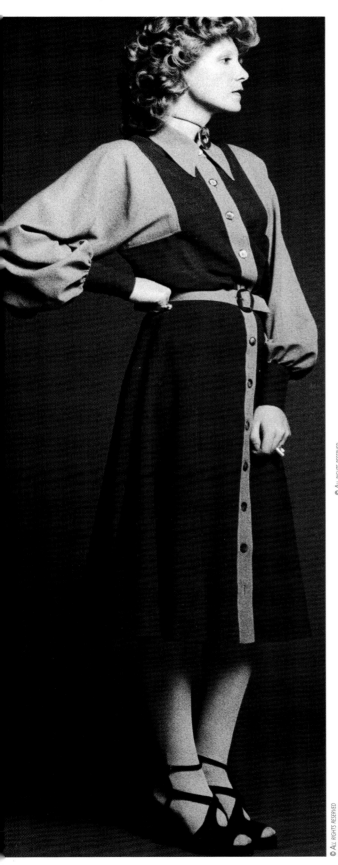

© ALL RIGHTS RESERVED

1977
Fall/Winter collection
1977-1978.
"I am nostalgic for a past that I never knew, but not for a past that I know."
KARL LAGERFELD

1971
Karl Lagerfeld for Chloé, Spring/Summer collection. Charles Jourdan shoes created by Karl Lagerfeld, necklace by Jean Dinh Van.

Lagerfeld transposed and updated the signature Chanel design elements. He rejuvenated the line, paying tribute to the work of Gabrielle Chanel, although he neither copied nor parodied the formal vocabulary she had developed.

Tirelessly competitive and a workaholic, the talented Karl Lagerfeld designs custom-made clothes as well as ready-to-wear lines, furs, jewels, shoes, and gloves. He is fascinated by the theater of life. An art collector and connoisseur, he is also extraordinarily multifaceted, demonstrated by his fondness for photography, publishing, and theater. He has been able to impose his individual mark—nearly an indelible signature—wherever he has worked.

1991
Spring/Summer collection.
"Even the darkest shades never
overshadow color."
KARL LAGERFELD

© ALL RIGHTS RESERVED

© ALL RIGHTS RESERVED

© ALL RIGHTS RESERVED

1973
Trademark outfits from
Chloé's Fall/Winter collection
1983-1984 (far left),
and Spring/Summer 1983
(above).

1988
OPPOSITE PAGE:
Fall/Winter collection
1988-1989.
Frocks and capes are the
inspirations for this collection.

1994
PAGE 148, LEFT:
Spring/Summer collection.

1997
PAGE 148, RIGHT:
Fall/Winter collection
1997-1998.
"What I like about this business
is that you always have to rise
from your ashes."
KARL LAGERFELD

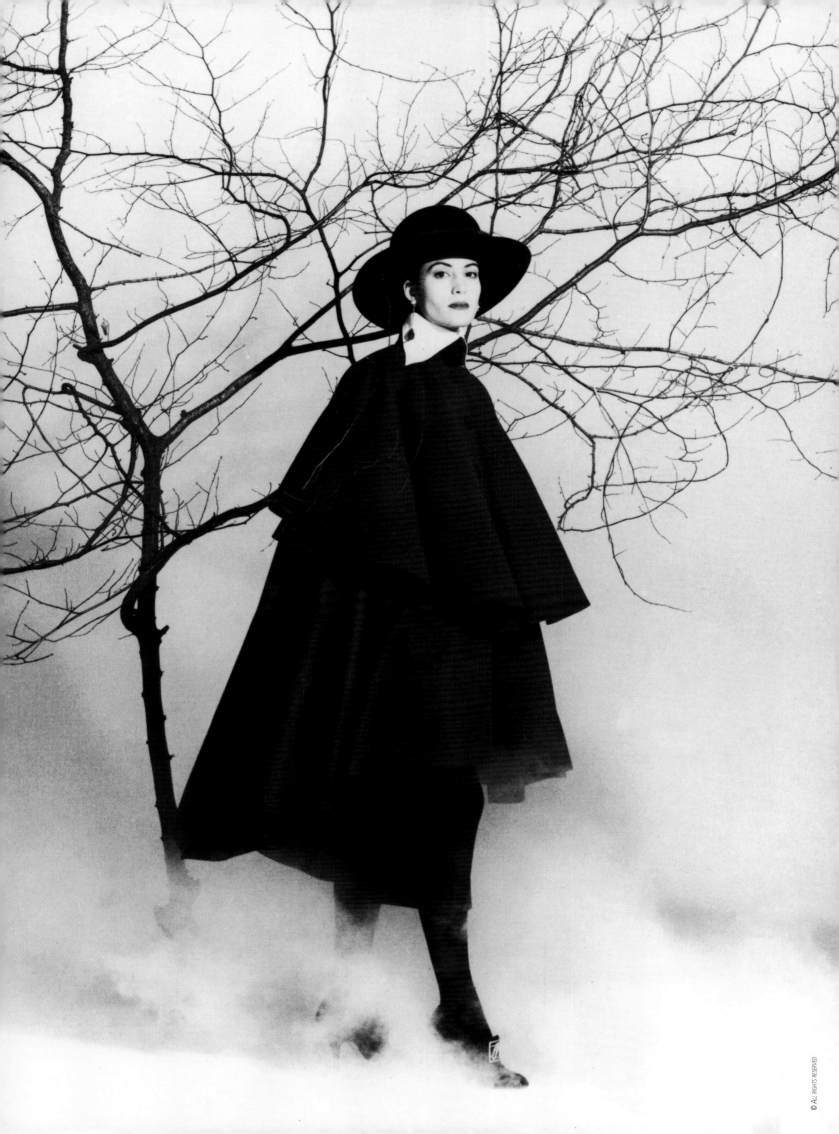

© ALL RIGHTS RESERVED

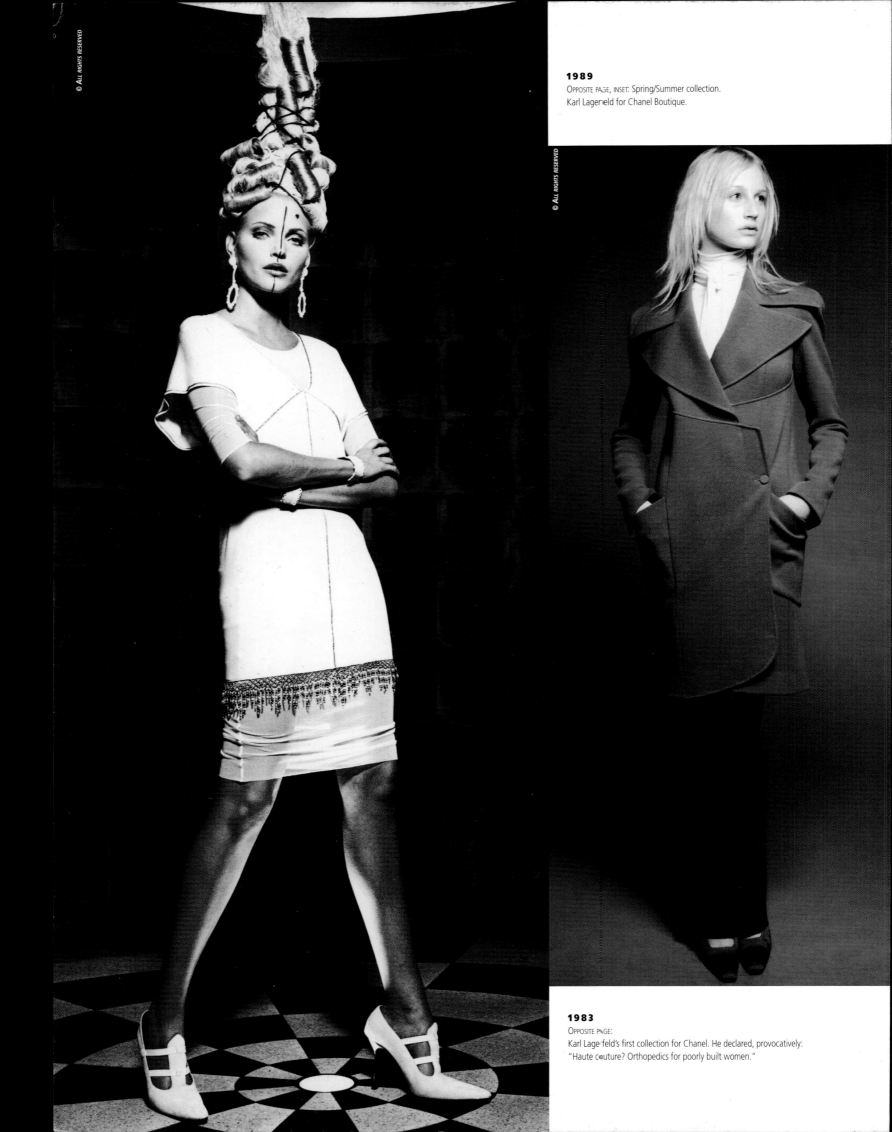

© ALL RIGHTS RESERVED

© ALL RIGHTS RESERVED

1989

OPPOSITE PAGE, INSET: Spring/Summer collection.
Karl Lagerfeld for Chanel Boutique.

1983

OPPOSITE PAGE:
Karl Lagerfeld's first collection for Chanel. He declared, provocatively:
"Haute couture? Orthopedics for poorly built women."

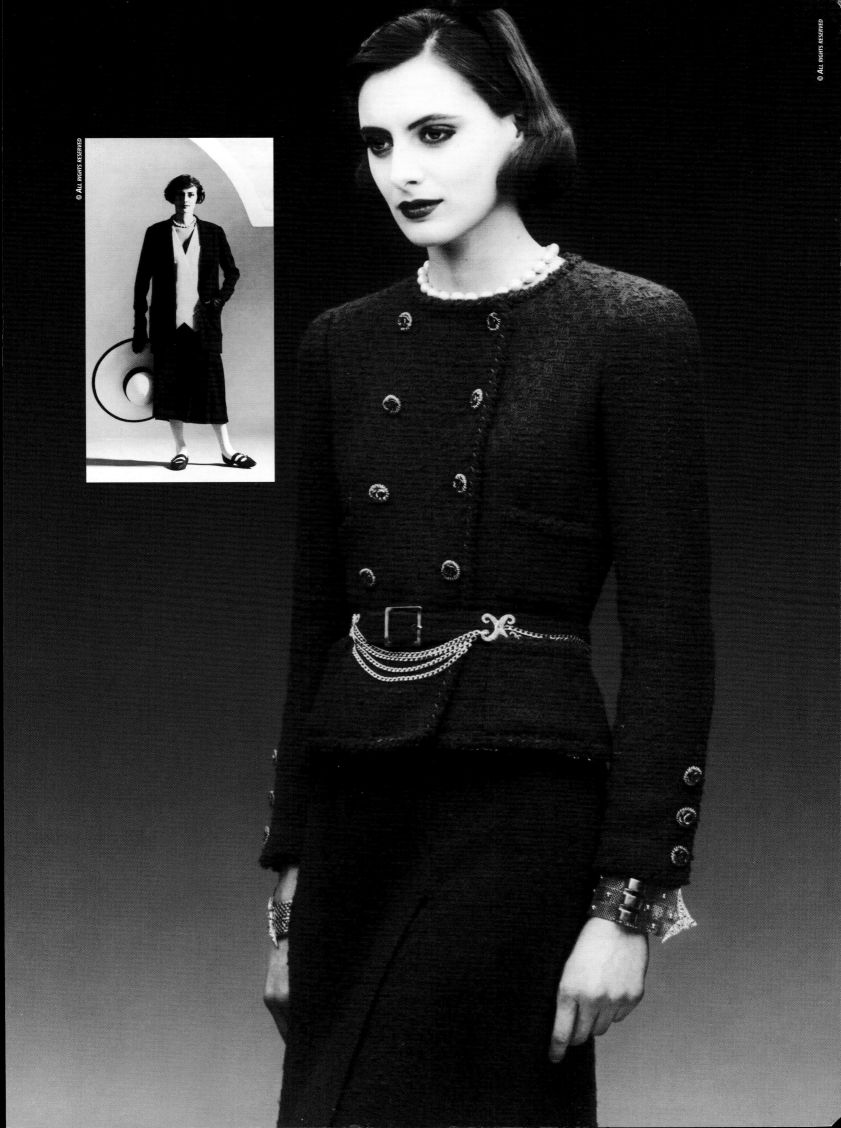

© ALL RIGHTS RESERVED

© ALL RIGHTS RESERVED

KENZO
Kenzo Takada

(Himeji, Japan, 1939)

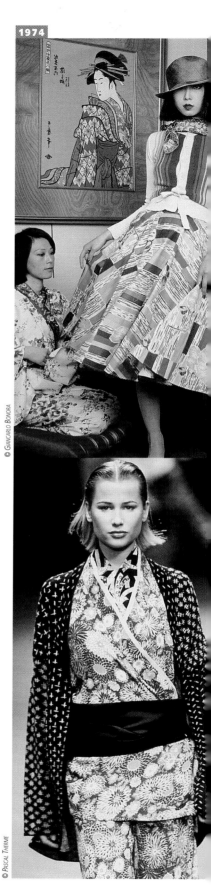

"To find Kenzo's inspiration, look more toward Japanese floral art than to the kimono."

MARIELLA RIGHINI

Kenzo Takada, the first Japanese designer in France, brought with him a subtle exoticism, associating Japanese materials and techniques with Western forms to create a relaxed new style. He arrived in Marseille in 1965 and then moved to Paris, where he worked as a free-lance designer. After spending some time with the Pisanti textile group, and later with Relations Textiles, a consulting company, Kenzo took over a former boutique in the Galerie Vivenne. In 1970, the "Jungle Jap" boutique, decorated with landscapes inspired by the paintings of the Douanier Rousseau, opened in Paris. It presented simple, practical, accessible and, above all, wearable designs that ran counter to the haute couture fashion, which he believed was too perfect for everyday life.

Trained at the prestigious Bunka Gakuen College of Fashion, Kenzo is a master of cut, weave, and colors. His unstructured forms are based on the straight-cut kimono technique; the clothes have no darts or zippers and are designed for free-spirited women. He shapes new volumes by making wider sleeves and armholes and by shifting shoulders, creating more space and freedom of movement. Kenzo draws his inspiration from kimono design to layer materials and colors, just as he borrows elements from the haoris, the Japanese coat, to line necklines, cuffs, belts, and sleeves with bright colors.

Kenzo does not show classics, but opts instead for separates that mix multiple colors and unusual prints. He is neither confrontational nor provocative. He concentrates more on details, paying special attention to the proportions and designs that are discreet combinations of two civilizations: East and West. From his first collections, Kenzo has quietly continued to transmit the same message of cultural diversity and ethnic mix that is a distinguishing feature of his own background. He retired in 1999 and was replaced by his longtime assistant, Gilles Rosier.

1975
Perfect examples of the technical influence of Kenzo's native Japan.

150

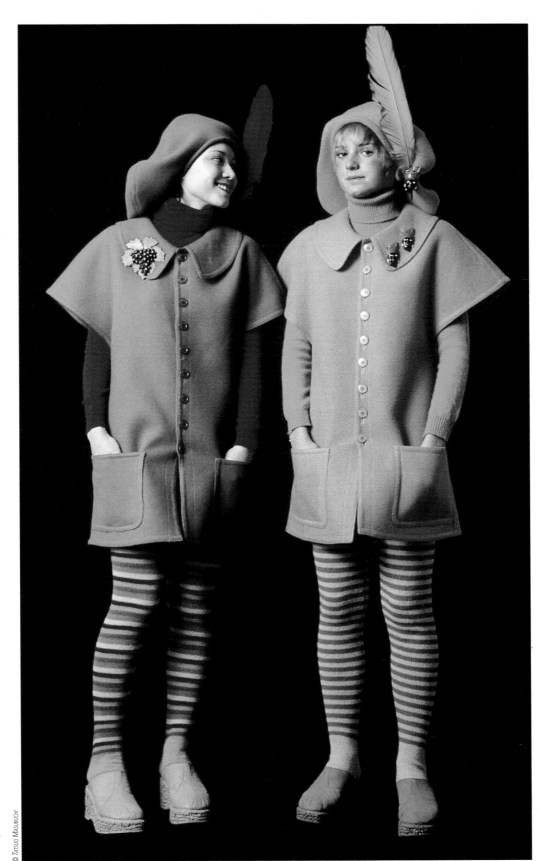

1993

Opposite page, bottom:
Fall/Winter collection
1993-1994.

1971

Fall/Winter collection
1971-1972.
"I try to express freedom of
spirit through my designs.
Spirit, in terms of wearing
clothes, is comfort, cheerfulness,
lightness."
Kenzo Takada

© Tatsuo Masubuchi

KENZO

© ALL RIGHTS RESERVED

1998
Fall/Winter collection 1998-1999.

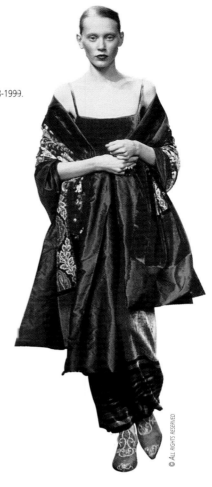

1973
Kenzo combines colors and patterns to describe his own folklore and impose his own style.

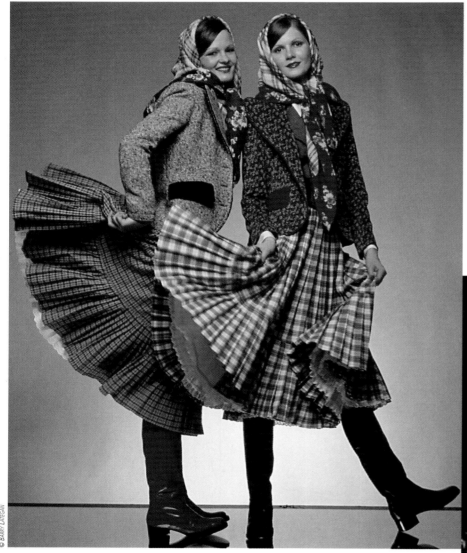

© BARRY LATEGAN

1982
Fall/Winter collection 1982-1983.

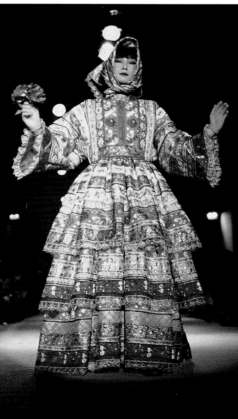

© ALL RIGHTS RESERVED

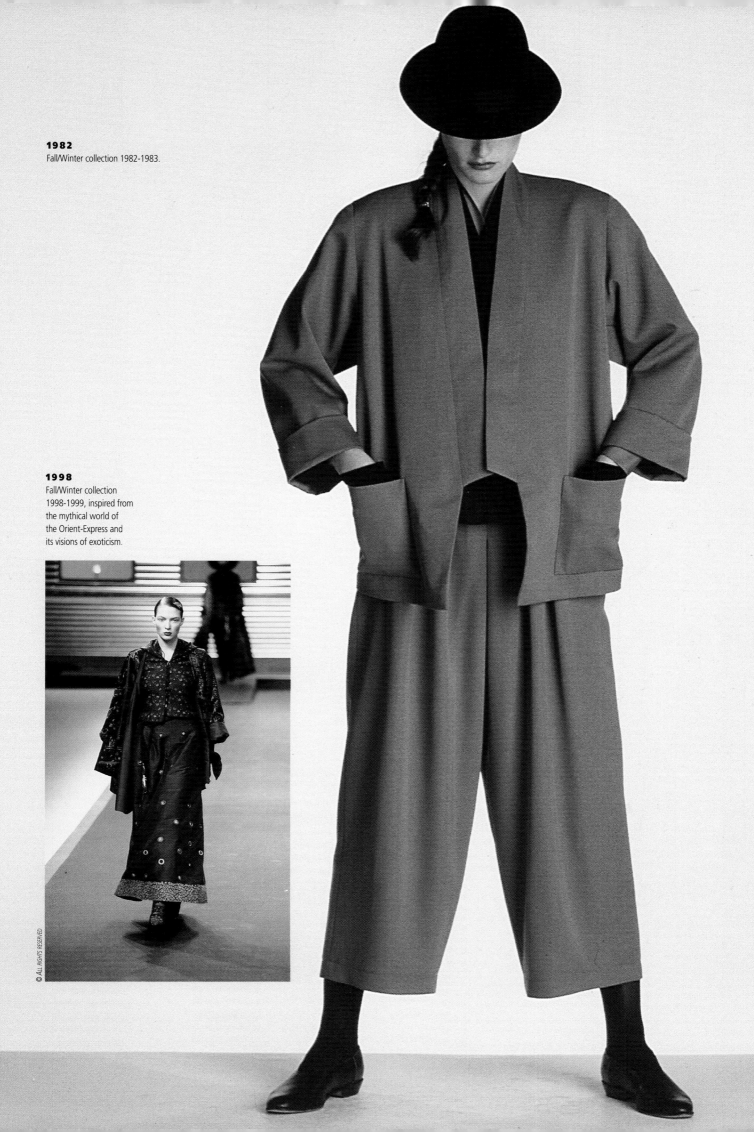

1982
Fall/Winter collection 1982-1983.

1998
Fall/Winter collection
1998-1999, inspired from
the mythical world of
the Orient-Express and
its visions of exoticism.

© ALL RIGHTS RESERVED

© JEAN-NOEL L'HARMEROLT

M A R Y Q U A N T

(London, England, 1934)

"I've always wanted young people to have a fashion of their own."

MARY QUANT

1967
Minidress with a zippered front, called the *Banana Split*.

© ALL RIGHTS RESERVED

Mary Quant, an emblematic figure of the London scene in the 1960s, is a pioneering designer of the post-war period. As early as 1955, she was offering clothes to a newly emerging generation eager for novelty. Quant was able to provide exactly what they sought. Her boutique, Bazaar, presented daring new clothes that were radically different from those worn by anyone in the older generation.

Mary Quant studied at Goldsmith's College of Art, where she met her future husband, Alex Plunket-Greene, who contributed his business acumen to their undertaking. Together with Archie McHair, they formed a triumvirate that would make her name an internationally known label. In 1955, they opened Bazaar on the corner of Markham Square and King's Road in Chelsea. It became an immediate social phenomenon. With no real training in fashion, Quant started selling clothes made by other people, but she soon decided that they did not correspond to her own vision of fashion. She then decided to launch her own designs. Bold and petulant, they were targeted to her own generation, seeking a way to distinguish itself. Her original ideas, such as the miniskirt, pinafore, and PVC raincoats, were inspired from what she saw around her on the streets of London; these were quickly integrated into the fashion vocabulary of many other designers. In 1957, a second boutique opened in Knightsbridge. In 1961, she started a line of furs, continuing the following year with a line designed specially for JCPenney, which had some 1,700 outlets throughout America. To meet the phenomenal demand for her clothes, she launched the Ginger Group, a wholesale manufacturing firm, in 1963. Mary Quant was creating twenty-two collections per year (clothes, raincoats, stockings, undergarments, bathing suits). In 1966, she launched a range of cosmetics after noting the lack of creativity in this sector. Her products included colors unavailable anywhere else and were the logical outcome of the research she had begun a decade earlier. Today, she has more than 140 boutiques.

Mary Quant designed a total look extending from tip to toe: a five-point geometric haircut designed by Vidal Sassoon; spectacularly short dresses; undergarments that fit like a second skin; and stockings make of brilliant colors or new materials—all with matching shoes and cosmetics. She was more than a fashion designer; she was the spokeswoman of an entire generation that, up to then, had no individuality of its own. She gave young people the tools with which to explore a new identity defined by an impetuous, confrontational fun and freewheeling lifestyle, in total contradiction to the reigning ambience. Queen Elizabeth II named Mary Quant an Officer of the British Empire.

MARY QUANT

© ALL RIGHTS RESERVED

1968
Collection of brightly
colored shoes made of
molded plastic.

1966
Portrait of Mary Quant.

MARY QUANT GIVES YOU THE BARE ESSENTIALS

© ALL RIGHTS RESERVED

1966
Advertising: the famous daisy
pattern, a virtual logo for
the era, drawn directly on
a model's skin.

1969

"The sight of Shirley Eaton
painted entirely in gold in *Gold-
finger* opened my eyes to the
extraordinary attraction of this
precious metal."
MARY QUANT
A lamé bodysuit, like a
second skin, conveys
the newfound pride in
the female body.

© ALL RIGHTS RESERVED

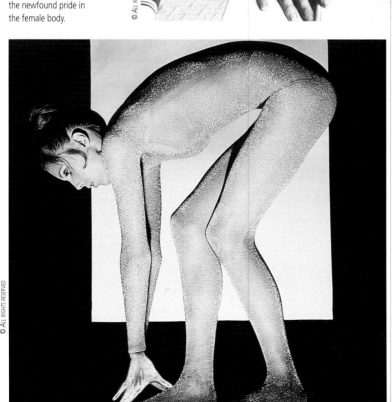

© ALL RIGHTS RESERVED

© ALL RIGHTS RESERVED

1965
Mary Quant introduces a line of stockings and lingerie.

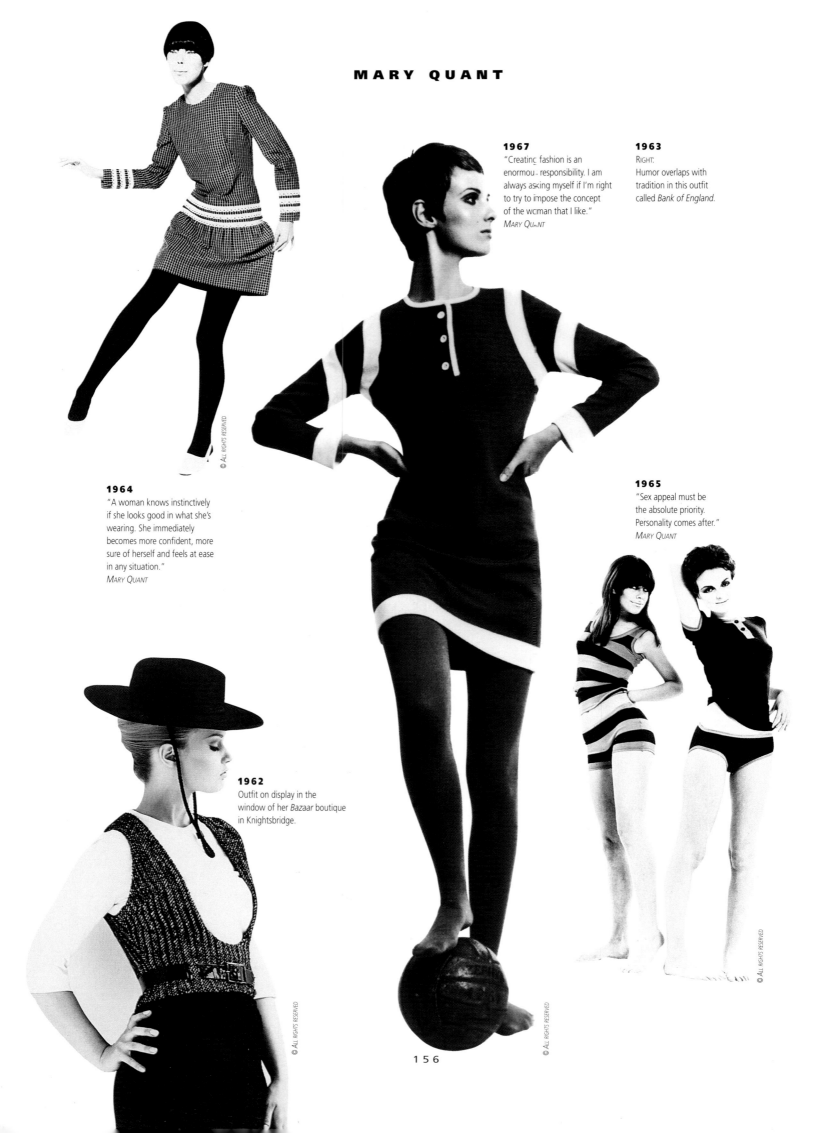

MARY QUANT

1967
"Creating fashion is an enormous responsibility. I am always asking myself if I'm right to try to impose the concept of the woman that I like."
MARY QUANT

1963
RIGHT:
Humor overlaps with tradition in this outfit called *Bank of England.*

1964
"A woman knows instinctively if she looks good in what she's wearing. She immediately becomes more confident, more sure of herself and feels at ease in any situation."
MARY QUANT

1965
"Sex appeal must be the absolute priority. Personality comes after."
MARY QUANT

1962
Outfit on display in the window of her *Bazaar* boutique in Knightsbridge.

© ALL RIGHTS RESERVED

156

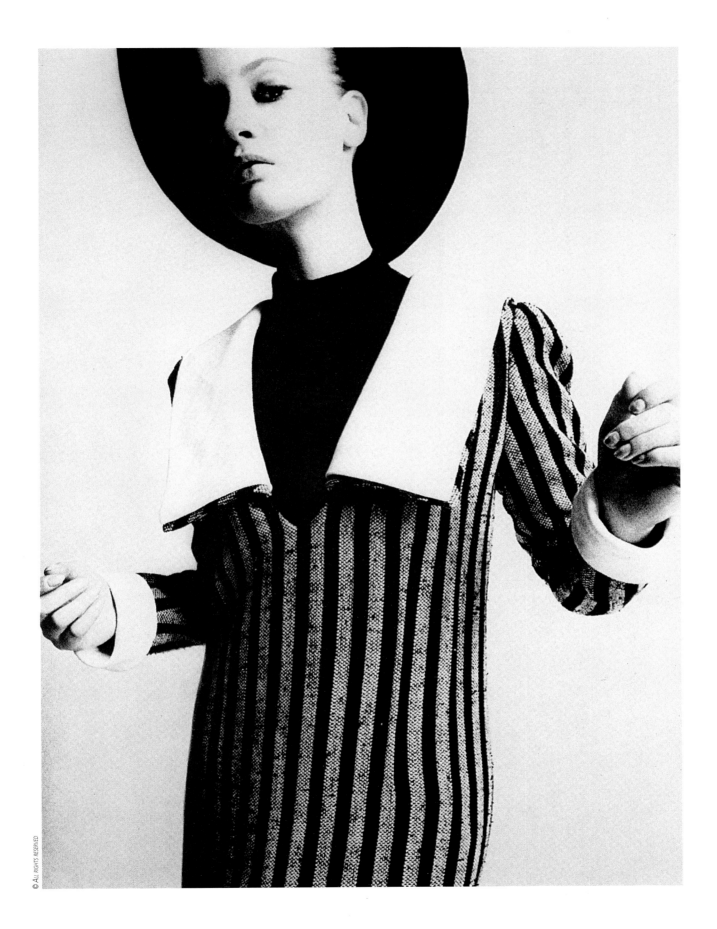

© ALL RIGHTS RESERVED

NORMAN NORELL

(Noblesville, Indiana, United States, 1900 – New York, 1972)

"Norman Norell made Seventh Avenue the rival of Paris."

THE NEW YORK TIMES

Norman Norell magnified American fashion, endowing it with a lavish yet subtle luxury. Even when designing for ready-to-wear, he considered himself a tailor and aimed for a certain technical perfection, in the great tradition of haute couture designers. His high standards redefined the capacities and limitations of the ready-to-wear industry.

Norman Norell moved to New York at the age of nineteen to study at Parsons School of Design and later at the Pratt Institute. He began his career in 1922 as a costume designer for Paramount. He worked on *The Hacienda* with Rudolph Valentino and on *Zaza* with Gloria Swanson. The following year, the studio moved to Hollywood, but Norell remained in New York to work with his private clients, notably the *Ziegfeld Follies* and the Cotton Club. From 1924 to 1928, he designed clothes for the dress manufacturer Charles Amour, then joined the staff of the famous American fashion house Hattie Carnegie. Here he perfected his technique by taking apart dresses from Parisian couture designers and adjusting the proportions to adapt them to the American silhouette. In 1941, he left Hattie Carnegie for Anthony Traina, agreeing to a smaller salary in exchange for a guarantee that he would have his name on the label of each of his dress designs, a rare gesture of recognition from a manufacturer.

From his first collection under the Traina-Norell label, Norell promoted a discreet, elegant style, distinguished by a confident simplicity and several specific elements: impeccably cut fabrics (a result of his technical brilliance); suits made of striped or gray wool (in homage to the elegance of men's tailored suits); and little black dresses (an essential item in any woman's wardrobe). His training as a costume designer influenced his spectacular form-fitting evening dresses—known as "mermaids" and covered entirely with glittering paillettes. This material, once seen only on Broadway sets, appeared on dresses parading down Park Avenue. Norell used a limited range of accessories in his pared-down line. These included sailor's collars and embroidered anchors, bold buttons in contrasting colors, fur trim, and lavishly opulent costume jewelry. Traina retired in 1960, and Norell's dream of owning his own fashion house finally came true. Norman Norell continued to evolve his design vocabulary up to his death in 1972, using sumptuous materials to create a clean, well-defined look, a reflection of his accomplished technical mastery.

1959
OPPOSITE PAGE:
Norman Norell with a model wearing a "mermaid" evening dress.

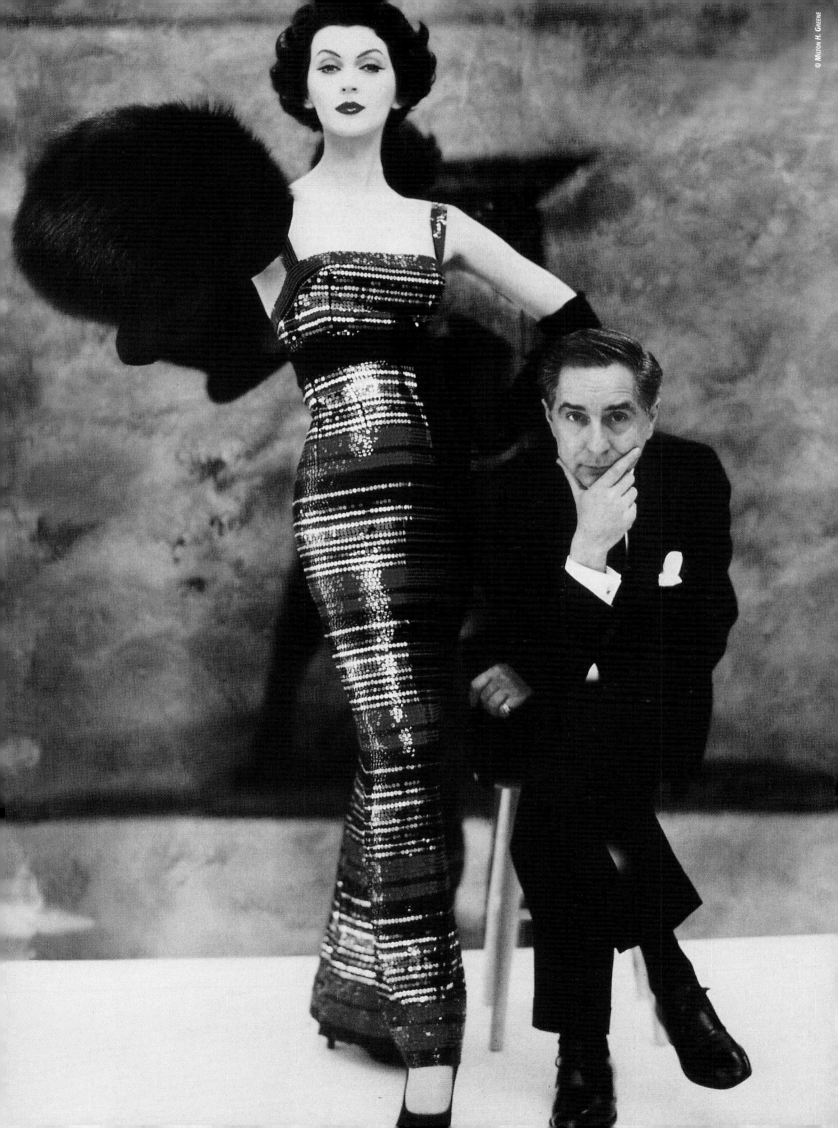

© MILTON H. GREENE

1965
"Norman Norell was
America's master of proportion
and cut."
WOMEN'S WEAR DAILY

© BERT STERN

© ALL RIGHTS RESERVED

1942

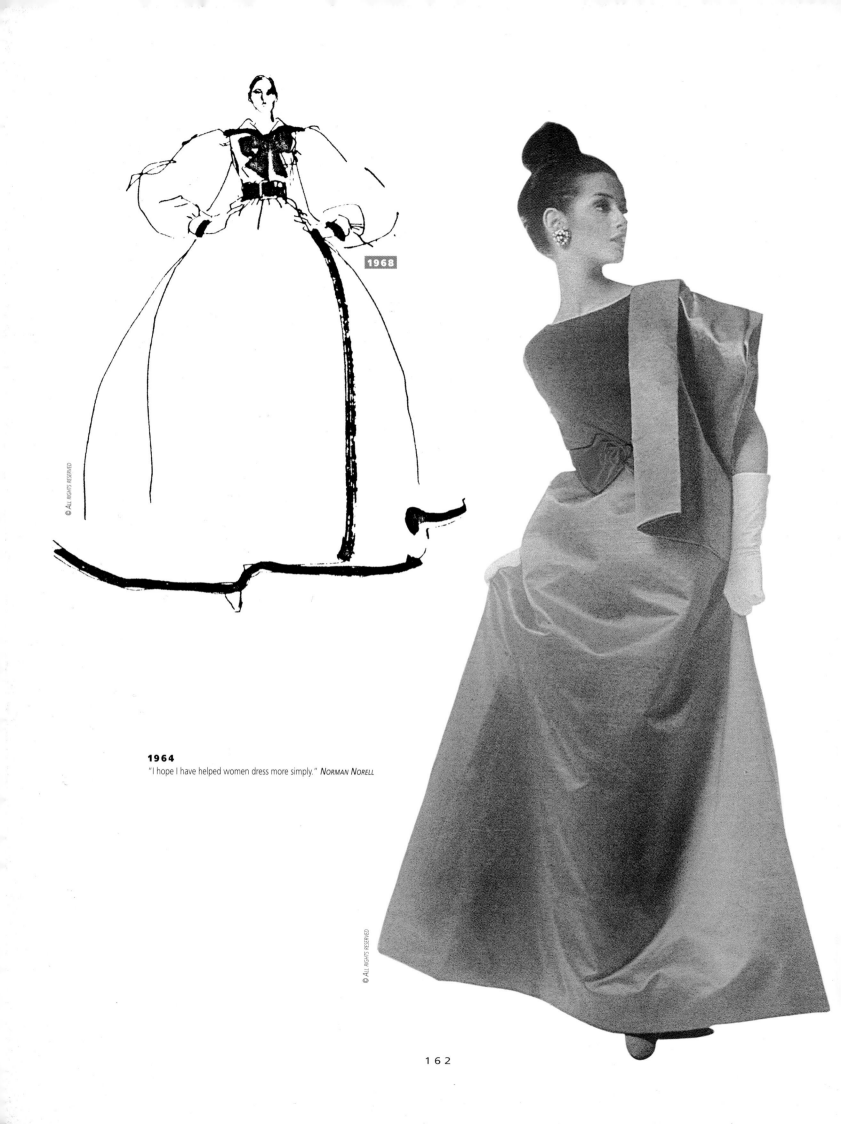

© ALL RIGHTS RESERVED

1968

1964

"I hope I have helped women dress more simply." *Norman Norell*

© ALL RIGHTS RESERVED

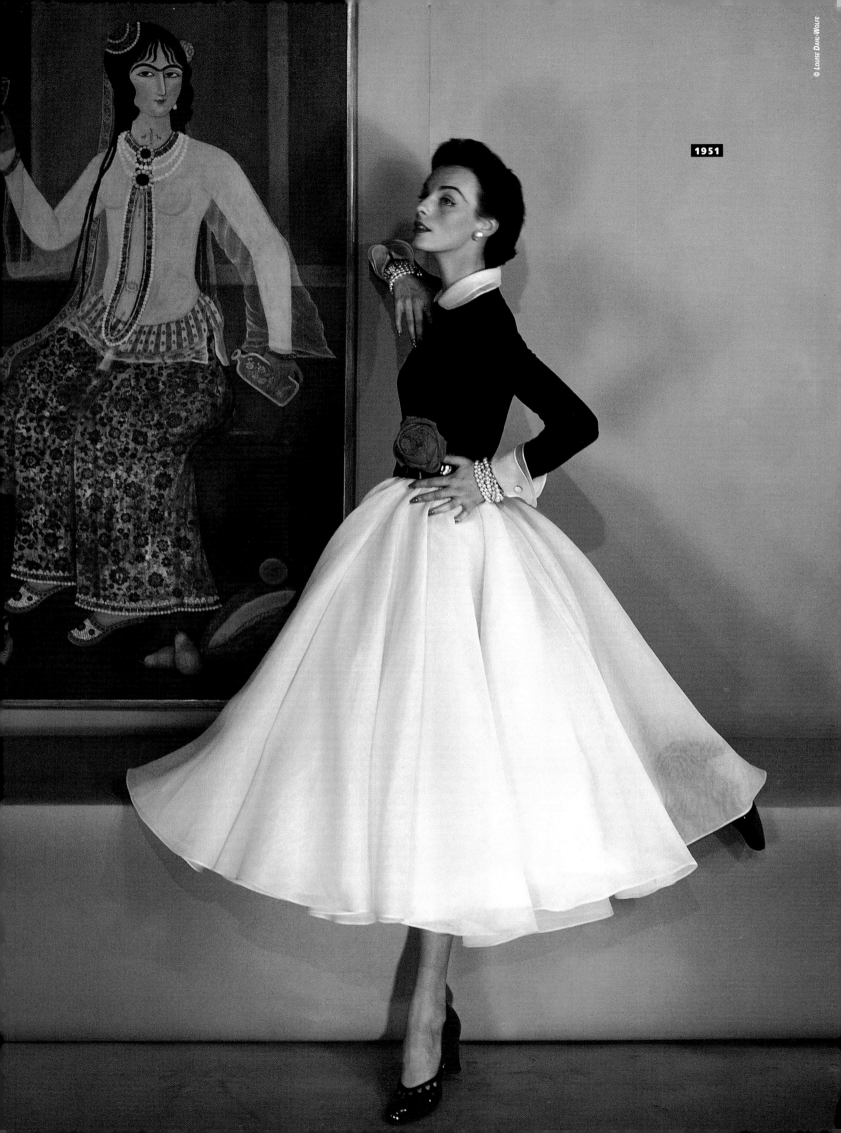

© LOUISE DAHL-WOLFE

1951

PACO RABANNE

(San Sebastian, Spain, 1934)

"A fashion designer, like any designer, must force the public to move forward; he must astonish, take the public beyond accepted traditions to reveal other possibilities, other frontiers."

PACO RABANNE

Paco Rabanne, like a number of contemporary artists, has a confrontational approach to the status quo. Born Francisco Rabaneda y Cuervo, he challenges the ultimate purpose of an item of clothing as well as the accepted materials and techniques of traditional couture. Rabanne remains more interested in the relationship between his clothes and their environment as well as their influence on movement than in developing new looks and systematically coming up with a new style. He brings a unique creative method to his use of unusual or even prefabricated materials, associating them with unconventional construction methods: hammered metal; cut-out pieces of Rhodoid plastic; knitted or stitched pieces of fur; leather riveted together or woven into links; feathers attached by tape or stuck into tubes; and cut up CDs.

Rabanne studied architecture from 1952 to 1964 at the École Nationale des Beaux-Arts in Paris. He financed

© ALL RIGHTS RESERVED

1994
ABOVE:
Spring/Summer haute couture collection.

1969
LEFT:
The "Nude" series, photographed by Jean Clemmer.

© ALL RIGHTS RESERVED

his studies by designing handbags for Roger Model and shoes for Charles Jourdan, then later moved on to accessories and embroidery for Balenciaga, Cardin, and Givenchy. After the spectacular success in 1965 of his cut-out plastic accessories, on February 1, 1966, he presented his first collection, entitled "Douze Robes Importables en Matériaux Contemporains" (Twelve Unwearable Dresses Made of Contemporary Materials). His barefoot models, wearing strips and sequins made of Rhodoid plastic and held together by metal rings, paraded down the catwalk to Pierre Boulez's *Marteau sans maître*.

For thirty years, Paco Rabanne has pursued his experimentation in the belief that innovation is born of refusal and rejection. He considers that design should not attract but should shock. Paco Rabanne uses the original forms of his clothes to impose a singular vision and to shape the person who wears them.

OPPOSITE PAGE, CLOCKWISE FROM TOP LEFT:

1968
Fall/Winter collection 1968-1969. After showing miniskirts made of cut-out pieces of Rhodoid plastic, Paco Rabanne introduced coats made of lace-like fur.

1969

1970
Spring-Summer collection fashion show. For the first time in four years, the designer created fabric outfits for the American clientele.

1992
Spring/Summer collection. Paco Rabanne used the specific features of folded metallic paper to create an interplay of light.

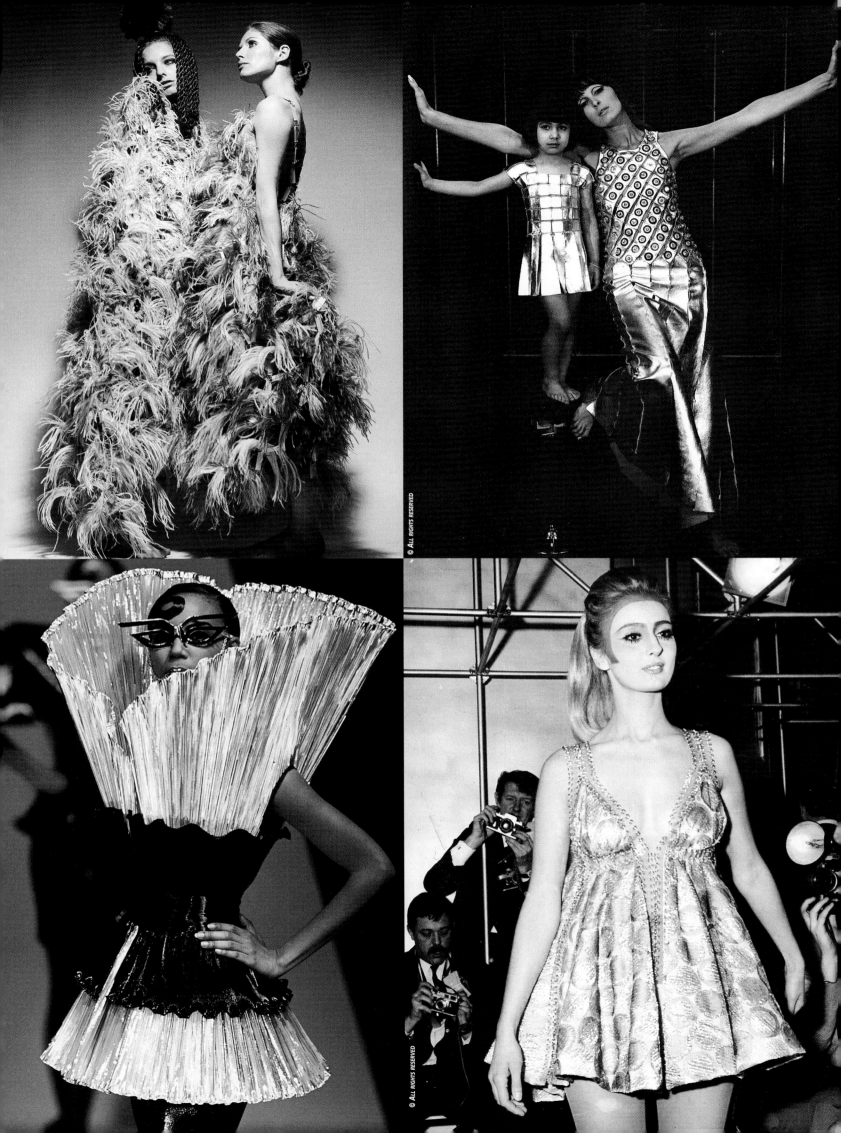

© ALL RIGHTS RESERVED

© ALL RIGHTS RESERVED

1970
Spring/Summer collection.
"He's nothing but a
metal-worker!"
GABRIELLE CHANEL

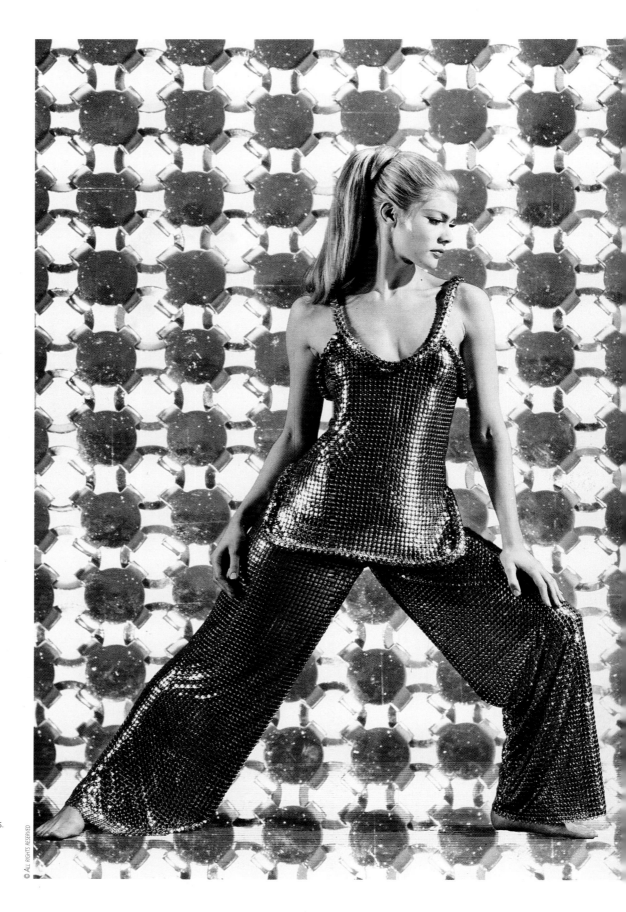

© ALL RIGHTS RESERVED

1967
OPPOSITE PAGE:
Françoise Hardy.
"My clothes are like weapons.
When you fasten them,
you can almost hear the
trigger of a revolver."
PACO RABANNE

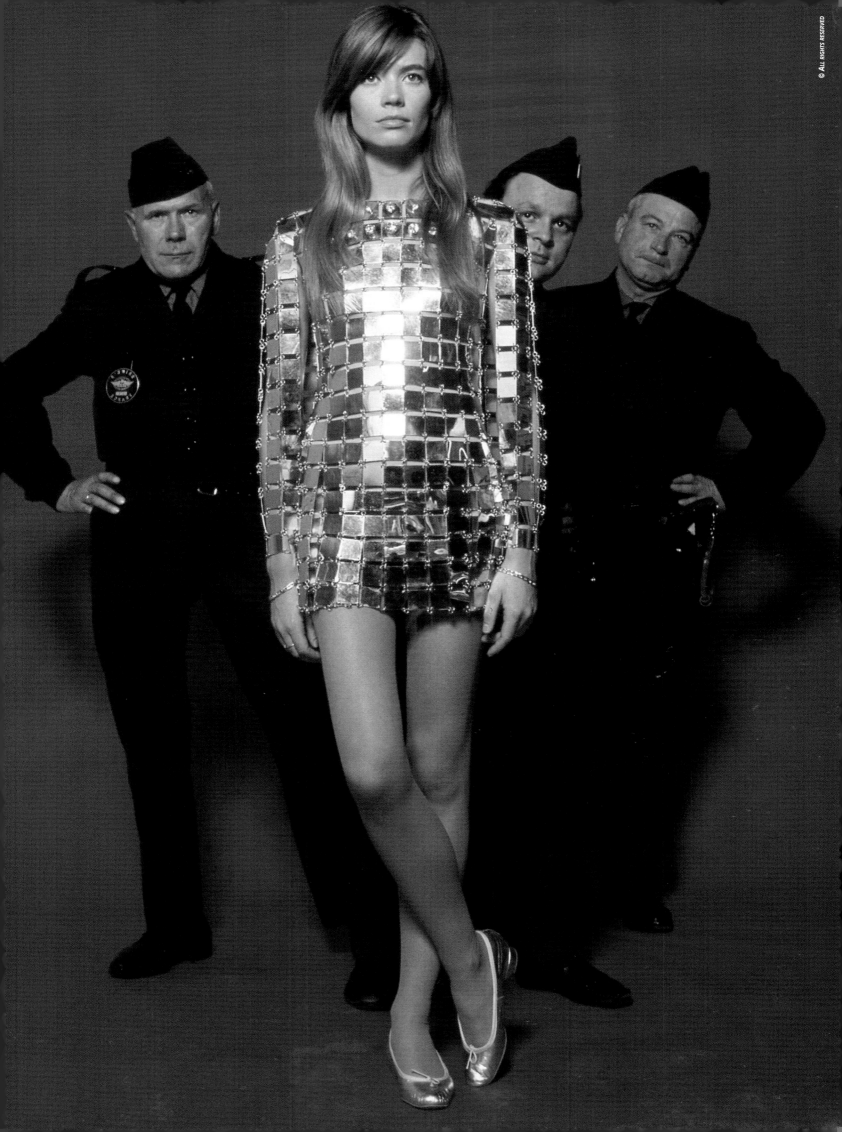

© ALL RIGHTS RESERVED

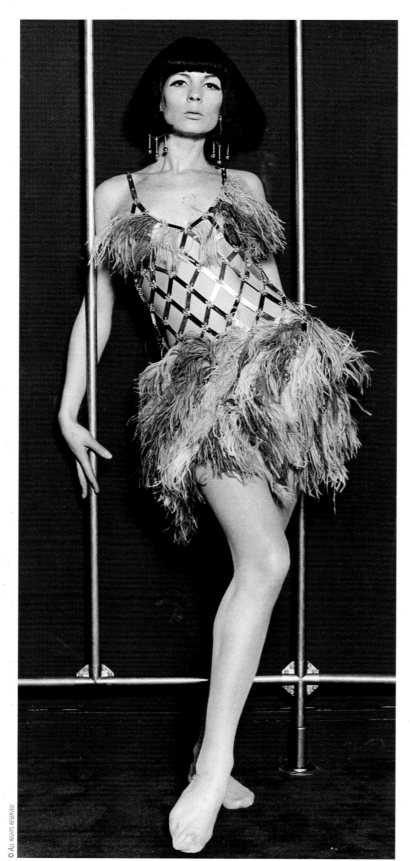

© ALL RIGHTS RESERVED

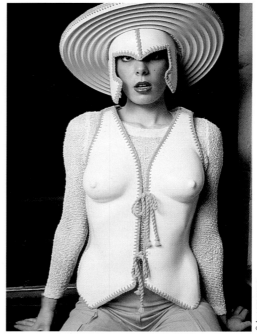

© ALL RIGHTS RESERVED

1966
An outfit worn by Elsa Martinelli to Eddie Barclay's "Fou, Fou, Fou" ball.

1974
Anatomical vest.
In 1968, Paco Rabanne introduces molded pieces of clothing; his goal is to bypass traditional couture techniques while reducing production time.

1989
Sketch by the designer for the Fall/Winter collection 1989-1990.

1966
OPPOSITE PAGE:
Fall/Winter collection 1966-1967.
Red berg coat with metal triangles.

© ALL RIGHTS RESERVED

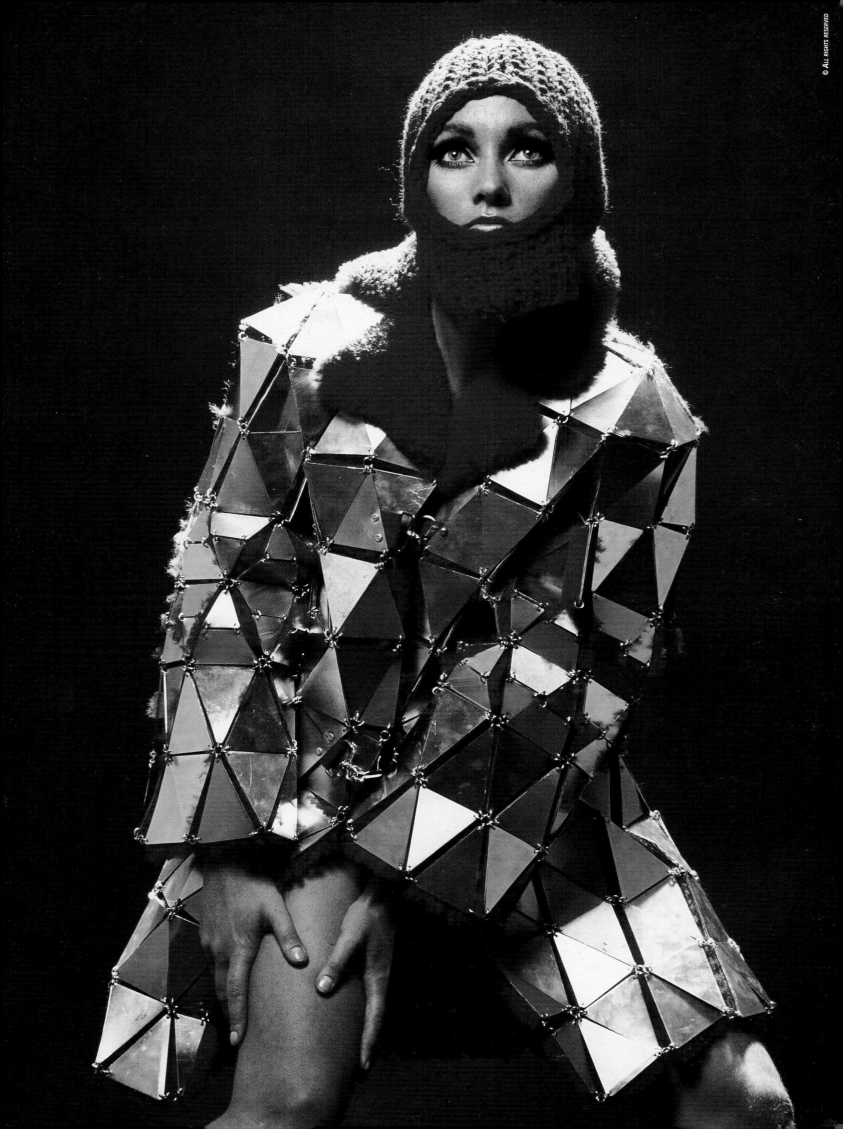
© ALL RIGHTS RESERVED

© CECIL BEATON

PIERRE BALMAIN

(Saint-Jean-de-Maurienne, France, 1914 – Paris, 1982)

"If I can't be like Schiaparelli, Courrèges, or Dior,
who revolutionized fashion,
I'll be known as the one who had the courage to refuse it."

PIERRE BALMAIN

The couture designer of queens, princesses, aristocrats, and stars, Pierre Balmain created a subtle style, the result of a gradual well-thought-out process that owed little to momentary trends. Favoring discretion and simplicity, he constantly refined the line of his previous collections, which he used as guidelines for his work in progress. Order, grace, majesty, and harmonious proportions were his bywords.

In 1934, he gave up his studies in architecture at the École des Beaux-Arts in Paris and started his fashion career with Molyneux. Five years later, he became a designer for Lucien Lelong. That same year, one of his designs, *Petit profit (Small Profit)*, a black crêpe afternoon dress, was ordered by 360 clients. After serving in the French army for two years, he returned to Lelong in 1941, where he shared responsibility for designing the collections with Christian Dior.

In 1945, Pierre Balmain opened his own fashion house at 44, Rue François-Ier. His inaugural collection, made by Mme. Catherine

1945
LEFT:
Sonia wears an outfit from Pierre Balmain's first collection.

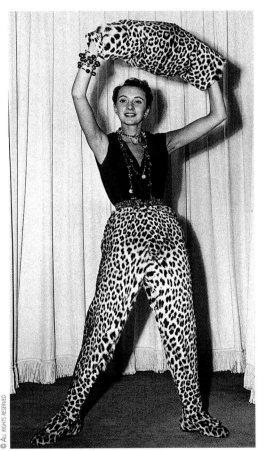

© ALL RIGHTS RESERVED

1951
Fall/Winter collection 1951-1952.
The leopard motif was a recurrent theme in Pierre Balmain's work.

(head of one of Balenciaga's workrooms) and shown on October 12, was immediately acclaimed by the press and public. Balmain based his look on the shoulder design—starting with the "new French style," named in 1945 by his friends Gertrude Stein and Alice B. Toklas, and continuing through to the "Jolie Madame" collections shown in 1952. The latter had the same name as his perfume, launched in 1949. He accentuated the bust and curved the waistline in, creating a more feminine look. He reworked the raglan sleeve, set in by angled seams from the neckline to the underarm front and back, creating an illusion of wide shoulders. The line became even simpler, but continued to be based on the initial theme of "Jolie Madame." Pierre Balmain sought to dress a distinguished woman who appreciated an elegant line and refused flashy ornamentation.

After Pierre Balmain died, Erik Mortensen, his assistant since 1951, succeeded as head of the fashion house. In 1991, Hervé Pierre became artistic director. He was replaced one year later by the American designer Oscar de la Renta.

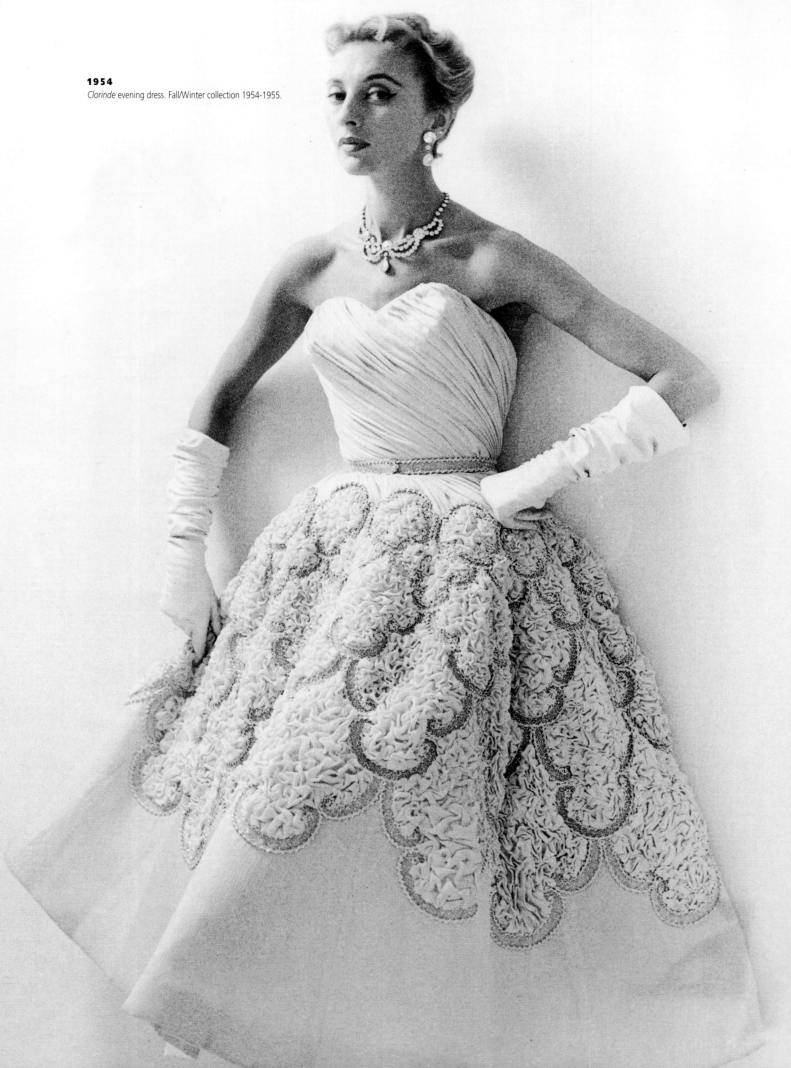

© ALL RIGHTS RESERVED

1954
Clorinde evening dress. Fall/Winter collection 1954-1955.

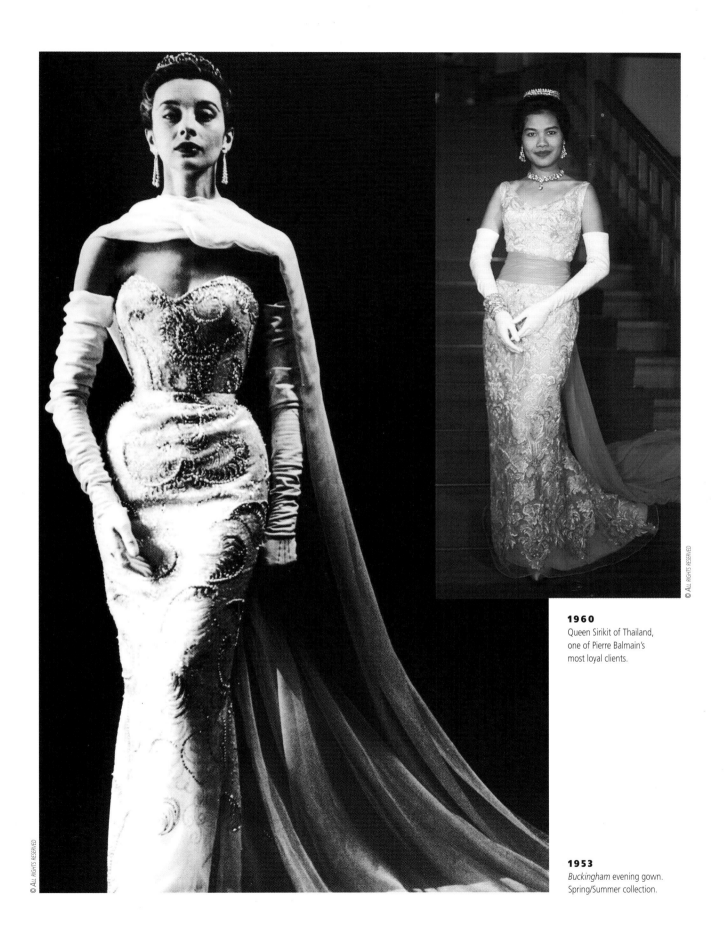

© ALL RIGHTS RESERVED

© ALL RIGHTS RESERVED

1960
Queen Sirikit of Thailand,
one of Pierre Balmain's
most loyal clients.

1953
Buckingham evening gown.
Spring/Summer collection.

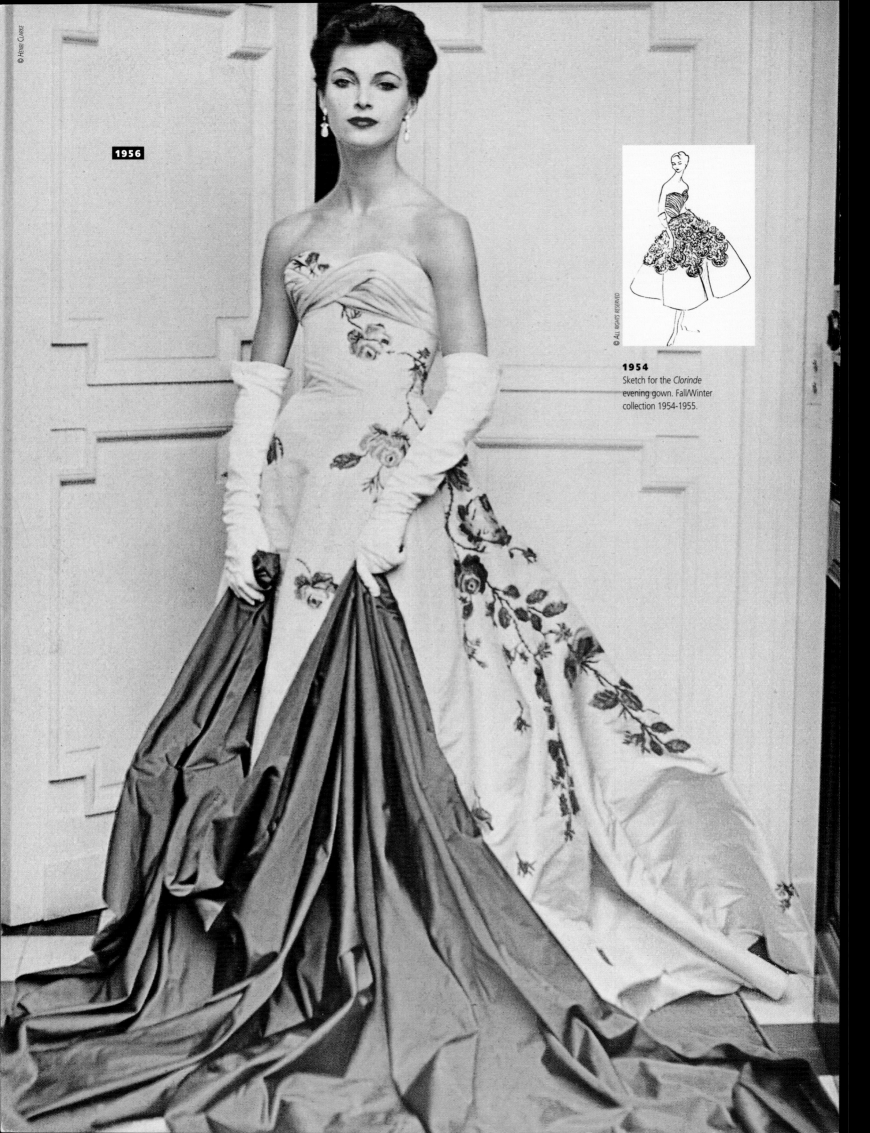

© HENRI CLARKE

1956

© ALL RIGHTS RESERVED

1954
Sketch for the *Clorinde*
evening gown. Fall/Winter
collection 1954-1955.

© ALL RIGHTS RESERVED

1972

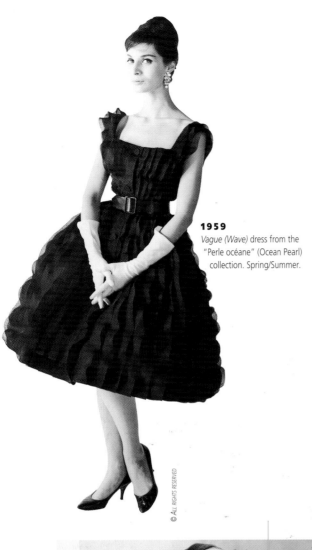

1959
Vague (Wave) dress from the "Perle océane" (Ocean Pearl) collection. Spring/Summer.

© ALL RIGHTS RESERVED

© ALL RIGHTS RESERVED

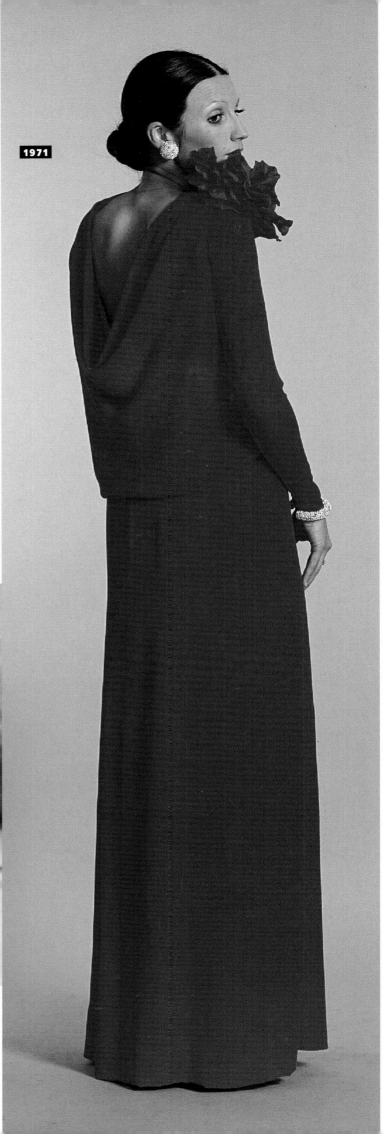

1971

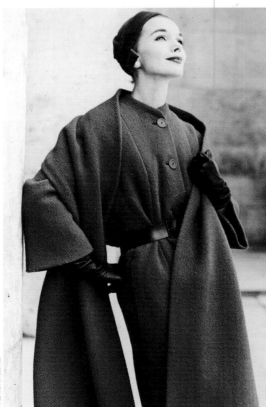

© ALL RIGHTS RESERVED

1957
Fall/Winter collection 1957-1958.

PIERRE BALMAIN

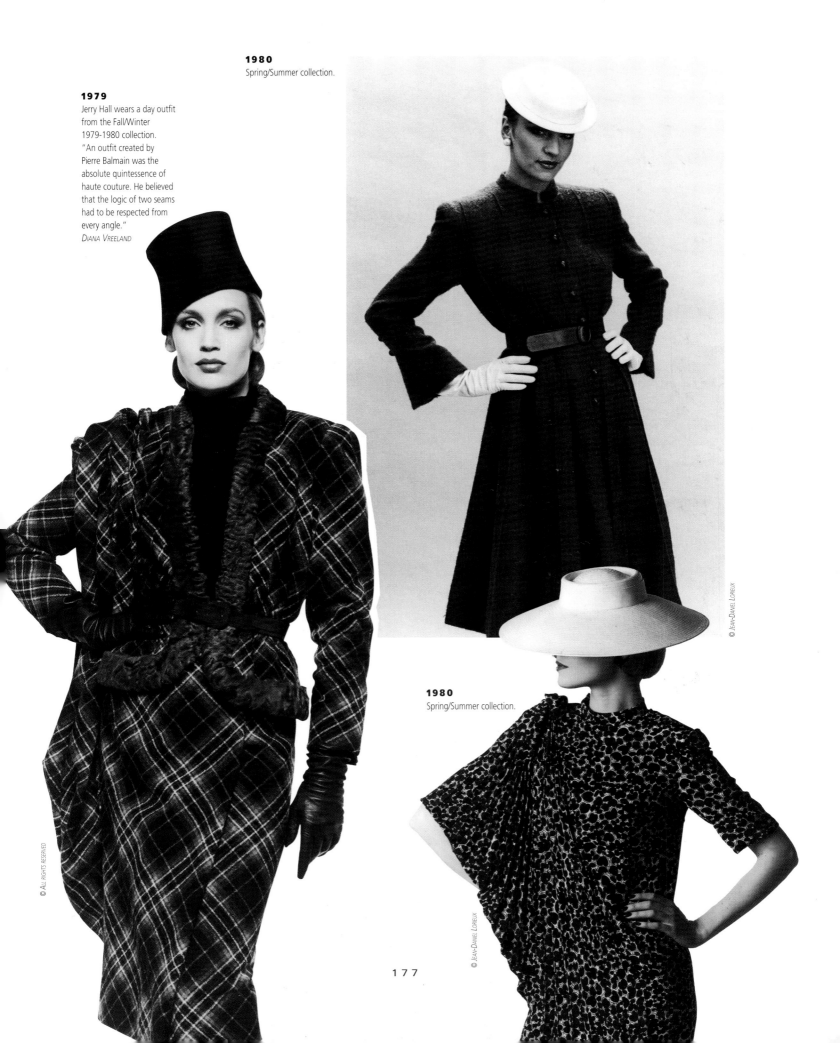

© All rights reserved

© Jean-Daniel Lorieux

© Jean-Daniel Lorieux

1980
Spring/Summer collection.

1979
Jerry Hall wears a day outfit from the Fall/Winter 1979-1980 collection.
"An outfit created by Pierre Balmain was the absolute quintessence of haute couture. He believed that the logic of two seams had to be respected from every angle."
DIANA VREELAND

1980
Spring/Summer collection.

PIERRE CARDIN

(Sant'Andrea di Barbarana, Italy, 1922)

"I managed to turn a label into a name.
A name is for always.
Being a billionaire is not enough to buy yourself a name.
You have to be a designer."

PIERRE CARDIN

P ierre Cardin—part visionary couture designer and part astute businessman—has been a unique personality on the fashion scene for the past forty years. The son of farmers, Cardin started his apprenticeship with Bonpuis, a tailor in Saint-Étienne, at the age of fourteen. After working for Manby, a tailor in Vichy, he finally moved to Paris. In 1945, he was hired by Paquin, then moved to Schiaparelli. Cardin directed the tailor workroom for Christian Dior when the house opened in 1947, and he therefore earned some credit for the success of the Bar suit, the defining silhouette of the New Look. He left three years later to establish his own fashion house. His first collection in 1953 consisted of impeccably cut suits and coats, which associated an inventive sense of design with careful attention to detail. In 1954, displaying a phenomenal amount of energy, he turned his attention to distribution, opening his first boutique, Ève, followed by Adam in 1957. His men's line, launched in 1958, revolutionized menswear: "Jackets you can wear to unscrew a bolt in a car and equally wear to go to the Windsor Castle. This is the definition of the new criteria of comfort and elegance."

Cardin demonstrates a ferocious appetite for experimentation, from the Mao

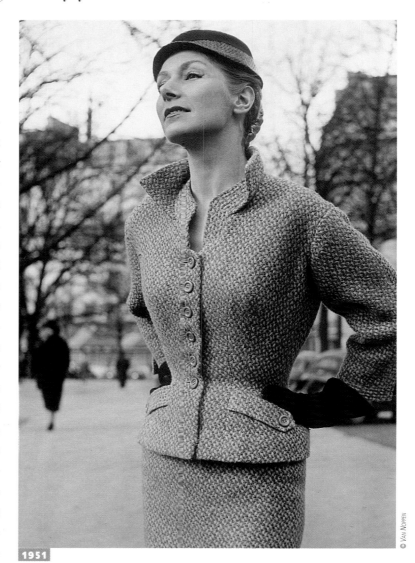

1951

© VAN NOPPEN

jacket to the balloon dress, cosmonaut style, unisex designs, pinafore dress with cutout holes, and molded dress made of synthetic fibers. His designs form geometric silhouettes based on circles and triangles: the sculptural volume requires the body to adapt to the clothes.

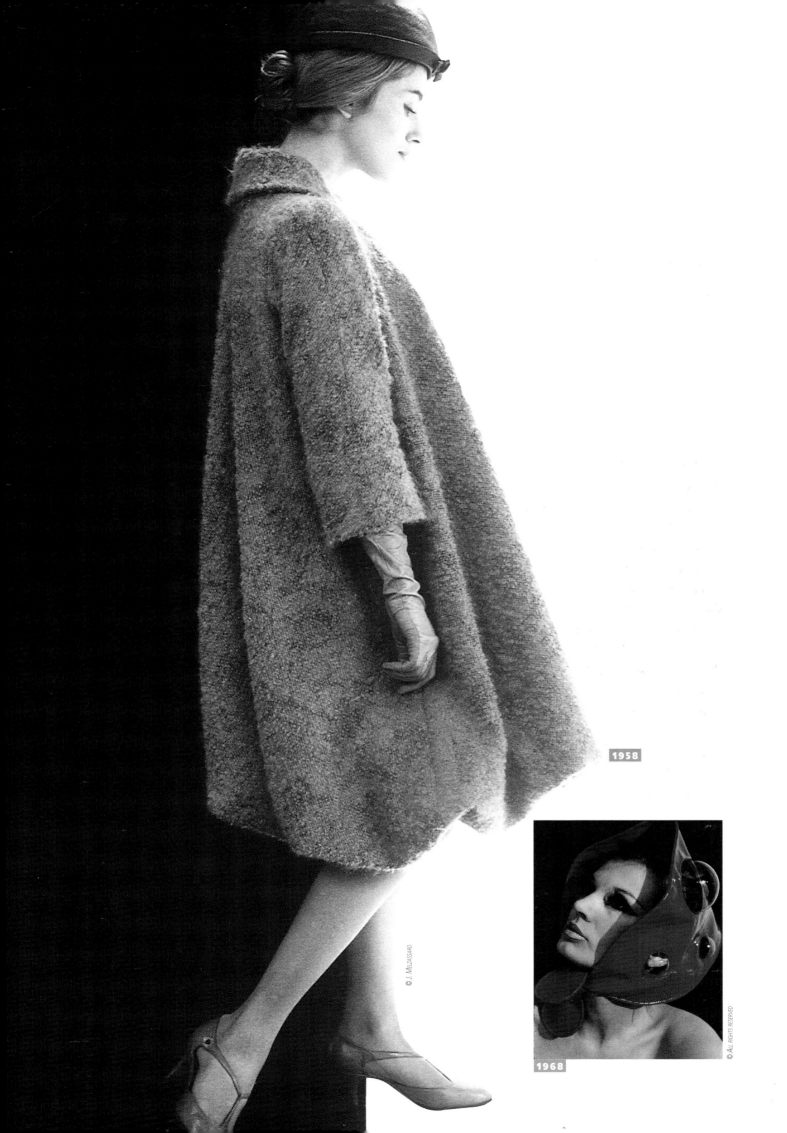

1958

1968

© J. MELZASSARD

© ALL RIGHTS RESERVED

His desire to develop his designs and make them accessible to all motivated his decision to set up a licensing system. Cardin makes the models and the industrialists manufacture the clothes, paying him a percentage of their sales; his signature is the foundation of his brand's development policy. With this type of production system, Cardin can adapt his concept to various markets, a tactic that has made him the world's largest license holder and highest-selling fashion designer.

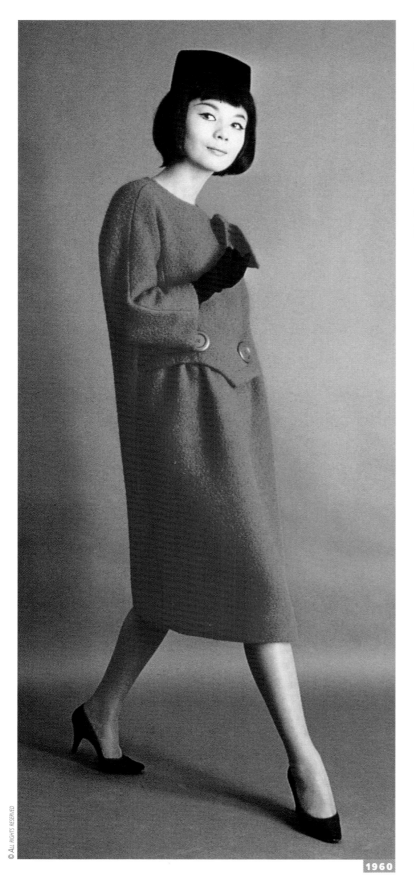

© ALL RIGHTS RESERVED

1960

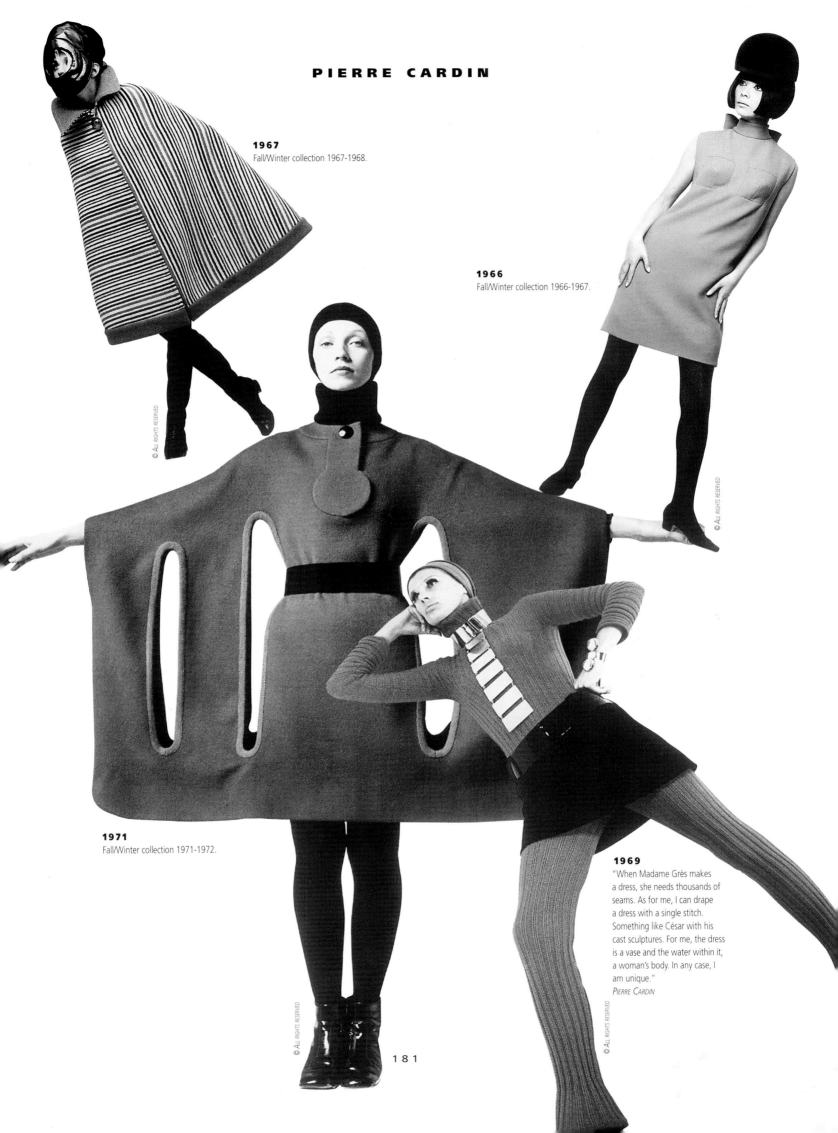

PIERRE CARDIN

1967
Fall/Winter collection 1967-1968.

1966
Fall/Winter collection 1966-1967.

1971
Fall/Winter collection 1971-1972.

1969
"When Madame Grès makes
a dress, she needs thousands of
seams. As for me, I can drape
a dress with a single stitch.
Something like César with his
cast sculptures. For me, the dress
is a vase and the water within it,
a woman's body. In any case, I
am unique."
PIERRE CARDIN

© ALL RIGHTS RESERVED

181

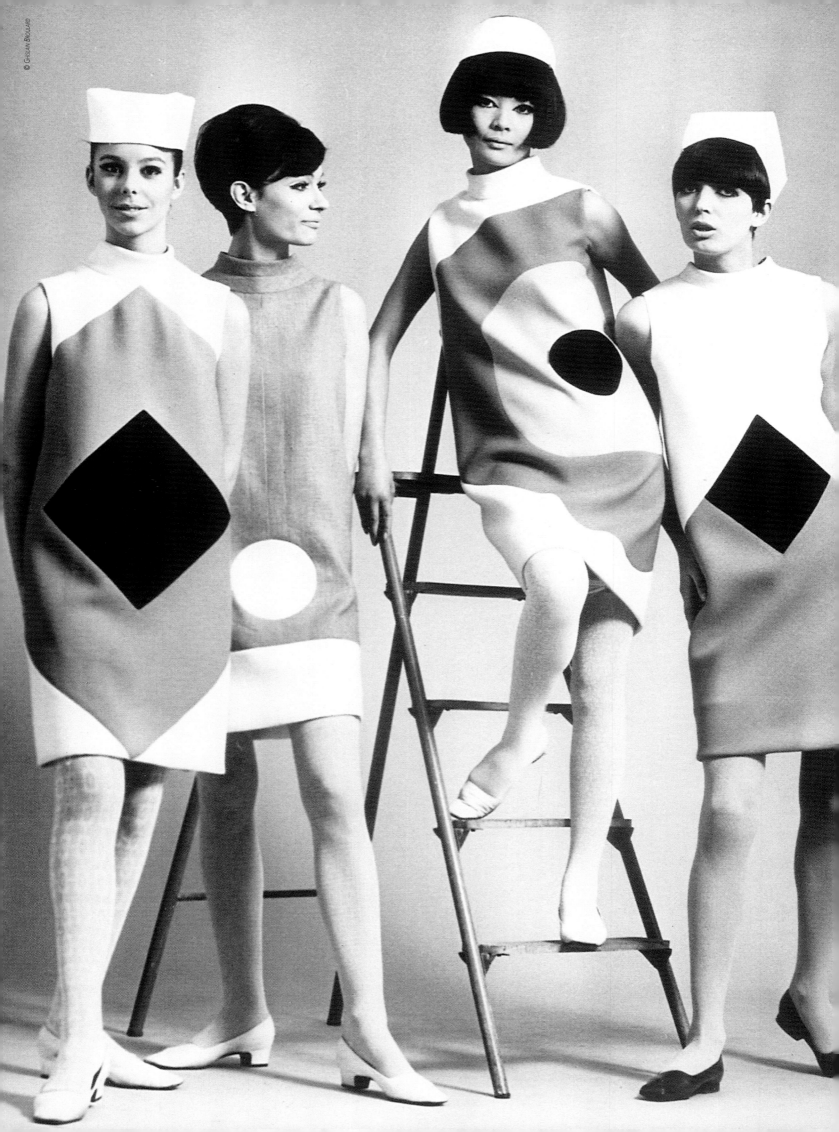
© GHISLAIN BROUARD

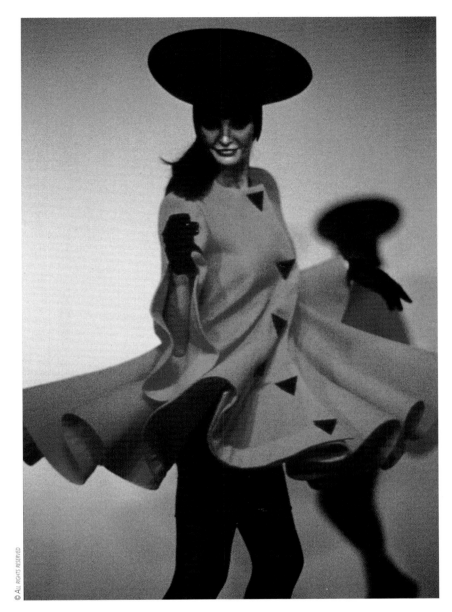

© ALL RIGHTS RESERVED

1965
LEFT:
Fall/Winter collection
1965-1966.

1989
ABOVE:
"The item of clothing that
I prefer is the one that I'm
creating for the world of
tomorrow."
PIERRE CARDIN

RALPH LAUREN

(New York, United States, 1939)

"I don't do a shoulder. I create a world."

RALPH LAUREN

Ralph Lauren's timeless clothes express an elegance that combines dream and reality. He sees himself as a writer adapting sophisticated screenplays, reinventing specific items of clothing that correspond to the role of each character. His concept is targeted at those who want to belong to an elitist and refined world. Lauren draws his inspiration from romantic dream images, rural aristocratic English styles, African safaris, and polo fields. His designs hark back to a world of fortune and distinction and are marketed as luxurious symbols to which everyone aspires.

Ralph Lauren is one of the few designers to have started in menswear. He began his fashion career as a salesman, then broke into the creative side of the business by designing for Beau Brummel Ties, a collection of high-quality ties that offered an alternative to the reigning fashion. The ties were twice as wide as the usual design, but also twice as expensive because

they were made from sumptuous fabrics. Ralph Lauren's ties revolutionized the stodgy, monotonous neckwear market. They were sold under the Polo label, which in 1968 became an independent company offering a complete range of products for men's fashion. Three years later, he opened his first boutique, Polo/Ralph Lauren, in Beverly Hills, where he launched womenswear versions of his menswear collection. In 1974, he dressed Robert Redford and the other male actors in *The Great Gatsby* by Jack Clayton. He also dressed Diane Keaton in Woody Allen's *Annie Hall*, which came out in 1977. The clothes in these two films are vintage Ralph Lauren, first with the nostalgic masculine elegance of the 1920s and 1930s, combined with a sophisticated dandyism; and second, with a relaxed, simple, and natural look for the women's outfits. These are all classics, updated to suit a more active lifestyle.

In 1983, Ralph Lauren created a new line offering an expanded range of products to his clientele. Anticipating their every need, he developed his Ralph Lauren Home Collection, which sells a diverse line of accessories for the home. This line offers a total lifestyle approach combining Ralph Lauren's unique blend of theatrical design and lavish decorum.

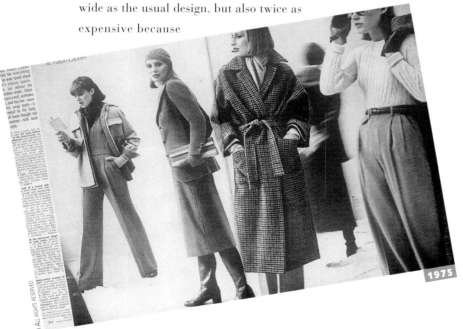

1975

© ALL RIGHTS RESERVED

RALPH LAUREN

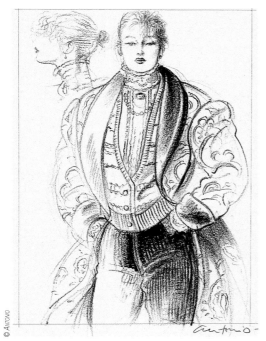

© Antonio

1979
A drawing by Antonio in
the portfolio for the annual
Coty American Fashion Critics'
Award, held in New York.

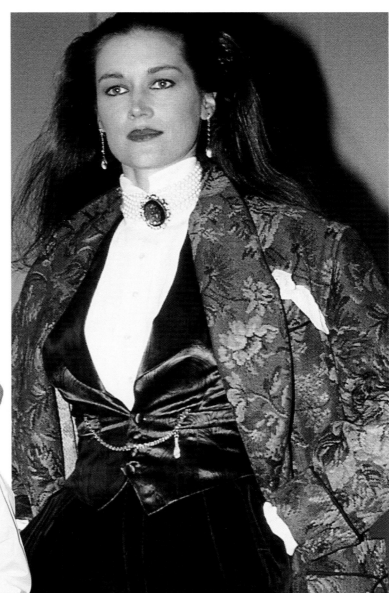

© All rights reserved

1985
Spring/Summer collection.

1986
Above:
Fall/Winter collection
1986-1987.

1987
Right:
Spring/Summer collection.

© All rights reserved

© All rights reserved

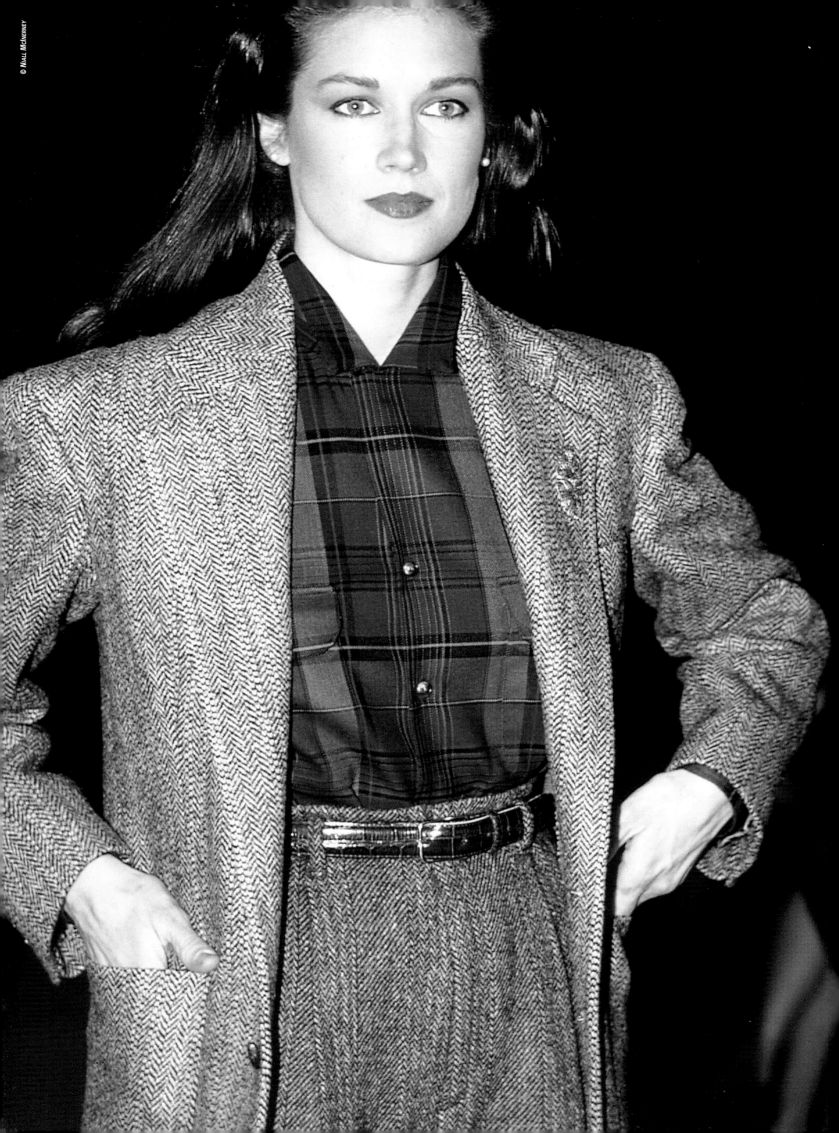

© NIALL MCINERNEY

1984

OPPOSITE PAGE:
Fall/Winter collection
1984-1985.
Clotilde, one of Ralph Lauren's
favorite models during the
1980s.

1995

Fall/Winter collection
1995-1996.

1985

Fall/Winter collection
1985-1986.

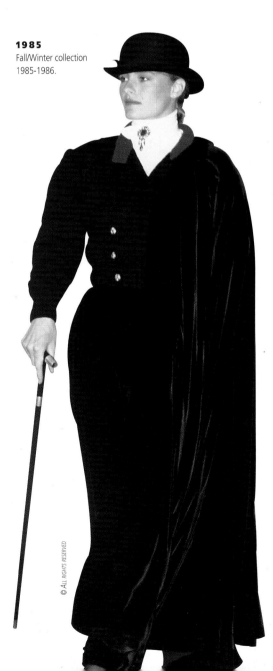

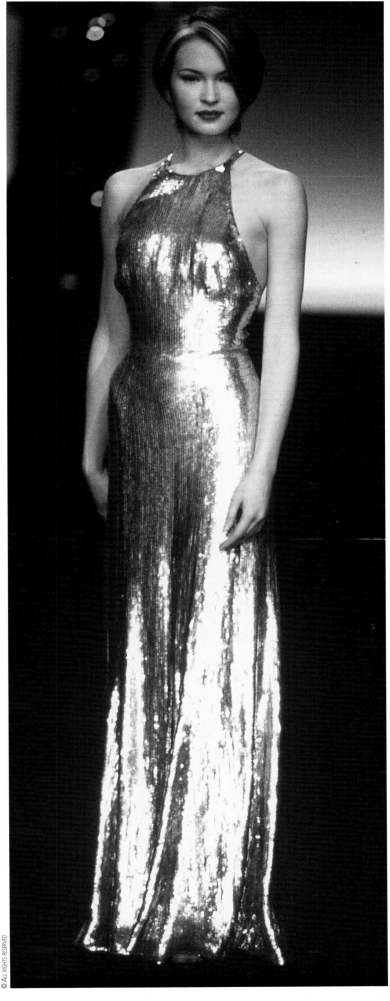

© ALL RIGHTS RESERVED

© ALL RIGHTS RESERVED

SONIA RYKIEL

(Paris, France, 1930)

"... But, to be able to be natural, I had to find 'my' uniform, 'my' unique form."

SONIA RYKIEL

In the early 1960s, the Americans nicknamed Sonia Rykiel "The Queen of Knitwear." Her clothes are designed for all aspects of a woman's life—family, professional, and personal. She does not show a series of collections, but rather a single collection that stretches over time.

In 1962, Sonia Rykiel was pregnant and started designing dresses and sweaters for her husband's boutique, Laura. Made of soft materials such as wool, angora and mohair, her clothes were all form-fitting, to set off the body rather than hide it. Her tunic sweaters were an instant success. In 1968, she opened her first Sonia Rykiel boutique. In 1977, she was the first designer to create outfits for the 3 Suisses mail-order company, thereby making her clothes accessible to everyone.

Her clothes have no hems or linings. The seams are often on the outside, which, like exposed beams, follow the curves of the body. Pockets are functional and large. The carefully designed proportions between the shoulders and hips are extremely well balanced. Her jackets are wide enough to turn inside out and the sleeves can be rolled up. According to Rykiel, layering is "the freedom to show off your best aspects and conceal your worst."

Her trademark color is black, a symbol of non-conformity, freedom, and elegance. She uses it as a backdrop to set off unusual and unexpected combinations. Crêpe and jersey, her favorite materials, are both supple and graphic and confer a purity to her clothes. In addition to the timeless small black sweater, tweed or checkered suit, and pants or Bermuda shorts, she designs outrageous eveningwear, complete with feathers and poetic inscriptions in rhinestones.

Fascinated by painting, sculpture, theater and film, Sonia Rykiel creates a style that reflects the evolution of contemporary life. What began as a strictly personal and independent foray into fashion has become a lifelong career aimed at clothing women of every generation, by adapting them to the inner personality and image of each one. Sonia Rykiel offers the luxury of a natural elegance with a style free of any superfluous elements.

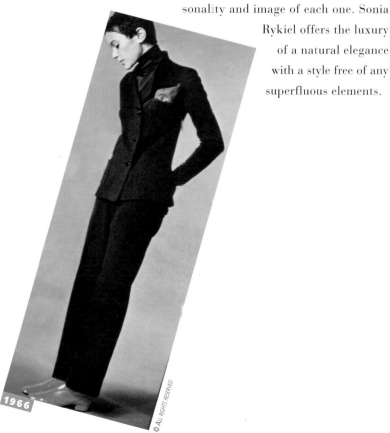

1966

© ALL RIGHTS RESERVED

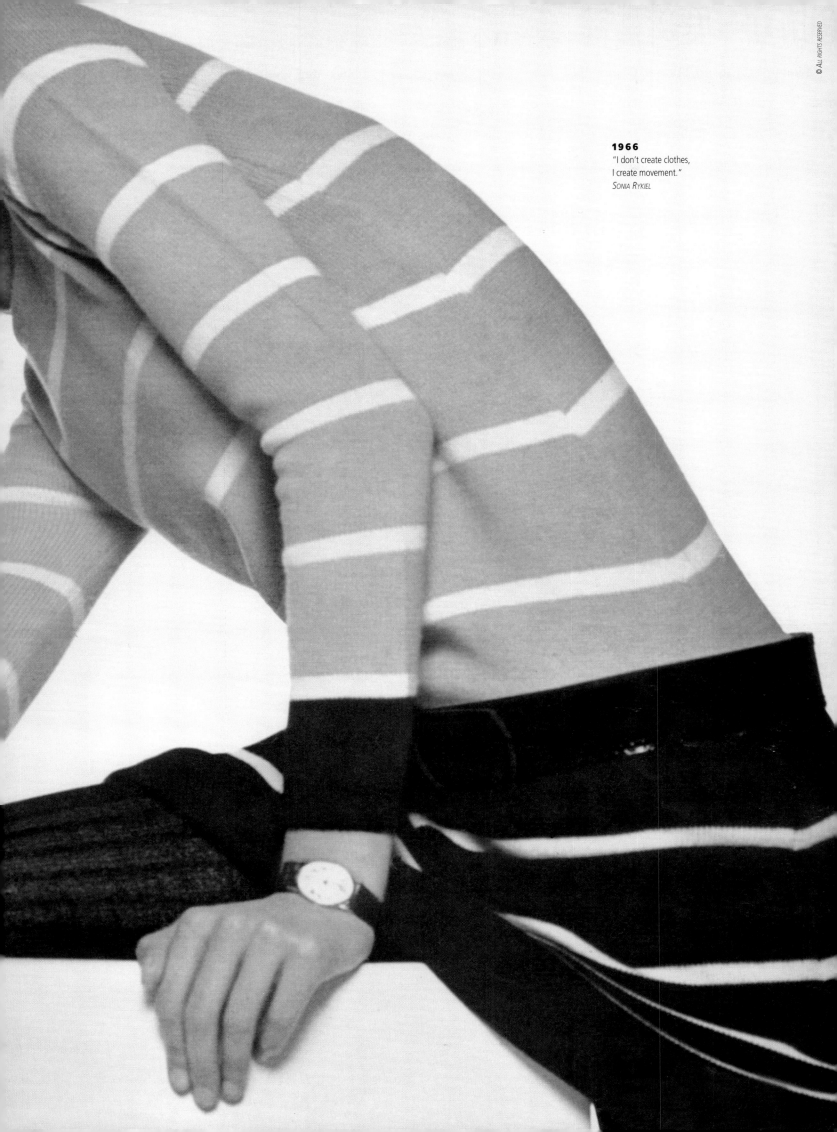

© ALL RIGHTS RESERVED

1966

"I don't create clothes,
I create movement."
SONIA RYKIEL

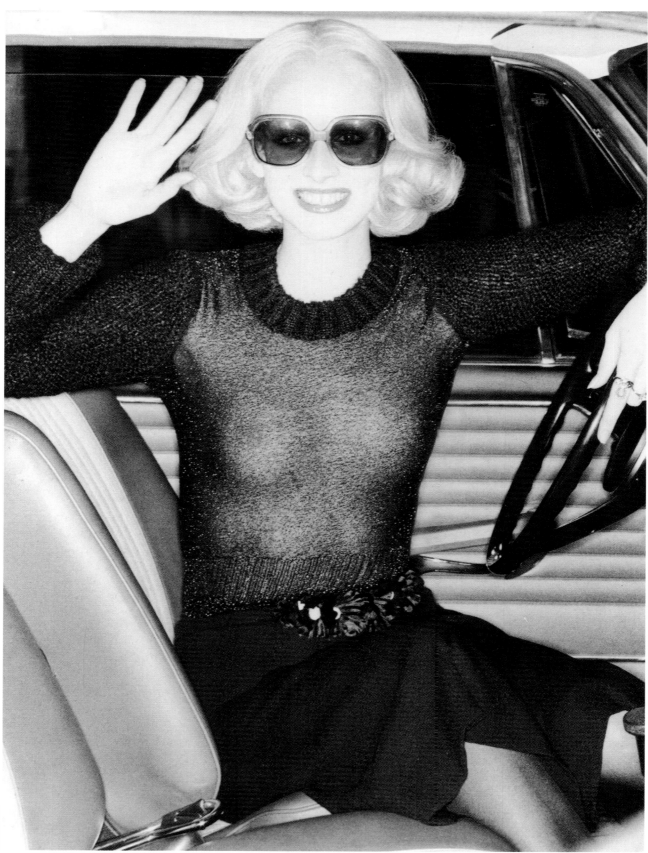

© HELMUT NEWTON

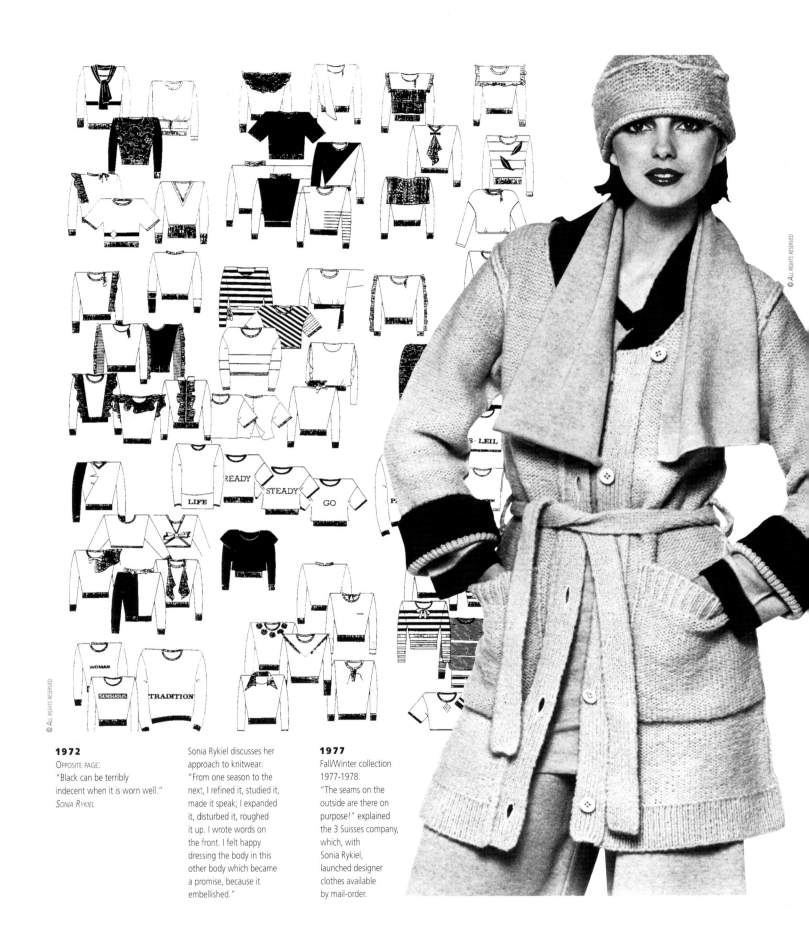

© ALL RIGHTS RESERVED

© ALL RIGHTS RESERVED

1972

OPPOSITE PAGE:
"Black can be terribly indecent when it is worn well."
SONIA RYKIEL

Sonia Rykiel discusses her approach to knitwear:
"From one season to the next, I refined it, studied it, made it speak; I expanded it, disturbed it, roughed it up. I wrote words on the front. I felt happy dressing the body in this other body which became a promise, because it embellished."

1977

Fall/Winter collection 1977-1978.
"The seams on the outside are there on purpose!" explained the 3 Suisses company, which, with Sonia Rykiel, launched designer clothes available by mail-order.

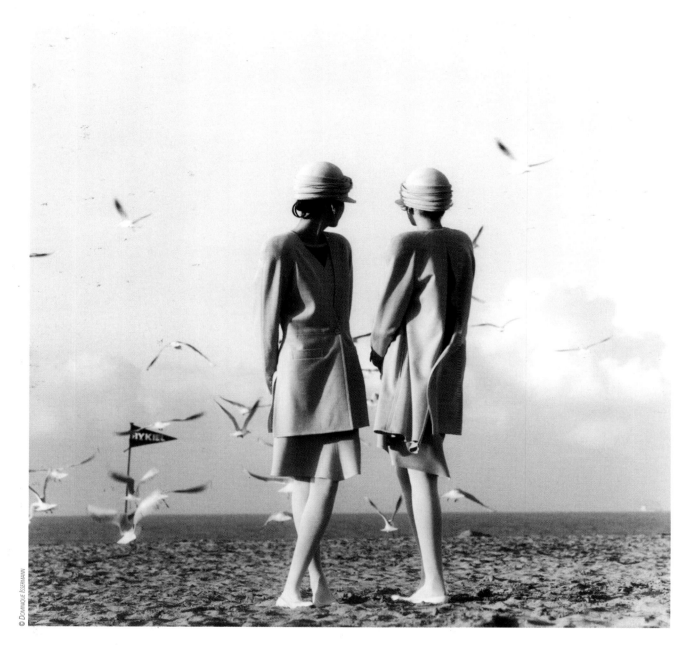

1987
Spring/Summer collection.

SONIA RYKIEL

1998
Fall/Winter collection 1998-1999. A celebration of thirty years of fashion.

1972
BELOW:
Spring/Summer collection.
"Do you know why I like pants
so much? Because they are
impartial: total equality."
SONIA RYKIEL

1994
BELOW, RIGHT:
Fall/Winter collection
1994-1995. Fashion show at
the Carrousel du Louvre in Paris.
Robert Altman filmed this show
for Prêt-à-porter.

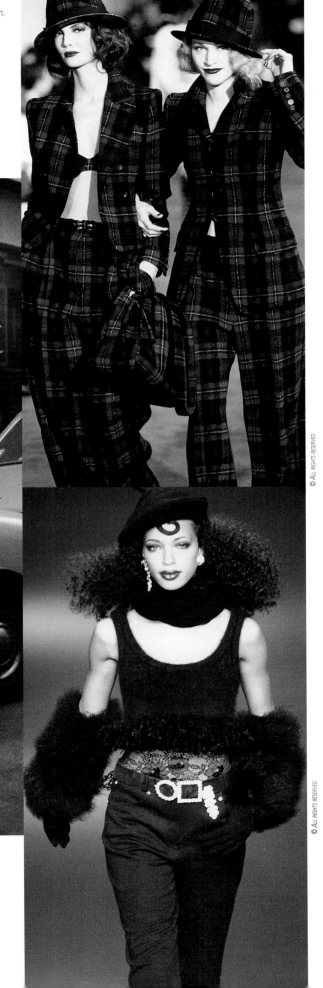

© ALL RIGHTS RESERVED

© ALL RIGHTS RESERVED

© ALL RIGHTS RESERVED

THIERRY MUGLER

(Strasbourg, France, 1948)

"I design for the women I call the winners, the triumphant,
the fighters—women who know what they want,
who use their femininity as an asset and not as a handicap."

THIERRY MUGLER

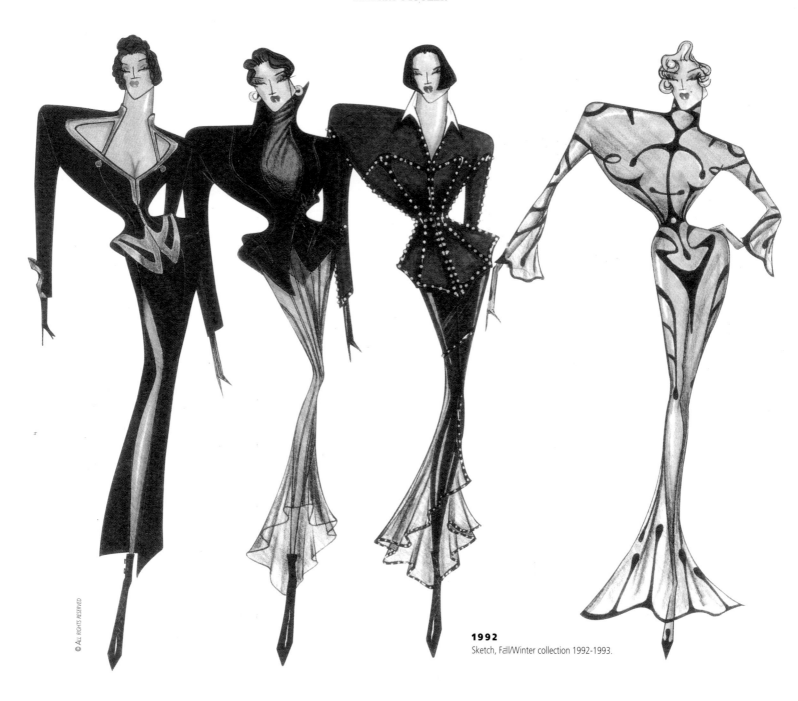

© ALL RIGHTS RESERVED

1992
Sketch, Fall/Winter collection 1992-1993.

THIERRY MUGLER

Thierry Mugler works for an idealized body, molded to a provocative, sexually powerful woman who has firm control over her life. He launched the "woman as star" era. His heroine, a fantasized mirror, must possess the femme fatale's panoply: total duplicity, profound arrogance, and unbridled sensuality. She imposes silence and demands respect. His designs are built around a frame that imprisons the silhouette and curves the body, in a form-fitting structure that functions like a second skin. The proportions of his outfits are ample and exaggerated, offering deliberately outrageous volumes.

At the age of fourteen, Thiery Mugler became a dancer with the Opéra de Rhin. "Dance taught me a great deal about physical bearing, the organization of a piece of clothing, the importance of the shoulders, and the rhythm and interplay of legs." While dancing, he attended classes at the École des Arts Décoratifs in Strasbourg, then moved to Paris in 1968. He was hired right away by Gudule, a trendy boutique on the Rue de Buci, as an assistant designer and window-dresser. Five years later, he created his own label, Café de Paris. While fashion was promoting a folklore look, Mugler presented his sophisticated and dynamic "Parisienne." The following year, he created the Thierry Mugler company. In 1977, he presented his first "collection/performance." The celebration of the tenth year of his fashion house was a grandiose event, held at the Zenith

1988
Spring/Summer collection.

1979
Fall/Winter collection
1979-1980.

© PATRICE STABLE

© LOTHAR SCHMID

performance arena in Paris; more than 350 models paraded in front of 6,000 paying guests. In 1992, he showed his first haute couture collection, which allowed him to move away from the realities of ready-to-wear and perfect the technical aspects of his vision. Thierry Mugler presented the fabulous creatures that populate his world like shooting stars—from spy to madonna, Hollywood diva, secretary, amazon, and "flower-woman." An extraordinarily imaginative designer, Thierry Mugler choreographs a perpetual show linking extravagance and provocation to embellish the theater of everyday life.

1995

Right:
The Fall/Winter collection
1995-1996 celebrated
the twentieth anniversary of
Mugler's fashion house.
The show/performance
was held at the Cirque d'Hiver
in Paris. During the thirty-seven-
minute show, seventy models,
aged sixteen to sixty, presented
one hundred and twenty outfits
(instead of the usual sixty)

1982

Opposite page, top:
Ravishing beauties,
à la Watteau.

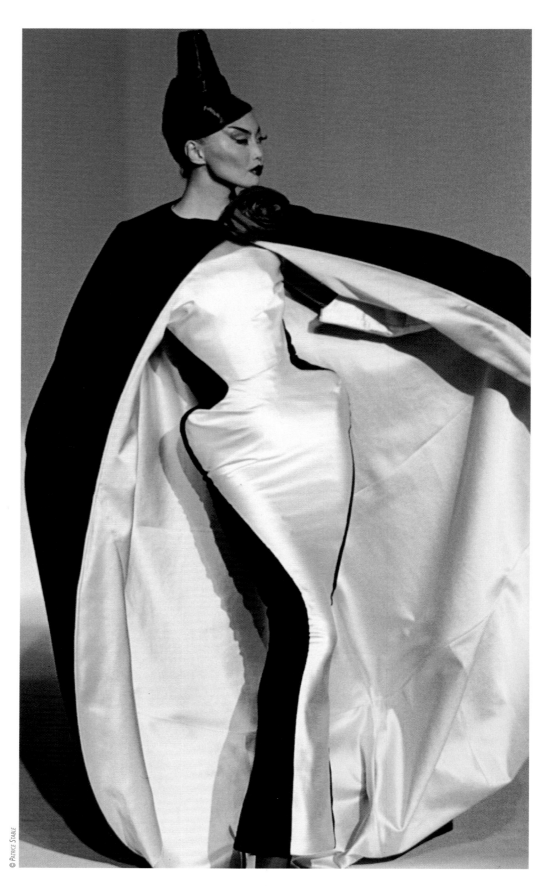

© Patrice Stable

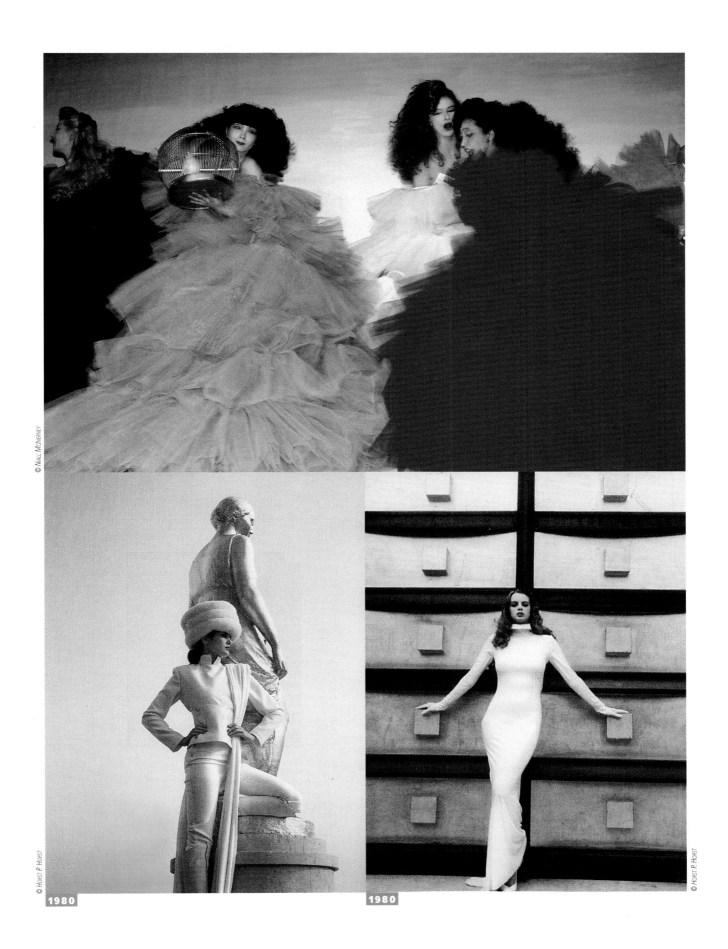

© Niall McInerney

1980

1980

© Horst P. Horst

© Horst P. Horst

1986

RIGHT: Spring/Summer collection. The creatures dreamed up by
Thierry Mugler range from spy to madonna, Hollywood diva,
secretary, and amazon.

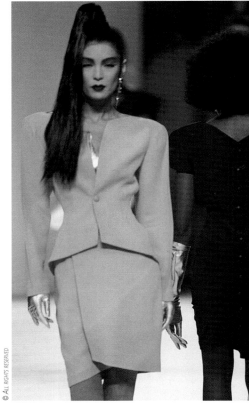

1988
Spring/Summer collection.

© ALL RIGHTS RESERVED

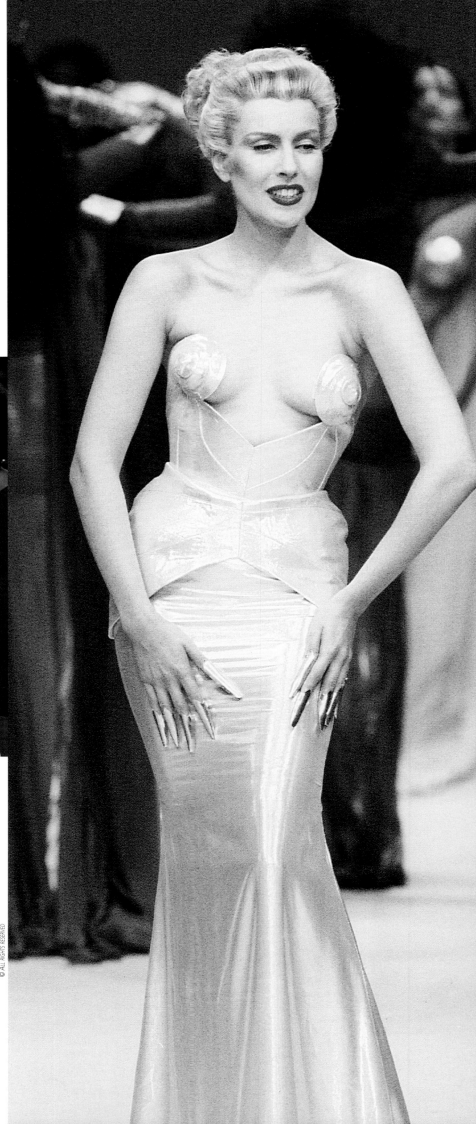

© ALL RIGHTS RESERVED

1995

BELOW: *Robot couture* dress. Fall/Winter collection 1995-1996. "This collection, which costs the trifling sum of ten to thirteen million francs, took me six months of work. Today, everyone is interested in fashion, yet at the same time no one really cares. People forget that it is both an art and a science, an ongoing research into modern techniques that renews fashion and moves it forward."
THIERRY MUGLER

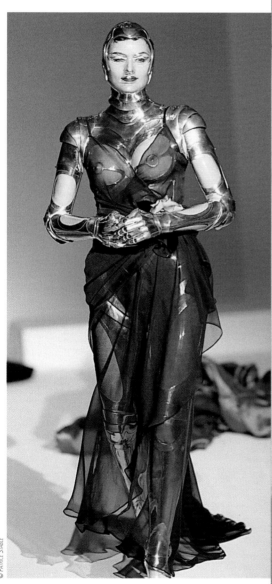

1997

RIGHT: *Chimère couture* evening gown. Fall/Winter collection 1997-1998. A fantasy articulated animal sheath.

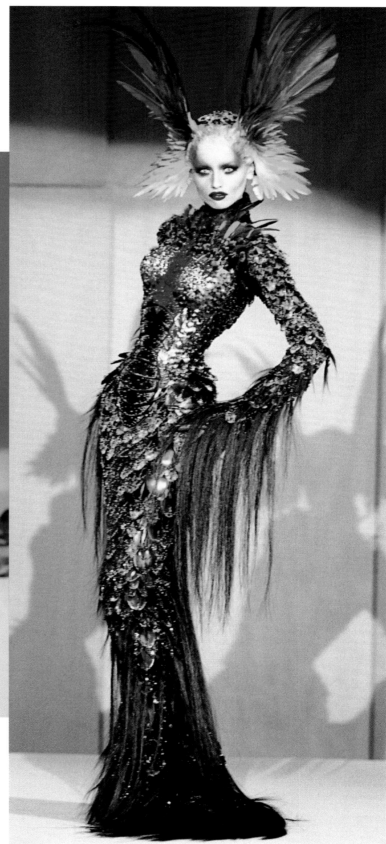

VIVIENNE WESTWOOD

(Glossup, Derbyshire, England, 1941)

"Chanel probably designed for the same reasons that I do really:
irritation with orthodox ways of thinking and a certain perversity.
She was a street-fashion designer."

VIVIENNE WESTWOOD

Vivenne Westwood is provocative, eccentric, and passionate. The great priestess of punk likes to play with extremes: masculine-feminine, dressed-undressed. Breasts, hips, and waist are key points in her look, the places where she overlays and juxtaposes shapes. She combines anarchic collages and mixed-up styles with past and contemporary elements. Removed from their original context, they form the subtext of the stories she presents at each collection. A supporter of the "total look" brand of fashion,

1996
Fall/Winter collection
1996-1997.
Drawing by the illustrator
Ruben Toledo for
the "Tempest in a Teapot"
collection.

Westwood designs with a view to the overall picture: hair style, hat, makeup, jewelry, and shoes. A self-taught designer, she concocts complex scenarios that oppose the status quo and challenge the traditional ideals of feminine beauty. Westwood was the first to show undergarments worn on top of clothes and demonstrates her avant-garde bent through layers, platform shoes, and wide hips.

Vivienne Isabel Swire was seventeen when her family moved to London. She was

© ALL RIGHTS RESERVED

working as a teacher, augmenting her salary by designing jewelry for the Portobello Road market. Meeting Malcolm Edwards, alias Malcolm McLaren, in the late 1960s was a decisive event. In 1971, they opened a shop at 430 King's Road, a mythical address that changed names and decor according to the whims of the two partners. For them, music and clothing were inseparable. While recognized fashion was promoting a hippie look, Westwood and McLaren opened Let It Rock, selling objects, clothes, and records from the 1950s. The following year, they renamed the boutique Too Fast To Live, Too Young To Die and shifted to a harder, rock-inspired style with T-shirts emblazoned with provocative slogans and studded leather clothes weighed down with chains and zippers. A precursor of the punk movement, Sex (the name of the shop in 1974) became *the* boutique specializing in fetishism. She offered sado-masochistic leather and latex outfits as well as T-shirts sporting pornographic images. Malcolm McLaren started the Sex Pistols group, which crystalized the punk movement and its violent nihilism. The immense popularity of these outrageous clothes—which were ripped, torn, and lacerated—sprang from Seditionaries, as the shop was named in 1977. In March of 1981, they designed the "Pirate" collection, which heralded a neo-romantic look and finally brought Westwood international recognition. "Savages" (1981), "Buffalo Girls"

(1982), and "Hobos" (1983) reflected their goal of creating a tribal look. The boutique was then renamed World's End. In 1982, a second boutique, named Nostalgia of Mind, was opened. It closed the following year, effectively confirming Westwood's separation from Malcolm McLaren. Westwood continued to create under her own name and established her own identity, based on historical and cultural references that she reworked into a contemporary context. Her 1985 "Mini-crini" collection marked a return to traditional cutting techniques. Mini-crinolines and hooped skirts were used to sculpt the body, while she shifted the exaggerated shoulder line toward the waist. She has been showing her collections in Paris since 1983, with a short break from 1987 to 1990. Named British Designer of the Year in 1990 and 1991, Vivienne Westwood also received the Order of the British Empire (OBE) from Queen Elizabeth II.

1987

"Harris Tweed" Fall/Winter collection 1987-1988. Westwood adopts the corset and platform shoes known as Rocking horses.

1982

RIGHT:

"Buffalo Girls" Fall/Winter collection 1982-1983. Bras worn over sweaters launch the idea of inside-out and vice versa.

© ALL RIGHTS RESERVED

© ALL RIGHTS RESERVED

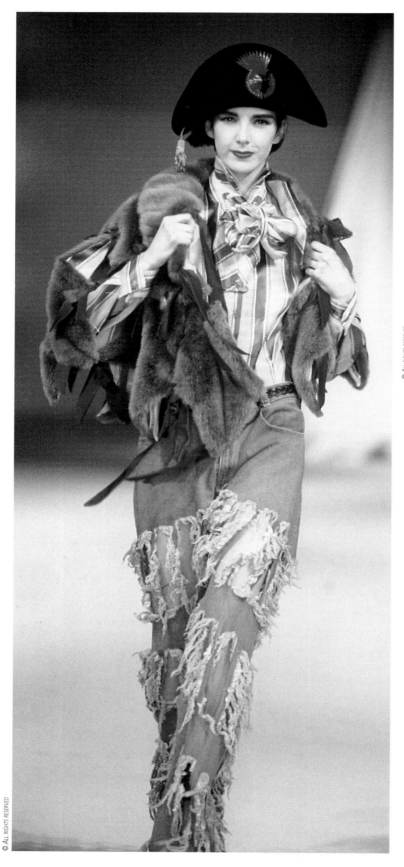

© ALL RIGHTS RESERVED

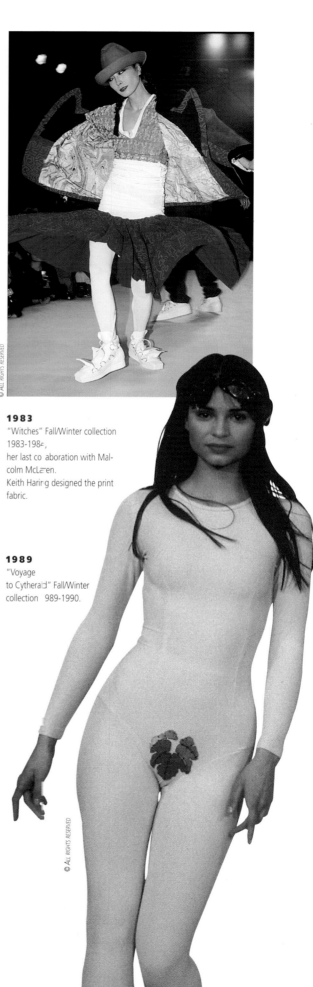

© ALL RIGHTS RESERVED

1983
"Witches" Fall/Winter collection
1983-1984,
her last collaboration with Mal-
colm McLaren.
Keith Haring designed the print
fabric.

1989
"Voyage
to Cytherad" Fall/Winter
collection 989-1990.

© ALL RIGHTS RESERVED

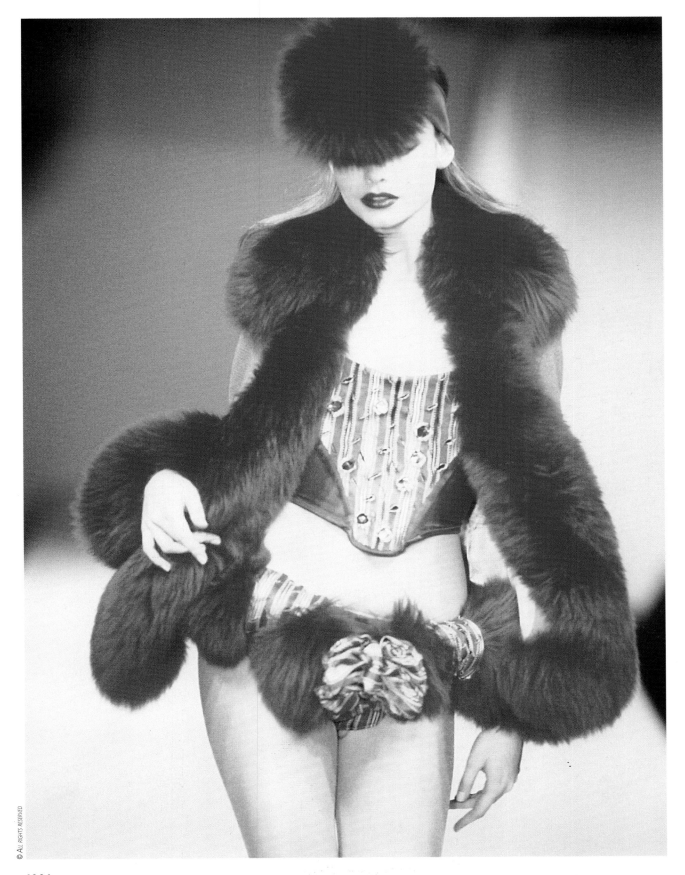

1991
"Dressing-Up" Fall/Winter collection 1991-1992. "Seventy-year-old women are my favorite clients." VIVIENNE WESTWOOD

© ALL RIGHTS RESERVED

VIVIENNE WESTWOOD

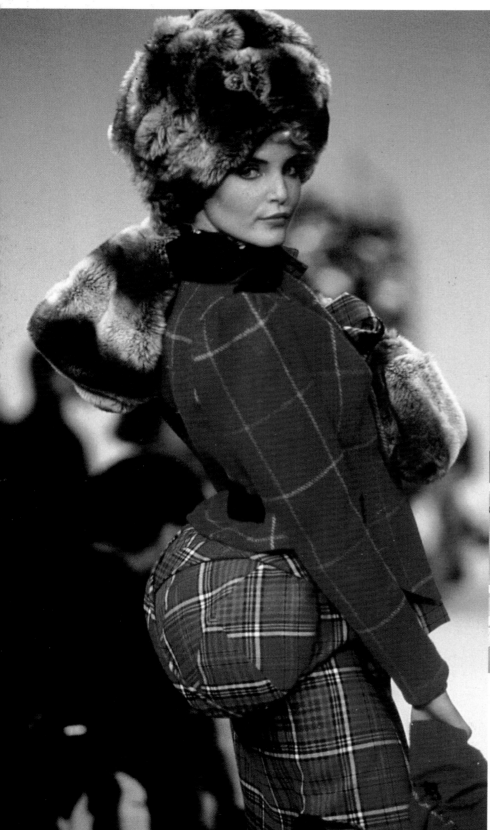

© ALL RIGHTS RESERVED

1994

"On Liberty" Fall/Winter
collection 1994-1995.
Bustles, prosthetics, and
humor are associated
with conservative Scottish plaids.

1988

"Pagan I" Spring/Summer collection.

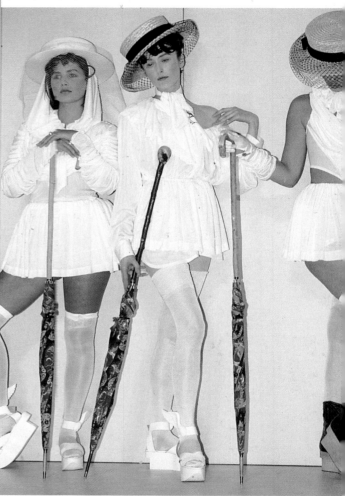

© ALL RIGHTS RESERVED

1997

OPPOSITE PAGE:
"Five Centuries Ago" Fall/Winter
collection 1997-1998.

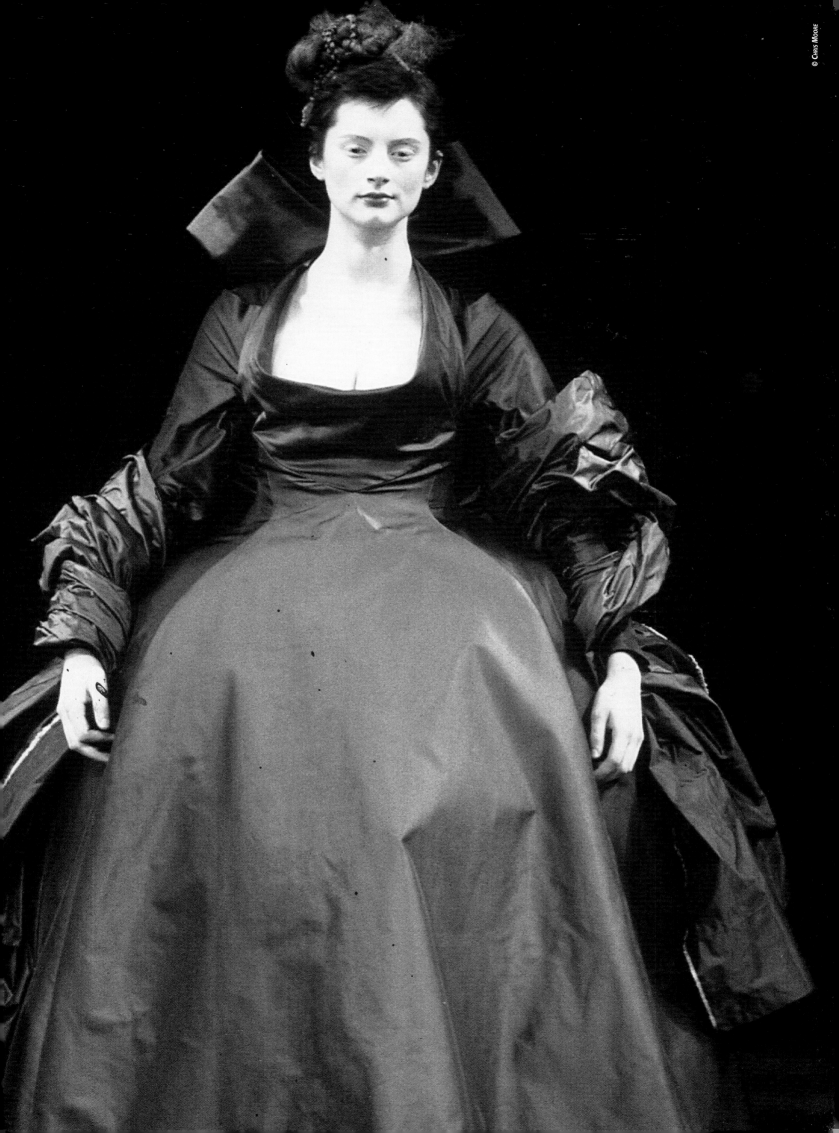

© CHRIS MOORE

YOHJI YAMAMOTO

(Tokyo, Japan, 1943)

"Space is movement."

YOHJI YAMAMOTO

With an austere, sober style, Japanese designer Yohji Yamamoto is part of a movement that liberated fashion from the shackles of Western tradition. He deconstructed the forms of the silhouette to create a new definition of beauty. In 1970, he started designing clothes for women, showing his first collection in Tokyo in 1977 and then in Paris in 1981.

Asymmetry, the basic element of his design, unbalances the proportions to create a different sense of movement. He believes that these irregularities allow for a kind of communication prohibited by a symmetry based on an inhuman and frightening form of perfection. Using a minimalist approach to forms and constantly juggling lines, materials, and colors, Yamamoto pursues his abstract vision of structure in which the body is secondary.

According to Yamamoto, two "colors" facilitate his process: black and white. Black is a reference to the traditional Japanese *bunraku* theater, where figures dressed entirely in black accompany and prepare the main characters on stage. Black is also considered to be a sum of all other colors, the final shadow and silhouette. White is associated with light. Colors are perceived as illusions created by light; they are unreal and have no place in a question for authenticity. This tightly restricted palette underlines his pared-down, harmonious forms.

The starting point for his designs is the fabric itself. Its nobility dictates the ultimate look. The designer's work consists in creating a relationship between the fabric and the body, and therefore, the space between the two. Initially inspired by a landscape, Yamamoto then tries to translate its texture. Once he has selected it, he designs the garment with a pen or brush. He creates the form by positioning the heaviest point of the fabric on the collarbone. This draping on the body provides a structure for the modest, sensual forms.

The role of clothing, treated as a "dignified accessory," is not to decorate and embellish the body; rather, it should allow the personality of the wearer to come through. The layered fabrics convey a playful, mysterious dimension to a silhouette firmly anchored in its time.

© ALL RIGHTS RESERVED

1985

LEFT:
Drawing by the designer.
"I want people to walk by, setting their heels down first. With high heels, the calf muscle seems overly developed, and I don't like to see a high-heeled woman walking in front of me; all I see are her calves. She immediately seems older, terrifying."
YOHJI YAMAMOTO

1983

RIGHT:
The look that defines his style "is that of vagabonds, gypsies, travelers, all those who carry their lives on their backs. It's the perfect piece of clothing for everything they own, their memories, their treasures, their secrets: nothing better can ever be made."
YOHJI YAMAMOTO

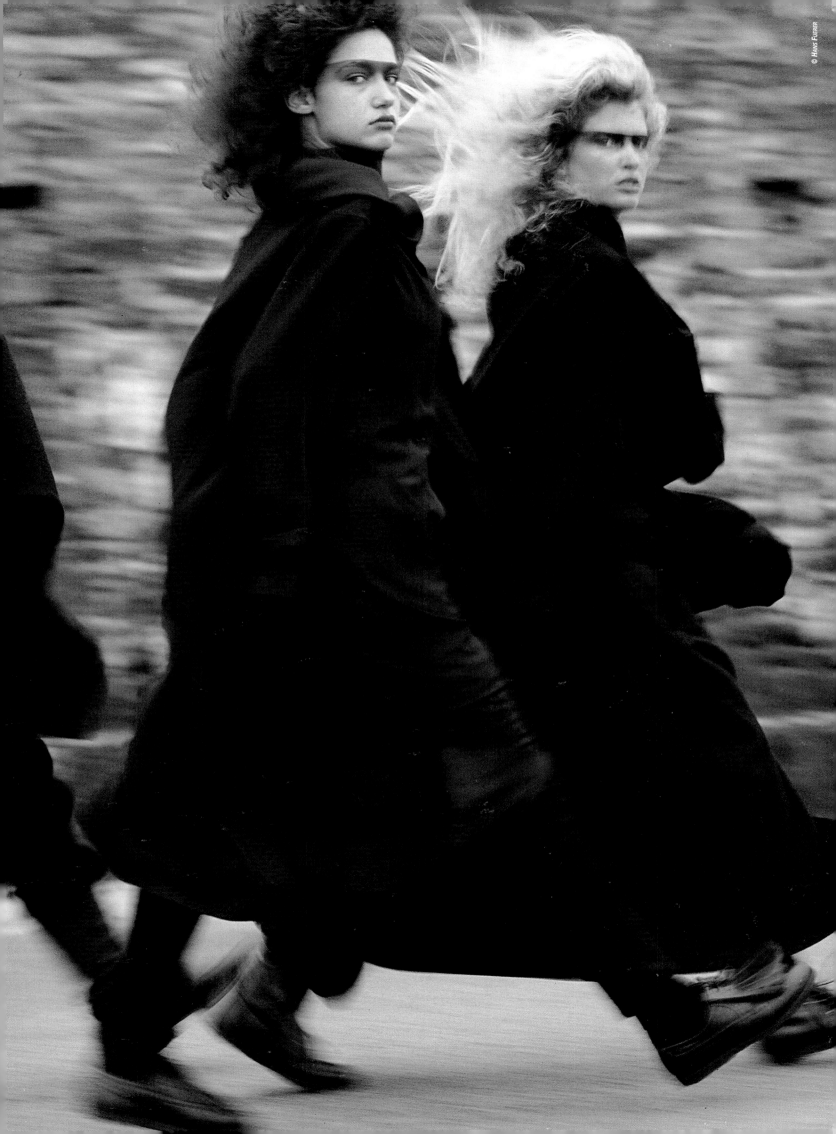

© Hans Feurer

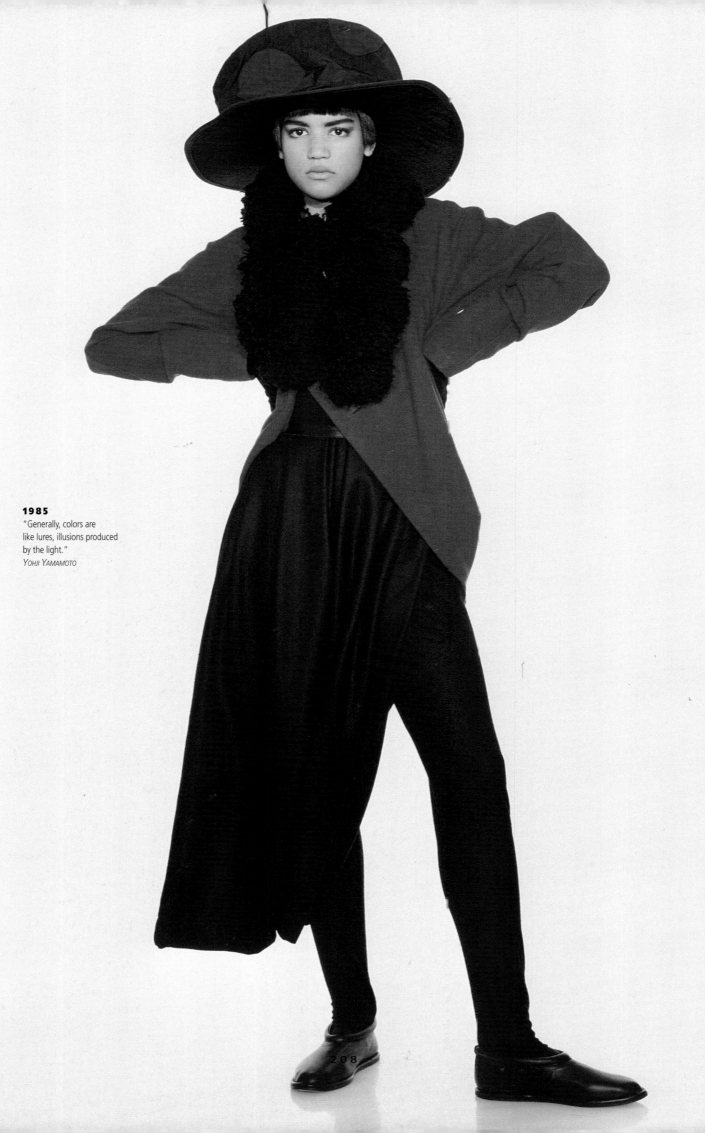

1985

"Generally, colors are like lures, illusions produced by the light."
Yohji Yamamoto

© PATRICK DEMARCHELIER

208

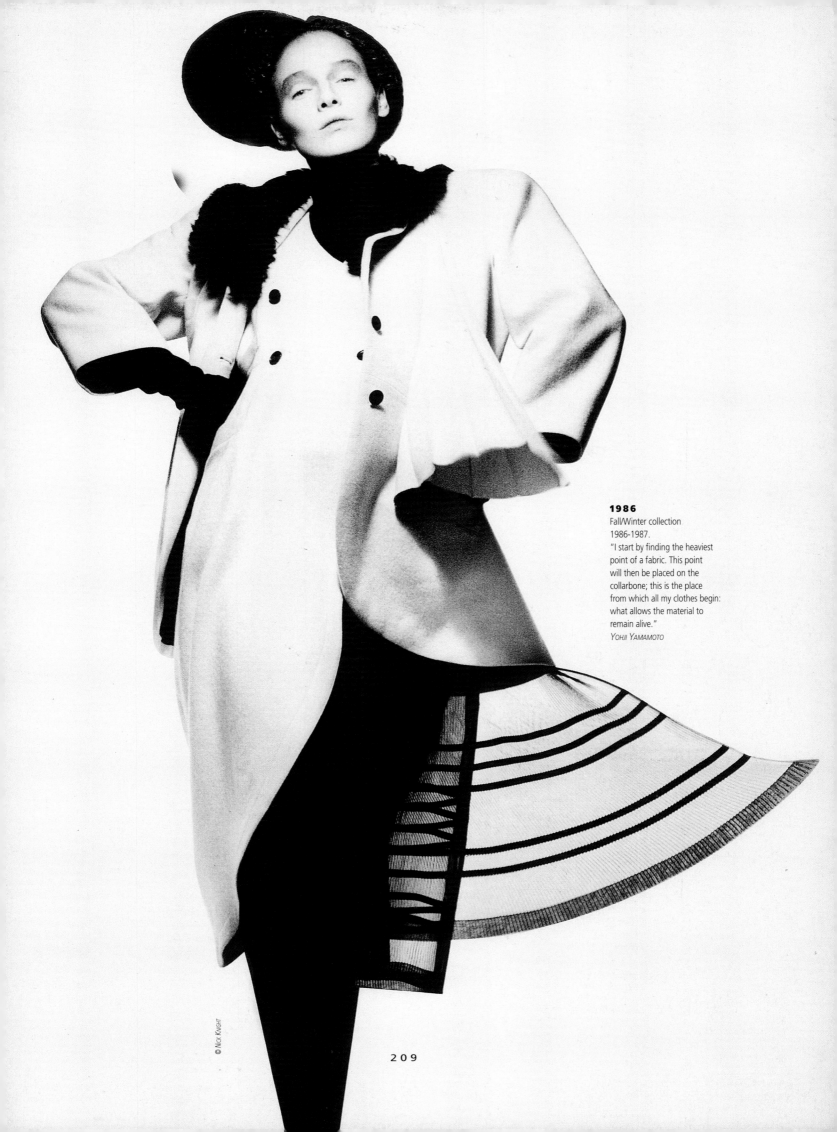

1986
Fall/Winter collection
1986-1987.
"I start by finding the heaviest
point of a fabric. This point
will then be placed on the
collarbone; this is the place
from which all my clothes begin:
what allows the material to
remain alive."
YOHJI YAMAMOTO

209

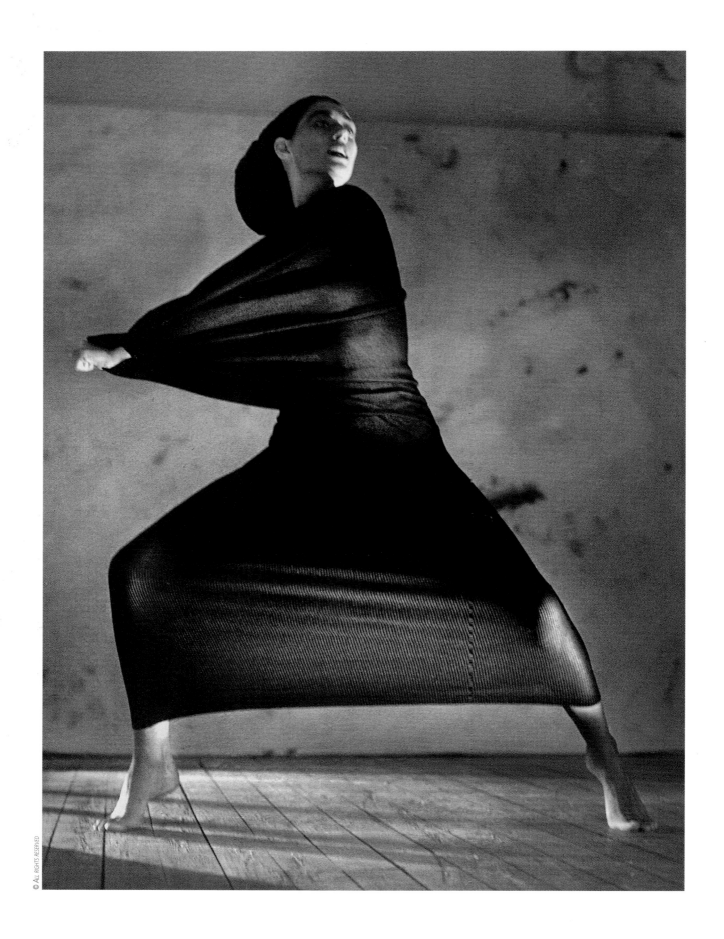

© ALL RIGHTS RESERVED

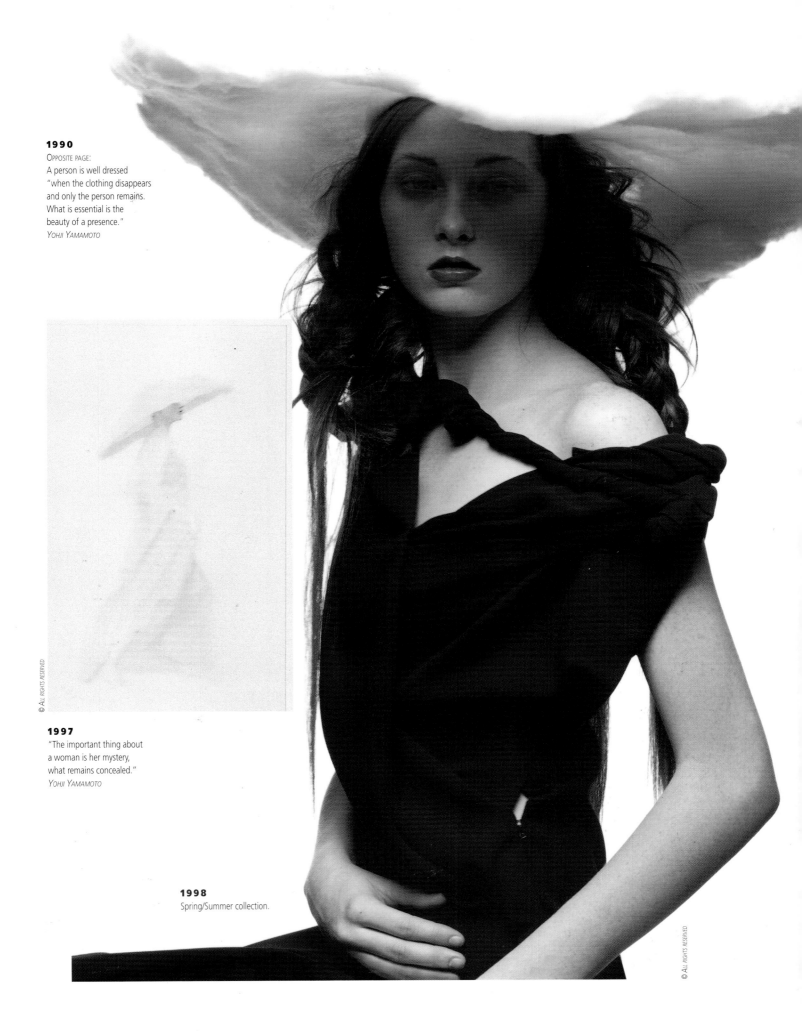

1990

Opposite page:
A person is well dressed
"when the clothing disappears
and only the person remains.
What is essential is the
beauty of a presence."
Yohji Yamamoto

1997
"The important thing about
a woman is her mystery,
what remains concealed."
Yohji Yamamoto

© ALL RIGHTS RESERVED

1998
Spring/Summer collection.

© ALL RIGHTS RESERVED

YVES SAINT LAURENT

(Oran, Algeria, 1936)

"Yves Saint Laurent's great talent has been to give
an aristocratic allure to the affectations of his time."

LUCIEN FRANÇOIS

Yves Saint Laurent, the direct heir to the couture tradition of Gabrielle Chanel, Cristobal Balenciaga, and Christian Dior, has explored, discovered, and refined the infinite possibilities of his vocabulary over his forty-year career. Appropriating the signs and codes of his era, he has written the basic grammar for the contemporary wardrobe and has imposed his own language, an obligatory reference of the twentieth century. Seeking a uniform of elegance, Saint Laurent combines the highest possible technical standards with extremely sophisticated forms to create impeccably cut, well-proportioned clothes. The beauty of the outfit is meant to showcase the wearer.

After earning his baccalaureate in philosophy from the Lamoricière lycée in Oran, Algeria, Yves-Mathieu Saint Laurent moved to Paris in 1953. The following year, he won first prize in the "dress" category of the International Wool Secretariat competition. In June of 1955, he was hired by Christian Dior as assistant designer, then became chief designer for the fashion house when his mentor died in 1957. In late January, 1958, he showed his first collection, the "Trapeze" line, which rocketed him to international fame and assured his position as Christian Dior's successor. In 1960, his beatnik-inspired collection was misunderstood. He left the fashion house to perform his military service. On his return, in July of 1961, he became partners with Pierre Bergé and created his own fashion house. The official inauguration took place in December 1961. One month later, he launched his first collection, which was instantly successful. In 1966, Yves Saint Laurent, receptive to the changing demands of his clientele, designed a line of luxury ready-to-wear clothes—not intended to be a mediocre replica of his haute couture collection, but as a truly separate entity. He inaugurated the first Yves Saint Laurent Rive Gauche boutique, maintaining control of the design, manufacturing and distribution of the clothes—finally producing a high-quality product for a rapidly growing sector.

Saint Laurent captures the ephemeral through a perpetual quest for beauty. His approach favors a methodical technique, consisting of recurring themes

1955
Fall/Winter collection
1955-1956,
Soirée de Paris evening gown,
Yves Saint Laurent's first dress for
Christian Dior. "Black was the
expression of my first collection;
large black lines that symbolized
the line of a pencil on a white
page: the silhouette at the peak
of its purity."

© ALL RIGHTS RESERVED

presented as homages. Instead of referring directly to his various sources, he draws inspiration from the artists themselves; traces of Braque, Picasso, Matisse, and Mondrian can all be seen in Saint Laurent's styles. He pushes exoticism to its limits and uses the vernacular to illuminate his palette. "Africans," "Russians," and "Chinese" appear as leitmotifs deeply rooted in his work. His innovations can be traced to the masculine wardrobe, which he alters and transposes into tuxedos, pantsuits, safari jackets, and pea jackets to combine masculine and feminine elements into a single design. "Yves Saint Laurent has the brilliance of a poet, and when he dresses a body, he reveals the soul," said Madeleine Renaud.

1968

Fall/Winter collection 1968-1969. "My research is to find basic clothes that never go out of style, so that a woman is always well dressed, no matter what the fashion is, allowing her to mix what she buys with what she already has."

1958

Spring/Summer collection. Yves Saint Laurent's first collection for Christian Dior. The elegance and simplicity of the line is entirely due to the purity of its construction.

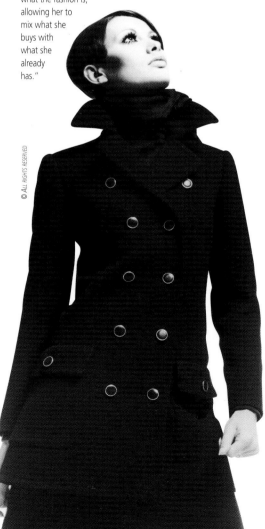

© ALL RIGHTS RESERVED

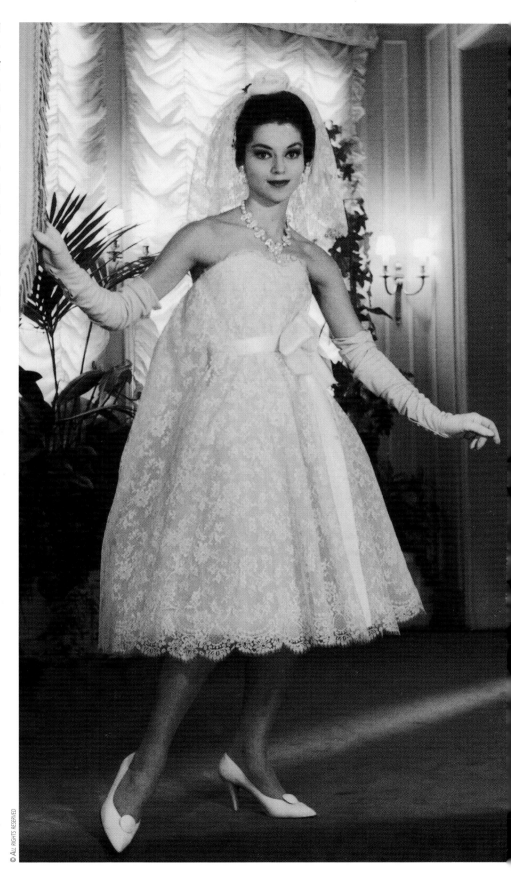

© ALL RIGHTS RESERVED

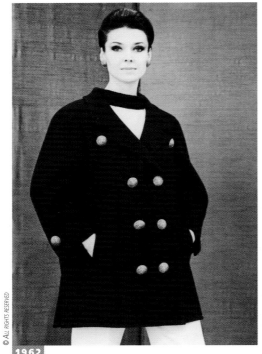

1962

© ALL RIGHTS RESERVED

1964

© ALL RIGHTS RESERVED

1968
The safari jacket becomes a classic for both daywear and eveningwear.

© ALL RIGHTS RESERVED

1964
"For me, the model is essential. Without a live model, I could not create a dress, because it wouldn't have any life; this is how I differ from many couture designers, who work on wood mannequins. I can only work with people who inspire me."

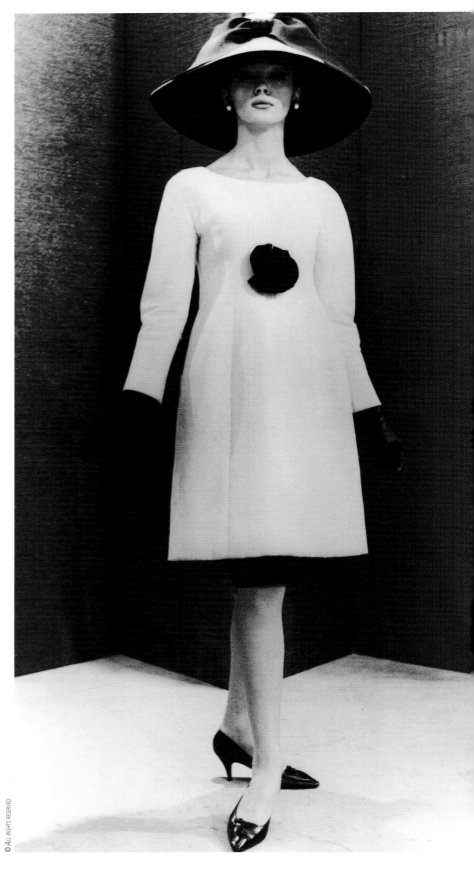

© ALL RIGHTS RESERVED

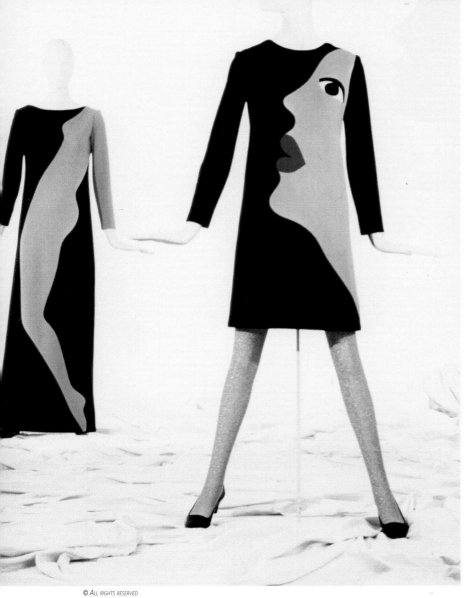

© *All rights reserved*

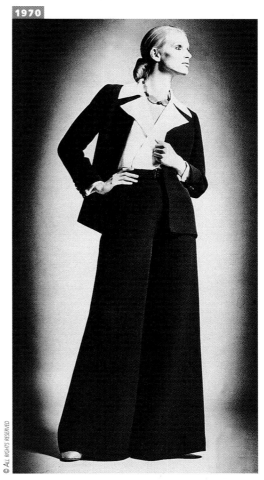

© *All rights reserved*

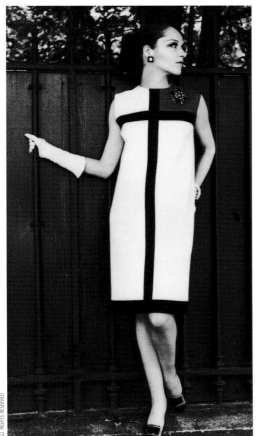

© *All rights reserved*

1966

"Pop Art" Fall/Winter collection 1966-1967, inspired by Andy Warhol, Roy Lichtenstein, and Tom Wesselmann.
"Like any contemporary designer, Saint Laurent plays with references, sophisticates the art and the culture of his time."
Diana Vreeland

1965

"Mondrian Fall/Winter collection 1965-1966.
"As opposed to what people may think, the strict lines of the paintings go very well with the female body."
Yves Saint Laurent

1969

Bust sculpted by Claude Lalanne, Fall/Winter collection 1969-1970.

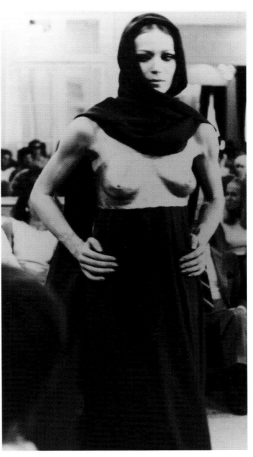

© *All rights reserved*

YVES SAINT LAURENT

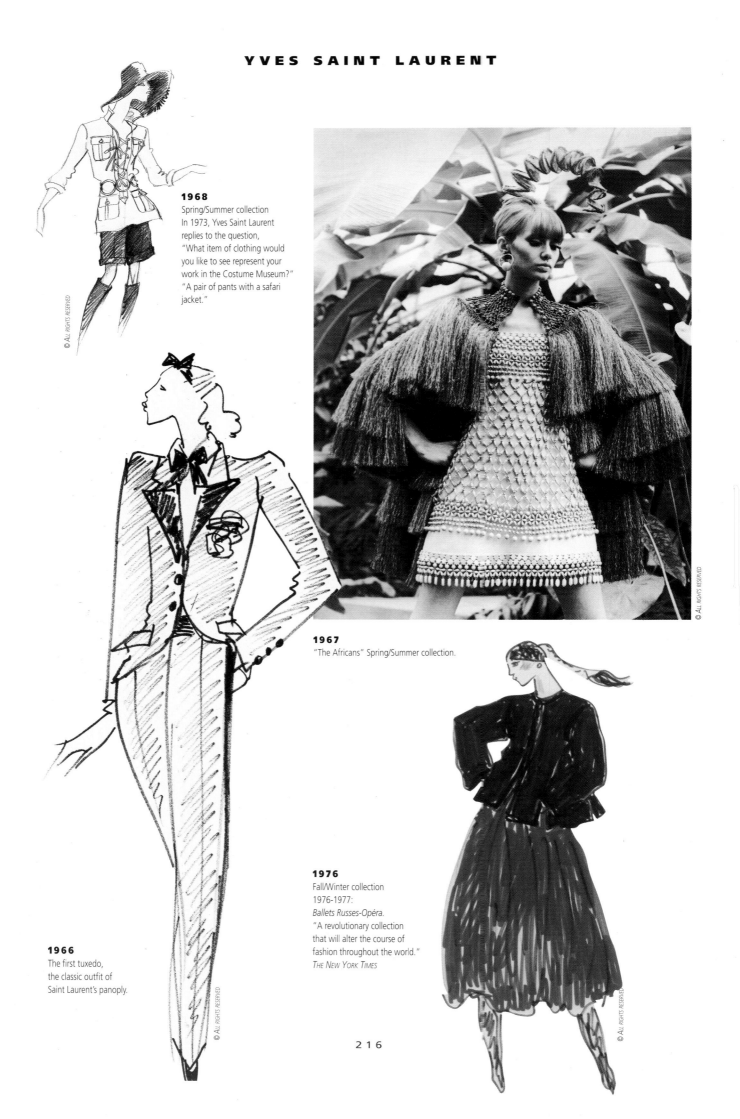

1968
Spring/Summer collection
In 1973, Yves Saint Laurent
replies to the question,
"What item of clothing would
you like to see represent your
work in the Costume Museum?"
"A pair of pants with a safari
jacket."

© ALL RIGHTS RESERVED

1967
"The Africans" Spring/Summer collection.

© ALL RIGHTS RESERVED

1976
Fall/Winter collection
1976-1977:
Ballets Russes-Opéra.
"A revolutionary collection
that will alter the course of
fashion throughout the world."
THE NEW YORK TIMES

1966
The first tuxedo,
the classic outfit of
Saint Laurent's panoply.

© ALL RIGHTS RESERVED

© ALL RIGHTS RESERVED

216

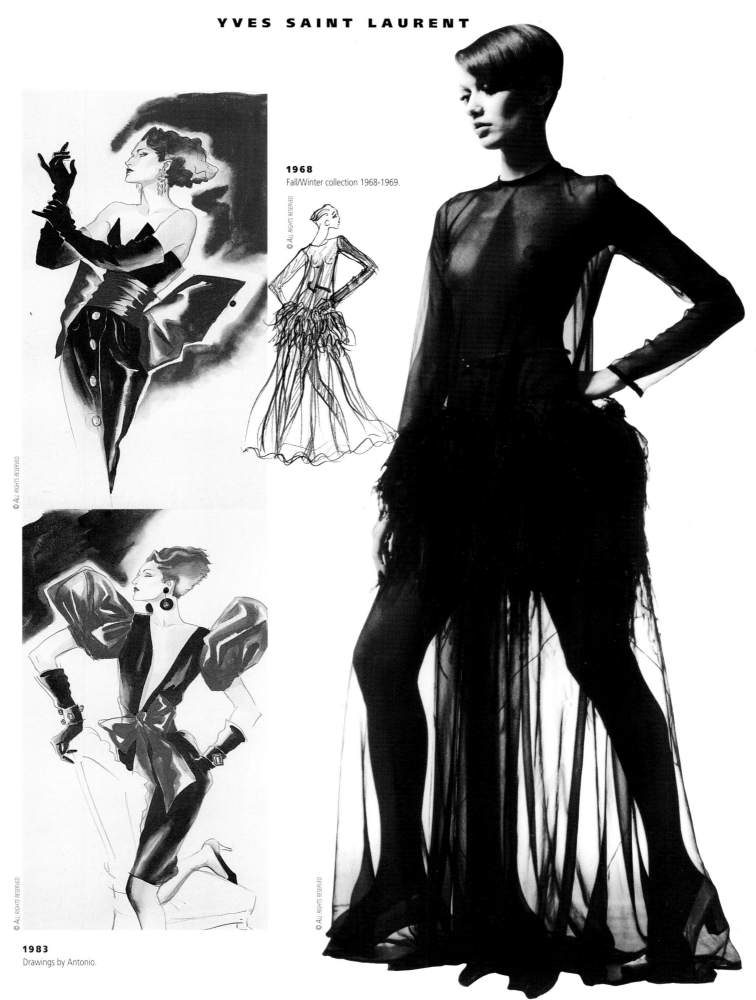

1968
Fall/Winter collection 1968-1969.

© ALL RIGHTS RESERVED

1983
Drawings by Antonio.

YVES SAINT LAURENT

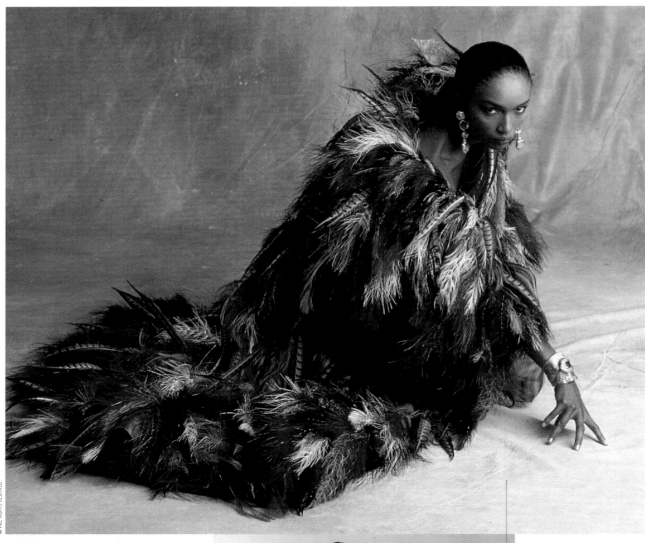

© ALL RIGHTS RESERVED

1990
Fall/Winter collection 1990-1991.

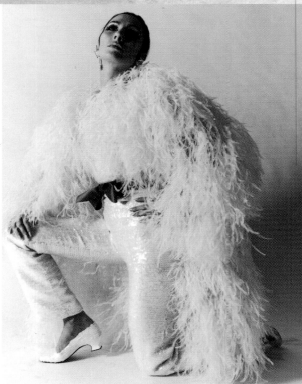

© ALL RIGHTS RESERVED

1968
Spring/Summer collection.

1979
OPPOSITE PAGE:
Fall/Winter collection
1979-1980, a tribute to
Sergei Diaghilev and his
work with Pablo Picasso.
"In a certain way, with maturity
I have become a painter. Even
more than the beauty of the
line, it is the relationship with
the material that fascinates me."
YVES SAINT LAURENT

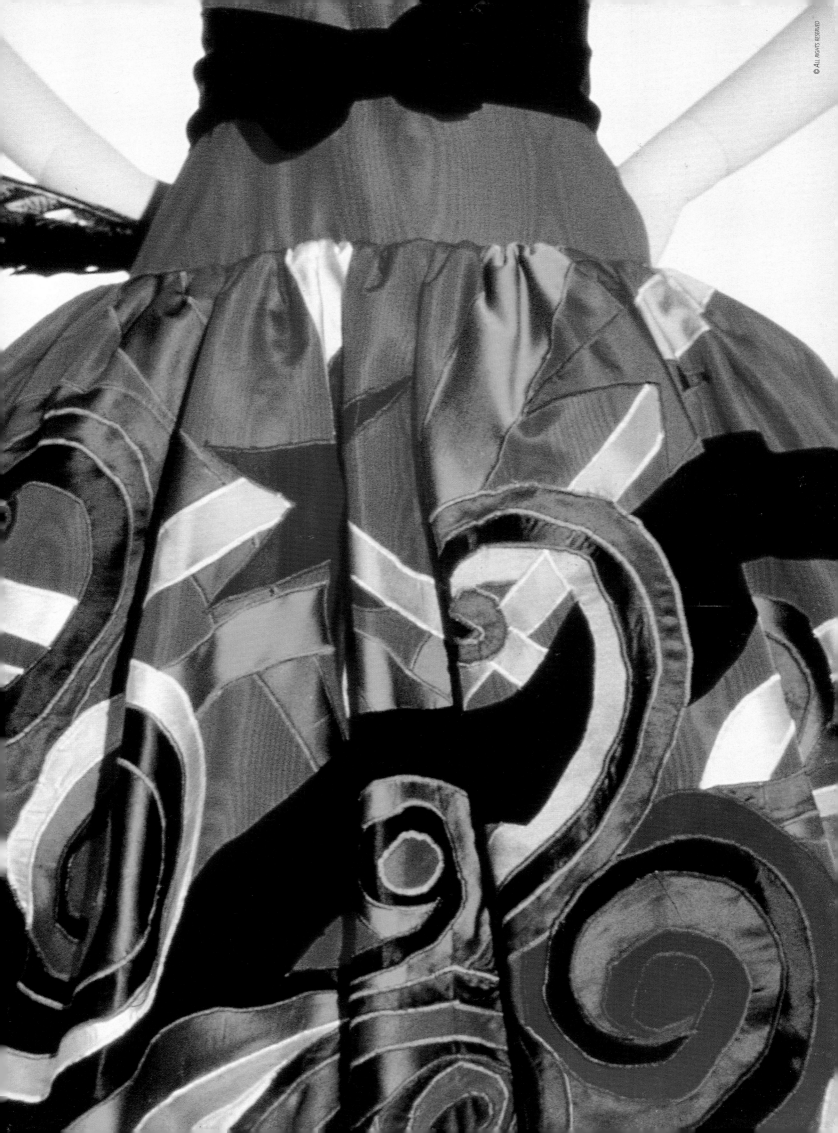

© ALL RIGHTS RESERVED

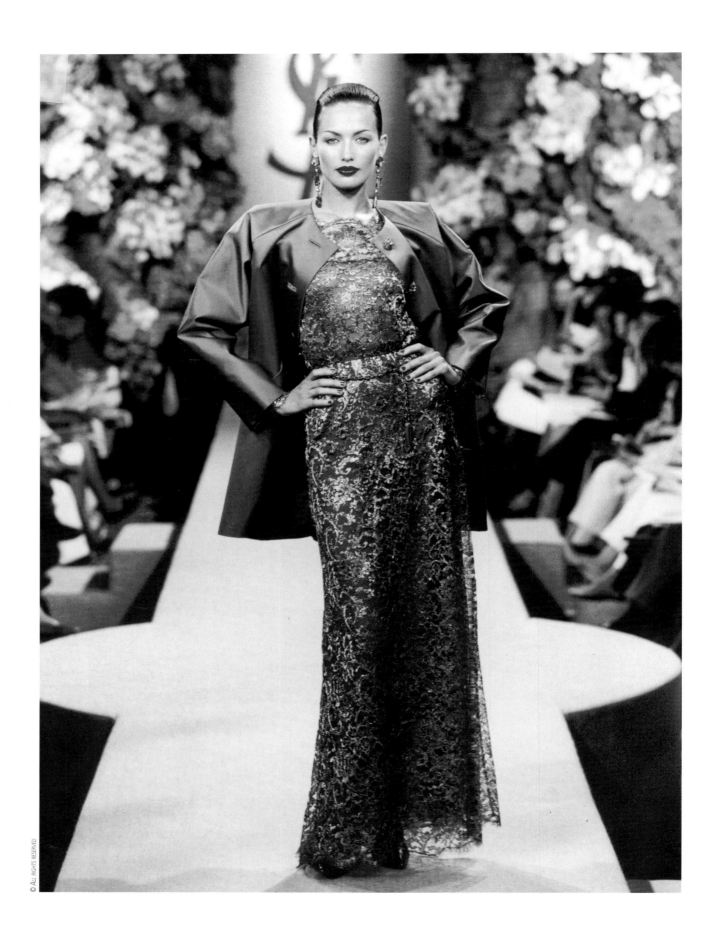

© ALL RIGHTS RESERVED

1998

LEFT:

Fall/Winter collection
1998-1999.

"At the school of Dior and
Chanel, I learned to free myself
from the limits of the drawing,
to become more sensitive to
the material, the color, the music,
and the body of the model."

YVES SAINT LAURENT

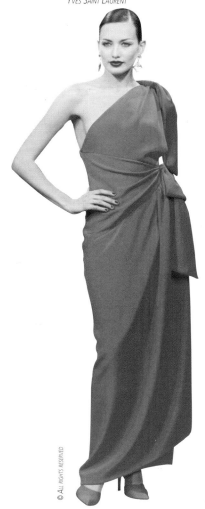

© ALL RIGHTS RESERVED

1999

ABOVE:

Spring/Summer collection.
"It is the woman who is
important, not the dress.
There are women who don't
have money, who can't
dress up, yet are marvelously
elegant in their movements
and their intelligence."

YVES SAINT LAURENT

BIBLIOGRAPHY

BALMAIN, Pierre. *My Years and Seasons*, Cassell & Company Ltd., London, 1964.

BENAÏM, Laurence. *Yves Saint Laurent*, Grasset, Paris, 1993.

CHARLES-ROUX, Edmonde. *L'Irrégulière*, Grasset, Paris, 1974.

COLEMAN, Elizabeth Ann. *The Genius of Charles James*, Holt, Rinehart and Winston, New York, 1982.

COMBRAY, Richard de. *Armani*, Franco Maria Ricci ed., Milan, 1982.

DELPBOURG-DELPHIS, Marylène. *La Mode pour la vie*, éd. Autrement, Paris, 1983.

DIOR, Christian. *Christian Dior et moi*, bibliothèque Amiot-Dumont, Paris, 1956.

DIOR, Christian. *Je suis couturier*, éd. du Conquistador, Paris, 1951.

DU ROSELLE, Bruno. *La Mode*, Imprimerie nationale, Paris, 1980.

GAULTIER, Jean-Paul. *À nous deux la mode*, Flammarion, Paris, 1990.

GIVENCHY: 40 ans de création. Musée de la Mode et du Costume, Paris-Musées, 1991.

GRUMBACH, Didier. *Histoires de la mode*, éd. du Seuil, Paris, 1993.

GUILLAUME, Valerie. *Jacques Fath*, éd. Paris-Musées/Adam Biro, Paris, 1993.

HOLBORN, Mark. *Issey Miyake*, Taschen, Germany, 1995.

JOUVE, Marie-Andrée, and DEMORNEX, Jacqueline. *Balenciaga*, éd. du Regard, Paris, 1988.

KAMITSIS, Lydia. *Paco Rabanne*, éd. Michel Albert, Paris, 1996.

KOIKE, Kazuko, ed. *Issey Miyake East Meets West*, Heibonsah Ltd, Tokyo Pub., 1978.

LACROIX, Christian. PÊLE-MÊLE, Thames & Hudson Ltd., London 1992.

LACROIX, Christian. *Journal d'une collection*, Thames & Hudson, Paris, 1996.

LEMOINE-LUCCIONI, Eugénie. *La Robe. Essai psychanalytique sur le vêtement* (followed by an interview by André Courrèges), éd. du Seuil, Paris, 1983.

MCCARDELL, Claire. *What Shall I Wear? The What, Where, When, and How Much of Fashion*, Simon and Schuster, New York, 1956.

MENDES, Valerie. *Pierre Cardin. Past Present Future*, Dick Nishen Pub., London, 1990.

MORAND, Paul. *L'Allure de Chanel*, Hermann, Paris, 1977.

PARMAL, Pamela A. *Geoffrey Beene*, Museum of Art, Rhode Island School of Design, Providence, 1997.

PIAGGI, Anna. *Karl Lagerfeld: journal de mode*, Office du livre, Switzerland, 1986.

POCHNA, Marie-France. *Christian Dior*, Flammarion, Paris, 1994.

SPANIER, Ginnette. *It Isn't All Mink*, Random House, New York, 1960.

STEELE Valerie. *Women of Fashion: Twentieth Century Designers*, Rizzoli Int. Pub, Inc, New York, 1991.

TRACHTENBERG, Jeffrey A. *Ralph Lauren, The Man Behind the Mystique*, Little, Brown, New York, 1988.

TRAIN Susan, ed. *Le Théâtre de la mode*, Paris, éd. du May, 1990.

TSURUMOTO, Shozo, ed. *Issey Miyake Bodyworks*, Shogakukan Pub. Ltd., Tokyo,1983.

VEILLON, Dominique. *La Mode sous l'Occupation*, éd. Payot, Paris, 1990.

Album du musée de la Mode et du Textile (L'), Union Centrale des Arts Décoratifs-RMN, 1997.

Hommage à Balenciaga. Musée Historique des Tissus de Lyon, September 28, 1985 - January 6, 1986, Herscher Éd., Paris.

Hommage à Christian Dior 1947-1957, Musée des Arts de la Mode, Palais du Louvre, March 19 - October 4, 1987.

Nos années 80, Musée des Arts de la Mode, Paris, November 29, 1989 - April 1, 1990.

Pierre Balmain: 40 années de création, Musée de la Mode et du Costume, Palais Galliera, December 20, 1985 - April 6, 1986.

Issey Miyake & Miyake Design Studio, 1970-1998, Obunsha, Tokyo, 1985.

Yves Saint Laurent par Yves Saint Laurent, Musée des Arts de la Mode, May 30 - October 26, 1986, Herscher Éd., Paris, 1986.

Yves Saint Laurent, Metropolitan Museum of Art, December 14, 1983 - September 2, 1984, Clarkson N. Potter, Inc., New York.

PHOTOGRAPHIC CREDITS

The publisher would like to apologize to the photographers whose works are credited with "all rights reserved." We did not have all the necessary information when the illustrations were sent for photogravure. Below is a a complete, page-by-page list of photographic credits for each image published in this book.

All rights reserved for those documents for which we could not identity the source. Any rightful owners that we could not find, despite our efforts, are asked to contact the publisher.

t.: top; b.: bottom; r.: right; l.: left; m.: middle.

All rights reserved for the sketches illustrating the introduction.

ALAÏA
p. 16, t. Arthur Elgort/Vogue Paris (February 1983), b. Gilles Bensimon Scoop/Elle; p. 17, l. Bill King/Vogue Paris (August 1986), r. Illustration Gérard Failly; p. 18, Gilles Bensimon/US Elle (May 1992); p. 19, l. Albert Watson/Vogue Paris (April 1985), r. © Agence Gamma; p. 20, Marie Claire © Jean-Noël L'Harmeroult; p. 21 r. and l. Ilvio Gallo/Archives Alaïa.

BALENCIAGA
All the photographs are by Jean Kublin/Archives Balenciaga with the exception of: p. 23, t. Balkin/Vogue Paris (May-June 1947); p. 27, b. Henry Clarke/Vogue Paris (September 1951) © Adagp, Paris 1999.

CALVIN KLEIN
p. 30, Archives Calvin Klein; p. 31, l. Arthur Elgorth © 1983 by The Condé Nast Publications, Inc., tr. Peter Lindbergh/Archives Calvin Klein, br. Illustration, DR: pp. 32-33, Richard Avedon/Archives Calvin Klein.

CHANEL
p. 34, l. collection Georges Bernstein-Grüber © Chanel, r. © British Vogue/The Condé Nast Publications Ltd; p. 35, tl. coll. Georges Bernstein-Grüber © Chanel, m. Hulton Getty/Fotogram Stone Images, tr. Courtesy Vogue Paris; p. 36, m. Jean Cocteau/Archives Chanel © Adagp, Paris 1999, tr. Courtesy Vogue Paris; p. 37, tl. Archives Chanel, bl. Mademoiselle Chanel, circa 1930, DR, r. Courtesy Vogue Paris; p. 38, r. Courtesy Vogue Paris, l. Illustration Drian for L'Officiel 1932; p. 39,

l. Horst P. Horst, Courtesy Vogue Paris, tr. Henry Clarke/Vogue Paris March 1971 © Adagp, Paris 1999, br. Françcis Kollar © Ministère de la culture – France; p. 40, tl Clarke/Vogue Paris March 1971 © Adagp, Paris 1999, b.n Echo de la Mode, 1965 private coll., tl private coll., bl. Helmut Newton/Vogue Paris September 1964; br. Frances MacLaughlin/Vogue Paris September 1956; p. 41, Botti/Stills Press Agency.

CHARLES JAMES
p. 42, t. Photograph courtesy the Brooklyn Museum of Art, b. Illustration Bill Wilkinson Photograph courtesy the Brooklyn Museum of Art; p. 43, Cecil Beaton Photograph courtesy of Sotheby's London; p. 44, tl. Louise Dahl-Wolfe courtesy the Brooklyn Museum of Art, tr. John Rawlings courtesy the Brooklyn Museum of Art, b. Illustration Antonia/Archives Paul Caranicas; p. 45, Horst P. Horst © 1949 (Renewed 1977) by the Condé Nast Publications, Inc; p. 46, Louise Dahl-Wolfe (private coll.) ; p. 47, Prigent, the Brooklyn Museum of Art; pp. 48-49, Cecil Beaton © 1948 (Renewed 1976) by the Condé Nast Publications, Inc.

CHRISTIAN DIOR
p. 50, l Serge Balkin © 1947 (Renewed 1974) by the Condé Nast Publications, Inc, r. Illustration Christian Bérard "Le Tailleur Bar", coll. Galerie Bartsch & Chariat; p. 51, t. Henry Clarke/Vogue Paris March 1953 © Adagp, Paris 1999, b. Archives Dior; p. 52, l. Frances MacLaughlin/Vogue Paris September 1952, r. Illustration René Gruau "le manteau" coll. Laure Hertzberger; p. 53, Willy Maywald © Association Willy Maywald – Adagp Paris 1999; p. 54 Horst P. Horst/Vogue Paris October 1952, pp. 55, 56, 57, Willy Maywald © Association Willy Maywald – Adagp Paris 1999.

CHRISTIAN LACROIX
p. 58, l. Guy Marineau, r. Archives Christian Lacroix p. 59, Guy Marineau Musée de la mode et du textile, collection UFAC; p. 60, Guy Marineau; p. 61, tl. Jean-François Gaté, tr. bl. and r. Guy Marineau; p. 62, sketch/Archives Christian Lacroix, bl. Guy Marineau; p. 63, Guy Marineau.

CLAIRE McCARDELL
p. 64, Illustration Vogue US January 1946; p. 65, Geneviève

Naylor/courtesy Staley-Wise, New York; p. 66, Photo by Irving Solero, courtesy of the Museum at the Fashion Institute of Technology, New York; p. 67, Norman Parkinson © 1950 (Renewed 1978) by the Condé Nast Publications, Inc; p. 68, Photo by Irving Solero, courtesy of the Museum at the Fashion Institute of Technology, New York; p. 69, Prigent © 1952 (Renewed 1980) by the Condé Nast Publications, Inc; p. 70, Horst P. Horst © 1947 (Renewed 1975) by the Condé Nast Publications, Inc; p. 71, John Rawlings © 1947 (Renewed 1975) by the Condé Nast Publications, Inc.

CLAUDE MONTANA
p. 72, l. Les Goldberg, private coll., r. Niall McInerney; p. 73, tl. Fayçal/Archives Montana, bl. Niall McInerney, r. Lothar Schmid; p. 74, Niall McInerney; p. 75, Tyen; p. 76, sketch Archives Montana, bl. Illustration Antonio/collection Paul Caranicas, tr. Graziano Ferrari/Archives Montana; p. 77, tl. and r. Graziano Ferrari/Archives Montana, bl. sketch Archives Montana.

COMME DES GARÇONS
p. 78, Comme des garçons (DR); p. 79, Paolo Roversi; p. 80, l. Craig McDean/A+C Anthology, d Thomas Schenk © CBA; p. 81, Annie Leibovitz/Contact Press Image.

COURRÈGES
p. 82, DR; p. 83, Gunnar Larsen/Musée de la mode et du textile, coll. UFAC; p. 84, l. and tr. Musée de la mode et du textile, coll. UFAC, br. Gunnar Larsen/Musée de la mode et du textile, coll. UFAC; p. 85, Patrick Sauterets, private coll.

DONNA KARAN
p. 86, l. and r. Pierre Sherman/Archives Donna Karan, m. Pierre Sherman/Archives Robert Lee Morris; p. 87, Pierre Sherman/Archives Donna Karan; p. 88, l. Pierre Sherman/Archives Donna Karan, d Herb Ritts/Vernon Jolly; p. 89, Denis Piel.

EMANUEL UNGARO
p. 90, Archives Ungaro; p. 91, IWS/Musée de la mode et du textile, coll. UFAC; p. 92, Musée de la mode et du textile, coll. UFAC; p. 93 tlr. mlr. bl. Archives Ungaro, br. Tony Kent/Archives Ungaro, bl. Peter Knapp/Archives Ungaro; p. 94, tl. Musée de la mode et du textile, coll. UFAC, t. Archives Ungaro, br. Jean-Loup Sieff, bl. Terence

Donovan/Archives Ungaro; p. 95, l. and tr. Archives Ungaro, br. Marc Hispard.

GEOFFREY BEENE
p. 96 l. Niall McInerney, r. Illustration Joe Eula; p. 97, tl. and b. tr. Niall McInerney, br. Penati © by the Condé Nast Publications, Inc; p. 98, Andrew Eccles/Acte II Out Line; p. 99, Jack Deutch.

GIORGIO ARMANI
p. 100, tl. and r. DR, br. Aldo Fallaï/Archives Giorgio Armani; pp. 101, 102, Niall McInerney; p. 103, Albert Watson/Archives Giorgio Armani.

GIVENCHY
p. 104, Archives Givenchy S. A.; p. 105, tl. and br. Archives Givenchy S. A., tr. Seeburger for L'Officiel 1954, bl. Pottier for L'Officiel 1957; p. 106, tl. and r. Pottier for L'Officiel 1957, bl. Yurek for L'Officiel 1957, bm. Archives Givenchy S. A. ; 107, l. private coll., r. Jean-Luc Fornier; p. 108, tl. and bm. DR Illustration for L'Officiel 1958, tr. DR for L'Officiel October 1955, bl. and r. Archives Givenchy S. A.; p. 109, Skrebneski, private coll.

GRÈS
p. 110, l. Archives Grès, r. Eugène Rubin/Archives Grès; p. 111, l. Musée de la mode et du textile, coll. UFAC, r. Archives Grès; p. 112, l. Archives Grès, r. DR/private coll.; p. 113, DR/private coll.; p. 114, l. and r. DR/private coll.; p. 115, DR/private coll..

HALSTON
p. 116, Duane Michaels © 1975 by the Condé Nast Publications, Inc; p. 117, tl. Francesco Scavullo © 1975 by the Condé Nast Publications, Inc, m. The Metropolitan Museum of Art, Gift of Faye Robson, 1993, tr. Women's Wear Daily/Fairchild Publications, bl. Francesco Scavullo © 1974 by the Condé Nast Publications, Inc; pp. 118-119, Duane Michaels © 1974 by the Condé Nast Publications, Inc; p. 120, l. Illustration Kenneth Paul Block, m. Illustration Steven Meisl , r. The Metropolitan Museum of Art, Gift of Jane Holzer, 1993; p. 121, The Metropolitan Museum of Art, Gift of Jane Holzer, 1980.

ISSEY MIYAKE
p. 122, b. Sepp/Scoop Elle, t. Kishin Shinoyama/Archives Issey Miyake; p. 123, l. Kishin Shinoyama/Archives Issey Miyake, r. Sepp/Scoop Elle; pp. 124-125, Kishin Shinoyama/Archives Issey Miyake; p. 126, l. Gilles Tapie/Archives Issey Miyake, r. Albert Watson; p. 127, Christophe Sillem/ Blanpied Rubini.

JACQUES FATH
p. 128, tl. Roger Schall © Jean Frédéric Schall, bl. André Ostier/Thomas Gunther, br. Musée de la Mode et du Textile, coll. UFAC; p. 129, Irving Penn © 1950 by the Condé Nast Publications, Inc; p. 130, bl. Rutledge/Musée de la Mode et du textile, coll. UFAC, d Roger Schall/Musée de la mode et du textile, coll. UFAC; p. 131, t. Willy Maywald © Association Willy Maywald Adagp Paris 1999, r. Musée de la mode et du textile, coll. UFAC; p. 132, Pottier, private coll.; p. 133, Rutledge, private coll.

JEAN-PAUL GAULTIER
p. 134, l. Illustration /Archives Jean-Paul Gaultier, r. Archives Jean-Paul Gaultier; p. 135 l. t. and b. Illustration/ Archives Jean-Paul Gaultier, r. Niall McInerney; p. 136 tl. and b. Archives Jean-Paul Gaultier, r. Illustration Cathy Graham; p. 137, l. and r. Archives Jean-Paul Gaultier, m. Illustration/ Archives Jean-Paul Gaultier; pp. 138-139, Jean-Marie Perrier/Scoop Elle.

JIL SANDER
pp. 140 to 143, all photographs by Alfredo Albertone.

KARL LAGERFELD
p. 144, Illustration Karl Lagerfeld; p. 145, l. private coll., r. Claus Ohm, private coll.; p. 146, l. and r. Niall McInerney, m. © Karl Lagerfeld; p. 147, © Karl Lagerfeld; p. 148, © Karl Lagerfeld; p. 149, Dominique Isserman, tl. © Karl Lagerfeld.

KENZO
p. 150, l. Masanobu Tanaka/Édition Bunka "Kenzo" stylisme: Sueo Irie, tr. RCS/ Giancarlo Bonora, br. Pascal Therme; p. 151, Tatsuo Masubuschi/Édition Bunka "SO-EN" 1971; p. 152, l. Barry Lategan/Scoop Elle, tr. Archives Kenzo, br. Archives Kenzo; p. 153 Archives Kenzo, r. Marie Claire © Jean-Noël L'Harmeroult.

MARY QUANT
All the photographs are from the Mary Quant archives, except for: p. 155, bl. Clive Arrowsmith © British Vogue/The Condé Nast Publications Ltd; p. 156, m. Hulton Getty/Fotogram Stone Images.

NORMAN NORELL
p. 159, Milton H. Greene; p. 160, Bert Stern, private coll.; p. 161, Photo by Irving Solero, courtesy of the Museum at the Fashion Institute of Technology, New York; p. 162, l. private coll., r. Horst P. Horst, 1964 by the Condé Nast Publications, Inc.; p. 163, Louise Dahl-Wolfe, courtesy of the Museum at the Fashion Institute of Technology, New York.

PACO RABANNE
p. 164, t. Guy Marineau/Archives Paco Rabanne, b. Jean Clemmer; p.165 tl. and br. Musée de la mode et du textile, coll. UFAC, tr. Dominique Weitz/ private coll., bl. Michel Béchet; p. 166, DR/private coll.; p. 167, Luc Vassal; p. 168, l. DR/private coll., tr. Alain Dejean/ Sygma, br. sketch Archives Paco Rabanne; p. 169, DR/ private coll.

PIERRE BALMAIN
p. 170, Cecil Beaton Photograph, courtesy of Sotheby's London; pp. 171, 172, 173, Archives Pierre Balmain; p. 174, Henry Clarke/Vogue Paris March 1956 © Adagp, Paris 1999, tr. Musée de la mode et du textile, coll. UFAC; p. 175, Musée de la mode et du textile, coll. UFAC; p. 176, tl. and r. Musée de la mode et du textile, coll. UFAC, bl. Musée de la mode et du textile, coll. UFAC; p. 177, l. Archives Pierre Balmain, r. t. and b. Jean-Daniel Lorieux.

PIERRE CARDIN
p. 178, Van Noppen/Musée de la mode et du textile, coll.UFAC; p. 179, l. J. Melzassard/Archives Pierre Cardin, br. Archives Pierre Cardin; p. 180, l. Archives Pierre Cardin; p. 181, Musée de la mode et du textile, coll. UFAC; p. 182, Ghislain Broulard, Musée de la mode et du textile, coll. UFAC; p. 183, Archives Pierre Cardin.

RALPH LAUREN
p. 184, Duane Michaels © 1975 by the Condé Nast Publications, Inc; p. 185, tl. Illustration Antonio/ coll. Paul Caranicas, tr. bl. and r. Niall McInerney; pp. 186, 187, Niall McInerney.

SONIA RYKIEL
p. 188, Helmut Newton; p. 189, Guy Bourdin; p. 190, Helmut Newton © 1972 by the Condé Nast Publications, Inc.; p. 191 l. Archives Sonia Rykiel, r. Archives Fondation 3 Suisses; p. 192, Dominique Issermann; p. 193, Archives Sonia Rykiel.

THIERRY MUGLER
p. 194, Illustration Thierry Mugler/Archives; p. 195, l. Lothar Schmid, r. Patrice Stable/Archives Thierry Mugler; p. 196, Patrice Stable/Archives Thierry Mugler; p. 197, t. Niall McInerney, bl. and r. Horst P. Horst/Vogue Paris August 1980; pp. 198, 199 l. and r. Patrice Stable/Archives Thierry Mugler.

VIVIENNE WESTWOOD
p. 200, Ruben Toledo; p. 201, m. DR/private coll., r. Niall McInerney; p. 202, l. and br. Christopher Moore Ltd, tr. Niall McInerney; p. 203, Christopher Moore Ltd; p. 204, l. Christopher Moore Ltd, r. Niall McInerney; p. 205, Christopher Moore Ltd.

YOHJI YAMAMOTO
p. 206 Yohji Yamamoto; p. 207, Hans Fuerer; p. 208, Patrick Demarchelier © British Vogue/The Condé Nast Publications Ltd; p. 209, Nick Knight, Art director: Marc Ascoli; p. 210, Javier Vallhonrat/Vogue Paris November 1990; p. 211, l. Paolo Roversi, r. Inez van Lamsweerde & Vinoodh Matadin/A+C Anthology.

YVES SAINT LAURENT
p. 212, Mike Dulmen/Archives Christian Dior couture; p. 213, l. Archives Yves Saint Laurent, r. Willy Maywald © Association Willy Maywald – Adagp Paris 1999; p. 214, Archives Yves Saint Laurent; p. 215, t. and bl. br. Archives Yves Saint Laurent, tr. Guégan for L'Officiel, March 1970; p. 216, Archives Yves Saint Laurent; p. 217 tl. and b. Antonio/coll. Paul Caranicas, m. and r. Archives Yves Saint Laurent; p. 218, t. Jean-Claude Sauer/Scoop Paris Match, b. DR/private coll.; p. 219, Duane Michaels/private coll.; p. 220, Guy Marineau/ Archives Yves Saint Laurent; p. 221, Frédéric Bukajlo/Archives Yves Saint Laurent.

COVER
Paolo Roversi (Yohji Yamamoto).

© page DR/1950 Courtesy the Brooklyn Museum of Art.

INSIDE COVERS
DR.

CONTENTS

ACKNOWLEDGMENTS

The author and publisher would like to express their gratitude
to Sylviane Rochotte for her invaluable assistance.

Special thanks to:
The staff of the Musée de la Mode et du Textile, and Teri Agins, Janie Bain,
Annie Barbera, Safia Bendali, Pierre Bergé, Jean-Pascal Billaud, Elizabeth
Bonell, Katell Le Bourhis, Pierre Buntz, Paul Caranicas, Madame Casiez,
Pat Christman, Patty Cohen, Astrid Combes, Estelle Damlan, Lisa
Davidson, Dominique Deroche, Beth Dincuff, Élite Model Management,
Ford Models, Laure Esnault, Odile Fraigneau, Caroline Fragner, Annie
Goldstein, Cathy Graham, Valerie Guillaume, Michel Hakimian, Susannah
Handley, Susan Hay, Jean-Pascal Hesse, IMG Models, Nathalie Jalowezak,
Jelka Music, Marie-Andrée Jouve, Farida Khelfa, Kathy Kawaja, Christian
Lacroix, Milaine Lajoie, Laurent Latko, Caroline Lebar, Phyllis Magidson,
Marilyn Agency, Richard Martin, Fabien Mage, Rose-Marie Makino-
Fayolle, Niall McInnerney, Patricia Mears, Jacqueline Montana, Denyse
Montegut, Anne-Marie Muñoz, Next Management Paris, Yorgos Nikas,
Maryvonne Numata, Ruth Obadia, Nathalie Ours, Pamela Parmal, Hector
Pascual, Laure de Pavillon, Isabelle Picard, Pier Fillipo Pieri, Rolande
Pozo, Mary Quant, Stefan Reyniak, Arnold Scaasi, Rebecca Schanberg,
Ellen Shanley, Kishin Shinoyama, Irène Silvani, Irving Solero, Valerie
Steele, Kesoki Taketomi, Robert Trifus for their assistance.

Colette Véron, my editor
and François Huertas, my artistic director
who provided advice and friendship throughout the entire project.

PAMELA GOLBIN

EDITOR
Colette Véron
assisted by Brigitte Leblanc
RESEARCH AND DOCUMENTATION
Sylviane Rochotte
GRAPHIC DESIGN AND LAYOUT
François Huertas
ENGLISH TRANSLATION
Lisa Davidson
ENGLISH COPY EDITING
Elizabeth Ayre
PHOTOENGRAVING: PackÉdit, Paris